Photo Restoration and Retouching Using
Corel® PaintShop Photo™ Pro
Second Edition

Learn How to Rescue Old Photos and Improve Your Digital Pictures!

Robert Correll

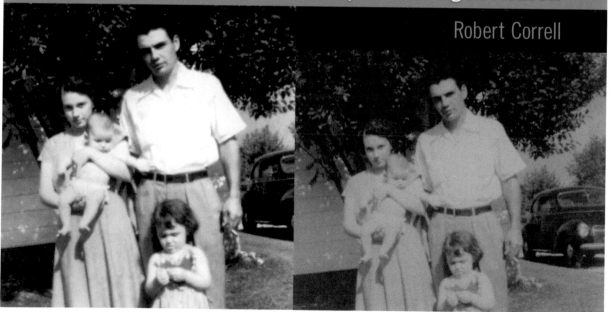

COURSE TECHNOLOGY
CENGAGE Learning™

**Photo Restoration and Retouching
Using Corel® PaintShop Photo™ Pro,
Second Edition
Robert Correll**

**Publisher and General Manager,
Course Technology PTR:** Stacy L. Hiquet

Associate Director of Marketing:
Sarah Panella

Manager of Editorial Services:
Heather Talbot

Marketing Manager:
Jordan Castellani

Acquisitions Editor:
Megan Belanger

Project and Copy Editor:
Marta Justak

Technical Reviewer:
Lori Davis

Interior Layout:
Shawn Morningstar

Cover Designer:
Mike Tanamachi

Indexer:
Sharon Shock

Proofreader:
Michael Beady

Printed in the United States of America
1 2 3 4 5 6 7 12 11 10

For product information and technology assistance, contact us at

**Cengage Learning Customer and Sales Support,
1-800-354-9706**

For permission to use material from this text or product, submit all requests online at
cengage.com/permissions

Further permissions questions can be emailed to
permissionrequest@cengage.com

Library of Congress Control Number: 2010922089
ISBN-13: 978-1-4354-5680-8
ISBN-10: 1-4354-5680-7

Course Technology, a part of Cengage Learning
20 Channel Center Street
Boston, MA 02210
USA

Cengage Learning is a leading provider of customized learning solutions with office locations around the globe, including Singapore, the United Kingdom, Australia, Mexico, Brazil, and Japan. Locate your local office at:
international.cengage.com/region

Cengage Learning products are represented in Canada by Nelson Education, Ltd.

For your lifelong learning solutions, visit **courseptr.com**
Visit our corporate website at **cengage.com**

To my family

my wife Anne, and my kids: Ben, Jacob, Grace, and Sam

Foreword

NOTHING BRINGS US JOY like photos and photography. Whether you are looking at family heirlooms from another era or photos that you shot at last week's game, these images document our lives, family, and experiences. When we think of the many photos of our family and friends, people we know and places we've visited, we are made more complete by these memories.

Photography is also a great adventure. Those of us who shoot photos love to share our images. We take pride in creating a picture with the right depth of field and perfect lighting that captures the exact emotion we're trying to convey. Our photos become our art. They are the expression of our creative side.

Cameras and photo software have come a long way over the last few years—the quality is stunning, and the power is simply amazing. With more options than ever, today's cameras give greater control over a broad variety of shooting conditions from very low-level existing light to high-speed, rapid-fire situations. Likewise, software has increased in options and functions, enabling us to produce simple to reality-bending changes.

The challenges in all these possibilities are twofold. First, you need to take steps to simply be aware of the breadth of options that are available. Second, there's always a learning curve, from small changes that build on what you already know to entirely new processes that may take more time to master.

This book is an exceptional resource to help you uncover the possibilities of what you can do with your images—both new and old—taking you step-by-step through the execution of restoring and enhancing your photos. The excellent examples and detailed instructions will enable you to fully explore techniques that you can use regularly while improving your current work or preserving heirloom images for future generations!

Photo Restoration and Retouching Using Corel PaintShop Photo Pro, Second Edition demystifies photo editing, whether you are making the most subtle or intense changes. This book is your ally in creating photos to be proud of.

Craig Copley
Senior Product Manager,
Corel PaintShop Photo Pro X3
Corel Corporation

Acknowledgments

AS WITH THE FIRST EDITION, I have many people to thank. Publishing this book was a team effort from start to finish, no less hard than the first.

Thanks to David Fugate, my agent and the founder of LaunchBooks Literary Agency. Thank you for working so hard to get the first edition published. Double thanks for this, the second edition!

Many thanks to all the great people I met and worked with at Course Technology. Thank you to Megan Belanger, for believing in the book; Marta Justak, for your excellent editing and encouragement; Shawn Morningstar, for your great layouts; Mike Tanamachi, for your work on the cover; and Jordan Castellani, for your marketing efforts.

Tremendous thanks go to Lori Davis, the technical reviewer.

Thank you to many people at the Corel Corporation. It's been a pleasure using PaintShop Photo Pro to show people how to restore and retouch their photos. Thank you for your support and help, which was consistent and enthusiastic from the first edition through today. Special thanks go to Jessica Gould (Senior Public Relations Manager), Craig Copley (Senior Product Manager, Corel PaintShop Photo Pro X3), and Greg Wood (Communications Manager). Additional thanks go to Derek Tucker (America's Marketing Manager, Paid Search) for his enthusiasm and support of me and the book.

Thanks to Bruce Gaylor and Mike Bergum of New Castle Chrysler High School for assisting me in setting up and shooting in the Fieldhouse. Thanks to everyone who e-mailed with questions or comments. Very special thanks to Wayne Schneider for compiling a comprehensive list of errata from the first edition of the book.

To the lives and memories of all those who appear in the photos of this book.

Thanks to my family for your support, ideas, encouragement, and love.

About the Author

ROBERT CORRELL is an author, photographer, and artist with a lifetime of film and digital photography experience. He is a longtime expert in photo editing and graphics software such as Corel PaintShop Photo Pro (formerly Paint Shop Pro), Adobe Photoshop, and Adobe Photoshop Elements. He also retouches and restores photos.

His latest published works include *High Dynamic Range Digital Photography for Dummies, HDR Photography Photo Workshop, Your Pro Tools Studio,* and the first edition of *Photo Restoration and Retouching Using Corel Paint Shop Pro Photo.* Robert also authors creative tutorials for Corel Corporation and the Virtual Training Company. His VTC titles range from MasterClass!—Adobe Photoshop CS4 HDRI to several tutorials covering Corel PaintShop Pro Photo, to single tutorials on Adobe Photoshop Elements, Sony ACID Pro, and Cakewalk SONAR. He contributed to every issue of the now defunct *Official Corel PaintShop Pro Photo Magazine* as the resident photo-retouching expert.

Robert provides professional authoring, software testing (Windows and Mac), tutorial and manual writing, advertising copywriting, and other services to companies such as Adorama Camera and HDRsoft.

Robert is also a music producer, audio engineer, and musician who makes his music on the electric guitar and bass. He graduated with a Bachelor of Science degree in History from the United States Air Force Academy and has worked in the publishing, education, and marketing and design industries.

You can reach Robert by sending an e-mail to contact@robertcorrell.com. His Web address is www.robertcorrell.com. He encourages you to contact him.

Table of Contents

Introduction

WELCOME TO *Photo Restoration and Retouching Using Corel PaintShop Photo Pro,* Second Edition. Follow along with me as I retouch and restore over 60 "real-world" photos from my own print and digital photo collection. I'll address a wide range of problems that many photos have, whether they are new or old, digital or print, color or black-and-white. I'll show you different techniques for problems with lighting, color and contrast, tears, scratches, and other blemishes. You'll learn what works along with what doesn't, and
discover how to judge for yourself. I'll also cover photo-retouching topics that range from retouching people, adding, moving, or deleting objects, to retouching good photos and very bad photos.

Photo Restoration and Retouching Using Corel PaintShop Photo Pro, Second Edition, is focused, comprehensive, practical, and effective at showing photo retouching and restoration techniques. It is not a general PaintShop Photo Pro tutorial/ reference.

Most of the tools and techniques I use in this book were developed for and tested using older versions of PaintShop Photo Pro, but I was careful to update each existing and every new photo study using PaintShop Photo Pro X3. In addition, I was able to incorporate several new X3-only features in a few of the studies. Although the focus is on X3, this book should be accessible to users of all recent versions of the product.

Download the (slightly downsized) "before" versions of each photo study from my Web site, www.robertcorrell.com or at www.courseptr.com/ downloads.

Paint Shop Pro Naming Conventions

The official name of the latest version of what began life as "Paint Shop Pro" is *Corel PaintShop Photo Pro X3.* I sometimes refer to older versions of the product as Paint Shop Pro, but have tried to refer to the latest product by name or simply as "X3."

What You'll Find in This Book

Photo Restoration and Retouching Using Corel PaintShop Photo Pro, Second Edition, contains over 60 practical photo studies, each aimed at a specific photo restoring and retouching element. Each study is fully restored or retouched. The book is filled with empowering, practical examples that cover the following topics:

► Scanning photos and other material

► Organizing your photo collection

► Focusing on new features in PaintShop Photo Pro X3

► Removing specks and dust

► Reducing noise

► Retouching shots for online auctions

► Improving brightness and contrast

► Correcting distortion

► Making color corrections

► Making colors more vibrant

► Repairing borders, scratches, creases, holes, and missing corners

► Erasing pen, pencil, marker, spots, and other marks

► Moving things

► Adding people

► Creating montages

► Removing red eye

► Performing face makeovers

► Glamorous retouching

► Introducing full-body makeovers

► Retouching hair

► Restoring very badly damaged photos

► Making good photos better

► Using your photos as the basis of artistic retouching

Whom This Book Is For

Photo Restoration and Retouching Using Corel PaintShop Photo Pro, Second Edition, is for anyone who wants to restore or retouch photographs. I love restoring old photos and retouching digital ones. It's a passion of mine, and this book is designed and created to share that passion with you. It's not rocket science. All you need are the photos, PaintShop Photo Pro, the desire, and time. Want to learn more? Read this book and look at the sample photos. Everything you see on these pages has been done in PaintShop Photo Pro.

Restoring and retouching photos complements many other activities. The restored and retouched photos you use will enhance whatever you're doing. If you're involved in any of the following activities (to list a few), you'll get a lot out of this book:

► Everyday life (taking digital photos and retouching them for your family and friends)

► Amateur and professional photography (retouching new digital photos)

► Scrapbooking (restoring or retouching new and old photos, artistic retouching)

► Family history/genealogy (restoring and preserving family photos)

► Art (artistic retouching)

► Publishing (retouching new photos for Internet and traditional media)

► Small-businesses (using photography to augment your business)

► Home-businesses like direct sales (retouching your product photos)

My focus is to show you how to restore and retouch photos—not provide a ground-up tutorial on PaintShop Photo Pro. If you're a beginner to computing or graphics programs, you will want to spend time outside of this book learning how to use the basics of the program.

How This Book Is Organized

Photo Restoration and Retouching Using Corel PaintShop Photo Pro, Second Edition, is organized into 11 chapters and two appendices. Following the first chapter, each chapter focuses on a specific aspect of photo restoration or retouching.

▶ **Chapter 1, "Preparing for Work":** This chapter gets your feet wet. You'll find information on PaintShop Photo Pro X3, how to scan, and considerations on starting a photo restoration/retouching business. The chapter concludes with two photo studies that walk you through the process of restoring and retouching photos from start to finish.

▶ **Chapter 2, "Removing Specks, Dust, and Noise":** This chapter has five photo studies, each looking at a different aspect of removing specks, dust, and noise. Techniques range from using the Clone Brush to the Digital Camera Noise Removal tool.

▶ **Chapter 3, "Finding the Right Brightness, Contrast, and Focus":** You'll learn how to make brightness, contrast, and sharpness adjustments to your photos in this chapter, which has nine photo studies. You'll compare and contrast the results of several different techniques as you search for the best method in this chapter.

▶ **Chapter 4, "Making Color Corrections":** Old and new photos alike can benefit from the proper color balance and intensity. Follow along with five photo studies in this chapter. Multiple techniques are again compared, ranging from Fade Correction to the Histogram Adjustment tool.

▶ **Chapter 5, "Repairing Physical Damage":** Six photo studies tackle the difficult task of repairing damaged photos. You'll learn how to repair borders, scratches, creases, cracks, holes, and missing pieces of photos, mostly with the Clone Brush.

▶ **Chapter 6, "Erasing Writing and Other Marks":** This chapter features five photo studies that show you how to remove writing and other marks from photos. You'll learn how to separate HSL channels in this chapter.

▶ **Chapter 7, "Moving, Adding, or Removing Objects":** Follow along with seven photo studies as you learn how to move a teddy bear, add people to a photo, or take your reflection out of a glass door. Multiple techniques are analyzed, ranging from the simple "copy and paste" to using the Clone Brush and Object Remover.

▶ **Chapter 8, "Retouching People":** This powerful chapter uses 11 photo studies to walk you through the important skill of retouching people. Learn how to eliminate red eye, smooth skin, whiten teeth, remove distracting blemishes, perform makeovers, and hide hair loss.

▶ **Chapter 9, "Prognosis Negative":** This chapter uses six photo studies to rescue "impossible to repair" photos. You'll be surprised what you can do with even the most damaged print.

▶ **Chapter 10, "Making Good Photos Better":** These eight photo studies form the basis of this chapter, which involves taking good photos and making them better. You'll learn how to critically analyze photos that you may not think need retouching and get the most out of them.

▶ **Appendix A, "Paint Shop Pro Tools":** This appendix reviews every tool on the PaintShop Photo Pro X3 Tools toolbar with an eye toward how to use them in photo restoration/retouching.

▶ **Appendix B, "Methods Summary":** This appendix reviews several of the methods used in the book, from how to use working layers to performing a merged copy.

▶ **Appendix C, Online Bonus Chapter 11, "Artistic Restoration and Retouching":** This book continues online with an artistic note. Learn how to artistically retouch photos as you follow along with nine unique examples of artistic retouching. Each photo study starts with a standard photograph and applies artistic license to transform it into a new work of art.

What's New in This Edition

You'll find 18 completely new photo studies sprinkled throughout this edition of the book. Many are techniques and ideas that were not in the first edition, such as "Dusting Off Shots for eBay" and "HDR Photo Merge." Others are brand new photos for existing studies, such as "Lightening a Dark Subject." In those cases, the main thrust of the study remained unchanged.

Every other photo study in the book has been reviewed and updated in PaintShop Photo Pro X3, and in many cases, substantively improved upon from the first edition. For example, the photo did not change in "Minor Sharpening," but the technique and result were revised to make the final photo much better.

Companion Web Site Downloads

You may download the companion Web site files from www.courseptr.com/downloads. You'll find:

▶ The "before" shots of all the photo studies (slightly downsized) for you to practice on and use as you follow along with the book.

▶ Chapter 11, "Artistic Restoration and Retouching." Don't miss out on this bonus chapter! It contains nine photo studies that open up the world of artistic photo retouching for you. The studies will spark your imagination and give you ideas on how to turn your own photos into creative works of art. Among other things, you'll learn how to use effects in creative ways, use the Pen tool to create vector art, learn how to Smudge Paint, and see how to de-restore a photo.

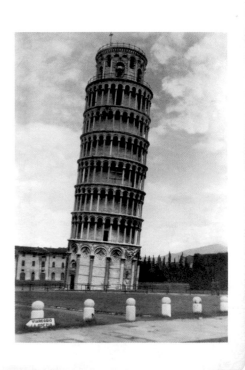

Preparing for Work 1

THIS CHAPTER GETS YOU STARTED DOWN the path of photo restoration and retouching using Corel PaintShop Photo Pro. I'll cover some general aspects of restoration and retouching, introduce PaintShop Photo Pro, review the new features of PaintShop Photo Pro X3, share a few organizational tips, look at the process of scanning, and talk about how to turn this into a business.

I'll finish with two photo studies, which are designed to give you an overview of the process of photo restoration and retouching. This is the format I've chosen for this book. I use a single photo at a time to address an issue related to the chapter at hand, and then summarize the steps I took to completely restore or retouch it. I call these *Photo Studies*. There's a before photo, one or more figures showing progress along the way, and then an after photo.

▶ **Photo Study 1: Restoring a Print from Start to Finish**—This study starts with scanning an old photo of the Leaning Tower of Pisa and walks you through the basic steps of restoring a print photo that has been physically damaged.

▶ **Photo Study 2: Retouching a Digital Photo from Start to Finish**—Although you will use many of the same skills, digital photos often have different problems and call for a different workflow than print photos. I'll introduce the process of retouching digital photos using this shot of my son, Ben.

Photo Restoration and Retouching

PHOTO RESTORATION AND retouching are artistic endeavors. They use the side of your brain that sees beauty and value and tries to preserve them. They are also practical and technical activities. Evaluating light, color, contrast, and composition may invoke the artist, but repairing cracks, scratches, tears, and covering blemishes calls upon the craftsman in each of us. It takes technical acumen to understand how to use all the tools PaintShop Photo Pro has to offer. In addition, retouching and restoring photos requires a degree of hand-eye coordination as you operate your mouse or pen tablet. There's a little bit for everyone to enjoy, no matter where you place yourself on the artist-craftsman-technician spectrum.

Photo Restoration

Photo restoration (in this context) is the process of digitally repairing old, damaged, and deteriorating print photos. Damage occurs from the natural process of aging and handling, and includes things like torn corners, creases, dust, specks, tears, and other physical problems. You may be able to fully restore a photo to its original glory. When a photo is too badly damaged, however, your satisfaction will have to come from doing the best you can. The end product is a graphics file that you can view on your computer, upload to the Internet, or print out. Boxes of photos and photo albums are steadily deteriorating as I type this sentence. They capture the memories of your life and are a link to your past and the past of your ancestors. They take up a lot of space, however, and are prone to loss and damage. Photo restoration saves, restores, and preserves these memories. You don't have to be an art expert or have a degree in antiquities conservation to start restoring photos.

Photo Retouching

Photo retouching is oriented toward the digital cameras and digital pictures. Who doesn't have one or more digital cameras today? Or a cell phone with a built-in digital camera? Digital cameras have taken over the photography market and are here to stay (until the 3D holographic positronic image revolution begins in 2030). As a result, we're not taking as many film-based photographs. We receive a good deal of instant gratification taking digital photos. We can view them almost instantly and don't have to send them off to get developed.

Digital pictures are stored on hard disk drives, so they don't have torn corners or faded colors. Common problems are poor lighting, color, sharpness, and composition. Photo retouching enhances these pictures, whether they're good or not to begin with.

One of the biggest lessons I've learned with digital photos is that even good ones need our helping hand to look their best. Don't think of photo retouching as only making bad photos better. It's not.

Prints

I love printed photos. You can hold them in your hands and look through albums of old photos together with family and friends. Before scanners and digital cameras, this was the only choice you had. Or, rather, the choice you had was whether or not to take slides or photos. Sadly, slides are a relic of the past now.

Using PaintShop Photo Pro

PAINTSHOP PHOTO PRO is an amazing program for the price, and has a long history as the leading contender for the amateur and semi-professional graphics market. I've used various versions of Paint Shop Pro (I had to leave the old name in at least once or twice) since it began life in 1992 as a shareware program and was owned by Jasc Software, Inc. Paint Shop Pro was enthusiastically embraced from the beginning, and PaintShop Photo Pro (as it is now known) continues to have a very loyal following.

Jasc?

Jasc stands for Jets and Software Company, two of the passions of Robert Voit, Paint Shop Pro's inventor and the founder of Jasc Software, Inc.

Corel Corporation bought Jasc Software in 2004 specifically to acquire Paint Shop Pro, which they began to reposition as a photo-retouching tool for amateurs and semiprofessionals. Version X (ten) was released in September 2005 and was favorably received. The transition in emphasis away from basic image creation and editing toward digital photo manipulation was further emphasized in September 2006 when Corel renamed the product and launched Corel Paint Shop Pro Photo XI (followed thereafter by X2 and X2 Ultimate).

Today, PaintShop Photo Pro X3 has undergone another revision and name change, both of which continue to put the emphasis on serving the photographer and digital photo retouching.

If you have PaintShop Photo Pro installed, go ahead and fire it up as I take you on a quick tour around the interface. I'm going to focus on the elements of the program that make it particularly useful for photo restoration and retouching.

Kicking the Tires

PaintShop Photo Pro's interface is both logical and easy to use. And if that's not enough for you, you can customize it by turning palettes on and off, dragging them around the workspace, and docking them to various sides—you can even change the menus and toolbars. Figure 1.1 shows PaintShop Photo Pro X3 in Edit mode with several of the palettes turned on. This figure shows the Graphite Workspace Theme, which is the default.

Learning PaintShop Photo Pro

I don't have room to start at the beginning and show you everything you need to know about installing, running, and working with PaintShop Photo Pro. To get the most out of this book, you should already know things like how to use the Selection tools, the Layers palette, the Materials palette, and so forth. My purpose is to show you how to use elements of the program in the context of photo retouching and restoration. Having said that, I will try to ease you into many of the tools I use and tell you how to get started with them.

I've annotated the interface elements in order to provide a quick overview of what each piece does.

▶ **Menu bar:** Most commands and many options are located here.

▶ **Standard toolbar:** The toolbar that has many common commands within easy reach, such as New, Open, File Save, Undo Last Command, Resize, Palettes, and so forth.

▶ **Tool Options palette:** Looks like a toolbar, but is really a palette. The Tool Options palette changes based on what tool you have selected and displays the options applicable to that tool. You can do things like select brushes, enter pertinent data (such as the dimensions of a selection box), make adjustments (such as the line thickness of a vector object), and accept or reject an operation here. This is one of the most important interface elements in PaintShop Photo Pro. Master it!

▶ **Learning Center palette:** Gives assistance to quickly lead you through various tasks. It is context sensitive. When you click on different tools, the content changes to match what you are doing.

▶ **Tools toolbar:** Known as the bad boy of the entire program. You'll use this to choose and select from many of the tools PaintShop Photo Pro has to offer.

▶ **Other palettes:** View the other visible palettes; their importance depends on what you are doing. If you are painting or entering text, for example, you'll need the Materials palette to select the color and material of the object you are creating. The Layers palette is another important interface element to master. I use layers all the time, even when I am working to restore or retouch a photo.

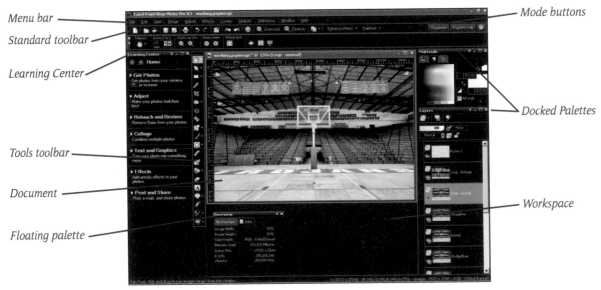

Figure 1.1
The PaintShop Photo Pro X3 interface is powerful and flexible.

Reclaiming Space

I turn off the Learning Center palette, Organizer, and Photo Trays but keep the Materials and Layers palettes visible at all time. This gives me more room to work and keeps information I use a lot on screen. Give yourself even more room to work by turning off the Materials and Layers palettes when you are working on a photo intensely and don't need to quickly change materials or layers.

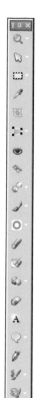

Figure 1.3
PaintShop Photo Pro's tools.

Jump to Appendix A

I've listed each tool on the Tools toolbar in Appendix A, "PaintShop Photo Pro Tools," along with a complete description. I point out the ones that I find the most useful for photo work—and why.

I've turned off the dark theme in Figure 1.2 using the View ❯ Use Graphite Workspace Theme menu and closed a few of the extra palettes. This is the workspace color scheme I will use for the rest of the book because it looks better in print. Don't let that stop you from using the Graphite Workspace Theme. It isn't my intention to state a preference for one over the other.

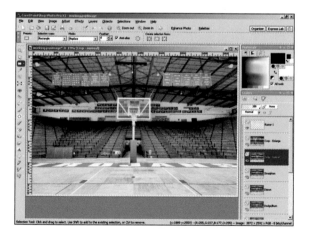

Figure 1.2
The original color scheme.

Before I continue, I want to point out all the tools on the Tools toolbar. I've found that I use quite a few tools for many different tasks, so it pays to become familiar with them. Sure, you'll develop your favorites like I have, but you need to be able to use any tool in the arsenal. The Tools toolbar is illustrated in Figure 1.3. You'll notice that many of the tools have a light triangle in the lower-right corner. This indicates that there are tools grouped together to save space. Click on the arrow to show the tool group.

New or Improved in X3

If you've been using earlier versions of Paint Shop Pro, it shouldn't take you long to become acquainted with X3. Although there are new and improved features, the overall functionality of the program is very similar to prior versions. The most significant change to X3 is the Organizer, which isn't critical to photo restoration or retouching.

A New Organizer

In prior versions, the Organizer was a palette that you could turn on or off. In X3, it's a separate program mode. This means, in part, that you can't work in the Organizer and Full Editor at the same time. Figure 1.4 shows the Organizer in Preview (as opposed to Thumbnail) mode.

Figure 1.4
The new, full-screen Organizer.

The Organizer has some of the same functionality as the old one, but it's larger and meant to be distinct from the editing environment. Notice the folder list on the left of the window. This is where you manage the folders and where PaintShop Photo Pro watches for new pictures and keeps them organized. In the center, there is a large space to preview a single photo at a good size. The area to the right is where you can see information about the photo, like its name, the date you took it, the file size, and other EXIF info. You can also tag photos, rate them, and create captions here. Finally, the bottom window has thumbnails of the photos in the folder you've selected from the Collections or Computer tab at the top left. When in Preview mode, the thumbnails occupy the bottom of the screen. When in Thumbnail mode, they take up the entire central part of the window, and the preview area disappears.

Notice also the buttons at the top-right portion of the screen, just above the General Info area (see Figure 1.5). This is where you can change between Preview and Thumbnail modes for the Organizer, enter the Express Lab, or choose to go to the Full Editor. The last button is for the Corel Guide.

Figure 1.5
Change modes here.

PaintShop Photo Pro X3 starts out in the Organizer. If you would prefer to start in the Full Editor, or launch in whatever mode you last used, change the Default Launch Workspace preference from the File > Preferences > General Program Preferences menu.

Better Raw Support

Thankfully, PaintShop Photo Pro X3 offers more robust support of camera raw photos, including a new interface element, the Camera RAW Lab, shown in Figure 1.6.

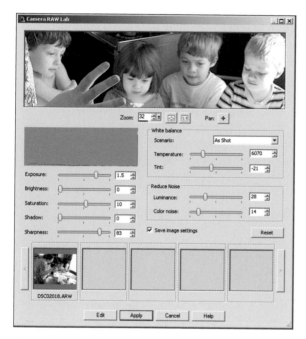

Figure 1.6
The New Camera RAW Lab.

Use the Camera RAW Lab to convert your camera raw photos to files you can edit and save. I tend to convert the raw files to .pspimage files if I am going to do a lot of work on them. Otherwise, I go straight to .TIFF or .JPEG to print or put them on the Internet. The Camera RAW Lab is covered more fully in Chapters 2 and 10.

If you would rather use Smart Photo Fix to open raw files, uncheck Open RAW Images with Camera RAW Lab in File ❯ Preferences ❯ File Format Preferences. This opens the raw image in 16 bits/channel format. You can then edit using your favorite adjustments or use Smart Photo Fix to get yourself going.

Vibrancy

Vibrancy is new to X3 as well. It's a variation on saturation. Increasing a photo's saturation increases the color saturation of every pixel. Vibrancy, however, increases the saturation of poorly saturated areas of the photo only. This lets you boost a photo's color without making already saturated colors look garish and unrealistic. The control, as shown in Figure 1.7, is very simple. You've got less and more. Although it is subtle, notice that the muted sky and tree are more colorful in the After window.

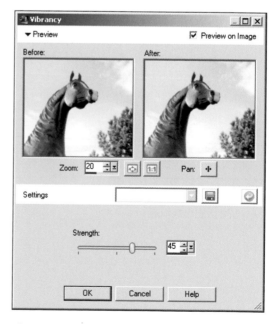

Figure 1.7
Boosting poorly saturated areas with Vibrancy.

Local Tone Mapping

Local Tone Mapping takes the place of what in previous versions was called *Clarify.* The idea is to bring out more detail in a photo through local contrast enhancements. Although Local Tone Mapping is related conceptually to High Dynamic Range imaging, you can use it on any photo. Figure 1.8 shows the interface. Again, it's pretty simple. The key is choosing the right Strength so that your photo is enhanced but not overwhelmed. Look carefully at the grass and clouds in this figure. The clouds have more detail, while the grass and far trees are brighter.

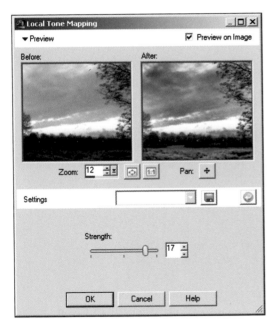

Figure 1.8
Boosting Local Tone Mapping.

Improved Express Lab

The Express Lab, shown in Figure 1.9, consolidates many photo retouching and restoring tools into a single, less-cluttered window. The most common tools are conveniently located at the bottom of the screen. Tools making their appearance in the X3 version of the Express Lab are: Local Tone Mapping, Color Balance, Adjust Brightness/Contrast, Sharpen, and One Step Noise Removal.

Notice that you don't have access to the Layers palette, Materials palette, and other tools necessary to accomplish some photo restoration tasks. However, X3 has added tools to the Express Lab, making it a pretty convenient place to perform routine retouching.

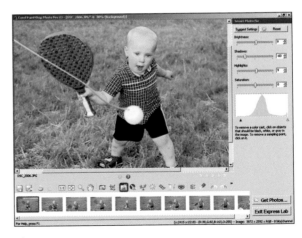

Figure 1.9
Express Lab consolidates photo tools.

Other Changes

There are, of course, many other changes to PaintShop Photo Pro X3. Some of the other new or improved features are listed here:

▶ **Multiphoto editing:** This feature makes it possible to capture simple edits and apply them to other photos. Within the Organizer, choose a photo and enter Express Lab. Make your changes (like Sharpen, Rotate, or Smart Photo Fix) and then exit the Express Lab, saving the changes to the photo. Back in the Organizer, right-click the thumbnail of the photo you just edited and select Capture Editing. Finally, select one or more different photos, right-click, and choose Apply editing.

▶ **Convert camera raw photos directly to another format:** This feature makes converting raw photos a breeze. Within the Organizer, right-click a camera raw photo and choose Convert Raw. Choose a type (with options), location, and new name, if desired.

▶ **Smart Carver:** This feature automates some aspects of recomposing photos. In other words, if you need to cut someone out and leave everyone else alone, try the Smart Carver. I am in the process of removing Ben from the photo in Figure 1.10. After you select the area to remove, keep pressing the arrows to compress the photo.

▶ **Object Extractor:** This feature automates some aspects of removing an object from a photo. In other words, you're cutting out what you want to keep. I run through this technique in Chapter 3.

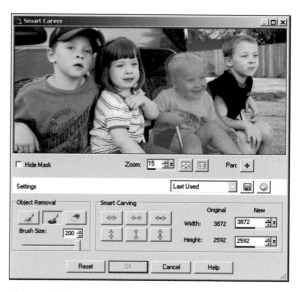

Figure 1.10
Using the Smart Carver.

Rationale

I've made the decision not to overdo coverage of some elements of PaintShop Photo Pro that automate removing or moving objects, like the Smart Carver and Object Extractor. That's not necessarily an editorial comment on my part about the program. I would rather you learn the harder, manual method from this book so if you need to do it "the hard way," you can. Go ahead and experiment with all the new and time-saving features on your own to see if they work with your photos.

Using a Pen Tablet

I used to use a mouse for all my computer pointing and clicking needs, but I was talking to a friend of mine who is a radio, TV, and film professor at Cal State Fullerton. We were talking about his experiences as an animator for Disney (he sounds like a cool friend to have, and he is) and the fact that I had seen a behind-the-scenes segment on Disney animators from a DVD that showed them using their pen tablets to draw actual animations from the movie. I asked him about them, and he said he used one all the time.

I immediately did some more research, some budgeting, and then bought a Wacom Graphire4 6×8 pen tablet for my wife's birthday. Although there are newer and better models available now, ours is still going strong—three years later. Can I just tell you how much easier it is to paint and draw with a pen than a mouse? It is, trust me. I love it. My wife loves it. Our kids love it. As an added bonus, it integrates perfectly into PaintShop Photo Pro.

Practice That *Thang*

The pen tablet takes some getting used to. Our minds and muscles have been indoctrinated into *mousing* so much that you have to retrain yourself. It's well worth it. You'll almost certainly find that you will have more control than you did using a mouse. As an added bonus, you can use the pen tablet in many other applications besides PaintShop Photo Pro.

Figure 1.11 shows Wacom's (www.wacom.com) newer Intuos4 models. This is the professional line, although you can choose different sizes to suit your needs and budget. Wacom (pronounced like "wok-a-mole" without the "ole") also offers a Bamboo line that is priced for consumers. Among the cool features found in many tablets of both lines is the ability to switch the left- or right-handedness of the tablet and buttons.

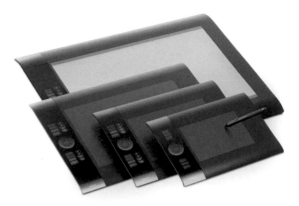

Figure 1.11
The new line of Wacom Intuos4 pen tablets.

You have to run the installation program in order to get your system to recognize the pen tablet as a valid pointing device, but once you do this, you'll be off and running.

Updating the Program

Let's talk about updating and patching. Updating PaintShop Photo Pro should be a priority. Programmers do their best to release software that is functional and doesn't break down all the time, but with the geometric rise in the complexity of coding since PCs first appeared, bugs and teething pains are inevitable. Bugs and teeth are never a good mix.

Corel continues to provide support for each version of PaintShop Photo Pro after it is released. Their team of developers release updates, often called *patches*, which continue to improve the program. Take advantage of this free service by keeping your version of PaintShop Photo Pro in tip-top, updated shape.

To manually check for updates, follow these steps:

1. Make sure that your computer has a working, active connection to the Internet.

2. Select the Help menu and choose Check for Updates. PaintShop Photo Pro will connect to Corel and determine whether or not there are new patches available for download. If not, you will see a message box telling you there are no updates available. You can click it away and continue with the knowledge that you've got the latest version of the program.

3. If there are updates, you'll see a message from Corel. Download and install the updates to your version of PaintShop Photo Pro.

Organizing Your Digital Photo Collection

WE'VE GOT THOUSANDS of digital pictures that we've taken over the last several years. They pile up like crazy once you realize, "Hey, we don't have to pay to have these things developed!" Aside from not having to pay to have them developed, being able to store the photos on your hard disk drive and retouch them at your convenience is one of the greatest conveniences of going digital. Later, when you realize it would be nice to have prints, you can decide whether or not to print them at home or have them professionally printed.

Printing and Archiving

I've written sidebars in four chapters that cover various aspects of printing and archiving. Here is a quick reference of what they address and where you can find them.

Printing at Home, Chapter 2, "Removing Specks, Dust, and Noise"

Retail Outlet Printing, Chapter 4, "Making Color Corrections"

Professional Printing, Chapter 6, "Erasing Writing and Other Marks"

Archiving, Chapter 10, "Making Good Photos Better"

Organization is the key to not going crazy when you have this many digital photos to manage. I also try to think long-term. When it's time for me to pass them down to my children and I'm no longer here, how are they going to make sense of things? Are things logically organized so that my children and their children can spend their time reminiscing and not fighting the system?

Folder and File Organization

I've gone through several organizational schemes over the years. I think I've finally found one I'll stick with, but I want to show you the progression.

First, there was the "Throw them in subject folders" idea. It seems ridiculous now, but those were the days of 8MB memory cards and COM port connectivity between the camera and the computer. Digital photos were a new thing, and I don't think my wife and I took more than 25-30 pictures in a normal month. We just didn't think about it the same way. At that time, we organized our pictures in subject folders within one overall digital photo folder and left the names alone.

When 2002 rolled around, we had our first child. I decided to try and organize things a bit because the subject folder scheme was getting too complicated. When I took a picture of my wife and my son and the cat all together, did the file go in the "Robert" folder, the "Anne" folder, the "Cats" folder, or the "Ben" folder? That's when I implemented the date scheme on the folders, and it seemed natural to start renaming the files, too.

During my "Year-Month-Day-Number I Took Them" scheme, I created folders by year and month, and then downloaded the photos into them, renaming each photo afterwards. Figure 1.12 shows the folders from 2004.

Digital Photo Downloading Options

Programs that automatically download pictures to your computer from your digital camera normally come with the camera you have. These programs can also be associated with a graphics application or photo-editing program, such as Corel PaintShop Photo Pro.

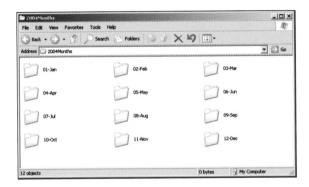

Figure 1.12
My old monthly organizational scheme.

Figure 1.13 shows how I renamed each photo, according to the date and sequence I took it.

I really liked this system because I could look at any photo and tell you exactly when I took it from the name. For example, I can tell from the file name that the oddball photo of steaks we were grilling (Figure 1.14) was the twelfth photo I took on May 9, 2000. (Yes, I went backward from 2002 to rename the files I already had.) Notice that the steak on the left looks exactly like South America and the one on the right is the spitting image of Africa (including the Arabian Peninsula).

Figure 1.13
My old system of naming digital photos by date and numerical sequence.

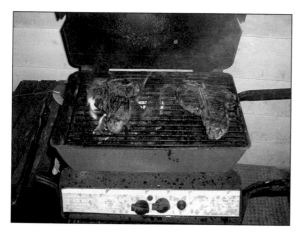

Figure 1.14
Grilling South America and Africa on May 9, 2000.

Again, the reason this worked was the fact that we had one camera and took maybe 50 photos a month.

Know Your Digital Camera

Check the documentation that comes with your digital camera and see what file-naming options you have. You might have several to choose from, find one that fits your needs, and never have to manually name a file again.

When we got a new, 3MP camera, I changed organizational schemes again. By this time, I was tired of naming every single file, so I dropped that. I was also tired of putting photos by month into folders. So I just copied the folder the camera used on the memory card over to the computer and left it alone. I call this my "I give up" scheme. Figure 1.15 shows what this looked like.

Figure 1.15
Folders created by our camera had up to 100 digital photos inside each folder.

Free Undelete

We had a major crisis where 150 digital photos were accidentally deleted from our camera's memory card while it was attached to our computer. We hadn't had a chance to save them to the hard drive yet. If this happens to you, don't do anything to the card in question. Don't copy files to it, delete more from it, or touch it in any way. If you do, you will dramatically lower the possibility of recovering anything from the card.

First, quarantine the card by disconnecting it from the computer. When you have time, plug it back in and run some form of undelete program. I used one called FreeUndelete (officerecovery.com/freeundelete), and thankfully, it successfully recovered every photo. Whew.

These were important photos. They were of our son's 5th birthday!

The only thing I do outside of software is keep the photos organized when I download them to the computer. For that, I use the following process:

1. I have dedicated an entire drive to photos. I create a folder for each camera, as shown in Figure 1.16. I think of this as a safe place to store the negatives.

Figure 1.16
My topmost camera folders.

The moral of this story is that technology changes. The solutions to the challenges that prompted me to over-organize in the past have been implemented into the programs of today. I don't need to organize by subject anymore; I can tag photos. I don't need to organize by year-month-day-sequence because I can sort my photos in whatever software I use to organize them. Programs today use the EXIF information for this, unlike many in the past.

Today, I have two dSLRs and four compact digital cameras and super zooms with more on the way. I don't have time to spend messing with this.

2. When I download photos, I create a folder for the day I download within the camera folder (see Figure 1.17). I do it this way to have some sense of when I've taken pictures if I look at things from the folders. If I have more than one download, I sequence them to keep them apart. This is all very easy to do and straightforward. My particular naming scheme is to put the camera name, year (so the folders sort by year), month, day, and sequence. I separate the month and day to make them easier to spot when I'm looking at the folders.

Figure 1.17
My daily download folders.

3. I then make a copy of the download folders for archiving. I never touch the photos in the copied folders. I don't even change the folder names at this point. Over time, I move the copies to an external hard drive for long-term storage and protection.

You can load the original folders into whatever organizational software you use. Then edit, tag, and organize to your heart's content.

Protecting Your Files

Unlike physical photos that are developed from negatives, there is no negative with a digital image. The image file is the only primary source you'll ever have of the photo. Protect it at all costs!

What's a Primary Source?

A primary source is the original work. With film, the primary source for all prints should be the original negative. For digital photos, the unretouched digital photo file is the primary source.

I made this mistake when I got my first digital camera. I rotated, cropped, or resized a photo, then saved it, only to realize that I had just overwritten my master copy. My primary source was gone forever. Let that sink in. It was as if I had held up the negative and burned it, leaving me with a resized print that would never be as good as the original. I learned my lesson.

My wife will attest to my rigorous efforts to protect one copy of our digital photos from ever being edited, resized, cropped, or otherwise tampered with. I suggest you get into the habit, at least for important pictures (weddings, births, birthdays, and so forth), of always making a "Do-Not-Edit" copy of the photos you download to your computer and placing all of those files into one folder that is clearly marked. Leave them in there for safekeeping and later, archive them away.

Organizing with PaintShop Photo Pro

Programs like PaintShop Photo Pro have come a long way in terms of trying to help you get organized. As I've described, organizing a photo collection used to require a lot of manual labor and image editing programs did little or nothing to help. PaintShop Photo Pro comes with a powerful photo organizer built right in, called the *Organizer*.

The Organizer takes the workload off your shoulders by organizing your photo collection (including edited photos and other graphics files). At the heart of this system are folders that you select for PaintShop Photo Pro to monitor. PaintShop Photo Pro scans those folders when you start it up, creates resizable thumbnails of the files in those folders, allows you to tag and categorize photos, and enables you to have quick access to the folders to edit and print your photos. Figure 1.18 shows the Organizer in thumbnail mode.

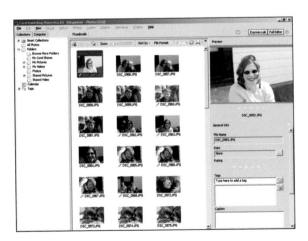

Figure 1.18
The PaintShop Photo Pro Organizer showing thumbnails.

There are folders on the left side of the Organizer and thumbnails of the photos either on the bottom (when in Preview mode) or in the center (as shown here). General information is displayed to the right. Navigate to the folders on the left by clicking the folder in the list. It works just like Windows Explorer.

Since I introduced the Organizer in the "New or Improved in X3" section, I won't belabor the point. However, here are some other tips on using it:

▶ Double-click a photo to launch the Full Editor.

▶ Select more than one photo and then select the Full Editor button at the top right of the screen to open them all in the editor.

▶ Don't forget the Express Lab. Select one or more photos and then choose Express Lab from the top right.

▶ You can safely ignore the Organizer if you want. It is not crucial to photo restoration or retouching. However, I strongly encourage you to use it or another program to help you view, tag, and sort photos. Since it is a part of PaintShop Photo Pro X3, it makes sense to give it a try.

▶ Most menu items are grayed out. This is because they are for the editor. Don't freak out about it.

▶ The Organizer organizes videos, too.

▶ Don't forget the Preview and Thumbnail mode buttons at the top of the screen.

▶ The Organizer toolbar has most of the tools you'll need to use. You'll be able to capture and apply edits, sort thumbnails, print contact sheets, delete photos, change thumbnail sizes, and more.

The Science of Scanning

SCANNERS ARE WONDERFUL. I love them. I can scan things for hours on end, and I've filled up many gigabytes of hard drive space with scanned photos, pictures of books, maps, and the like. You could also scan negatives or slides. Scanners are the best way of digitizing (strange how old-fashioned that sounds) material that exists in the real world and making it available on your computer, which is how I make printed photos accessible to edit in PaintShop Photo Pro.

How Scanners Scan

Here's how a scanner works. You put a picture on a flat pane of glass that's part of a boxy thing plugged into your computer, press a button, and then you see what was on your scanner show up in your monitor. Do you really need to know any more than that? Probably not, but I'll share some interesting tidbits.

Scanners shine a powerful light through a clear glass plate onto something reflective. In this context, that's most likely a photo. The light bounces off the photo and is captured by photo-sensitive receptors in the scanner. These are called *charge-coupled devices*, or CCDs. Your typical flatbed scanner has three arrays of CCDs, each of which senses a different wavelength of light that correspond to the colors red, green, and blue. After the scanner scans the photo, it saves the information to your hard disk drive (normally via USB) as an image file.

Scanner Types

There are many types of scanners. Aside from the flatbed scanner (the most common, and the one I am writing about), there are hand-held scanners, rotary, drum, planetary, 3D scanners, and probably more that I didn't come across in my research. They all have different strengths and weaknesses, but most of this information is irrelevant to this book.

Choosing the Right Resolution

Scan resolution for the typical flatbed consumer scanner (the type you and I can most likely afford and buy) is measured in dots per inch (dpi). It's analogous to the pixel, which is the standard measure of resolution for computer monitors and graphics files because it's the smallest piece of an image. When you ratchet up your screen resolution, you add more pixels-per-inch of screen space. In the not-too-distant past, a screen resolution of 640×480 was more than adequate. Today, the minimum resolution we tend to use is 1024×768. I am in 1680×1050 widescreen mode as I write this. Thus, I am looking at 1,764,000 pixels instead of 307,200—on roughly the same physically-sized screen (adjusted for inflation). I say "roughly" because I am using a new, larger monitor, and it is widescreen, but even so, it's not over five times larger than our old one. I can discriminate much smaller objects on my monitor and have much finer detail with a higher resolution. Edges don't look as jagged, and I have the appearance of a

much larger workspace (even though sometimes the icons are much smaller). Having a larger number of pixels is better in almost every instance, but it does demand more from your computer system—for example, more RAM, a better monitor, etc.

What's a Pixel

Pixel is short for picture element, which is short for useless trivia.

The effects of increasing the dpi of a scanned image are similar to the effects of increasing your screen resolution. More dpi equals more fidelity to the true image, allowing you to capture greater and finer details. However, since we don't live in Utopia with a terabyte of RAM in each computer, unlimited disk space, and super-ultra-fast peripheral connectivity (someday this sentence is going to be very funny), we scale the dpi we choose to the application we are scanning for (see Table 1.1). Figure 1.19 illustrates the quality and size difference between photos scanned in from 72 to 1200dpi.

Reference button

Figure 1.19
Showing the difference between 72, 150, 300, and 1200dpi.

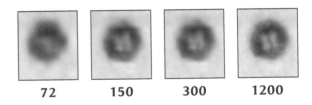

| 72 | 150 | 300 | 1200 |

Table 1.1 Typical DPI Uses and File Sizes		
DPI	**Use**	**File Size (4×6 photo, 24-bit color)**
72-100	Internet or desktop use	509KB @ 72dpi
100-300	Higher-resolution computer use	1.68MB @ 100dpi
300	Standard photo work and reasonable printing quality	6.30MB @ 300dpi
Up to 1200	High-quality photo work and printing	98.5MB @ 1200dpi
Over 1200	Ultra-high fidelity restoration and archiving	393MB @ 2400dpi

As you can see from Table 1.1, the file sizes start to get ridiculous when you get to 1200dpi. This data is for a 4×6 inch photo, which is on the small side of things. If you are working at 5×7 inches or larger, the sizes are going to be even greater.

The Terabyte Barrier

I was proud to cross the Terabyte Barrier as I wrote the first edition of this book. Today, I have over six terabytes of hard disk space and am planning several more for backup and archiving.

Another adverse effect of higher scan resolution is that you start to scan the actual microscopic surface (and defects) of the photo, and not the photo itself. Sometimes, it's good *not* to know all the pits, specks, and microscopic dust that are present on a photo. You'll be tempted to want to restore things that, to be honest, won't be caught if you scan the photo in at 300dpi. Figure 1.20 shows the difference between a photo scanned at 300 versus 2400dpi.

Notice that there is a trade-off that occurs. At 300dpi, the photo is clearly not as sharp as at 2400dpi. However, there are far more scratches on the 2400dpi version. You'll have to experiment to find the precise resolution you prefer working with. I've found that the resolutions I use the most are those that my computer can handle without choking. That's somewhere between 300 and 1200dpi, depending on the photo size. There are times when I scan at 2400, but for the most part this is to save a high-res scan for archival purposes only. I reduce the resolution when I plan on working to restore the photo. Yeah, I know. Reality sometimes stinks.

Figure 1.20
The visible difference between 300 and 2400 dpi.

Don't Forget About Bit-Depth

We tend to focus on dpi as the single measure of scan quality. While it is very important, don't forget to use an appropriate bit-depth. This ensures that you scan the photo with enough colors (or levels of grayscale detail). For the highest quality, scan at 48 bits and save your files as 16 bits/channel TIFFs (16 bits per channels times three channels equals 48 bits). While less capable than 48 bits, 24-bit scans (also called 8-bit images, because 8 bits per channel times three channels equals 24 bits) are acceptable in most instances. If your scanner has the ability, experiment with each type and examine the trade-offs between image quality and file size (48 bits will be much larger). I scanned everything for this book at a bit depth of 16 bits/channel, or 24-bit color.

Scanning Photos and Other Objects

I'M READY TO GET DOWN to the task of scanning things. I've covered a bit about photo restoration, PaintShop Photo Pro, organizing photo collections, and scanning. Here's where you get to put some of this information to practical use.

Although I mostly refer to photos, this information applies to other objects as well. Don't forget about old newspaper clippings, obituaries, baseball cards, postcards, letters, patches, maps, diplomas, and other historical objects. Be creative with objects that are larger than your scanner bed. I scan a small portion at a time and later put all the pieces together like a puzzle using PaintShop Photo Pro.

Cleaning Your Scanner

Be fanatical about cleaning your scanner. Clean it before every use. I use a popular brand of glass cleaner that stays next to the scanner at all times. This saves me the time and trouble of having to get up, go to the kitchen, look under the sink, get the cleaner, come all the way back to the computer, and then clean the scanner. I'm serious. I'm looking over at my spray bottle as I type this. It's sitting right between the printer and scanner, within easy reach.

Right next to my cleaner I have a pile of unused coffee filters. The brand-name isn't really that important, but experiment with the size. Mine are for a small coffee pot, which I think is a four-cupper. I just walked to the kitchen to check, and yes, they are four-cup filters. We've got a larger coffee pot downstairs, but since those filters are more expensive I don't use them to clean glass.

I Started Here

This was the first section I wrote for this book, which provides some insight on how important I think it is to clean your scanner. That and the fact that the bottle of window cleaner is staring me in the face all the time.

There are commercial coffee machines that take much larger filters. Oh yeah, baby. I love cleaning sliding glass doors with the commercial filters. They are nice and large, and you can clean a lot of glass with those guys.

My point about using coffee filters comes from years of glass-cleaning experience. I've come to the tried and tested opinion that the lowly coffee filter is the best, often cheapest, and most dust-free solution to glass cleaning. When I was in college at the United States Air Force Academy, we underwent rigorous room inspections. Newspapers were our tool of choice to clean the mirrors and glass in our rooms. The problem with using newspapers, however, is the ink. When you get done cleaning the glass, you need to clean your hands!

The dust-free part is pretty important, and that's the reason newspapers work well, but it's also why coffee filters shine. Who wants to drink coffee that has lint in it from the filter?

Cleaning Photos

If your photos need to be cleaned, you should consult a professional or research photo cleaning on the Internet and follow the advice that best suits your problem. To dust photos, I use pressurized air that helps you blow dust out of a computer keyboard or case (and scare the cat). Here are a few practical guidelines for photo cleaning:

► Don't use anything that will scratch the photo, such as a rough paper towel.

► Don't rub or buff vigorously, or you'll scratch or fade the photo.

► Don't use a cleaner that could chemically interact with the print and destroy it.

► Be careful with "canned air," as it can condense water out of the air and blow it all over the photo. Make sure to get a variety that says "moisture and residue free." Regardless, be careful and do some test runs with plain paper on humid days.

Handling Photos

It goes without saying (but I'm going to say it anyway) that you should handle all of your photo prints with care. Make sure to clean your hands prior to touching old photos, or better yet, wear protective gloves. The oil your skin naturally produces will damage photos over time. If you decide not to wear gloves, by all means handle the photos from the edges and support them from underneath. This will prevent your fingerprints from getting all over the photo. When you scan in a photo at 300dpi, things like fingerprints will stand out far more than you can see with your naked eye.

I try to be very careful when I handle photos or other documents that are in an album. Older albums are especially prone to grabbing onto photos and not letting them go. The first step in restoring an old photo is often rescuing it from a poorly designed storage environment.

Be Careful How You Treat Other People's Photos

If you plan on restoring or retouching other people's photos, especially if you are going to do it for money, please take every possible safety precaution to protect the photos and yourself. Wear gloves when you handle the photos, scan them carefully, and get them back to their owner quickly.

The plastic "protective" sheet (or sleeve, as the case may be) may stick to the photo, or the sticky paper of the album may be sticking too much. If this is the case and the photo is important, you should seek the assistance of a professional conservator or photographer with this type of experience. If you are going to remove the photo yourself, carefully try to peel the protective sheet back, but if you feel the surface of the photo starting to give way, stop immediately. Never try to peel the photo off the page. You may bend and damage the photo irreparably.

It often pays to think outside the box. I had a problem with one of the photos I've chosen to feature in this book not coming out of the album. I was able to peel back the plastic sheet, but the photo was stuck to the page. Want to know what I did? I just put the album down on the scanner and scanned the photo in, stuck and all.

Running Your Scanner Software

Make sure that your scanner is plugged in, powered on, and connected to your computer. Make sure that you've correctly installed the scanning software that came with your scanner and that it is operating correctly. Once you've accomplished that, you're about ready to start.

Be on the lookout for automatic corrections that may be turned on by default. There's nothing intrinsically wrong with them, but you're scanning in photos so that *you* can restore them, not the scanner. Look at Figure 1.21 to see all the automatic corrections my scanner is capable of, as well as the overall software interface. Most scanner software will feature similar options.

Figure 1.21
A typical scanner software interface.

It's quite hard to place a photo or other object on the scanner perfectly straight. If you put your photo at the edge of the scanner bed, you're very likely going to lose a little bit of your photo because it's outside of the scanning area. Try it and see. That's why I use a plastic ruler that rests against the bottom or any side of the bed. It gives me a straight offset from the border of the bed, and I crop it out later.

Having said all that, here is a general scanning workflow. Use it as a baseline to fit your situation and to jog your memory so you don't forget things:

1. Open the lid and clean the scanner bed.

2. While the scanner glass is drying, gather the material you want to scan. Make sure that the scanner bed is clean and dry before continuing.

3. Place your ruler or other straightedge on the scanner bed to give yourself a square, straight photo placement helper.

4. Place the photo against the rest. Make sure that it doesn't go under or over it.

5. Close the scanner lid. If the ruler or straightedge you use keeps the scanner from closing properly and securing the photo to the glass, you may have to put the photo in by hand and straighten it later in PaintShop Photo Pro.

6. If you haven't started your scanner software, do so now.

7. Depending on your software, you may have different options here, but you'll probably want a preview or overview scan of what is on the scanner bed. This is done very quickly at a much lower resolution than the final scan.

8. Select the area you want to scan. When you are scanning small photos, this really helps keep file sizes down. For sizes of 8×10 or so, you won't save on file size, but it will keep cropping down to a minimum. I like to leave a little border around each side that's larger than the photo itself so I can decide later exactly how I want to crop it.

9. Select a scan resolution and bit depth (sometimes called *image type*).

10. Make sure that automatic corrections are turned off.

11. Scan. You can normally select to scan to a file or image type. If you choose .jpg, make sure that the image quality is set to "highest," or 100%. I always choose uncompressed .tiff, which is a high-quality image format.

12. Bask in the glow of a job well done.

Choosing a Commercial Solution

Believe it or not, you don't have to scan everything yourself at home. You can choose to have photos commercially scanned at a fairly reasonable rate. This would be most cost-effective if you were restoring and retouching photos as a small business and could offset the expense by including scanning costs in your quotes, but in small batches, paying a professional to scan your photos isn't too costly. You can also take your photos to photo-printing kiosks, but this is no better than scanning at home (unless, of course, you don't have a scanner).

I use a local print and copy business that I became familiar with when I was freelancing in the marketing and design industry. We would send them quite a bit of professional printing business and had a good working relationship. When my wife's grandfather died, we used them to scan in several old photos so that the family could concentrate on other, more important matters.

Search your local area for print and copy companies that might perform this service, call them up, and ask for their rates. If you plan on using them a lot, ask for a discount. Make sure to verify what dpi they are capable of scanning and what format you want the files to be saved in before closing the deal.

Making a Business Out of Photo Restoration

THIS SECTION IS FOR THOSE of you who have or will get the bug of photo restoration and retouching and decide to make a small or part-time business out of your passion. I want to encourage you to go after your dreams. Don't let these general "things to think about" scare you or make you not try, but do so with clear expectations and a plan for success.

Passion

It starts with passion. I have a passion for this. I can stay up late at night working on photos and cleaning them up. You obviously have more interest in photo restoration and retouching than the average person, otherwise you wouldn't have bought my book. Good on ya, mate! That means you probably have what it takes to pursue this as a hobby, and if you are interested, to think about this as a part-time gig where you get paid for your efforts.

About Me

My other passions are my family, the guitar, recording, music, photography, learning foreign languages, movies, writing, genealogy, computer graphics, woodworking, football, motorcycles, technology, and more.

Infrastructure

Before you begin pursuing this as a side business, you should take a look at the infrastructure you have or plan to have. Think about your computing power and whether it is up to snuff. Got enough RAM to handle working on a 500MB 1200dpi photo? Is your processor fast enough or do you have a system on its last legs? Have enough hard disk drive space? What kind of scanner do you have? Do you have a Web site that you can set up with FTP access so people can send you large files without them bouncing when they hit your e-mail server?

Some of this is to save you frustration when the pressure is on and people are depending on you to restore their family heirlooms. It's nice *not* to have to battle the computer when the stakes are higher than retouching your own photos. You can still succeed with a more limited system and fewer resources, but it may take you longer to work on the photos and finish them.

Time

Time is another factor in deciding whether or not to pursue photo restoration and retouching as a side business, or how much you are willing to take on. If you have a 9–5 job, you'll have to work on photo restoration at night and on the weekends (or whatever your days off are). Factor this information into when you tell clients their photos will be done.

Advertising

It helps if people know you are selling your services as an independent photo restorer. Initially, try marketing yourself through word-of-mouth advertising. Use your family and friends as advertisers. Tell people at church, your job, school, your softball team, and other places where you meet and know people. Seek out opportunities to use your skills in your community. Chances are, your first clients will be people you know. Do a good job so they will happily refer you to others. Seriously consider buying a domain name and putting up a Web site, even if you are doing this part-time. You can put information about yourself, your services, prices, terms and conditions, and display samples of your work on the Internet.

Money and Taxes

You can set the prices you charge in a few different ways. Start by researching what other people charge to restore photos. Look around on the Internet and investigate Web sites where people list their prices. Often, you'll find the price is dependent on the type and amount of restoration that needs to be done. It will be less for small touch-up work and more for a major overhaul. I would forego an hourly rate and charge per job, because, quite frankly, you'll price yourself out of a job if you want a decent hourly rate. Be open and honest about how you price, and be prepared to give quotes.

If you are legitimately conducting a side business, you should look into how it will affect your taxes. You may be able to write off part or all of your computer equipment, Web site, software, and advertising expenses. Be careful that you include any sales taxes your state or locality may require and report all your income accurately. You may never make a profit at photo restoration or retouching, but it's quite possible that it could help your tax situation.

Tax Disclaimer

Taxes (be they local, state, or national) are a touchy subject. The laws are sometimes difficult to understand and can change. I make no claim at being any sort of tax expert, especially if you are reading this outside of the United States. You should consult an accountant or your tax preparer for official guidance on how to start your small business. This section of the book is more or less to tell you to do just that.

Expectations

It may not be a good idea to quit your job (the one providing money for food and a place to live) and start a photo retouching business with no clients, thinking they're going to fall out of the sky and into your lap. Retouch your photos and tell people what you're doing. Put samples on the Web and see if anyone is interested. If you are a professional or semi-pro photographer, photo retouching and restoration skills will undoubtedly help you extend and grow your business. It will make what you do that much better.

Regardless of whether anyone else ever offers to pay you to retouch their photos, you'll always have yours.

Now it's time to start retouching and restoring. The next two sections will walk you through my efforts to restore and retouch two photos: an old print and a brand new digital photo. I want to show you what happens from start to finish, a sort of overview. The rest of the book focuses on addressing specific problems.

Photo Study 1:
Restoring a Print from Start to Finish

FIGURE 1.22 IS A PHOTO my wife's grandfather took when he was in Europe during World War II. He saw his first combat in North Africa, and his unit was involved in the invasion at Anzio in 1944. He continued to serve in Europe until the end of the war.

While Bud was in Italy, he found the time to take this photo of the Leaning Tower of Pisa. It's a compelling photo of an immediately recognizable landmark, taken during a historically significant time in modern human history. The topper is that someone in our family took the photo. I can't think of a better candidate for photo restoration.

Before I began work, I took a close look at the photo with a critical eye toward what was wrong and could be fixed. First, there is a huge blob of gunk, or whatever it is, staining the sky. That's going to have to go. There are several creases and cracks in the finish. I think I can fix those. The border is looking shoddy. Check. And, in general, it's faded and yellowed.

Figure 1.22
Wartime photo of the tower at Pisa, Italy.

Critical Viewing

Learn to look critically at photos. You're going to need this skill to see what's wrong with a photo. There are times when it will be immediately obvious, but at other times the problems will be more subtle. Imagination and some experience will help you get into this groove.

Having identified several flaws and turned them into my restoration goals, the following steps took me through the process of restoring this wonderful photo from start to finish.

1. Scan the photo. This photo was scanned at 600dpi and 24-bit color. It's a fairly small photo to begin with, so 600dpi was not too unwieldy. (See the previous sections in this chapter for more information and tips on scanning.)

2. Open the photo in PaintShop Photo Pro and straighten it, if necessary. I straightened it a bit. You'll find that most photos, even modern 4×6 prints, aren't perfectly straight on all sides. In this case, I chose one of the long sides of the photo itself, not the border, to use as a straightedge. Save the file as a .pspimage in order to preserve the original scan.

3. Next, I went to work on cleaning up the photo border. It's a fairly easy way to get started on a photo and work your way up to the harder parts. This border is yellowed and cracked with age. There are several approaches you can take. You could create a new border, crop the old border out entirely, or lighten the original border. After I duplicated the Background layer, I lightened the border with the Lighten/Darken Brush (see Figure 1.23) on the new working layer. See Chapter 5, "Repairing Physical Damage," for more information on repairing borders. Notice that I selected the border area to keep the brush out of the photo. If you don't want a solid white border, you can lower the opacity of the border working layer to blend it in with the original. That is an effective way of minimizing the damage but retaining some of the original border.

Figure 1.23
Use the Lighten Brush to wipe away an old photo border.

4. Next, I addressed the sky, with the exception of the large, gunky spot. I used the Clone Brush to cover up the most obvious creases and spots. (There were so many that I eventually had to choose to stop.) This photo didn't have a dust or a speck problem. For large Clone Brush operations (as is the case with this photo), I create a new raster layer to use as my Clone Brush destination. See Chapter 2, "Removing Specks, Dust, and Noise," as well as Chapter 5 for more information.

5. With the majority of the sky repaired, I moved on to tackling the gunk. I used the Clone Brush to cover up this unsightly stain (see Figure 1.24). I needed to be very careful not to be obvious about it. Larger sections of cloning can be much more visible than smaller areas if done improperly. I used the Soften Brush to make the edges of my clone work less visible. See Chapter 6, "Erasing Writing and Other Marks," for more information on cleaning gunk.

Figure 1.25
Focus on getting the right texture as you clone.

Figure 1.24
Go away, gunk.

6. I worked on the grounds (see Figure 1.25) next. This included the pavement at the front of the photo, the trees on the right side, and the buildings on the left. Once again, the Clone Brush was my friend.

7. I made a lot of progress up to this point, but hadn't touched the central feature: the tower. The tower (Figure 1.26) proved to be a more time-consuming process than the rest of the photo. In situations like this, take your time and don't feel like you have to repair everything in one sitting. The key to restoring the tower was to vary the size of the brush so it was not too large and to pull the right source material from columns and spaces that had the same shadow and tone. I pulled material from areas above, below, and to either side of the feature I was restoring. It takes a bit of practice to get this part right.

Figure 1.26
Imaginative cloning.

Figure 1.27
Sharpening focus.

8. The final touches were next. I left these for last because I wanted to be able to adjust a clean photo. Since this is a black-and-white photograph, I reduced the yellow cast very slightly with Fade Reduction. See Chapter 4, "Making Color Corrections," for more information.

9. Next, I increased the sharpness with Unsharp Mask (see Figure 1.27) very slightly. I didn't overdo it. A stronger setting brought out extra noise and made the remaining imperfections stand out.

10. Finally, I made a Smart Photo Fix adjustment (see Figure 1.28). I accepted the suggested settings except Sharpness, which I reduced to 0 since I had already sharpened the photo. See Chapter 3, "Finding the Right Brightness, Contrast, and Focus."

11. With work on the photo done, I saved a final version.

Figure 1.28
Improving with Smart Photo Fix.

As you look at the finished photo in Figure 1.29, I want to explain something that may surprise you. I purposely did not restore every pixel of this photo to its original state. First, that would have been too time-consuming. Second, there are times when it is impossible. You may have to step back and say "it's done," even when there are still flaws. At those points, you may actually do more damage to the artistry of the original photo if you continue, as well as making it obvious to one and all that you've retouched it. That's a bad thing, and in my opinion, it's better to stop at the point where your hand is still invisible. This isn't a zero-sum game. In other words, if you make it better, you are doing your job. How much better is mostly an artistic decision, but worse is definitely worse.

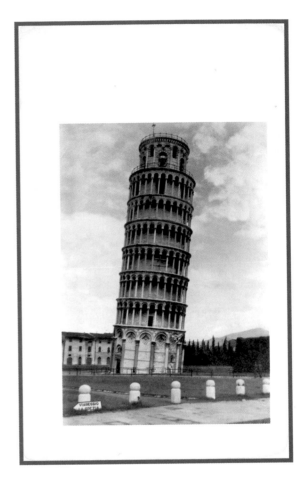

Figure 1.29
Presenting the restored Leaning Tower of Pisa.

Photo Study 2: Retouching a Digital Photo from Start to Finish

FIGURE 1.30 is a photo from 2009 of our oldest son, Benjamin, getting ready for a haircut. My wife, Anne, took this photo outside in front of the garage with one of my dSLRs. Unlike the Leaning Tower of Pisa, this is just a quick family photo. It's casual, but good. Probably like a lot of the photos you take.

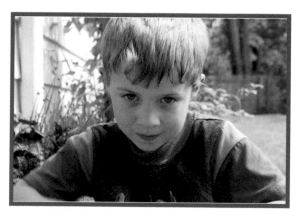

Figure 1.30
Prepping for a haircut.

Film Versus the Computer

Although you might not think film and digital photography have anything in common, most of the photo retouching tools and concepts of programs like PaintShop Photo Pro were invented in the darkroom by photographers working to develop film and make prints. Things like dodging and burning are direct descendants of old-school darkroom techniques. Every decision film photographers made—what filters to use, whether or not to employ one or more flashes, which film type and ISO to use, the camera settings, exposure techniques, darkroom tools, and other exposure tricks—all affected the end result (the print) one way or another. That's not so different than you sitting at your computer deciding how to retouch a photo in PaintShop Photo Pro.

To begin, the decisions I make when I retouch a digital photo are different than with an older print. First, I know I don't need to scan the photo in. The resolution and overall quality have already been determined by the camera. Being digital, there are no dust problems, scratches, gunk, or other surface damage that I have to repair. Digital photo retouching is largely in the domain of lighting, color, focus, and composition.

Here are the steps I took to retouch this recent digital photo.

1. I began by downloading the photo to our computer from our camera's storage card. You may receive photos over e-mail or from family and friends on CD-ROM. If so, copy the photo to a working location of your choice as if it were any other computer file.

2. I immediately made a copy of the file and placed it in a different folder on my hard drive than the original. This keeps my working copy separate from the original photo and ensures that I have the master to return to, if needed.

Auto-Preserve

PaintShop Photo Pro has a cool feature that preserves the original photo and saves any edits in a new file. Turn it on (or off, as the case may be) from the Auto-Preserve tab of the General Preferences dialog box. Experiment with copies of photos to get the hang of it and see if you like it. Don't practice with original photos until you're sure you like this feature.

3. I opened my working copy of the photo (digital photos are often in .jpg or .tif format) in Paint Shop Pro Photo and saved the file as a .pspimage. With the housekeeping done, I started retouching.

4. First, I should say that the photo is very good to start with. Remember, things don't have to be torn in half for you to retouch a digital photo. The process I followed was to enhance the best aspects of this picture to make it even better.

The first thing I did was to tweak the image with Histogram Adjustment, as shown in Figure 1.31. Ben's face was partly in shadow, so I lightened him by moving Gamma toward the High side.

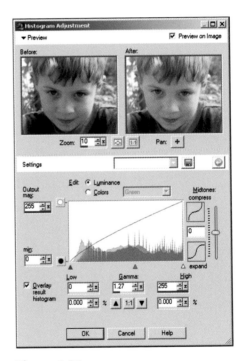

Figure 1.31
Brightening Ben's face.

5. Next, I realized that when I zoomed in, the focus was a bit soft. I decided to subtly sharpen it. Figure 1.32 shows the Unsharp Mask dialog box with the settings I used.

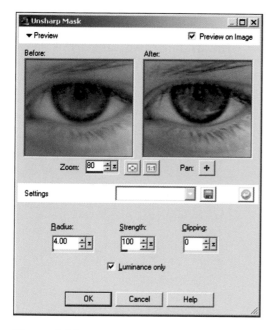

Figure 1.32
First round of subtle sharpening.

6. I then decided to take some noise out of the photo, as shown in Figure 1.33. (The noise was more apparent in the background.) Sometimes, I'll sharpen and then perform noise reduction. At other times, I'll do the reverse. It comes down to what I see in the photo. If I need a little sharpness and there isn't much noise to begin with, I'll sharpen first. If there is too much noise to start with, sharpening it only makes the photo look worse. Here, the original was very good to begin with, so I was able to sharpen first and then use noise reduction to keep the noise down.

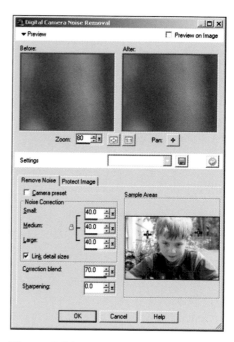

Figure 1.33
Noise reduction in action.

7. Next, I smoothed Ben's skin (see Figure 1.34). This was mainly an artistic decision. I wanted his skin to be smoother than it is, but not so much that it looked artificial.

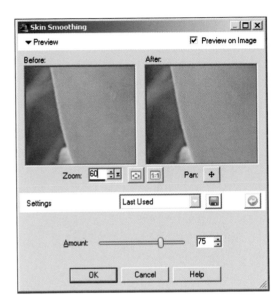

Figure 1.34
Artistically smoothing his skin.

8. After this, I increased the color saturation of parts of the photo with Vibrancy. This boosts low-saturated areas while leaving colorful parts alone (see Figure 1.35).

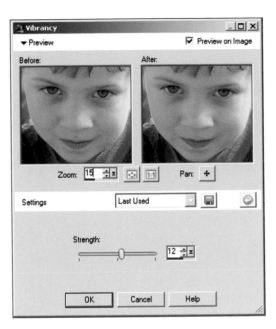

Figure 1.35
Adding more color.

9. The photo was almost done at this point. I looked carefully for any imperfections and cloned them out with the Clone brush or smoothed noisy areas away with the Soften bush.

10. All that was left for me to do was recompose the shot to get a more dramatic close-up of Ben's face. When I did that, I decided to brighten him a little with Highlight/Midtone/Shadow (10/15/0).

The final photo is shown in Figure 1.36. As I mentioned previously, the original photo was very good, but I was able to find several areas to improve on. What often happens with good photos is that you discover subtle imperfections once you start working on them. In this case, I didn't realize Ben's face was too dark until I started looking at alternate Histogram Adjustments. The light in the photo is natural and strong, but it's coming from his back left. This puts his face in shadow.

You can combat this as a photographer by using a fill flash or by bumping up the exposure so that people's faces are brighter. However, once the photo is taken, it's taken. With digital photos, the only recourse you have to fix issues like this is in the computer with software like Corel PaintShop Photo Pro. The end result is a fine digital photo worth framing and showing off.

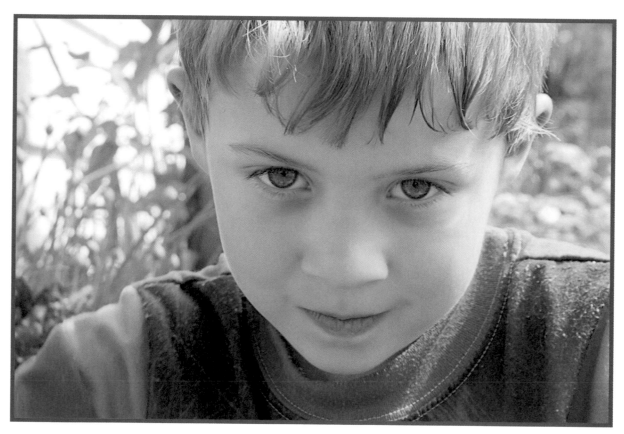

Figure 1.36
Ben, retouched and looking better.

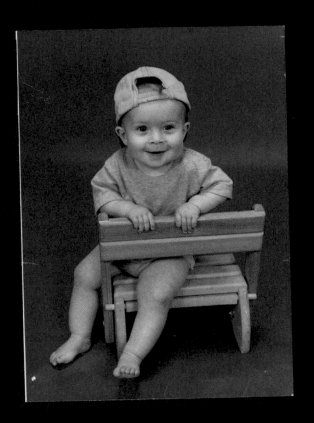

Removing Specks, Dust, and Noise

<div style="text-align:right">

2

</div>

STARTING WITH THIS CHAPTER, I am going to focus on photo studies—specific retouching and restoration examples with one or more main teaching points connected to the chapter's subject. In this case, the focus is on common problems we all have to deal with at one time or another, whether we are working with scanned or digital photos. The problems are specks, dust, digital noise, more dust, and texture problems (which can sometimes be treated as noise or film grain). Here are the photo studies I will cover in this chapter.

▶ **Photo Study 3: Removing Specks**—Specks are a common problem with scanned photos, especially at higher resolutions. The effect of a number of small specks (even tiny ones you can't see with the unaided eye) is to take away clarity and color from a photo. I'll introduce you to one of the most helpful photo retouching tools in this study: the Clone Brush.

▶ **Photo Study 4: Eliminating Dust**—I'll tackle removing a combination of dust and specks in this photo of the front straightaway of the Indianapolis Motor Speedway. I'll show you a technique that will enable you to get at hard-to-see problems.

▶ **Photo Study 5: Taking Care of Digital Noise**—Noise is to digital photos as film grain, dust, and specks are to photos printed from film and scanned into your computer. I'll walk you through several digital noise removal options using a photo of my daughter Grace.

▶ **Photo Study 6: Dusting Off Shots for eBay**—The problem with dust and digital photos is the dust that settles on your subjects, not the dust on film. If you're going to take shots of things to sell on eBay, then pay attention to this photo study.

▶ **Photo Study 7: Wrestling with Studio Prints**—If you need to scan in a studio portrait for digital archival or retouching purposes, then this study is for you. I'll get rid of the dust and scratches from a print of my son Ben, in addition to looking at surface texture problem these prints often have.

Photo Study 3: Removing Specks

FIGURE 2.1 IS A PHOTO OF MY father-in-law's late brother, Jim. Jim was a retired veteran of the United States Army and a real firecracker. He had a great sense of humor. He married a German woman named Liz whom he met while he was stationed in that lovely country. Jim and Liz lived several states away, and they would come driving up in their large, red Lincoln Town Car most Thanksgivings. They made a great couple.

After Jim died, Liz asked me to retouch a special photograph of Jim for her. I was honored, and a little intimidated, because no one had ever asked me to retouch a photo for them. This is going to happen to you after people hear you've been retouching photos. Relax, do the best you can, and learn from each experience.

The casual photo, which Liz took as they were driving, is simply of Jim in the car. It's not a noteworthy photo, as you can see. Not historical. Not that interesting. Just Jim in the car, driving. It's funny how these types of photos sometimes carry great weight. Despite the fact that it's just a casual shot, it is highly prized.

Getting Started

Since this is the first detailed photo I will restore or retouch, I want to include the scanning, straightening, and cropping steps. After this photo, I will assume that you know how to do this and leave these details out.

1. Turn on your scanner and clean the glass with a lint-free cloth, newspaper, or coffee filter and glass cleaner. Make sure the glass is dry before continuing. I find "canned air" helpful in removing dust from the glass or the photo.

2. Place the photo on the glass as straight as you can. I use a clear ruler lined up against the edge of the scanner (if you're a wood-worker, the ruler is acting as a fence) to help me position the print. This allows me to place the photo away from the sides of the scanner and avoid the dreaded "The edge got cut off!" problem.

3. Launch your scanner software. Make sure to turn off all automatic color and focus tools in your scanner software. You want to scan the photo without any automatic adjustments.

Figure 2.1
This photo looks nice, but a closer look reveals major problems.

4. Choose a resolution, color depth, and file type to save the scan. I chose 300dpi, RGB color, and .tif for most scans. There are times I scan in using a higher resolution (for archiving or if the photo is very small), but I normally resize those down in PaintShop Photo Pro to make working with them less of a hassle.

Measure Twice, Crop Once

I always scan an area larger than the photo and crop it in PaintShop Photo Pro. I want that warm fuzzy feeling I get when I know I've got the entire image and didn't leave anything out. Additionally, I get a much more precise crop in PaintShop Photo Pro, which also allows me to straighten, if necessary.

5. When the scan is finished, close your scanner software. You can now open the scanned photo in Corel PaintShop Photo Pro (see Figure 2.2).

6. First, make sure that the photo is straight. Select the Straighten tool and drag one of its ends to a corner of your photo. Zoom in really tight so that you can place the tool precisely (see Figure 2.3).

Figure 2.3
Using the Straighten tool.

7. Zoom out and drag the other end of the Straighten tool to the other matching corner; then accept the changes. For borderless photos, use the edge of the photo itself as a guide to straighten. For photos with borders, I align the Straighten tool with the photo edge rather than the border.

8. Next, crop out the extra area (the scanner bed) you scanned. Select the Crop tool from the Tools toolbar and make sure that Maintain aspect ratio is unchecked. Drag the crop area to one corner of your photo. Expand the crop area toward each of the other corners, either one corner at a time (see Figure 2.4) or diagonally to the opposite corner.

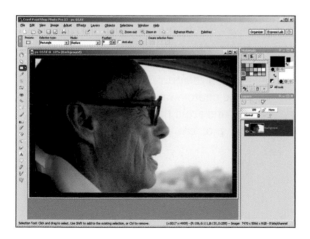

Figure 2.2
The initial scan in Photo X3.

Figure 2.4
Setting the initial crop box to the corners.

9. Zoom out and check the crop area against the sides of your photo. Adjust the crop area inwards to catch areas that aren't straight. You'll often lose a few rows of pixels along one or more of the edges, as photos aren't always perfectly square or rectangular (see Figure 2.5).

Figure 2.5
Fine-tuning the crop area.

10. Finish the crop by clicking Apply.

11. Finally, save your straightened and cropped photo as a .pspimage file.

Naming Advice

I treat my scanned, straightened, and cropped .pspimage files like photo negatives. In other words, when I scan the photo in, straighten, crop, and save it, I use that file as my master unretouched photo and not the original scan. It saves time not having to continually straighten and crop the photo if I want to start over. I save my working copies with new names so I don't overwrite this corrected scan.

Zooming In

After you scan the photo, straighten, crop, and save it with a suitable name, you're ready to start working, right? Almost. Look around and see what needs to be done. I chose this photo to illustrate how to remove specks and dust, which are plentiful. Why so much? Partly because I scanned the photo in at 1200dpi. This almost always results in more tiny specks, dust, and damage that you have to fix. If you have the patience, however, it's well worth it. Figure 2.6 shows a close-up area of some of the specks and microscopic scratches on the surface of the photo. Notice how they appear to sit "on top" of the photo? At very high scan resolutions, the damage to the surface of the photo looks like, well, like it's on the surface and not part of the image itself. This makes it easy to distinguish between surface problems and photo content.

Figure 2.6
Specks galore.

Figure 2.7 shows another area of the image. These are mostly small scratches that were probably caused by sliding the photo on a surface, perhaps into and out of an envelope. How can I tell? Because they are going the same direction.

Figure 2.7
Nice scratches, too.

Take a look at the texture of the photo in Figures 2.6 and 2.7. It's pretty complex. This is an example where you won't be able to zoom out and broadly paint with the Clone Brush. Nope. This calls for very close-in work. For this photo, in fact, I kept things zoomed in to at least 200%. The technique I use is the systematic erasure of as many specks, dust, and scratches as I can take using the Clone Brush to transplant undamaged material over the blemishes. I make the destination a new raster layer, shown in Figure 2.8, which preserves the original photo layer underneath. Make sure to enable the "Use all layers" option in the Clone Brush and that your empty (at first) destination layer is selected in the Layers palette.

Figure 2.8
Using a special destination layer to clone on.

Negative Function

If you're tempted to use the Blemish Fixer (one of the Makeover tools) with this method, forget it. You can't fix a blemish on another layer. It will work great if you fix blemishes on the same layer, but that defeats the purpose of preserving the original detail in a separate cloning layer. That's not to say I ignore blemishes for photos like this, but I normally clone first and then lock those changes in before moving on to the Blemish Fixer. You'll find more obvious examples of using the Blemish Fixer and Makeover tools later in the book.

How to Clone

At first, cloning seems incredibly easy. Hit the tool, select a source area, and lay down the new material over the bad area. Presto, you're done. It looks great, and everyone will applaud your magnificent skills. Not so fast. There are times when cloning *is* that easy. This isn't one of them. I want you to look at some examples from this photo to see the difficulties you'll have to overcome. Bad technique will make your work obvious and not improve the photo.

The importance of making sure that you're getting just the right color match between the source and destination is made clear in Figure 2.9. Notice that I chose a source area that was pretty close to the speck I wanted to cover up. The problem is that I got a little too far into the dark area, and you can see where it's not matching. I'll have to undo it and start over.

Figure 2.9
Poor color match from source to destination.

I am using the correct technique in Figure 2.10. I've chosen the right color area and am brushing with the "grain" of the color gradient. The results are completely invisible.

For Clarity's Sake

Most of the figures in this section are lighter than the image so you can see what's going on. I've also chosen to zoom in and crop very tightly to the action. After all, you don't need to see what's happening on the other side of the photo.

Figure 2.10
Good color match from source to destination.

Figure 2.11 shows a different problem. Here, I am trying to cover up a rather large scratch that is running across the viewing area. See the problem? Yup, I've drug my Clone Brush horizontally across the image, focusing on the shape of the blemish and not the result. This also shows the effects of different shades of a source and destination area, even if the differences are very subtle. The destination varies from light to dark along the scratch, but the scratch is mostly contained in a whiter "cloudy" area. You could try the Scratch Remover on this, but I am trying to show you the ins and outs of cloning.

Figure 2.11
Obvious linear cloning.

I am using a better technique in Figure 2.12. I've selected a source area that matches the scratch area, and I am not simply dragging the brush along the scratch. I've mixed up my brushing so that I brush with a variety of fairly short strokes that don't all go in one direction. It blends in much better.

Figure 2.12
Hiding a scratch without it being obvious.

Figure 2.13 illustrates another common problem, the dreaded "speck transplant." I've gotten specks and blemishes in the source circle of my Clone Brush and then transplanted them to another area of the photo. Definitely bad. Even if you do this on a small scale, people will notice the repeating pattern of specks, dust, or other features. You want to avoid this.

Figure 2.13
Cloning specks.

I am demonstrating the correct technique in Figure 2.14. I've chosen a smaller brush and taken special care to keep any blemished areas out of the source circle of the Clone Brush.

Figure 2.14
Avoiding "speck transplant."

Figure 2.15 illustrates the results of not matching the proper color, even though the source area I've chosen looks like a pretty close match. Part of the problem here is that the surface texture of the photo (in this case, Jim's face) is very complex. I'm not zoomed in enough to get at the details with the precision I need.

Figure 2.15
Tough color match shows I'm not zoomed in enough.

I've zoomed in to 200% in Figure 2.16. Notice that each little crease stands out very well, which gives me a fighting chance of getting all these little specks isolated and fixed. Take care to follow the "lay of the land." Keep your source in the dark areas to fix dark areas and likewise for light areas. This almost looks like a contour map. Clone hills to hills and valleys to valleys.

Figure 2.16
Good color match at 200%.

Figure 2.17 shows the results of careful cloning on this small patch of skin. If you didn't have Figure 2.16 to compare this to, you wouldn't know there had ever been a problem (he says while patting himself on the back).

Figure 2.17
Completed section of hard-to-match skin.

Working a Pattern

Completely removing the specks, dust, and very small scratches in this photo study required successfully using the Clone Brush approximately 10,000 times. I didn't actually count them all up, but it sure felt like a lot. Take lots of breaks, don't be in too much of a hurry, and if your eyes get too tired, stop. I work in a grid pattern based on a good zoom percentage for the particular photo I'm working on. In this case, there were so many physical speck and dust problems that I chose 200% as my optimum working resolution. A representative section of one of the grids (cropped and enlarged for you to see better) is shown in Figure 2.18, filled with plenty of problems to fix.

Figure 2.18
Grid number one, before.

Figure 2.19 illustrates the payoff. Here's one little area of the photo cleaned of problems. I only need to do this about 299 more times. Yes, that is a tremendous amount of work. Don't lose hope or get too bogged down. Start. Make progress. Every little bit helps, and before you know it, you'll be done.

Figure 2.19
Grid number one, after.

Finishing the Photo Study

The completed restoration of Jim driving his car is shown in Figure 2.20. I've finished removing all the specks, dust, and other surface imperfections of the photo using the Clone Brush. I've also worked with the brightness, contrast, and color saturation of the photo. You'll learn more about that in Chapter 3, "Finding the Right Brightness, Contrast, and Focus."

Figure 2.20
A treasured photo restored and now without specks and scratches.

Photo Study 4: Eliminating Dust

FIGURE 2.21 IS A PHOTO FROM THE grandstand on the front straightaway of the Indianapolis Motor Speedway in 1998. Home to the "Greatest Spectacle in Racing," the Speedway is a truly awesome place. Imagine as many people in one place at the same time as you've ever seen in one place at the same time before—and then imagine more. It's astounding, really, and that's before a single car starts its engines and roars by. When that happens, it literally takes your breath away.

Anne and I were engaged at the time and had fantastic seats. If you look at the figure, the shot is looking south down the grandstand toward turn one. We were literally within yards of the Start-Finish line, and you can see the famed scoring pylon rising up.

Behind the Scenes

You know, it literally took me about an hour to find the name of the scoring pylon. I didn't want to call it "that black tower thingy with all the numbers on it," so I researched different sites on the Web, including the official Indianapolis Motor Speedway site and Wikipedia to find out what the dang thing is called.

I took one of those "disposable" panoramic cameras to the race that year. At various times, I try to take photos of different things or events with panoramic cameras. (I shoot digital panoramas and HDR a lot now—and take my old Nikon FE2 along if I want to shoot film.) I really like them for special purposes.

Figure 2.21
A great day at the Indianapolis 500, except for the dust on this dark photo.

This camera wasn't any good for action shots of the cars whizzing by, but it was ideal for sweeping panoramas of the grandstand and crowd. This was shortly before the cars were given the command to start their engines. You can see the pit crews and cars on the front straightaway.

Obvious and Not-So-Obvious Problems

Looking at the scan of the original photo, you can see dust all over the image. It's in the crowd and in the rafters. There are other problems as well, but I want to focus on the dust in this photo study. You would think the dark rafters would be an easy fix, but it's hard to fix things you can't see very well.

I want to share a technique that will allow you to see better in situations like this. Use an Adjustment layer to show the hidden details of a photo; then use the Clone Brush to remove the dust, specks, and scratches. After you're done cloning, the Adjustment layer can be discarded.

1. Create a Levels Adjustment layer in the Layers palette, as shown in Figure 2.22. Make sure it's on top of the photo layer.

The Cool Thing About Adjustment Layers

Adjustment layers are pretty convenient, depending on how you work. You can make dramatic changes without altering the photo and then go back and change the settings or create different Adjustment layers to compare effects. I use them mostly to experiment with different settings (usually Levels and Curves) before I lock those in and move on.

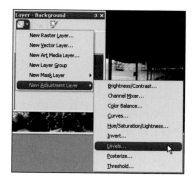

Figure 2.22
Create an Adjustment layer to bring out hidden details.

2. I'm going to alter the levels, as shown in Figure 2.23, in order to bring out the hidden details. The best way to bring out details in shadows is to lower the sliders towards the left side of the dialog box. You can start with the white diamond, and the gray diamond will be "squished" proportionately. Fine-tune the gray diamond to see if you can bring out more details. The point here is not to make the photo look good, but to make the problems stand out.

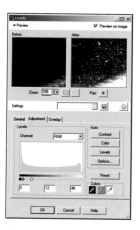

Figure 2.23
Alter levels to lighten dark areas of the photo.

Happy Little Accident

I discovered this technique by accident. I was altering the levels toward the end of restoring this photo (the first time), and realized there was much more detail in the rafters than I could originally see. In other words, I adjusted the levels and then saw a lot more problems (more specks and a lot of cloning that didn't match). I went back and used an Adjustment layer just like the one I've shown you here so I could see where to clone, and then started over.

3. Next, create a new raster layer that will serve as your clone destination. I've named mine "Clone" (see Figure 2.24). Put it between the photo and Adjustment layers.

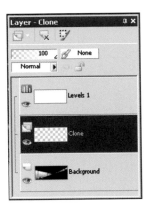

Figure 2.24
Sandwiching the clone destination layer.

4. Select the Clone Brush tool.

5. Uncheck the "Use all layers" option. You don't want to pick up material from the Adjustment layer. You'll know if you do because it looks all weird.

Very Important

These next few steps are critical. You'll need to pay attention to which layer you are working on when you select a source area and when you use the Clone Brush. These layers are purposefully different. Keep practicing until it becomes second nature to switch layers between each operation.

6. Select your photo layer in the Layers palette (see Figure 2.25) and right-click (you can also Shift+click) in the photo to establish a source area on the source layer. It's very important that you realize the photo layer must be the source and the "Use all layers" option must be turned off for this to work.

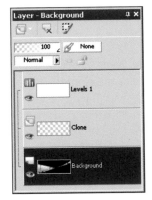

Figure 2.25
Selecting a source patch from the photo layer.

7. Next, select the layer you want to clone on (this would be the destination layer, which I've named Clone) in the Layers palette (see Figure 2.26) and brush accordingly. Your cloning should blend right in. If it doesn't, then you've selected the wrong layers.

Figure 2.26
Applying the brush on the working layer, named Clone.

Figure 2.27
Before-and-after cloning, with the Adjustment layer active.

8. Continue alternating back and forth between selecting a source from the photo layer and then applying the Clone Brush to the working clone layer (again, the one I named *Clone*). Figure 2.27 shows what this region of the photo looked like before and after I cloned out the specks.

If I turned off the Adjustment layer now it would be too dark to see the effects of the cloning. When (or possibly if) you adjust the overall lightness of the photo, you'll be secure in knowing a bunch of cloning you did in the shadows won't show up as a big obvious messy patch in the middle of your photo.

Home Study

Try to cause this problem on purpose so that you can see firsthand what it looks like. In other words, find a dark photo that has dust or blemishes, then fix them without the aid of an Adjustment layer. After you're done, use a Levels Adjustment layer to brighten the photo and see if you can tell where you cloned.

You can apply this technique to the entire photo if you need to. There are parts of the crowd where it will make a difference. In fact, Figure 2.28 shows two shots of the same area. The first area is prior to cloning, and the second is after (both have the Adjustment layer active). It's not perfect in every way, of course, but when this photo is brightened, it will look really good.

Finishing the Photo Study

All that's left to do now is to finish removing the dust, specks, and other imperfections, and then do some touch-ups on the overall brightness, contrast, and color of the photo. In the end, I also made an additional Levels adjustment, applied a small amount of Local Tone Mapping, and warmed areas of the crowd and sky (they were too blue). Make sure to delete or hide the Adjustment layer. Its purpose is finished, and you no longer need it. Figure 2.29 shows the finished result.

Figure 2.28
Showing the effects of this technique in the crowd.

Figure 2.29
Celebrating a dust-free Indianapolis 500.

Printing at Home with the Right Printer

With the advent of affordable color inkjet printers, printing photos at home has become the new normal. It's been a revolution to the photo printing industry. Thankfully, these changes put more power into your hands as an artist and consumer.

Most of us now have high-quality inkjet printers that can print 1200dpi or more. You can even buy specialized photo inkjet printers for under $100. Because there are so many types, it can be confusing about which one to select. There are general printers, as well as those that are specifically targeted at a particular user group, such as photo enthusiasts. Some photo printers print only a few specifically sized prints, such as 4×6 or 5×7. If you need to print 8×0 or other sizes, you should note that and buy a printer with that capability. Many printers now are all-in-one printer/scanner/fax–capable. You can also buy a combo digital camera and printer dock!

From a technical standpoint, you should focus on at least four different areas: type, compatibility, connectivity, resolution, and "other."

Type is type. Is it just a printer or is it a photo printer? Is it an inkjet or laser printer or an all-in-one contraption? Personally, I think inkjets are fine if they are high quality, and if you buy the right ink and paper for the specific model of printer you have. Photo inkjets tend to have features that make sense for photo restorers, like borderless printing, panoramic photo printing, and color photo ink cartridges.

Color laser printing can get really expensive. If you have limited funds, I would buy the best scanner you can and save the printer for later. You can always take your file to a print shop to get the job done, but the scanner will enable you to get prints into your computer to edit. If you work totally with digital photos, you won't need a scanner at all.

Compatibility is whether or not your printer is compatible with your computer and operating system version. Most are, but you always want to make sure, especially when new operating systems hit the market like Microsoft Windows 7 (especially if you're running 64-bits). Another consideration is whether or not you are running Windows on an Intel-based Mac with Bootcamp. Always confirm compatibility.

Connectivity is how you send data to the printer to print. Most often, this will be USB 2.0. Make sure that your printer is up to the latest specification if you want to take advantage of the highest speeds. One word of caution: The farther you get into this, the more you realize everything is tied together. If your computer is an older model, your motherboard might not even be capable of supporting the latest versions of USB or Firewire. You've also got to have an open port (USB, let's say) to plug your printer into. We have, let's see, one USB mouse, one USB keyboard, one USB scanner, one USB audio interface (a Digidesign Mbox 2), one USB iLok audio security dongle, two USB external hard disk drives, one USB printer, and one dedicated USB port to download digital pictures with, and an open USB port for thumb drives. That's a total of ten USB ports that we need, and our computer only has six.

I've had to go out and buy extra USB ports on a card that I had to install in the computer. Another factor is deciding if you need networking capability and printer sharing over a network. If so, make sure your prospective printer is capable of that. Does it have a high-speed Ethernet connection?

Resolution is how detailed your prints will be. In most cases, the printers you will be looking at will have more than enough. Non-photo printers, however, might have less.

Other is a catch-all category of points to ponder. Do you need auto red-eye removal in a photo printer? No, not if you are going to do it yourself. Do you want an automatic 5×7 photo paper tray? Maybe. Do you need Bluetooth? Possibly, but Bluetooth is not really necessary for photo restoration and printing. Find a printer that has only what you need. You're paying for a lot of stuff you don't need otherwise. If the printer has RAM slots to upgrade its memory, go for it! I would soup it up as much as I could. Printing 1200dpi 8×10 photos is very memory intensive.

Do your homework so you don't get burned. Spend time on the Web looking at printers. There are a lot of reputable manufacturers to choose from (HP, Canon, Epson, to name a few). Check out what you see online and maybe go to an electronics store (or other retail outlet) to speak with someone in person about your printing needs. Look for reviews and ratings.

Photo Study 5: Taking Care of Digital Noise

FIGURE 2.30 IS AN ACTION SHOT OF my daughter, Grace, taken in 2007. She is running back and forth in the basement, probably chasing after or otherwise playing superhero with her brothers.

Pardon the mess. I didn't realize I would be putting such candid photos of my life into a book like this. But this is real. It's the type of photo you might take in your basement. That's an important ingredient to my approach for this book. I want it to include photos that everyone can relate to and learn from, not just photos a professional photographer would take.

What Is Digital Noise?

We have a tendency to think the digital revolution (as compared to the old-fashioned analog way of life) has brought about Nirvana, and we no longer have to deal with pesky problems like noise. Alas, this is not the case. We don't live in a perfect world, and we are not able to design and manufacture perfect machines or computers. Data that is digital is not immune to error, noise, or fluctuations in quality as it is being captured. It is precisely at this point, where the data is measured and converted from analog (wavelength, intensity, etc.) to digital, that we have the most trouble.

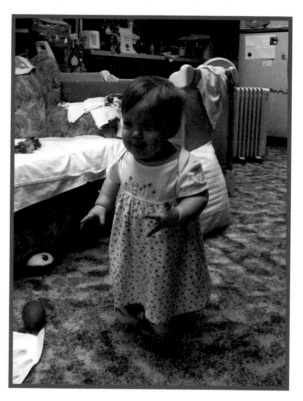

Figure 2.30
Great action shot marred by digital camera noise.

Although I've written this section from the perspective of digital noise in digital photos, you may find noise in scanned photos that can be treated just like digital camera noise. Feel free to review these techniques and try them on older prints (as I do).

Trial and Error

With so many different ways to remove noise, it's helpful to come up with a method to keep your evaluations straight; something that enables you to evaluate different strategies and decide on the best method without going crazy. I've found that I can make sense of the process when I create duplicate layers and apply different techniques to them; then I toggle them on and off to compare. Here's how I do it:

1. Open the digital photo in PaintShop Photo Pro.

2. Duplicate the Background layer several times.

3. Rename the duplicated layers according to the techniques you want to try (see Figure 2.31).

4. Apply the techniques. I will illustrate several different techniques in the following subsections.

5. Show and hide the layers for a direct comparison.

When you've decided on the best way to solve the problem, hide or delete the other layers. If you want to avoid "image bloat," delete the extra layers—they can add significantly to the file size of your photo.

Figure 2.31
Create duplicate layers to experiment with possible solutions.

One Step Photo Fix

It always pays to try this first. Select the Adjust menu and choose One Step Photo Fix. You never know when you'll hit the jackpot and not have to do anything else. Figure 2.32 shows the result.

As you can see, One Step Photo Fix is not particularly suited to removing noise. It works best on photos that have brightness, contrast, or color problems.

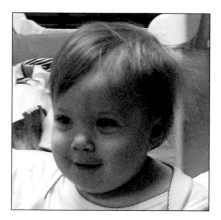

Figure 2.32
Better, but still noisy.

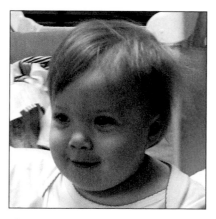

Figure 2.33
Smart Photo Fix isn't the answer here.

Enhance Photo

There is a button on the Standard toolbar called Enhance Photo. It's located right in the middle, beside the Palettes button. Don't forget to check there for commonly used photo enhancement tools like this one.

One Step Noise Reduction

One Step Noise Reduction is available from the Adjust menu. Simply select it and let 'er rip. Figure 2.34 shows the result. (From here on out, the detailed figures are a bit brighter than the working image so you can see the noise better.)

Smart Photo Fix

Smart Photo Fix is a little harder to use than the One Step Photo Fix, but not by much. Give it a try by selecting the Adjust menu and choosing Smart Photo Fix. You'll be given the option of changing brightness, saturation, or sharpness sliders to see if those work for your photo, or you can ask PaintShop Photo Pro for suggested values. I've accepted the suggested values for this photo in Figure 2.33.

As you can see, it's about the same as the One Step Photo Fix, without the one step. Smart Photo Fix is best left for fixing brightness, contrast, and color problems, rather than removing noise. Again, you never know when this will work so it always pays to try it before you discard it.

Figure 2.34
Good noise reduction, but I can do better.

Don't let the fact that there's another noise reduction tool named "Digital Camera Noise Removal" fool you. Try this on digital photos, too.

Median Filter

Although the Median filter can do a pretty good job at times, it doesn't really help here (see Figure 2.35).

Figure 2.35
Median filter doesn't work as well with this photo.

It obviously has had an effect, but in this case, has caused other problems. I don't particularly like the blotchiness, and because this is a color photo, I think it stands out more.

Digital Camera Noise Removal

I could have jumped right here to this section and told you this was the effect I would use and ignored the rest, but that would have been a disservice to you and not accurately portrayed how I work. I often go through all the above options to see if they work or not. Yes, when I'm removing digital noise from a digital photo I tend to end up here, but I check out other options and examine their effectiveness if digital noise removal doesn't seem to be cutting the mustard.

One of the strengths of Digital Camera Noise Reduction is noise sampling areas. The routine selects three areas automatically (one in dark, one in medium, and one in light areas) that you can remove or change in the Preview window. When you draw them, don't make them too large or include areas of detail you want to keep. Otherwise, you'll lose valuable details.

Select Adjust ❯ Digital Camera Noise Removal to open up the Digital Camera Noise Removal dialog box (see Figures 2.36 through 2.40).

Figure 2.36 shows the effects of too much smoothing. I've lost a lot of detail in the photo. Again, you are confronted with the trade-off of detail versus smoothness. Always experiment with the settings.

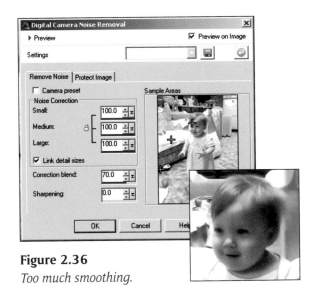

Figure 2.36
Too much smoothing.

The next example (Figure 2.37) shows a moderate noise reduction with 100% blend (how much noise reduction gets blended in with the original photo). It's not too bad, but is still smoothing too much detail out. At high magnification, you can see artifacts around Grace's forehead and the side of her face.

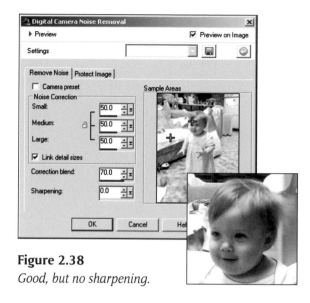

Figure 2.38
Good, but no sharpening.

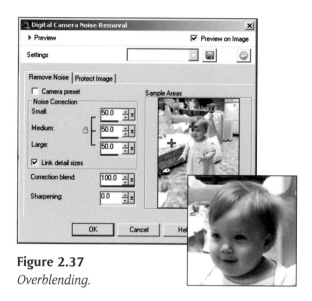

Figure 2.37
Overblending.

The effects of no sharpening, moderate noise reduction, and a good deal of blending are shown in Figure 2.38. It's not too bad. In the end, however, I want something a bit sharper.

The next example (Figure 2.39) shows the effects of total sharpening, which are readily apparent. It looks like chicken tracks have been placed on her face. Avoid these artifacts, as they are a pain to remove.

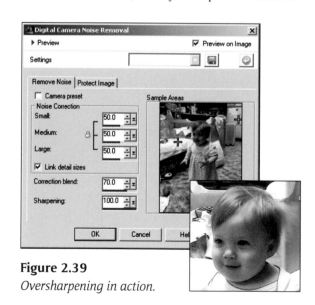

Figure 2.39
Oversharpening in action.

Having seen the extremes of smoothing, blending, and sharpening, I can come up with a pretty good middle ground for this photo (see Figure 2.40).

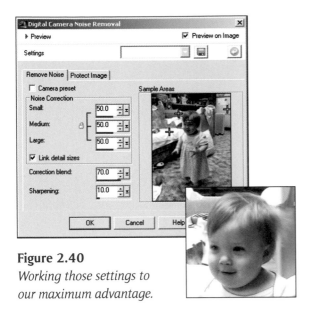

Figure 2.40
Working those settings to our maximum advantage.

I have chosen settings in the middle-ground that, to be honest, aren't perfect. However, the result is a good balance between smoothing away the digital noise and preserving important details. By the time the image is finished and printed out at a normal size, it'll look much better. If you're going for a wall-sized poster (something in the order of 24 by 36 inches—the kind you can't print on your desktop printer), an image with this much noise is either going to show the noise or your attempts to remove it.

Finishing the Photo Study

After applying digital noise reduction, I did several things to finish the photo. First, I looked closely for artifacts created by the noise reduction process and used a combination of the Clone and Soften Brushes to remove them. Next, I used the Sharpen Brush to selectively sharpen Grace's features so that she would stand out better. I set the opacity of the brush to a very small amount, 10, to avoid oversharpening, which creates more problems than it solves. I blended those sharpened areas with the Soften Brush, and finally made some overall color corrections. The basement is a very yellow room and our photos often reflect that by looking far too yellowish. Figure 2.41 shows the completed photo.

Figure 2.41
Grace, saved from the evils of digital camera noise.

Photo Study 6: Dusting Off Shots for eBay

FIGURE 2.42 IS AN UNRETOUCHED photo of an older camera I bought in 2009 from a local camera shop. It's a Nikon FE2 35mm film SLR produced in the mid-to-late 1980s. I decided to pick it up to explore and compare film photography versus digital with a very straightforward but capable camera. I haven't been disappointed.

The FE2 came with a reasonable 50mm lens, but I wanted a bit more versatility. I therefore scoured eBay and picked up two additional lenses at good prices: a 28mm wide angle prime and a 35-70mm zoom with a macro feature. Together, the camera and lenses make a nice collection—the sort of thing you might find on eBay.

While the photo looks reasonably good, the exposure is too dark, and dust settled on the camera and lenses (despite my best efforts to blow it off with canned air). What's a person to do? Load the photo in PaintShop Photo Pro and fix it.

Fixing the Exposure

The first thing I want to do is fix the exposure—lighten it up so I can see the black lenses and parts of the camera better. I want to make sure, however, not to brighten it up so much that I cause the highlights to blow out. I'm going to load the camera raw and JPEG images separately and compare how the process works for each.

Figure 2.42
A lovely vintage camera a little underexposed.

Working from Raw

Before I had a dSLR camera, I didn't have the opportunity to work with camera raw photos. It was only when I decided to get serious about developing my photography skills (as opposed to just fixing things in the computer) and bought a Sony Alpha 300 that I began to learn about raw photos firsthand.

When your camera's sensor captures a scene, it takes the photo (which has been processed, but that is the technical part I am skipping) and stores it in a digital file called a raw exposure. That raw file has about as much data as the sensor captured, is essentially "undeveloped," and is therefore not in a format you normally use. When you load this file into your computer, you have to "develop" it. You can use a third-party program to do this (most camera manufacturers have raw conversion programs) or use PaintShop Photo Pro.

When you use JPEGs, the "development" decisions have been made for you. The raw sensor data has been processed with whatever creative settings you input into the camera. There are several consequences of this: some good and some not so good. It's more convenient and portable, but you don't have as much creative control on the front end, and you have less data "headroom" to work with as you make brightness, contrast, and color changes to the photo in software.

With raw photos, you are the one developing the data and, within limits, controlling how it is converted to a JPEG. You, not the camera. Since you're the one creating the JPEG from the original data, you get to push or pull things the way you want.

Raw Isn't for Everyone

Although I love working with raw photos, I don't use raw with every photo. It adds more time and additional work to the process.

However, I always shoot and save both raw and JPEG if my camera supports it. This way I can go back and work with the raw file if I need something at the highest possible quality—or if there are problems I can fix them more easily in raw.

In this case, I want to improve the brightness first and make sure the photo is relatively noise-free and sharp. All I need to do is drop the photo into PaintShop Photo Pro and use the Camera RAW Lab to develop it. The Lab has the following settings you can play with:

▶ **Exposure:** Brightens or darkens the image, much like the exposure control on your camera.

▶ **Brightness:** Brightens the photo. You can't darken it from here.

▶ **Saturation:** Increases or decreases the color intensity. You can create black-and-white photos if you desaturate the image completely.

▶ **Shadow:** Darkens shadows.

▶ **Sharpness:** Sharpens the photo.

▶ **White Balance:** Changes the white balance of the image according to the scenario or specific temperature and tint. Experiment with this one if the colors look off in your photo.

▶ **Reduce Noise:** Reduces brightness (Luminance) or color noise.

As you can see from Figure 2.43, I've bumped up the Exposure a bit to lighten the photo and chosen to reduce the Color noise a tad. I didn't mess with the other settings for this photo, as they seemed pretty good to me. When I'm ready, I can press Edit to open the image in PaintShop Photo Pro. (Apply applies the settings to the photo and exits the Lab.)

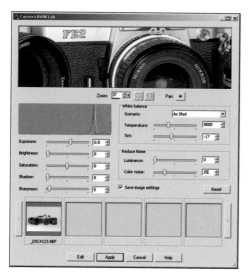

Figure 2.43
Using the Camera RAW Lab.

Figure 2.44
Brightening up the image.

Using JPEGs

Unlike working with raw files, JPEGs require no additional dialogs to open them. What you'll find, however, is that you'll need to perform the same retouching tasks, using different tools in the program. For this photo, that means Levels and Digital Camera Noise Removal.

Opening Levels (Adjust ❯ Brightness and Contrast ❯ Levels) does the trick here nicely, as shown in Figure 2.44. Notice that I've moved the white and gray diamonds to the left. This has brightened the black of the camera lens considerably. I might not do that with a photo of a person, but for this photo I want the dark areas to be light and very clear. Notice that you can see into the lens now. Nice.

Next, I will remove a bit of noise with the Digital Camera Noise Removal tool. Figure 2.45 shows the dialog box with the settings I've chosen. I have zoomed in to show the center of the lens on the camera, which reveals the noise (or absence thereof) nicely. Rough surfaces tend to hide noise.

Figure 2.45
Lightly reducing noise.

Tackling Dust

Now it's time to dust. This is the dust problem that plagues digital photos when you're taking really nice, high-resolution shots of stuff. Dust settles on everything. I try to blow it off with compressed air, but even then it's a battle that I have to continue fighting in software.

There are a few ways to go about manually dusting photos such as this: the Blemish Fixer, and where that's not possible, the Clone Brush. Routines that automatically remove dust, noise, and scratches tend to smooth out too many details.

The camera body itself doesn't seem to have very much dust, but there are several spots around the lenses I can see at high magnification. The trick is to zoom in and select the right tool for the area you're working in. If you have room around a dust particle for the Blemish Fixer (see Figure 2.46), then use it.

Figure 2.46
Using the Blemish Fixer where possible.

If you're working with an area that has a lot of borders (between different parts, colors, tones, or textures) like you see in Figure 2.47, use the Clone Brush. Make the brush very small. Right-click carefully to match tones around the area you're covering up, and be careful not to stray into or across the border, which in this case is part of the front of the lens housing.

Figure 2.47
The Clone Brush fits into tighter spaces.

Creating a New Background

Now that I have a nicely exposed photo that's dust free, I want to separate the camera and lenses from the dingy background and create a perfectly white backdrop that will show them off. This makes the subject show up much better in a smaller, online photo, and it will look like a professional presentation.

I'm going to cover a few ways to do this. In each case, set up your image so that you have a white (or whatever color, texture, or other appearance you want) layer underneath the photo layer to serve as the new background.

Erasing

The old-fashioned method is to use the Eraser. The good news is that it's pretty easy. The even better news is that you can unerase what you've erased by right-clicking and dragging on a layer with the Eraser. In this sense, erasing works like a mask. You can return later and unerase what you've erased, even after you've saved and reopened the file. Try it and see how you like it!

The one caveat is that if you unerase on an area that was originally transparent, you'll get black instead of transparency. That's not normally going to be a problem with a photo, though.

Background Eraser

The Background Eraser is almost as easy to use as the Eraser. Experiment with different Sampling methods from the Tool Options toolbar. In this case, since the background I want to erase is a fairly uniform grayish white, they all work about equally well. However, I have to be careful where the shadows change the tone of the backdrop and around the silver of the camera body. In these areas, the Background Eraser can become confused (see Figure 2.48).

Figure 2.48
Be careful when your subject matches the background you're erasing.

Masking

Masking is no harder that using the Eraser, but it involves setting up the mask first, which many people find daunting. First, create a Show All mask layer. Then simply erase everything *on the mask layer* that you want to hide (make sure black is the Background and Fill Properties color), as seen in Figure 2.49. Black hides and white shows. If you remember that, masks aren't hard at all. There are a number of ways to create masks. You can make a selection and choose Layers > New Mask Layer > Hide (or Show) Selection.

Figure 2.49
Masking out the background.

The Object Extractor

The Object Extractor is new to X3 and is essentially an automated mask. If you like working with masks, you will probably give this a shot and then go back to masks. If you are intimidated by masks, this may be the thing for you. Here are the steps to use if you want to try the Object Extractor:

1. Open up the picture you want to extract something out of.

2. Select the Image ❯ Object Extractor menu. If it's a picture with a background layer only (like a JPEG), you'll be warned that this layer must be promoted, so there can be transparent areas in it. If you're already working with a .pspimage or upper layer, don't worry about this.

3. With the green brush, circle what you want to extract, as shown in Figure 2.50. Overlap the edges of the area you want to keep. Adjust the size of the brush accordingly and use the eraser if necessary. Remember, this has to be an enclosed shape or border on the edge of the photo. The most important thing to remember is that the brush stroke should overlap the border between what you want to extract and the background up to half the brush width, but no more. It's like you're identifying the edge detection area, because you are. If you don't cover the edges, the Object Extractor won't identify the correct boundary between what to keep and what to throw away.

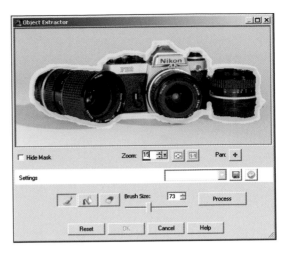

Figure 2.50
Circle what you want to keep in green.

4. Refine the shape to get close to the edges of what you want to extract until you've got a good border. Zoom in to get a tight shot. Press and hold the Spacebar to change the cursor into a hand so you can drag the image around in the preview window to get to different areas. Switch to the Object Extractor Eraser to erase any mistakes and start over.

5. Switch to the red paint bucket and click in the enclosed area. This fills the area with red (see Figure 2.51), which marks that area as the part of the image that should be kept (which is to say, extracted from the background).

6. Select Process. Don't forget to do this part; otherwise, you won't be able to finish. If necessary, raise or lower the Accuracy slider to get a better edge. (You'll see it once you process the mask the first time.)

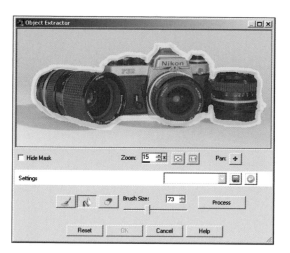

Figure 2.51
Fill the area in red.

Figure 2.52
Blotchiness means this technique is best left for another subject.

7. Select Edit Mask if necessary to fine-tune (this kicks you back to step 4). You can use the eraser control to remove sections of the green outline and redraw those sections with a smaller or larger brush, as appropriate.

8. Click OK to finish. You will return to PaintShop Photo Pro with the object extracted, as shown in Figure 2.52. This example shows the default Accuracy setting, which did a reasonably good job. Gray areas with relatively indistinct borders (the bottom of the camera) were tougher on the Object Extractor. Higher Accuracy settings improve edge detection and extraction accuracy, and you can always go back and refine the border you draw around the object.

Finishing the Photo Study

To finish the study, I saved the .pspimage, and then chose Select All (Ctrl+A), Copy Merged (Ctrl+Shift+C), and Paste As New Image (Ctrl+Shift+V). I am always looking for ways to protect my working files from the final version. I reduced the new image's dimensions with Image > Resize and exported the smaller image as a JPEG to put on the Web.

Even though this photo isn't of a family member, loved one, or cute animal from the zoo, it's still fun. I find it rewarding to turn something "raw" (pardon the pun) out of the camera into a finished shot. The finished photo, shown in Figure 2.53, is clean, neat, looks good, and provides a great view of the camera. And if you couldn't tell, I ended up using the JPEG version of the original shot.

Mask Tip

I masked out the background in Photo Study 6 and replaced it with a nice, white layer. For the most part, I used an eraser to whittle away at the mask edge, but then realized (toward the end of the process) that I should have used the Pen tool in x3 to create vector shapes for certain areas of the photo. I went back and did this for the straight edges and for curves around the lenses. There's a little-known menu selection called Selections ❯ From Vector Object that enables you to create an object with the Pen tool and then use that to generate a selection. Once you get the selection (it's sort of tricky, because once you select the menu option you have to switch tools for the selection to show up), you can select the mask layer and either delete or paint inside the selection to get really good mask borders.

Figure 2.53
A product shot worthy of eBay.

Photo Study 7: Wrestling with Studio Prints

FIGURE 2.54 IS A CUTE SHOT of our oldest son, Ben. It was taken in 2003, when he was about 9 months old. We had this taken in the mall by one of those professional chains. We would walk by the store on our way somewhere else, and they would invariably ask us in for a free sitting. We took them up on their offer a few times, and were always happy with the results.

Most of the time back then (and well before, of course), you never got digital files from a studio. You paid for prints, which can deteriorate over time. When I decided to scan this photo and preserve it as a digital image, I realized how much was wrong with the original. It had scratches and pits all over it. I also realized that studio prints like this sometimes have a texture to them that can interfere with the scan and make the digital image even harder to retouch.

Reducing Size to Experiment

The surface texture and other imperfections are a major problem for this photo. This one doesn't look easy, and promises to be downright tedious. There are times when I sit at the computer for hours trying different approach after different approach, searching to find just the right combination of things to restore or retouch a photo. I tell myself that I'm not wasting time—I'm solving a puzzle.

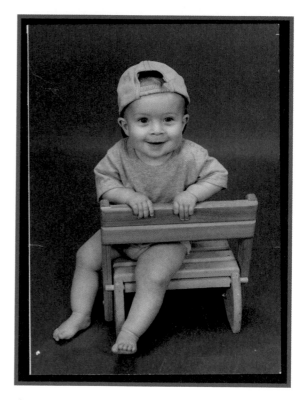

Figure 2.54
Scratches, specks, and texture problems abound in this studio print.

First Things First

Most of the time, I find it helpful to clean up my photos before I make any sweeping brightness, color, noise, or contrast adjustments.

You can treat some surface texture problems like noise, so that's how I am going to approach restoring this photo. Since I originally scanned this photo at a very high resolution, making constant noise adjustments to the overall photo takes a lot of processing power and time. Do. Wait. Undo. Wait. Do. Wait. Undo. Wait. Wait some more. Believe me, I've sat here and done a lot of waiting.

I will, therefore, use an alternate technique to experiment with different solutions. It saves me a lot of processing time. Here's what I do:

1. Open up the photo.

2. Select the Selection tool (Rectangular type) from the Tools toolbar.

3. Look around. Zoom in and out. Find a good area that will serve as a representative sample of the overall texture or noise problem.

4. Use the Selection tool to select a small portion of the photo (the area you identified in step 3).

5. Copy the area using Ctrl+C.

6. Select the Edit ❯ Paste as New Image menu.

7. Save the new image as an experimental working copy. Now you've got a smaller image to work with that won't take forever to apply a number of different noise removal techniques to and compare them against each other. Cool!

In Figure 2.55, I've zoomed in on an area that has part of the background and Ben's ear. This lets me see where the texture and noise stand out and how the noise reduction will affect both areas.

Figure 2.55
The test area.

Cleaning Up Noise

PaintShop Photo Pro has a number of different ways to tackle the problem. Deciding which one is best for a particular photo takes time and determination. This section is a grab-bag of techniques, most of which you'll immediately look at and say "UGH!" or "What?" That's because noise can be notoriously hard to remove without damaging the image (the UGH!) or make you wonder if it's doing anything (the What?).

One Step Noise Removal

This sounds promising. One step! What could be simpler? Apply it by selecting the Adjust menu and choosing One Step Noise Removal. Figure 2.56 reveals the result. It's hard to tell, but there is noise that has been reduced on Ben's ear and cheek. The specks, however, are still prevalent.

Figure 2.56
Good on the cheek, but ineffective against specks.

Despeckle

I have decided to include Despeckle because it's part of the Adjust > Add/Remove Noise menu. That's a perfectly reasonable place to expect to find tools that will help you remove specks, film grain, and noise. Figure 2.57 shows the result.

Figure 2.57
Hard to tell if anything changed here.

It doesn't seem to have done much for this photo. Keep trying on your own photos, because you never know when this will be the exact thing you need.

Edge Preserving Smooth

Another selection available from the Adjust >
Add/Remove Noise menu, Edge Preserving Smooth
sounds promising. I had to ratchet the setting up
to 20 to get it to do anything for this image. Figure
2.58 shows the result, which I thought was iffy at
first, but to be honest, is growing on me.

Figure 2.58
*Edge Preserving Smooth removes noise
at some detail.*

Texture Preserving Smooth

Texture Preserving Smooth is the same as Edge
Preserving Smooth, only completely different.
In this case, it tries to preserve the texture of a
photo inside the edges as opposed to the edges
themselves. For edges, think focus and sharpness.
For textures, think, well, texture. It's the surface
material. Choose Texture Preserving Smooth from
the Adjust > Add/Remove Noise menu.

Figure 2.59 shows the results of applying the
maximum Texture Preserving Smooth adjustment.
It has done a reasonable job of not oversmoothing
the image, but the specks are worse than Edge
Preserving Smooth.

Figure 2.59
*Texture Preserving Smooth is not so good
in this case.*

Salt and Pepper Filter

Another possible solution to the crisis is the Salt and Pepper filter from the Adjust > Add/Remove Noise menu. The only problem is that I don't see any salt or pepper. (Ha ha.) Figure 2.60 shows the results. There is a definite effect, but I'm not sure I like it. You can alter the speck size and the filter's sensitivity to specks in the dialog box, but this was about the best I could do with this photo (the settings I used were 5, 4, yes, and yes).

Figure 2.60
I think this might be the best.

Median Filter

The Median Filter (choose Adjust > Add/Remove Noise > Median Filter) is often quite good at removing film grain or noise in a photo. In this case, I'm fairly happy with it, but it has enough flaws (too many specks) that make me not want to use it. This is often the situation when you are restoring or retouching photos. It's sometimes very difficult to find a good solution, and there is often no solution that works the best. Figure 2.61 shows the result of the Median filter applied with a Filter aperture of 7. Going any higher resulted in a blurry, blotchy photo.

Figure 2.61
The Median filter has a harder time on specks unless you go overboard.

The Combo Platter

You always have the option of masking out your subject and applying different levels of noise reduction (or sharpening, or Levels adjustments, or whatever you want) to it versus the background. Duplicate the background layer (or your interim working layer) as many times as you have different areas you want to apply different levels of noise reduction to. In this case, I end up with one layer for the backdrop and another for Ben. I will optimize the noise reduction for each texture.

Figure 2.62 shows the Layers palette at the stage where I have the mask in place. Here are the layers and a description of their function within the file (from top to bottom):

▶ **Group—Ben:** This is the layer group formed when I created a mask to hide the background on Ben's layer.

▶ **Mask:** This mask hides the part of the layer just beneath it in this layer group. Black hides and white reveals. I used a combination of techniques to get the mask in order to cover what I wanted to hide.

▶ **Ben—lighter smoothing:** This is the layer that will show Ben. I can apply a different amount of noise reduction here (Median Filter, but not as strong as what I used on the backdrop) and hide the backdrop on this layer, allowing a lower layer (with more noise reduction) to show through.

▶ **Backdrop—heavy smoothing:** This is the layer that I want to use for the backdrop. It has heavier smoothing that does a better job of taking away the specks. The same amount on Ben would have taken away all his detail. Notice that I don't need to mask anything out of this layer because Ben's layer is on top of it.

▶ **Blemish Remover:** This layer was an interim step. I used it to remove larger blemishes in the backdrop before I smoothed it. It was created by copying everything beneath (a merged copy) and pasting as a new layer.

▶ **Clone:** This is another working layer. It has all the clone work I did on the backdrop and Ben.

▶ **Background:** This is the original photo layer, rotated and cropped.

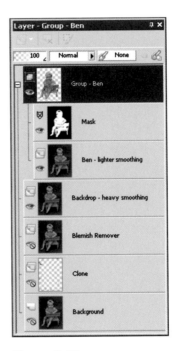

Figure 2.62
Selectively applying noise reduction to different areas of the photo.

Finishing the Photo Study

Figure 2.63 shows the final photo. This was a very challenging study because of the number of pits, specks, scratches, and other surface imperfections, not to mention the odd surface texture caused by being a professional studio print. However, a combination of cloning, blemish fixing, with different levels of smoothing made possible by a mask, made the photo much better.

For Ben's layer, I used a slight amount of Digital Camera Noise Reduction and Unsharp Mask after the Median Filter. These seemingly contradictory adjustments took out specks, smoothed his skin, and sharpened the edges—in that order. In the end, I edited the mask to allow the smoother backdrop to show through in darker, areas, even on Ben. That helped eliminate the last specks on his layer, and it goes unnoticed because of the way the shadows fall and where the focus changes from being sharp to blurry due to the depth-of-field effect caused by the lens' aperture.

After getting things smoothed and masked the way I wanted, I selected all (Ctrl+A), performed a merged copy (Ctrl+Shift+C), and pasted that as a new layer to lock everything in. I think I went over the image one more time with the Blemish Fixer and Clone Brush, removing any obvious problems. Always go back and clone or use the Blemish Fixer to touch up. I was able to knock out the remaining specks quite nicely, and any imperfections that are left lend to the authenticity of the photo (look at the scuff marks on the backdrop).

As a last step, I used One Step Photo Fix to brighten the photo.

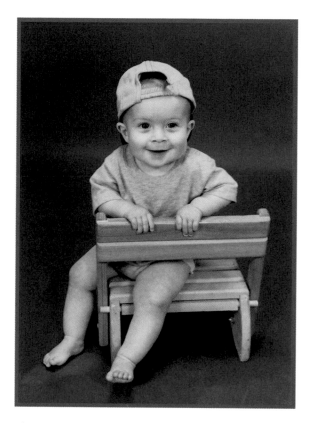

Figure 2.63
Looking good with the original background.

Finding the Right Brightness, Contrast, and Focus

THIS CHAPTER ADDRESSES how to tackle brightness, contrast, and focus problems. Brightness problems reveal themselves in areas of a photo that are too light or too dark and can affect the subject, the background, or the entire photo. Much of the time brightness problems are linked to flash, fading, a bright sky (possibly a window if inside), or a poorly lit interior. Contrast problems make a picture look like it has too much gray in it—like there is a gray veil over it. Focus problems are caused by blurring or a soft focus. I don't think I've run across a photo that was ever too sharp to begin with. I've also added in a few dedicated distortion studies to this edition, because lens distortion and perspective problems crop up quite a bit in newer photos.

Here are the photo studies I will cover in this chapter.

▶ **Photo Study 8: Darkening Overly Bright Areas**—Quite often we take photos of people, and areas of their faces reflect too much light. This is mostly confined to the forehead, cheeks, and chin. I have developed a color changing and blending technique that handles this problem very well.

▶ **Photo Study 9: Lightening a Dark Subject**—We've all been bitten by the "flash didn't flash" bug. Sometimes we forget to turn the flash on or have the flash on our digital camera in the wrong mode. Sometimes the conditions (shooting around bright windows especially) conspire against us to prevent the flash from firing. Whatever the reason, you're left with subjects that need to be lightened. I'll use this photo of my kids watching a science experiment to show you a few techniques to lighten their faces.

▶ **Photo Study 10: Lightening a Dark Background**—Often, you'll run into the opposite problem. In this case, you're probably in a dark room, and the flash successfully fires, but it isn't powerful enough to illuminate the entire room. That's the case in this photo of my son, Jake, getting a haircut. He and his stylist are reasonably well lit, but the background is distractingly dark. I'll show you a way to correct that in this study.

▶ **Photo Study 11: Sharpening Poor Contrast**—Poor contrast afflicts older photos as they fade. They lose their darks, and everything seems to turn to a middling gray. I've pulled out an old, faded, black-and-white photo to see what I can do to improve it.

▶ **Photo Study 12: Improving Brightness and Contrast**—Here is a Polaroid photo of me taken in the early 1980s, which is fading. I'll clean this photo up, make it brighter, and enhance the contrast in this photo study.

▶ **Photo Study 13: Sharpening**—Significant blurring is essentially impossible to fix. This isn't a televised crime-drama where you can press the magical "fix all the problems and magnify by 1,000% and improve the clarity and resolution" button. I love those segments where they take a tiny piece of a poor photo and blow it up to read the label on a can of soda from a mile away at night in the rain. The good news is that you can fix *some* blurring, if you know how. I'll show you how.

▶ **Photo Study 14: Minor Sharpening**—There are times when a little dab will do it. Watch me take this older photo that looks pretty good and make selective areas sharper with the Sharpen Brush.

▶ **Photo Study 15: Removing Lens Distortion**—All lenses have a certain amount of distortion to them (most often the photo bulges outward). I'll use a photo of a commemorative plaque to show you how to remove lens distortion and correct the overall perspective.

▶ **Photo Study 16: Manual Perspective Correction**—Sometimes, photos suffer from a combination of vertical and horizontal perspective problems that are best corrected yourself. I'm going to use an HDR image of a lamppost overlooking a river to show you how to use the Pick tool to minimize these issues.

Photo Study 8: Darkening Overly Bright Areas

FIGURE 3.1 IS A PHOTO of my wife, Anne, and me on our wedding night. I love looking back at these photos of our wedding. It was an awesome day! Contrary to what many people say, it wasn't the most important or best day of our lives. It was the first day we could call the "best day ever" (something our kids love saying).

Our wedding story is an interesting one. We started planning a conventional wedding, but that process became unbearable after about a week. My mother gave me wise counsel about planning a wedding that matched us the best; not something for everyone else.

After a lot of thought, I approached Anne with the idea of a destination wedding. I told her we could fly down to Florida and get married at sunset on the beach. She loved the idea. After a bit of incredibly fun planning, we and our immediate family were off to get married at a resort hotel on Florida's Gulf coast. We stayed for our honeymoon while everyone else flew back home after the weekend.

This photo is shortly after the wedding, during our small reception at the resort. It was a pretty hot evening, and we were sweating. These areas caught the flash and caused bright spots on our faces (see Figure 3.2). Our cheeks stand out the most, but you can also see bright spots on our chins and my forehead.

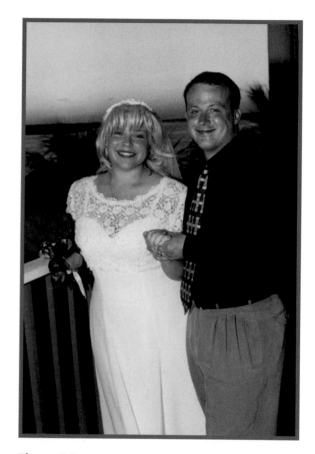

Figure 3.1
Newlyweds posing for the camera.

Bright spots Bright spots

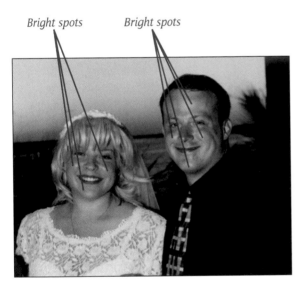

Figure 3.2
Close-up of overly bright areas.

My Magical Miracle Cure

I've tried many a technique with this problem, ranging from darkening the entire image to using the Burn brush to darken the bright spots. I haven't been happy with any of them, which is why I've developed a different approach. I came up with the idea when I was trying to use the Color Changer to replace the shiny spots with a better skin tone. The bright spots got better, but it made everything else look horrendous. I decided I could use the Color Changer on the bright spots only and blend them back into the photo on another layer. Here's how you can do it, too.

1. Take care of housekeeping tasks first. Scan (clean your scanner first) your photo if it is a print or make a working copy if it is digital.

2. Open the photo. Save the file as a .pspimage with an appropriate name.

3. Duplicate the photo layer and name it something clever, like *Darken* or *Blend*. The duplicate layer should be above the Background layer. Leave the Background layer alone. We're going to be working on the layer you just duplicated.

4. Select the top layer.

5. Select the Freehand Selection tool and change the Selection type to "Point-to-Point," which enables you to click and draw a multi-sided, straight-edged selection area. It's just like connecting the dots. Click where you want the dots to be, and PaintShop Photo Pro connects them. I will use this tool to select a general area that needs to be darkened. I am making my selection in Figure 3.3.

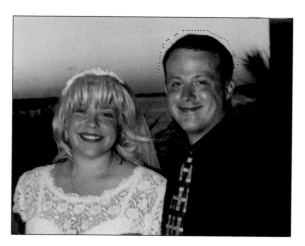

Figure 3.3
Limiting the work area.

You don't need to be too picky with this. Get all the areas you need, plus some extra space around them. That will be your blending space. You'll erase everything else in the end.

6. Select the Color Changer tool, as shown in Figure 3.4. This tool is located with the Flood Fill tool on the Tools toolbar.

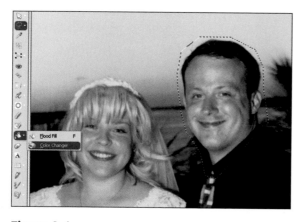

Figure 3.4
Going for the Color Changer.

7. Be patient with this part of the process. You may have to come back and try several times until you get just the right color that will blend in perfectly. Press the Control key to change the Color Changer tool temporarily to the Dropper tool and click on a darker skin color to replace the bright spots with. I can't tell you exactly what the color should be, but it should be in the same color range (skin tones to replace skin tones) and somewhat darker than the bright spot.

Alternate Idea

I've chosen to do all my selecting and color changing on one layer, but you can promote each selection you've made to a new layer every time you want to work with a bright spot. That will make erasing unneeded areas easier when the time comes to start blending, but you'll have to align the layers exactly.

8. Click a bright spot to replace the color. You may have to click, undo, click, and undo several times until you hit just the right pixel or decide to try another color. It's going to look funny even when it works (see Figure 3.5), but don't worry. You're looking for a blend between the bright spot and the surrounding areas. It took me a few tries and one color change to achieve my result.

Figure 3.5
Changing the bright spots.

9. Now do the same thing in other areas of the photo that need to be changed. Anne needs her bright spots blended, and since her skin tone is different, I will return to step 5 and repeat the process. I've used the Color Changer on her face in Figure 3.6. It looks like she put on a layer of makeup, which is exactly what I'm after. Don't worry if it looks like thick makeup, because you'll blend it later.

Figure 3.6
Doing the same for Anne.

10. Next, start erasing the outer area of your selection where the color changed but is obviously not an area where you're going to blend. (You could also use a mask and mask out the areas I erased here.) I'm erasing the area around my hair where I don't want the color blended at all in Figure 3.7. Don't erase too much. You want enough area to blend with what's outside of the bright spots.

Figure 3.7
Erasing unwanted areas.

11. Now it's time to blend. Double-click the layer thumbnail of the layer you've made the color changes to in the Layers palette to open up the Layer Properties dialog box (see Figure 3.8). Lower the opacity until it blends in nicely with the lower (original photo) layer. Take special care to look at how the bright spots disappear and blend in with the rest of the photo. Experiment to find the right setting. In this case, 50% looks good. You can also lower this layer's opacity directly from the Layer's palette.

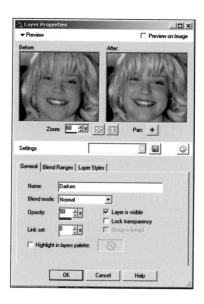

Figure 3.8
Blending with opacity.

Finishing the Photo Study

Figure 3.10 shows the fully restored photo of my wife and me at our wedding reception. To complete the restoration, I erased dust and specks and tweaked the levels a tad. I also desaturated our faces a small amount. If you are working on a photo like this, try creating a new layer by choosing the Edit menu and selecting Copy Merged. Paste this new layer on top of the others. The lower layers form an archive of your work. The new top layer will have your blended work fully integrated with the photo, and you can proceed to erase the dust and make your level changes on one final layer.

12. Finally, it's time to do some small touch-ups. Look for areas of the blend layer that might need to be erased to make the photo better. I've chosen to erase around Anne's teeth and eyes on the blend layer in Figure 3.9. Spend some time on this step to achieve the perfect blend.

Figure 3.9
Touch-ups.

Figure 3.10
Corrected bright spots blended nicely.

Photo Study 9: Lightening a Dark Subject

FIGURE 3.11 WAS OUR FIRST science experiment of 2010. Anne was in the kitchen showing the kids how baking soda and vinegar produced a bubbling, fizzy chemical reaction when I decided to grab the camera and take some photos. I got down close to the table so I could see Grace and Ben better. I decided not to use the flash as the sun was shining in the window, and I didn't want it reflecting off the glass. The problem is, their faces didn't get properly exposed, leaving them a bit dark. The good news is that it's a good photo to show you a few techniques to brighten people who turn out too dark in photos.

Finding the Right Answer

PaintShop Photo Pro has a number of tools to brighten specific areas or entire photos. That's one of the really cool things about using this program. You can experiment with different solutions and find which one will work best for your photo. Time and experience will reveal which techniques work most of the time and which ones are best suited for a particular application.

Figure 3.11
Watching the experiment carefully.

Fill Flash

I'm going to show Fill Flash first. That seems obvious, because that's exactly what this photo needs. Select it from the Adjust menu and choose Fill Flash. The Fill Flash Filter dialog box appears, as in Figure 3.12. You can alter the strength of the filter and the saturation (color intensity). In this case, I made the effect moderately strong, and I boosted the saturation just a bit. This actually isn't bad. Be careful when using Fill Flash, however, because stronger settings have a tendency to destroy contrast and bring out the worst in a photo.

Figure 3.12
Trying Fill Flash.

Histogram Adjustment

Histogram Adjustment (Adjust ❯ Brightness and Contrast ❯ Histogram Adjustment) enables you to alter the histogram of a photo. That's another way of saying that you can correct the exposure by editing the photo's overall luminance or the luminance of each separate color channel (red, green, blue).

What's All This Talk About Saturation?

Saturation is how intense a color is, ranging from none to total. It helps to know what "none" and "total" are, of course. *None* refers to gray. If you take all the intensity from medium red, it will turn gray. If you bump it up a notch, it moves toward total red. Double-click a color swatch on the Materials palette and look at the HSL values. Those stand for Hue, Saturation, and Lightness. You can modify colors here in addition to the more typical "RGB way of thinking." Make the color red and then move the S slider up and down to see what happens. Pretty cool, isn't it? I really like using HSL to lighten a color without changing the hue. That's one reason why we have it.

Take a look at Figure 3.13. You can see the histogram of the photo displayed in the lower center of the dialog box. The darker gray graph shows the number of pixels on the vertical axis compared to their luminance (from 0 to 255) on the horizontal axis. If you press the arrow beside the 1:1 ratio, you can enlarge the graph to see very small values.

Each spot on the histogram corresponds to something in the picture. For example, the bright spike is the white plate reflecting in the sunlight. Otherwise, there is an even distribution of pixels at all the other intensities, except for a slight lack of darks. That isn't necessarily good or bad—it just is.

Figure 3.13
Adjusting the histogram.

In this case, there are no obvious problems with the histogram except for the lack of darks. Therefore, I slid the dark triangle (it's technically called the *Low slider*) up, which expanded the histogram to cover the entire width of the graph and deepened the dark end. To brighten the picture, I moved the middle triangle (called the *Gamma slider*) up a bit. This pulls darker pixels up into the lighter area and brightens the photo. The Gamma slider is what actually controls the lightness of the image.

If you look carefully, you will notice that the Gamma slider is tied to the other sliders (but not vice versa). When you move the Low slider up, the Gamma slider is squeezed proportionately upward toward the bright side of the photo. It tries to maintain a one-to-one ratio. This is why the photo didn't lighten when I moved the Low slider.

The other thing I did was to slide the Midtones slider down a bit. This pushed some of the mid-tones (as opposed to all pixels) toward the bright side of the histogram.

The result? Not bad. I don't know if it's a keeper yet, but not bad.

Histogram Equalize

Histogram Equalize (Adjust > Brightness and Contrast > Histogram Equalize) distributes lightness across the photo, which it does in Figure 3.14. The only problem is, there is no way to control how it looks. It might look good, or it might look hideous.

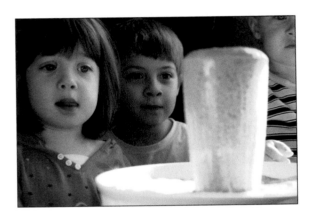

Figure 3.14
Histogram Equalize.

I don't think I need to dwell here. Try this stuff out and if it doesn't work, undo it. Keep trying because you don't always know when it will be the perfect solution.

What's a Histogram?

A histogram is a graph of the light or color intensities that are present in your photo. It's a good way to display information graphically that would otherwise be in a large table. Histograms are used in statistics and other fields as well.

Highlight, Midtone, and Shadow

Highlight, Midtone, and Shadow adjustment is one of my favorite ways to quickly fine-tune the proportion of lows to mids to highs in a photo. Think of it this way: you can lighten or darken specific tones of the photo based on their original luminance, as shown in Figure 3.15.

There are no tools to diagnose the photo, as with Histogram Adjustment. You basically have to use your eyeballs. In this case, (not coincidentally, since I just completed a test Histogram Adjustment), I darkened the shadows and boosted the mids, while leaving the brights alone.

Figure 3.15
Adjusting Shadows, Midtones, and Highlights.

Levels

Levels (Adjust ❯ Brightness and Contrast ❯ Levels) is another way to alter the brightness and contrast of a photo. Levels is a great tool. It's simple, yet powerful. Most of the time you can achieve the look you're after with a minimum of fuss.

Not this time. Figure 3.16 shows that brightening the photo by pulling the gray diamond slider down works, but at the expense of contrast. That's what I call a side effect. It's something that crops up when you're trying to fix one thing that adds to your workload because you'll have to fix it, too. I wanted to fix brightness, but if I used this I would have to fix contrast as well. Not the end of the world, but when I choose which technique to use, I try to find the one that has the best initial result and the fewest side effects.

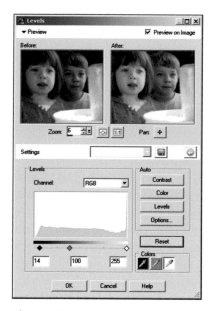

Figure 3.16
Levels disappoints here.

Curves

Curves (Adjust ❯ Brightness and Contrast ❯ Curves) is one of the better, yet intimidating, ways to alter the brightness and contrast of a photo. It takes the brightness levels coming in and allows you to remap them to new levels going out. So, if you want to brighten the darks, all you have to do is draw the right curve to do that. That's the harder part.

I have the Curves dialog box up in Figure 3.17, with two points on the graph. The lower point resets where black should be by taking out the empty space in the graph. The point in the middle remaps brightness values of 71 to 102, thereby brightening them.

Now for why I love Curves. Each point is connected to every other point very visually. The curve shows you that the changes you make take place in a context. It's not possible to yank one point out of alignment without affecting the rest of the curve. You can make whacked out adjustments, of course, but I find that Curves enforces a bit of discipline on me. By the same token, some adjustments seem to work better with Curves because of the interconnectedness of the curve.

I was able to brighten a limited range of the original photo with just two points on the curve and have it blend in seamlessly. Very nice, and I used this technique to finish the study.

Cleaning Up?

With the photo brightened, I decided to sharpen it, reduce the noise a tad, and look at saturation.

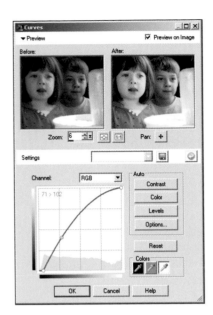

Figure 3.17
Curves is cool.

When I finished, I realized I had wasted my time with sharpening and noise reduction. I wanted the original photo sharper, but when I sharpened it, it accentuated the noise (see Figure 3.18).

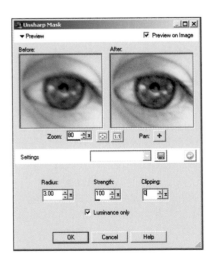

Figure 3.18
Sharpening sometimes increases noise.

Then, when I took out the noise even moderately (see Figure 3.19), I was left with a photo that needed to be sharpened again. There are times when I accept this course of events because I feel like I'm getting a better photo in the end. In this case, I thought the trade-offs were not allowing me to get that better photo. When that's the case, don't feel like you have to do it. Undo and start over.

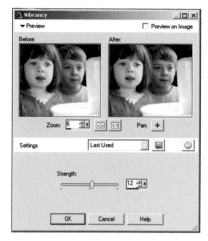

Figure 3.20
Enhancing color with Vibrancy.

Mask and Blend

Okay, now for something adventurous. If you don't want to do this, I understand. However, I've come to love masks over the years because they allow me to make targeted adjustments to different areas of a photo. For this image, that means allowing me to keep the kids bright (the point of the study) but not let the plate and glass get so bright they blow out.

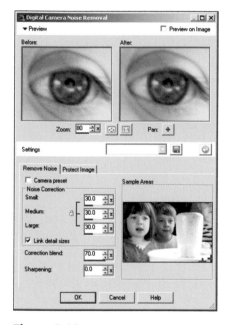

Figure 3.19
Reducing noise often reduces sharpness.

So I went back to the Curves adjustment, duplicated that layer again, and made a Vibrancy enhancement, as shown in Figure 3.20. I compared this to the Vivid Skin Tones photo effect (Effects > Photo Effects > Film and Filters) and thought it brought out their skin tones better.

I will abbreviate here because there are a lot of other studies that use masks.

I took my top working layer (the one with the Vibrancy adjustment) and duplicated it, renamed it to "Kids," and then created a mask from the Layers > New Mask Layer > Show All menu. The purpose of this mask is to hide the plate and glass. Therefore, I selected them with a rough freehand selection and made that part of the mask black, which hid them from this layer (see Figure 3.21). Notice that when you create a mask, you get a Group that has the mask and the layer you had selected when you created the mask.

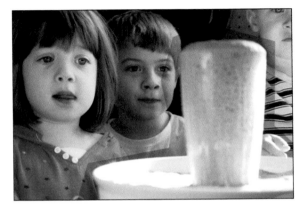

Figure 3.21
Creating the rough mask.

I then used the Eraser (with white as the background color) and erased around the plate and glass, as shown in Figure 3.22. I used a soft eraser to blend the edge of the mask so there were no harsh lines. The point of the mask is to be invisible.

Eraser or Paint Brush?

I always use the Eraser when I work with masks. I change the Foreground color to white and the Background color to black, in most instances. When I need to "paint" white on a mask, I'll switch the colors around. When I learned to use masks, there must have been some reason I gravitated to the Eraser, but I can't remember it now. Since then, I've never thought about switching. If you prefer the Paint Brush (or would like to experiment), there's really no difference.

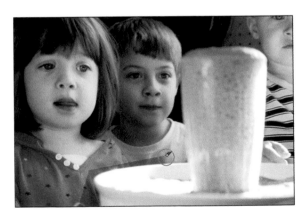

Figure 3.22
Fine-tuning the mask.

Figure 3.23 shows the layer with the kids brightened and the foreground masked out. I've hidden all the other layers so you can see where the mask begins and ends.

Figure 3.23
The completed mask.

After this, I duplicated the photo's Background layer and dragged it up to the Layers palette so it would be right under the mask. I renamed it "Foreground" and made a Levels adjustment so the glass would look nicer. Then I lowered its opacity very slightly so the brighter Vibrancy adjustment layer underneath would brighten the glass a bit.

Finishing the Photo Study

That's it for this photo. Figure 3.24 shows the final product. That seemed like a lot of work just to brighten a few dark subjects, but it was well worth it. This photo also illustrates the point that problems are often tied together (brightness and noise) and can't (or shouldn't) be corrected alone. Solving one problem naturally leads to the next and so forth. I hardly ever approach a photo and expect to solve one problem and be done with it.

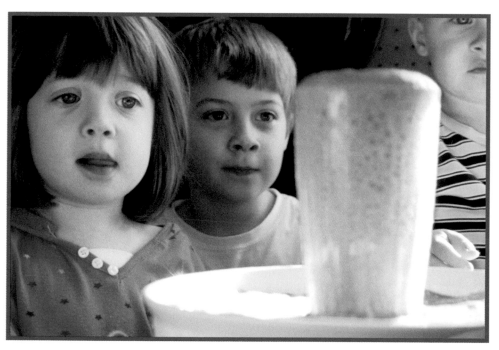

Figure 3.24
Nice photo of the kids.

Photo Study 10: Lightening a Dark Background

I N ANOTHER PHOTO FROM 2010, Figure 3.25 shows Jake getting his haircut from Lindsay, our stylist at the salon we frequent. It was a slow night, and I took all my cameras in to document the proceedings. You can tell I used a flash, but the room was large enough that everything beyond a few feet remained in darkness. This often happens in interior photography. The room seems light enough to your eyes, but when you take the picture, it turns out too dark.

Divide and Conquer

I was actually going to use this image for something else, but when I was playing around with Smart Photo Fix, I realized that the overall photo was better when the background was just a bit brighter. It's not going to be perfect, and there's an irritating shadow that you'll see later, but it will be better. That's a good thing.

There are two important things to remember when you're working with photos like this. First, separate areas of the photo into regions based on brightness (in this context, use the same technique to apply different levels of sharpness, noise reduction, and so forth) and apply different adjustments to them before locking the changes into a merged working layer. Second, don't try to force it. For this photo, that means I'm not going to be able to brighten the background and make it look like it was shot in a studio. If I try too hard, it's going to look bad.

Figure 3.25
Jake and Lindsay.

First thing to do is duplicate the Background layer as many times as there are different regions. For me, that was three times: once for the room, one for Jake, and one for Lindsay. Each required a different brightening strength. For this photo, Jake and Lindsay are too dark, but not by too much.

Lindsay needs more work than Jake, who is on the verge of being too light anyway. (He's probably just right, so in the end he may stay as is.) The room behind them needs to be pulled up more than they do. Keeping each area separate enables you to control and set the ratio of the brightness between the different elements better and result in a more realistic-looking photo.

Figure 3.26 shows the Layers palette with the working layers in place and renamed.

Figure 3.26
Setting up the working layers.

Next, select each layer in turn (make sure to hide the upper working layer when you're working on the lower working layer) and apply whatever brightness adjustment works best for each area. It might be Levels, Curves, Histogram Adjustment, Shadows/Midtones/Highlights, or even Smart Photo Fix.

The Photo Background

I am making a Histogram Adjustment in Figure 3.27 to brighten the photo's background. I hid the other layers and made sure the "Room" layer was selected. In terms of the adjustment, I ignored what the foreground in this layer looked like because the purpose of this adjustment is to correct the photo's background.

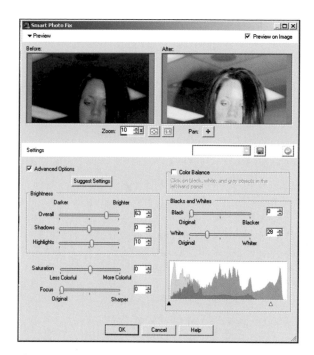

Figure 3.27
Lightening the room.

Since this was the bottom layer of those I was adjusting, there was no need for me to mask anything out of it. It will be the base that the other layers build on. Notice also that the adjustment helps the photo by lightening the background, but it doesn't turn it into "the perfect photo." That's okay. This one is a tough one, which means "better" is going to have to be good enough.

After several rounds of experimentation, I realized I was going to have to treat Lindsay and Jake separately. I couldn't find the right balance that brightened her but didn't wash him out. That means that there are two adjustment and mask layers to show you.

Lindsay

Since Lindsay needed more work, I moved to her next. For her layer, that meant making the adjustment and then creating a mask to hide everything but her face, shoulder, and hands on that layer. Here are the steps for that:

1. Select the working layer you want to make the adjustment on from the Layers palette, as shown in Figure 3.28.

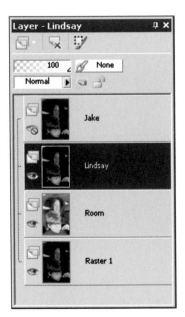

Figure 3.28
Selecting the correct working layer.

2. Make the brightness adjustment to the working layer. In this case, I made a Histogram Adjustment to brighten Lindsay, as shown in Figure 3.29.

Figure 3.29
Brightening Lindsay.

3. Change your Foreground color to white and the Background color to black in the Materials palette. This ensures that when you erase or select and delete areas of the mask, you hide the material. This is because black hides and white reveals. Erasing and deleting both use the Background color, which should be black if you are trying to hide things.

4. With the Mask layer selected, choose the Layers > New Mask Layer > Show All menu to create the mask layer group.

5. Select the Mask layer (not the group, but the layer within the group that starts out white) from the Layers palette. Make sure that you have this layer selected every time you want to edit the mask.

6. This optional step is designed to make erasing on the mask go faster in later steps by hiding a large area quickly. You'll use the eraser to fine-tune the mask.

 Select the Freehand Selection tool from the Tools toolbar and make a selection around what you want to show. In Figure 3.30, I have selected Lindsay because I want her to be visible on this layer.

 If you like, you can also make a selection before creating the mask layer, select the Layers ❯ New Mask Layer ❯ Show Selection menu, then erase to refine the edge of the mask.

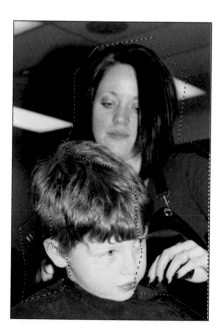

Figure 3.30
Selecting what I want to stay visible.

7. Next, select the Selections ❯ Invert menu and then press Delete. This turns what you have selected to black on the Mask layer, which hides material on the photo layer in the same group.

 Figure 3.31 shows how this turned the area I deleted black on the Mask layer. That hides it.

Figure 3.31
The mask in the Layers palette.

8. Select the Eraser from the Tools toolbar. Size it appropriately. I start with a moderately sized brush compared to the border of the mask I am refining and set the Hardness to 50% or less.

9. Erase on the Mask layer to refine the border around what you want to show. I am erasing around Lindsay in Figure 3.32, which paints black on the mask and hides the background.

Figure 3.32
Fine-tuning the mask.

10. Continue zooming in and refining the edge with the Eraser. Go with a smaller size to get into tight nooks, but use a larger soft brush to ease the transition between hidden and revealed pixels.

11. This is another optional step. Make sure that your mask is complete and you don't have any more edits before proceeding. Select the Mask layer and choose Adjust > Blur > Gaussian Blur. Depending on the size of the photo and how intricate the mask is, select a Radius that softens the mask edges but doesn't render them useless. In this case, 30 was about right (see Figure 3.33).

Figure 3.33
Blurring the edges of the mask.

That's it. Remember, you can use layer opacity to blend this adjustment in with the background if it looks too strong, and once you get your mask set up, you can replace the photo layer in the mask group with a new working layer and a different adjustment. In other words, you're not locked in yet. You don't have to start over from the beginning if you decide to use a different tool or strength on the current photo layer.

For example, I duplicated the Background layer and moved that into the mask group that I created for Lindsay in Figure 3.34. I used Curves to brighten her on this layer instead of the Histogram Adjustment. I can toggle it on and off to quickly compare the effect against the other photo layer in the group.

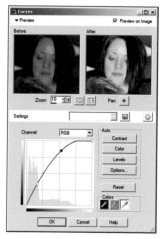

Figure 3.34
Testing a different solution in the mask group.

Jacob

With the photo background and Lindsay done, I could work on Jacob. His was the top layer of the three working layers I created, which meant that even if I wanted him to remain the same (for example, apply no adjustments to him to brighten him up), I needed to mask everything but him out on his working layer. This allows the other adjustments to show through.

Mechanically, I created the mask and refined the edge exactly like I did for Lindsay. Figure 3.35 shows the result.

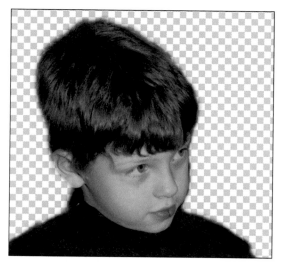

Figure 3.35
Jacob's mask.

When I saw Jake's layer masked out, in relation to the others, it was obvious he needed a small adjustment to lighten him up. I used Curves for this and quickly knocked it out on the layer in the mask group.

Blending and Locking in Changes

With each area adjusted and masked, the Layers palette looks fairly complicated, as shown in Figure 3.36. I have expanded the Mask Groups so you can see all the layers. That's one reason it is important to name your layers logically. That way, you can make sense of things more easily and not make a change to a layer you weren't intending to change by mistake.

Figure 3.36
Layers and masks can complicate the Layers palette.

Finishing the Photo Study

After getting all the masks and brightness adjustments done, I sharpened the merged layer and finished off with some noise reduction and tanned them a bit.

The final photo is shown in Figure 3.37. This was a challenging photo that required extensive use of masks and targeted adjustments. Overall, the photo really benefits from this treatment, as any one adjustment to make something better invariably made something else worse. I'm sure you will run across photos like this. When you do, you have a good technique to approach them with.

Figure 3.37
Complex retouching is very rewarding when it works out.

At this point, the challenge is to blend the groups together so the photo looks good as a whole. The Background layer is the ultimate reference point—the unchanged photograph. Above that, blend the layer groups by adjusting their opacity. In this case, lowering the opacity of Jake's layer brightens him because the layer beneath his is lighter. The same goes for Lindsay's group, because she is above the photo background. Lowering the opacity of the photo background group darkens it, because it is directly above the original photo.

Finally, I locked everything in by using Copy Merged and then Paste as New Layer.

Photo Study 11: Sharpening Poor Contrast

FIGURE 3.38 IS AN OLD PHOTO with, among other things, contrast problems. It's a photo of my wife's great-grandfather on her mother's side of the family.

This photo was taken sometime in 1930 or 1931, based on the age of Dwight II, the young boy. It is a good example of a very old photo that might not have had very strong contrast to begin with, which has faded with time, making the situation worse. When photos fade (as opposed to turning yellow), the colors become more muted. Photos also lose contrast as they fade, especially black-and-white photos.

Technique Shootout

I want to examine several techniques first to see what will work and what won't. I am not going to dwell for long on each technique. I want you to be able to see the results, make a determination, and move on. Trust your feelings, Luke. That's a skill you need to develop. You should be able to run through your bag of tricks quickly to see where your best prospects are.

Figure 3.38
An old photo with poor contrast.

Jumping Right in

I jumped right into the contrast issue here because it's the main problem with the photo. I like working this way—getting right at the main problem and experimenting with different fixes. After I decide on a technique to restore the contrast, I'll begin the overall restoration from the beginning and take care of the contrast at an appropriate point.

One Step Photo Fix

First, I want to try One Step Photo Fix, located at the top of the Adjust menu. Figure 3.39 shows the result. It lessened the fade and discoloration and quite possibly helped contrast.

Working Faster

This photo was scanned in at 1200dpi, and the original file size is over 80MB. Instead of waiting forever and a day to see the results of every operation, change the resolution and create a temporary working file so you can work faster. At lower resolutions and sizes, you can also afford to create duplicate layers and adjustment layers to compare techniques. When you've decided which technique to use, go back to your original image.

Smart Photo Fix

Smart Photo Fix (just under the One Step Photo Fix near the top of the Adjust menu) is almost as easy as One Step Photo Fix, but there are adjustments you can make to customize the result. The Smart Photo Fix dialog box is shown in Figure 3.40. I hit the Suggest Settings button to see what PaintShop Photo Pro says I should do and then continue from there. I also identified a black-and-white point in the photo, which is what took the color fade away. Overall, I'm pleased with this result, but not overly impressed. Smart Photo Fix successfully minimizes the fade and discoloration, but didn't really enhance the contrast. Remember, you don't have to accept these settings. In fact, I often turn sharpen off and save that for later.

Figure 3.40
Working with the Smart Photo Fix settings.

Figure 3.39
One Step Photo Fix performed fairly well.

Fade Correction

Figure 3.41 shows the Fade Correction (Adjust ▸ Color ▸ Fade Correction) dialog box with my settings. You can set the correction amount from 1 to 100. I've settled on a figure of 10 for this example.

I am pleased with the result. It's corrected the fade, although it's left the photo a bit dark.

Figure 3.41
Correcting fade can help improve contrast.

Adjusting Brightness and Contrast

Next up, Brightness and Contrast. If you haven't used adjustment layers yet, create a Brightness/Contrast adjustment layer on top of your base photo layer. I am entering my settings in the adjustment layer in Figure 3.42.

The other techniques looked all right from the beginning, but it took time for this one to grow on me. I began to realize this was a more difficult photo than I had originally thought. The other methods took out the color cast, which made the photo look better, but they didn't do a better job with the brightness or contrast. They look different in part because they helped reduce the fade.

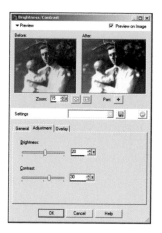

Figure 3.42
Adjusting brightness and contrast.

Changing Curves

I am creating a Curves adjustment layer and entering the settings in Figure 3.43. Normally, making curves adjustments is a pretty good choice, but this photo resists this technique. I spent a good deal of time trying to find the right settings that would enhance the contrast but not darken the photo too much. These settings were as good as I got with curves.

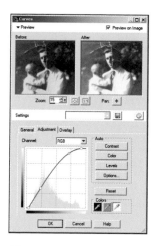

Figure 3.43
Trying curves.

Adjusting Levels

Levels is normally one of my favorite techniques, but this time it yields rather disappointing results, as shown in Figure 3.44. This photo presents a very hard balancing act. I want to enhance the contrast, remove the fade, take out the color cast, and not make the photo too dark.

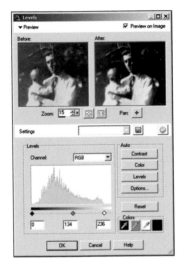

Figure 3.44
Altering levels.

Using Local Tone Mapping

Figure 3.45 shows Local Tone Mapping in action. Choose Local Tone Mapping by navigating to the Adjust menu, selecting Brightness and Contrast, and then choosing Local Tone Mapping. I bumped up the settings all the way to 20, and I like how it sharpened the photo and brought out hidden details. It doesn't fix all the problems, but I will keep this technique in mind.

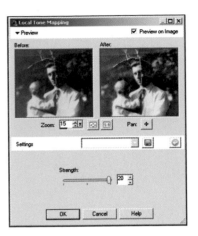

Figure 3.45
Local Tone Mapping.

Adjusting the Histogram

Although I normally choose to work with Levels over making a Histogram Adjustment when working with brightness, the opposite is true when I want to brighten and add contrast. I have entered my settings in the Histogram Adjustment dialog box in Figure 3.46. I've expanded the midtones, which is what boosted the contrast, and made some other small adjustments. They result in a better photo.

Figure 3.46
Adjusting the histogram.

Histogram Equalize

Figure 3.47 shows the effects of Histogram Equalize on this photo. Although I'm not overwhelmingly displeased with the result, it darkens the photo too much.

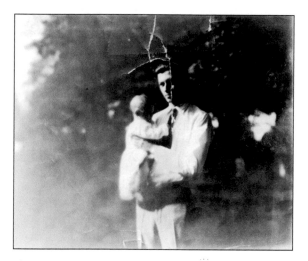

Figure 3.47
Histogram Equalize.

Fine-Tuning Highlights, Midtones, and Shadows

Finally, I am performing a Highlights, Midtones, and Shadows adjustment in Figure 3.48. I decided to brighten up the midtones dramatically, bump up the highlights a little, and darken the darks in the photo to try to improve the overall contrast. The photo looks clearer.

In case you're wondering, there are two ways to adjust these settings: relative and absolute. *Relative*, which I use virtually all the time, makes the pixels darker or brighter based on what you see in the photo. In other words, if you brighten a region, it gets brighter. *Absolute* alters the location of points of the three tonal regions in relation to their position on the histogram (75% for highlights, 50% for midtones, and 25 % for shadows). In other words, if you darkened highlights by -25 using the Relative method, you would darken them in relation to where they started, not an absolute reference point on the histogram. If you used the Absolute method, you would be setting their brightness against a point on the histogram, not in relation to their original brightness level.

Figure 3.48
Changing Shadow, Midtone, and Highlight values.

Layer Bonanza

In order to compare all these techniques, I created layers for each one (see Figure 3.49). This way, I can toggle them on and off to compare the results of each technique head-to-head. I've tried saving different files in the past, but this becomes too unwieldy in cases like this. I would have to manage 10 files and keep them all straight. It's very easy to hide or show layers in one file. Pay close attention to what layer you have selected. It might be the uppermost visible layer, an Adjustment layers, or a mask. You want to know what you're looking at is what you think you're looking at.

Finishing the Photo Study

This photo study (Figure 3.50) involved a lot of experimentation with different techniques to find the best one, or possibly the best combination of techniques, that would improve the contrast. I fixed the surface damage (tears, tape, and so on) first and then returned to improve the contrast. I chose to use Local Tone Mapping to bring out some hidden details, Fade Correction to resolve the yellow tint on the photo, and Levels to tweak the final brightness and contrast. It's not the perfect photo, but pretty good considering the source.

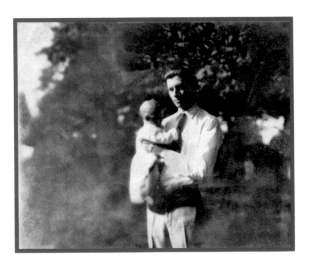

Figure 3.50
Trying my best to restore contrast and enhance detail.

Figure 3.49
Using multiple layers to compare results.

Photo Study 12: Improving Brightness and Contrast

THE PHOTO IN FIGURE 3.51 was taken in the early 1980s. I played the alto saxophone and was in Jazz Band throughout junior high and high school. This was a summer jazz ensemble, and we were performing on a downtown sidewalk in Muncie, Indiana. I'm sitting third from the left on the front row. I'm the one with the high tube socks.

This photo is an example of a Polaroid print. Those are the types of photos that came in large packages that looked like toaster pastries. You put the film package in the camera and pulled each photo out with tabs after you took the picture. The cameras were fairly large and bulky. The obvious advantage to a Polaroid camera was the film developed "instantly." Our family had a Polaroid camera, and I had fun holding the film under my arm while it developed. When it was time, you peeled the print off the "negative," and you had your photo.

The Death of Polaroid

Sadly, Polaroid went bankrupt, and its cameras and film are no longer manufactured or sold new. The advantage of an instant film camera disappeared quickly when it had to compete against digital cameras, and people didn't have to buy film or take the time to develop it. If you're a Polaroid lover, however, all is not lost. Fujifilm makes a modern instant film camera, and the Polaroid brand is back. There are some reports that Polaroid is planning to bring back a modern OneStep instant film camera.

Figure 3.51
Polaroid photo suffering from brightness and contrast issues.

Using Curves and Levels Together

I am going to combine techniques for this photo study: Curves and Levels. The Levels adjustment that I originally made (see Figure 3.52) didn't give me the brightness I wanted. The Curves adjustment (see Figure 3.53) went a bit too far.

Figure 3.52
Altering levels.

To blend the techniques and get exactly what I wanted, I created two duplicate layers (above my safety Background layer with the untouched photo) and made a Levels adjustment to the lower layer and a Curves adjustment to the top layer. I then altered the opacity of the top curves layer to blend it in with the darker levels layer.

Finishing the Photo Study

This photo had a lot of small specks and dust to clean up. Figure 3.54 shows the final, retouched photo, which used a combination of Levels and Curves adjustments to achieve just the right balance of brightness and contrast.

Figure 3.54
Much improved brightness and contrast.

Figure 3.53
Changing curves.

Photo Study 13: Sharpening

WE WERE AT THE PARK in 2009 when I took this photo of Sam, our youngest (see Figure 3.55). I was getting used to my new Nikon D200 dSLR and 35mm f/1.8G lens, which I have truly come to love.

I had finished shooting brackets for HDR and went over to the playground and decided to take some shots of the kids playing. I didn't have a flash and was shooting at ISO-100, which meant I had to open the aperture up wide to be able to get fast enough shutter speed to keep people from blurring. For this photo, I shot at f/1.8 and 1/180 second.

Obviously, that limited the depth of field so that Sam's left eye is sharper than his right. I want to correct that, if possible, so his entire face is sharper.

Sharpening Techniques

Sharpening a photo is all about edges. No matter what happens "under the hood," every sharpening technique detects and increases contrast along the edges. We perceive the increase in contrast as an increase in sharpness. On the other hand, things that don't have well-defined, contrasted edges look out of focus and fuzzy.

With noise reduction, you're always fighting a battle against losing too much detail. With sharpening, the struggle is against adding too much detail or detail where you don't want it. For example, if your photo is noisy or has a lot of grain or surface texture, when you sharpen, you run the risk of making the noise stand out even more.

Figure 3.55
Sam at play.

Figure 3.56 illustrates this danger. Shown is a small area from a photo study in Chapter 2. It's a scanned printed photo at high resolution that has a lot of specks and surface detail to it. I applied Unsharp Mask, and it increased the visibility of the noise dramatically as it sharpened.

Figure 3.56
Sharpening specks.

Another danger of sharpening is trying to sharpen something that isn't sharp on purpose. By this I am referring to photos that have a limited depth of field, which is the depth of the area that can be in focus. Depth of field is controlled by the size of the lens's aperture when you take the photo. Larger apertures (small f/numbers) used at close range limit the depth of field, sometimes to only a few millimeters. Smaller apertures (larger f/numbers) increase the depth of field, from a few feet to infinity.

By contrast, the area that isn't in focus is called *bokeh*. (I'm not talking about an out-of-focus photo here, but the out-of-focus area that isn't in the depth of field.) The characteristics of the bokeh depend on the lens. Some aren't as pleasing as others. People spend a lot of money on lenses that create the most aesthetically pleasing bokehs.

Figure 3.57 is a close-up of the background of the photo in this study. It's out of focus by design. I used my Nikkor 35mm f/1.8G lens for this photo, and the aperture was at its widest: f/1.8. The depth of field for this photo was very small, and the trees in the background will never be sharp. Sharpening this area won't do anything up to a point, but if you oversharpen it, it will start looking noisy and will develop overcontrasted halos around some of the objects.

Don't be afraid to sharpen photos with nice bokehs, but realize that you can't sharpen areas that are extremely out of focus (like the tree line in this photo study). If you push it too hard, you'll ruin the photo. If you need to, mask out the bokeh and selectively sharpen the rest of the photo.

Figure 3.57
Oversharpening the bokeh isn't a good idea.

With these preliminary warnings out of the way, I want to run through the main techniques quickly that you can use to sharpen photos. Each has its pros and cons, of course. At one time or another, I've used all of them, so don't be afraid to experiment and test which techniques work best on your photos.

Smart Photo Fix

Smart Photo Fix (Adjust > Smart Photo Fix) is a quick and easy way to sharpen a photo. I often use it to retouch a photo. There is only one setting: Focus. Raise it, as shown in Figure 3.58, to increase sharpness. I don't normally use this for problematic photos. In other words, if I need to really work on sharpness or if I need to use a mask, I'll use a different technique. Don't be afraid to zero out Focus and use your own sharpening technique later.

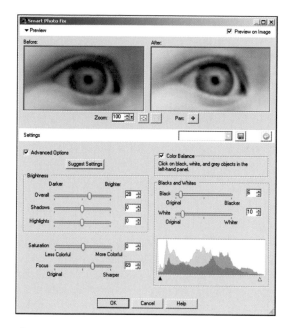

Figure 3.58
Sharpening with Smart Photo Fix.

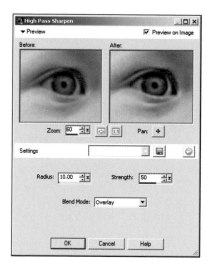

Figure 3.59
High Pass Sharpen.

High Pass Sharpen

High Pass Sharpen (Adjust ❯ Sharpness ❯ High Pass Sharpen) is a very good sharpening routine that gives you plenty of control over the process. There are three settings, as shown in Figure 3.59, Radius, Strength, and Blend Mode. Strength is pretty intuitive, but the other two deserve some explanation.

Think "range" when you see Radius. In other words, each pixel of the photo is evaluated, and if pixels within a certain range (this is the Radius) are different enough from that center pixel, they are sharpened (their differences are increased). Use a small Radius to limit the area in which dissimilar pixels are evaluated to be sharpened, and use larger values to increase this area.

Radius Versus Strength

Be careful not to confuse Radius with Strength. It's easy to do, and I catch myself doing the same thing sometimes. *Radius* refers to area. *Strength* refers to how much the pixels are sharpened over this area. It's possible to sharpen very little (low Strength) over a wide area (large Radius) or vice versa.

Given a certain Strength, increasing Radius may appear to increase the effect, but what is happening is that there is simply more of it—not that it's stronger. At high Strengths, Radius can have interesting effects, large or small. For example, setting the Radius to between 80 and 100 and the Strength to 40–60, you can produce an effect much like Local Tone Mapping.

Use Blend Mode to control how the sharpened pixels are blended back in with the original. There are three options: Overlay (increases edge detail), Hard Light (emphasizes contrast), and Soft Light (softens things so it doesn't look too sharp).

Sharpen

Sharpen (Adjust ❯ Sharpening ❯ Sharpen) is the ultimate in easy, but you pay for it by having no control. Select the menu, and the adjustment is applied. This works great when you just want a touch of sharpening and don't want to fuss with it.

Sharpen More

Sharpen More (Adjust ❯ Sharpening ❯ Sharpen More) is just like Sharpen, only more. There is a definite increase in sharpness with Sharpen More when compared to Sharpen. Use this when you want a little more sharpness all at once.

Unsharp Mask

Unsharp Mask (Adjust ❯ Sharpness ❯ Unsharp Mask) is the sharpening routine that gives you the most power and control. Figure 3.60 shows the dialog box.

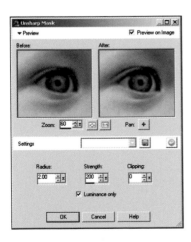

Figure 3.60
Unsharp Mask.

Don't be afraid of Unsharp Mask, even if the name seems odd. It's your friend, and it can make the difference between a so-so photo and one that brings out detail perfectly. There are four settings:

▶ **Radius:** The same as Radius in High Pass Sharpen. I normally keep this very small for what I call "focus sharpening" (tightening the focus), but raise it if I have to.

▶ **Strength:** Also the same. I raise this more than you might think. My normal settings are between 100 and 250.

▶ **Clipping:** This is a setting that ranges from 0 to 100 and allows you to control when the onset of sharpening occurs. At 0, everything is sharpened. At 100, most edges are not sharpened; only those with extreme differences in lightness are. Use Clipping to protect more delicate edges in the photo and keep them from being sharpened, even as you sharpen the rest of the image.

If you are basically happy with the other settings but see areas where sharpening looks too strong, try raising Clipping and see if that softens the effect.

▶ **Luminance only:** Check this to apply the sharpening to the Lightness channel only. This is a great tool that allows you to sharpen in the Lightness channel (potentially increasing the noise level) without messing with the color channels. If you need more sharpening, leave this unchecked.

Multiple Passes

Experiment with applying multiple passes of Unsharp Mask with different or the same settings. Make a light first pass and then reapply. Compare that to one pass with moderate or stronger settings.

Sharpen Brush

Finally, you can use the Sharpen brush to selectively sharpen areas of the photo. I use this in the next study, so I won't go into depth here. If I need to be selective over large areas, I'll use a mask and one of the other techniques. However, the Sharpen brush is a great way to sharpen single lines or areas of the face without having to go to the trouble of masking.

Finishing the Photo Study

This photo was not so terribly blurry that it needed extensive sharpening. That's on purpose. I chose it to show you how limited sharpening can make a positive difference in a photo. In fact, I use some form of sharpen on virtually all the photos I work on, even the best ones. The challenge here was to sharpen Sam's face and subtly extend the depth of field so that most of his face was sharper without damaging the good bokeh.

For this photo, I applied two separate levels of Unsharp Mask, both as Luminance only. This sharpened Sam up nicely, including his right eye and ear. (If you look carefully, his left eye is perfectly in focus, but that's it because of the limited depth of field.) After this, I carefully applied Digital Camera Noise Reduction to smooth his skin a bit and brightened the photo with Levels. Figure 3.61 shows the final result.

Figure 3.61
Sam at play, only a bit sharper and brighter.

Photo Study 14: Minor Sharpening

THE NEXT PHOTO STUDY FOR this chapter is a photo of my father-in-law, Don, as a young boy. He is standing with his Aunt Jo (the family calls her Grandma Jo because she raised Don after his mother died) and Uncle Sam in front of their car in Figure 3.62. Don says it's an old Dodge. From markings on the back of the picture, we know that the photo was developed on May 26, 1944.

Cleanup

When I'm faced with a photo that needs sharpening, the first thing I do is test to see what routines and strengths I want to use. Then I go back to the beginning and clean the photo up. There's no sense in sharpening noise, dirt, specks, or fibers in or on the photo. This photo has a lot of little things that I cleaned up, and I used the usual tools: the Clone brush and Blemish Remover. No need to show that here, but you should know not to skip over this important step yourself. You'll end up with a wonderfully sharp but messy photo that you have to redo.

Sharpen, Smooth, Sharpen

Figure 3.63 is a close-up of Sam's uniform. It looks a tad noisy. I want to use Edge Preserving Smooth, which is in the Adjust menu under Add/Remove Noise to smooth some of the noise out, but I know it's going to remove some detail from the edges. That's not what I want to do at this stage of the process.

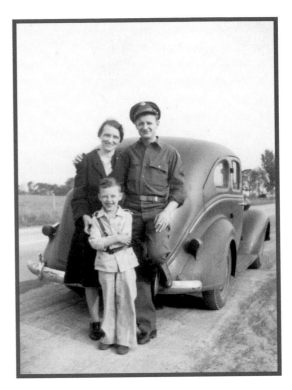

Figure 3.62
Lighthearted moment, 1944.

Always Look at Faces and Eyes

When you are smoothing a photo or reducing noise, always look at people's eyes. From this vantage point, you can see drops in clarity and decide whether the noise reduction or smoothing is worth it or not.

Figure 3.63
Noise or scan artifacts at close range.

Figure 3.64
First round of sharpening.

I used to get a queasy feeling when I sharpened a photo and then applied noise reduction or smoothing. It felt backward, not to mention a waste of time when I had to sharpen the photo again. I'm glad I got over it, because I get far better results now. Think of it this way. Some photos need an edge detail boost to undergo the rigors of smoothing successfully without losing too much crispness. At the end of smoothing, there's enough left to resharpen without adding too much noise back in. Not all photos, of course, but some—especially those that are a bit soft to begin with, like this one.

Therefore, I applied a subtle Unsharp Mask to this photo first, as shown in Figure 3.64. Notice that Sam's face is pleasantly sharper, but not to the extreme. I did this just to add crispness to the edges so they weren't removed completely by the next step.

Next, I smoothed the photo. I experimented with two different types: One Step Noise Reduction and Edge Preserving Smooth. Figure 3.65 shows the latter, very lightly applied. This technique does a good job of preserving edges, but even so, I had to lower the strength quite a bit. Thankfully, it did a good job smoothing Sam's uniform.

Figure 3.65
Using Edge Preserving Smooth to smooth.

Finally, you can apply another round of Unsharp Mask at a different strength or use the Sharpen brush to touch up any edges that look like they need it. I used the latter approach. Figure 3.66 shows where I am gently sharpening the features of Sam's face with the brush. I have the hardness at 0 and the opacity at 4.

Figure 3.66
Sharpening select features.

Although it doesn't look so hot when you zoom in this close, further back it adds a certain "legibility" to a photo because the lines are well defined. There's no need to go over everything this way. Concentrate on important features and lines. In this case, that meant everyone's face, the cut of their clothes, and the car.

Finishing the Photo Study

One of the lessons from this chapter is that there are few hard-and-fast rules. Some techniques work for some photos and not for others. Sometimes, you have to sharpen to smooth and then sharpen again. Don't be afraid to experiment and find what is best for each individual photo. Your persistence will pay off, and you will soon be able to judge which techniques to try first. You'll still be surprised at times, but that's part of the fun of restoring photos.

Masks and Sharpening

To selectively sharpen parts of a photo, you can also mask out what you don't want sharpened and apply a filter such as Unsharp Mask to the photo layer in the mask group. This way, you can have original (unsharpened) areas from the lower layers show through and keep the parts you want sharpened visible by not masking them out.

Figure 3.67 shows the final photo. After sharpening, I corrected the color with Fade and then made brightness and contrast adjustments with Curves.

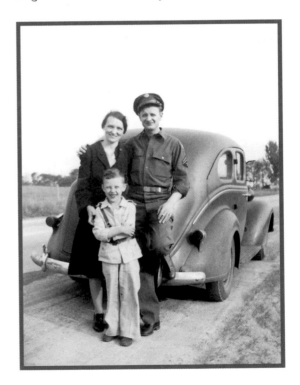

Figure 3.67
Fully restored photo with selective sharpening.

Photo Study 15: Removing Lens Distortion

I TOOK THIS PHOTO (see Figure 3.68) of this commemorative plaque in 2006. It dedicates a portion of an elevated rail running through our downtown and is a memorial to the mayor at that time, Harry Baals.

This photo shows off two types of distortion that I want to correct: lens and perspective. I took this with a compact digital camera, but even much more expensive cameras and lenses distort scenes, for example, wide-angle lenses, in particular. In this case, the plaque looks like it's bulging out (that's the lens distortion) and the sides aren't vertical (that's where perspective comes in, a combination of horizontal and vertical distortion).

Figure 3.68
Unique dedication plaque.

The goals here are pretty straightforward: fix the bulge (aka barrel distortion) and correct the odd perspective.

Types of Distortion

I want to describe quickly the main types of distortion before moving on to removing the distortion in this study's photo.

- ▶ **Barrel:** Barrel distortion looks like it has a bulge in the middle of the photo. Imagine a sailing ship coming toward you with its sails full of wind. They bulge, which is what barrel distortion looks like. Lines that should be straight in the photo aren't straight, especially around the corners. They bend toward the edges of the photo. It is the most common type and is generally simple to fix. This photo study suffers from barrel distortion.

 Remove with the Adjust ❯ Barrel Distortion Correction menu.

- ▶ **Pincushion:** Pincushion is the opposite of barrel distortion. It looks like someone has punched the photo in. Imagine a sailing ship moving away from you with its sails full of the wind. The sails are bulging in the opposite direction: away from you. As with barrel distortion, lines that should be straight aren't, but with pincushion they bend toward the center of the photo.

 Remove with the Adjust ❯ Pincushion Distortion Correction menu. The options are the same as Barrel Distortion Correction (shown in more detail below), only it works in reverse.

▶ **Fish-eye:** This is a specialized type of distortion created by shooting with a fish-eye lens.

Circular fish-eye is the ultimate in fish-eye distortion. These photos have a complete semi-circular field of view. The photo looks like a sphere in the middle of a dark frame.

Fish-eye lenses that don't offer a full 180-degree horizontal and vertical field of view result in less extreme fish-eye distortion. The limited field of view results in a photo that fills the frame. Think of it as a crop of circular fish-eye distortion. Fish-eye lenses that don't say "circular" take these photos, and their specifications should say something about having a "full-frame diagonal field of view," as opposed to a "circular field of view."

Remove with the Adjust ▶ Fisheye Distortion Correction menu. Rather than set a Strength, you set the Field of view.

▶ **Mustache:** This is a combination of barrel- and-pincushion distortion. Lines generally bulge out in the middle and then either level off or go so far as to bend away at the corners.

This type of distortion is not easily fixed, and using the Lens Distortion dialog in PaintShop Photo Pro is not an option.

Fixing Barrel Distortion

Fixing barrel distortion is straightforward and fast. I like working with duplicate layers, so I always duplicate the Background layer and fix the distortion on its own working layer. Once you're ready, select the Adjust ▶ Barrel Distortion Correction menu. That opens the dialog, as shown in Figure 3.69.

Distortion and Workflow

Fix distortion before you crop, resize, reposition, offset, or otherwise change the physical characteristics of the photo or your working layer. The distortion correction routines are mathematical models that translate pixel positions from where they are to where they should be, based on different distortion characteristics and the fundamental assumption that you haven't messed with the photo yet in that way. Feel free to sharpen, brighten, reduce noise, and so forth, before or after you correct distortion. Your call.

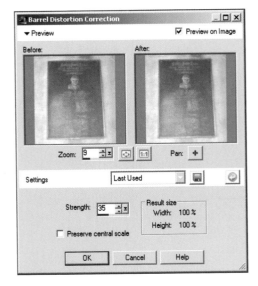

Figure 3.69
Removing barrel distortion.

As you can see, there are two options:

▶ **Strength:** From 0 to 100, the strength of the correction to apply. It's simple. Increase Strength to the amount necessary to remove the distortion. If 100 is too little, apply and come back for another round. (Then go get another camera or lens that doesn't distort this badly.)

▶ **Preserve central scale:** This setting changes how the correction is applied. It preserves the center and enlarges the photo to flatten the sides. In other words, the scale of the center stays the same and the image gets larger. You can see a readout of how much larger the image will get as a percentage of the original. Without this option, the scale of material in the center shrinks in order to push the offending bulge back in.

Conversely, if you are applying Pincushion Distortion Correction, the photo shrinks to keep the central scale constant, or if not checked, the center grows to flatten the dip.

For this photo, a Strength of 35–40 was adequate to remove the barrel distortion. If you are unsure, apply what you think looks good and then use the Straighten tool and put the end points on a line in the photo. Then see if it's straight. This photo makes that easy, as shown in Figure 3.70. I applied Barrel Distortion Correction of 100 to show you what too much looks like for this figure.

Figure 3.70
Checking for straightness.

Your photos may not have such features, so you'll have to go by "feel." Apply the strength that looks good on your working layer and then toggle that layer on and off to see the original below. If it looks like too much was taken out, create a new working layer and reduce the Strength. If there is still a bulge, create a new working layer and increase the Strength.

Correcting Perspective

Even though the distortion has been corrected, this photo still has a perspective problem. You can tell because it appears to tilt away from you. In this case, the fix is easy. Here's how:

1. Select the Perspective Correction tool from the Toolbar. This places a box on the photo, as shown in Figure 3.71.

Figure 3.71
Initiating Perspective Correction.

2. Set the tool options from the Tool Options palette. The only two you really need to worry about are Crop image and Grid lines. If you check the former, the image is cropped after you correct the perspective. This prevents areas that are added to the canvas to keep it rectangular but are not part of the original (see Figure 3.72) from appearing.

You would have to crop these out at some point anyway. The trade-off here is that you decide when, where, and how to crop if you leave this option unchecked, versus the convenience of having it done for you now.

Figure 3.72
Extra material is added to keep the photo rectangular.

Add grid lines if you need the help (see Figure 3.73).

3. Drag each corner handle to a rectangle that should be on the same plane. I've positioned two of the four corners on the plaque in Figure 3.74. You'll want to zoom in much more than I have, in order to be able to match precisely the corners of the object in the photo with the tool.

4. Continue until you've positioned all corners; then press Apply to finish.

Figure 3.73
Grid lines assist alignment.

Figure 3.74
Placing corners.

I don't like things that crop my photos, so I hardly ever let the Perspective Correction tool crop the image for me. I know I will have to go back later and either enlarge my working layer to fill the canvas (generally recompose the shot) or crop the image when I'm done. That extra work is fine with me because I want to control it. Choose whatever solution works for you.

Finishing the Photo Study

This photo shines up nicely once the lens distortion and perspective problems have been corrected (see Figure 3.75). I made standard changes to improve the brightness and contrast with Levels, sharpened the photo with Unsharp Mask, increased the Vibrancy, and then used Local Tone Mapping to bring out some details and textures.

Figure 3.75
That looks a lot better.

Photo Study 16: Manual Perspective Correction

FIGURE 3.76 SHOWS A HIGH dynamic range image I took in 2009. I sought out an area where there was a nice view of one of our rivers and set up my camera and tripod around sunset. I took five bracketed exposures of this scene and created the HDR image and tone-mapped it in another program.

You're seeing the result, which suffers from a mixture of vertical and horizontal perspective distortion. The lamppost is leaning away from you, and the horizontal slope of the scene moves up and to the left. This is often caused by the camera not being level (vertical problems) or aligned straight at the scene (horizontal problems). In this case, those problems are accentuated by the fact that I was using an ultra-wide-angle lens and was standing pretty close to the post.

If I can correct this a bit, I'll be much happier.

Using the Pick Tool

This type of distortion can often be fixed best with the Pick tool and your eyes. Here's how:

1. Duplicate the Background layer to give yourself a working layer that you can fix without affecting the original photo.

2. Select the new layer and rename it to something that makes sense, like "Perspective."

3. Turn on the rulers (View ➤ Rulers).

Figure 3.76
Cool HDR lamppost, but leaning.

4. Click in the ruler and drag some guides out onto the photo to use for alignment. I've dragged three out in Figure 3.77 and changed their color to purple so you can see them in the figure better. If you can't see them in your files, make sure View ➤ Guides is checked.

Figure 3.77
Using guides for alignment.

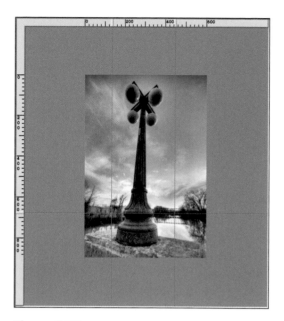

Figure 3.78
Making space to work.

5. You can perform the next step a few ways.

 If you like working with windows, zoom out
 so the document window shrinks, but not so
 small that you can't make things out. Then
 drag the window border to enlarge it, as shown
 in Figure 3.78. You want to be able to see the
 gray space outside of the photo. You'll need
 to see it to work with the Pick tool.

 Alternatively, maximize the document win-
 dow or use the Window ❯ Tabbed Documents
 menu (see Figure 3.79) to maximize the doc-
 ument's window. Zoom out so you can see
 the gray space around the photo.

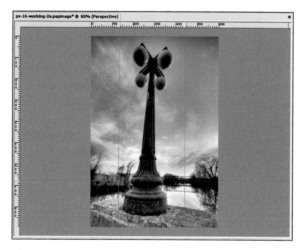

Figure 3.79
Using tabs and zooming out.

6. Select the Pick tool. You'll see the drag handles at the photo layer's corners and midpoints appear.

7. Select Free mode from the Tool Options toolbar. This is important!

8. Drag the corner handles around to correct the perspective. This is easier said than done.

 Fundamentally, you must recognize which direction the perspective is skewed in order to know what direction to move the corners to correct it, all the while looking at the scene to make sure that the correction doesn't get out of hand and look unrealistic.

 Correct vertical problems by widening or narrowing the top or bottom sides. This either enlarges or shrinks that side of the photo, making it appear to turn in your direction. If something is leaning away from you, the top side needs to be lengthened. Therefore, I have dragged the top corners out in Figure 3.80.

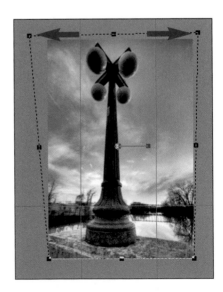

Figure 3.80
Dragging the top corners to begin correcting perspective.

You can also reduce the size of the opposite side and produce a similar effect, as shown in Figure 3.81.

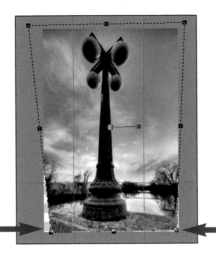

Figure 3.81
Correcting the opposite corners.

I tend to use a combination of shrinking and growing, watching out that I'm not dragging anything off-screen that I want to see. If I need to, I scale the layer down by switching temporarily to Scale mode and reducing the size.

Correct horizontal problems the same way, only grow or shrink the length of the sides, as shown in Figure. 3.82.

If need be, rotate the layer from a corner, as shown in Figure 3.83.

9. Finally, try to position the layer and scale it so it covers the entire canvas. This may not always be possible, but if it is, it prevents you from having to crop later. If you would rather crop yourself, correct the perspective problems now and use the Crop tool at your convenience.

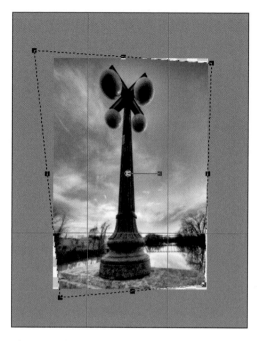

Figure 3.82
Correcting horizontal perspective.

Finishing the Photo Study

For the most part, this image was a finished product when I opened it. I was able to correct the horizontal and vertical perspective problems in PaintShop Photo Pro and then export the final result as a JPEG. That's a worthwhile illustration in that you don't always have to start with photos or images that are completely untouched. I can think of many times where you might be given a graphic or photo by someone else or be using different, specialized software to create images that you want to touch-up or finish off in PaintShop Photo Pro.

Figure 3.84 shows my final result. I chose to err on the side of leaving some perspective problems in the image. You'll find that there are times when the photo will look too unnatural if you try to take all the problems out. In this case, I split the difference and am very happy with it.

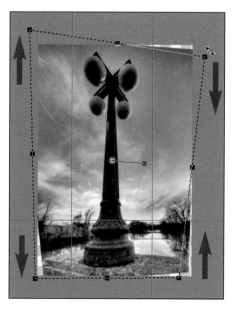

Figure 3.83
Rotate, if necessary.

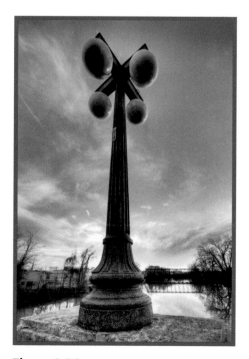

Figure 3.84
The lamppost leans less now.

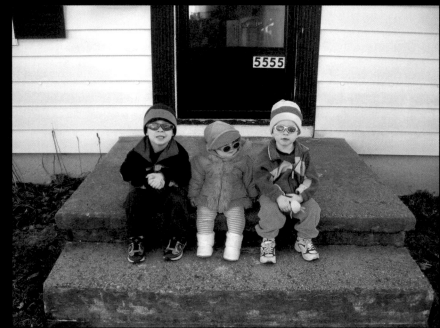

Making Color Corrections

<div style="float:right">4</div>

T HE SUBJECT AT HAND IS COLOR CORRECTION. That can
include older photos (even black-and-white ones) that have aged,
yellowed, or were not vibrant to start with. It can also include newer
digital photos that have color problems. Digital cameras, in and of them-
selves, don't guarantee a good photo or good color. This is because the cam-
era has to guess at the color temperature of the scene—and sometimes it
guesses wrong. Although color problems may appear to be insurmountable,
you can do a lot to correct them—probably more than you realize. I'm going
to examine five photos in this chapter from the vantage point of color.

> ▶ **Photo Study 17: Improving an Overly Yellow Color Balance—**
> Digital photos aren't immune to color problems. I'll show you how
> to subtract specific shades of color out of a photo and enhance
> what's left.

> ▶ **Photo Study 18: Warming a Cool Color Balance—**There is too
> much blue in the photo, resulting in a "cool" appearance. I'll warm
> it up dramatically by taking out the excess blue.

> ▶ **Photo Study 19: Restoring Photos Yellowed with Age—**This is a
> very common problem with older photos, even if they have been
> stored properly. Air and the oil from our hands react with the print
> and cause it to chemically "age." I'll restore a very yellow photo and
> make it look almost as good as new.

> ▶ **Photo Study 20: Improving Muted Colors—**Saturation is our
> focus in this photo study. I will improve the vibrancy of a photo of
> my dad's 1968 Pontiac Firebird.

> ▶ **Photo Study 21: Dealing with Oversaturated Colors—**In this
> photo, the colors are too strong (still a saturation problem, but the
> opposite of too little). So strong they almost hurt your eyes! I'll show
> you how to turn down color "brightness."

Photo Study 17: Improving an Overly Yellow Color Balance

WE HAVE A TRADITION in our family where we take our children to the mall on their first birthday for a special treat: a teddy bear. We broke with tradition with Grace. Unlike the boys, who each got teddy bears, we decided on an orange tabby cat for her. (We have since rectified that situation and she has her bear.)

Figure 4.1 is a photo of Grace holding Margie in the store. This photo is marred by the fact that it's overly warm (yellow). The store is filled with yellows and oranges, which were picked up by the camera. The wood floors are sort of a yellowish brown and the walls are a similar color. Grace's skin tone is in the same color range, and Margie is also orange.

There are several ways to alter the color balance of a photo in PaintShop Photo Pro.

Technique Smorgasbord

For our purposes, color has three components, and I want to talk about each one briefly:

▶ **Hue:** The perceived color, which for computer graphics (including digital photos), is traditionally a mixture of red, green, and blue values. The strength of each RGB component (from none, or 0, to full, or 255) determines the overall color. In the context of an RGB triplet, pure red would be written as 255,0,0. Hue also exists in different color spaces, such as HSL, which stands for hue, saturation, and lightness. In this context, hue is a continuous wheel of color ranging from red to yellow, through green and blue, to purple, and then back to red. Think of hue as the color, with different ways to measure and change it.

Figure 4.1
Grace holding Margie, the orange tabby.

▶ **Saturation:** The balance between the color itself and gray. A totally saturated color would be pure, such as pure blue, with no gray in it. Think "vibrancy." Blue with a lot of gray in it is muted by comparison. We can saturate (take gray out) or desaturate (put gray in) photos. Saturation is also related to contrast. The more gray a photo has, the less contrast it will appear to have. Ever go driving on a foggy day?

▶ **Lightness:** The balance of the color with white or black. This is pretty intuitive. Dark green has more black in it than light green.

As you look at the following photo studies, think in terms of RGB or HSL in order to come to a conclusion on how to fix the problem. Too little vibrancy? That's a saturation problem. Too dark? That's a lightness problem, which I cover in Chapter 3, "Finding the Right Brightness, Contrast, and Focus." Too blue? That's an RGB issue. Are the greens red and the blues yellow? That's something wrong with the hue.

There are several ways to turn colors up and down in PaintShop Photo Pro, and there are a lot of ways to push colors from one hue toward another and add or subtract the amount of gray present. I will show you several techniques as I restore this photo of Grace.

Camera RAW Lab

You have the option of opening raw-format digital photos in X3's new Camera RAW Lab. (Check your File Format Preferences to make sure it's turned on.) This replaces X2's Smart Photo Fix for raw photos. The problem with this photo is that it was shot with an old, compact digital camera that doesn't support raw.

Within the context of the Camera RAW Lab, color issues are resolved in the White balance section. It's called "White balance" because the human eye tends to see white as white, regardless of the lighting conditions. Cameras aren't so smart—they have no way to tell what should be white in a scene. We can help the situation by indicating what type of light the shot was taken in or by manually setting the color Temperature and Tint so that white is actually white. Select from one of the following scenarios to see if it fixes the color, or try to find the right Temperature and Tint settings on your own.

▶ **As Shot:** Data provided by the camera is used to set the white balance.

▶ **Auto:** Similar to telling the camera to figure the white balance based on its own internal algorithms (most people shoot with Auto White Balance), but in this case you're asking PaintShop Photo Pro to do it.

If you want a good comparison between how your camera and PaintShop Photo Pro differ in their estimation of the white balance, switch back and forth between As Shot and Auto, noting the changes in the photo as Temperature and Tint change.

▶ **Daylight:** Assumes the lighting conditions were daylight. Temperature is set accordingly. Tint is not. It stays on the setting provided from the As Shot setting, or Auto, whichever you last previewed from the list.

There is no point in repeating all this for each type of lighting, so here are the rest of the settings:

- **Cloudy**
- **Shade**
- **Tungsten**
- **Fluorescent**
- **Flash**

▶ **Custom:** As soon as you grab the Temperature or Tint controls yourself, the setting changes to Custom. The Temperature is the actual temperature of certain types of light. Some are hotter than others, and being hotter changes whether it comes across as blue or red. Tint applies either a green (more) or purple (less) tint to the photo. That seems odd, but you use it to counter the opposite shade. If your photo has a purple tint, increase Tint, which adds green to the equation.

One Step Photo Fix

There's little to say here. I normally give One Step Photo Fix a try, and it often works. Figure 4.2 shows the result for this photo. It didn't correctly identify the hue problem. Next.

Figure 4.2
One Step Photo Fix disappoints.

Smart Photo Fix

Smart Photo Fix, shown in Figure 4.3, is much better. The key with using Smart Photo Fix when you're addressing a color problem is to enable the Color Balance check box on the right side of the dialog box and then do what it says. Zoom in on areas in the left preview window and pick out good examples of objects that *should be* black, white, and gray and click on them to give PaintShop Photo Pro good reference points.

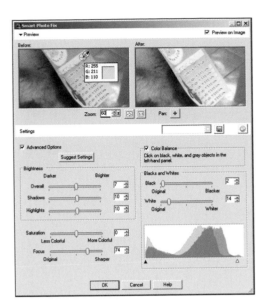

Figure 4.3
Smart Photo Fix is much better—note my color spots.

I was able to find three good color spots in this photo. I decided on the dark area of the stroller as black, the lighter fabric of the stroller to be gray, and part of the tag on Margie to be white. Manually selecting these points adds your "smarts" to the equation. The "white" spot I am in the process of choosing has a little color swatch come up for us to see, and it reads out the measured RGB value. Nice touch! You can also see that what should be white is very yellow. That's the problem, right there in a nutshell.

Color Temperature

Film reacts to light chemically. Because different films are designed and made differently, they can produce slightly different colors. Some, like Fuji Velvia, are prized for the beautiful colors and contrast they capture.

Color Balance

If you want a faster, easier fix, try Color Balance from the Adjust menu. Figure 4.4 shows the dialog box, which is decidedly simpler than the Smart Photo Fix dialog box. Leave the Smart White Balance option enabled (normally a good thing to do) and drag the temperature slider back and forth from cooler to warmer until you find the right balance.

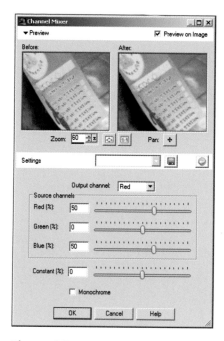

Figure 4.5
Channel Mixer is not for the timid.

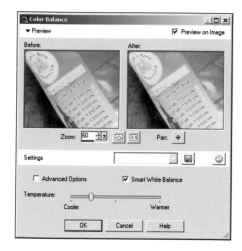

Figure 4.4
Cooling down a photo with Color Balance.

This photo has far too much yellowish orange in it, which makes it too "warm." I've drug the Temperature slider toward the Cooler side. It's not bad. You don't get as many options as you do with Smart Photo, but this is often a good place to start. If you're feeling adventurous, select Advanced Options and continue to experiment.

Channel Mixer

Figure 4.5 shows the Channel Mixer. You can open the Channel Mixer from the Adjust > Color menu. This approach gives you control over the balance of colors in each channel. With great power comes great responsibility. At least Spider-Man says so.

Uncheck monochrome for a color photo and then choose an output channel from the top list box. Figure 4.5 shows the Red channel. The main part of the dialog box shows the percentage change to apply to each component source channel. (That was a mouthful.) The values range from negative 200 percent to positive 200 percent. That means you can change the output mix of each channel by cutting or adding red, green, or blue to that channel. To maintain the overall brightness of the image, make sure the sum of the values for the three channels (per channel) is 100. If not, adjust the Constant setting up or down to try and compensate. Don't forget to switch to the other channels and adjust them as well.

Fade Correction

Fade Correction, from the Adjust > Color menu, works to restore the proper color balance to a scanned photo print that has aged or faded. Although this is a digital photo, Fade Correction often produces good results. Figure 4.6 shows the dialog box with a preview.

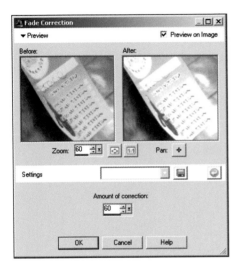

Figure 4.6
Try Fade Correction to reduce yellow.

Fade Correction turns out to be pretty good. You should understand why at this point. (Hint: Old photos often yellow with age.) Increase or decrease the amount of correction to strengthen or weaken the effect. I've put it at 60.

Adjusting Red/Green/Blue

Want to adjust the strength of the red, green, and blue component colors? Simply go to the Adjust > Color menu and choose Red/Green/Blue. The Red/Green/Blue dialog box is shown in Figure 4.7.

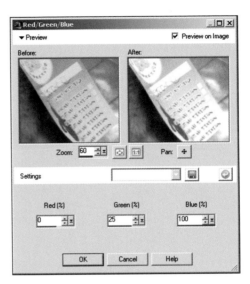

Figure 4.7
RGB is easy and effective.

Go to the Red, Green, and Blue colors and change them until you get a good balance. You can add or subtract up to 100 percent either way for each color. To use this method, it helps to know a little about color and where specific colors sit on the spectrum. For example, there's no option to turn down yellowish orange, which is what I need to do. Click on the foreground color in your Materials palette and look at the color wheel. Yellow and orange sit between red and green, with orange close to red. That's why I turned up blue a lot and green a little. I was able to counteract the excessive yellowish orange by turning those colors up. I love it when art and science come together!

Making Histogram Adjustments

Do you remember using the Histogram Adjustment tool in the last chapter? It's back in action here, because it's a useful tool with powerful color options, too. Figure 4.8 shows the Histogram Adjustment dialog box, with the Edit radio button set to Colors and the Red channel displayed. You can use the Histogram Adjustment settings to adjust the histogram of each color component of your photo by selecting the color (red, green, or blue) from the drop-down menu. Look carefully and compare the graphs for each color. This can be a diagnostic as well as restorative tool.

Red doesn't actually look too bad. I've adjusted the gamma (which is related to brightness and contrast) downward. This has the effect of darkening the red colors.

Figure 4.9 shows the Green channel. Whoa, baby. This one's out of whack. There are no (or very few) light greens present in our photo. I've moved the High value down, which has the effect of lightening the Green channel because it's remapping the existing dark greens upward (in this particular photo). It's pushing them into the lighter area of the histogram. Since the greens in this photo are skewed toward the darker side of the force, moving them upward restores balance to the photo.

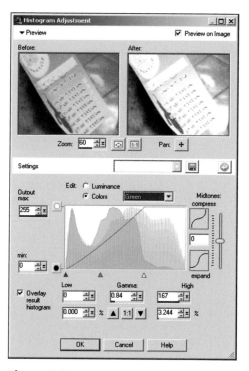

Figure 4.9
Yellow problems caused in part by the dysfunctional Green channel.

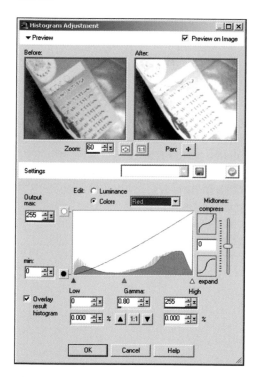

Figure 4.8
Adjusting individual colors can be powerful.

Figure 4.10 shows the last channel, Blue. Where is it? It's not really there. There is very little blue in this photo, which is why it looks so "warm" and overly yellowish orange. Drag the High slider down to lighten the blues in the photo.

Finishing the Photo Study

Figure 4.11 shows the final photo. It's amazing what a little bit of color correction can do. The winning technique? Good 'ole Smart Photo Fix.

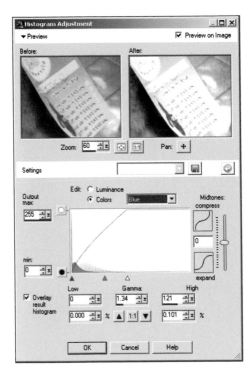

Figure 4.10
An overly warm photo lacks blue.

Figure 4.11
Touching photo rescued from yellow fever.

Remember, the finished photo in each study in the book is the result of *more* than what I've been showing you how to do. This is so I can show you the main teaching point but not leave you with a half-finished photo. To illustrate this fact, consider that I took the following steps to finish this photo:

1. Applied Smart Photo Fix from the Adjust menu. This was the main teaching point for this study and did the job of correcting the color imbalance. I ended my narrative here, but you can see the fully restored (or retouched) photo in Figure 4.11. When working on your photos, you will apply a number of the different techniques, too, ranging from noise reduction to color balancing to contrast adjusting or fixing physical damage, all on one photo.

2. Enhanced the contrast.

3. Duplicated this layer.

4. Performed a One Step Noise Removal on the bottom layer. This worked great on the background and stroller, but did not work as well on Grace's face. The stroller lost a lot of detail in the fabric, and Grace's face was still noisy. I came up with a way to solve that.

5. Performed Digital Camera Noise removal on the top layer. This worked great on the stroller and Grace's face.

6. Lowered the opacity of the top layer from step 5 to blend the two noise reduction layers together. I was looking to keep certain details (the fabric, for example) yet reduce the overall noise.

Copy Merged

I used to press Ctrl+A to select the entire canvas before pressing Ctrl+Shift+C to copy the merged layers together. I've learned fairly recently that I don't need to do this.

Pressing Ctrl+Shift+C (or using the Edit ❯ Copy Special ❯ Copy Merged menu) automatically selects and copies all visible (even semitransparent) pixels on the entire canvas, no matter what layer they are on.

I have one warning. Take care that you don't have another selection active, because if you do, as you press Ctrl+Shift+C, you'll create a merged copy of the selected area, not the entire canvas.

7. Selected the top layer. Pressed Ctrl+Shift+C to copy the merged layers together.

8. Pressed Ctrl+V to paste this blended composite layer as the top layer in the Layers palette. It was my new working layer.

9. Touched up other areas that needed smoothing or blending.

Sometimes, I'm able to give you quite a bit of detail on the extras, sometimes not. I always summarize what I've done to give you a sense of these other steps.

Photo Study 18: Warming a Cool Color Balance

FIGURE 4.12 SHOWS THREE of my four children (this was taken two days before Sam, our fourth, was born) sitting on the front porch posing for a group portrait. This digital photo was taken late one afternoon in the winter. It was cold, but it wasn't to the point where they needed their Arctic gear that day. We had Ben and Jake in their fleece jackets, cool sunglasses, and light-up shoes. Gracie was decked out in her pink coat, pink pants, pink boots, and, of course, pink sunglasses.

This is probably the sort of photo you have. It's a casual shot of everyday life that is a photo we want to keep. The problem is, it's incredibly blue. Photo-wise, blue is an opposite of the reddish-yellow colors in the previous photo study. Reds, browns, and yellows (think skin tones) make a photo look warm. Blue makes a photo look cool.

I'm going to run through several different ways to warm this photo up and then decide on a winner.

Color Temperatures

I keep putting the terms "cool" and "warm" in quotes because we use them to describe how we perceive the photo. Unfortunately, these descriptions are completely wrong when compared to the color temperatures. Although blue light is actually hotter than red, we tend to describe it as "cooler."

Figure 4.12
Brrrski-brrr.

Technique Trials

I won't go over the color theory again, but I will say this photo has the opposite problem than the previous photo study. There is too much blue instead of too little. The result is a photo dominated by the "cool" hue of light blue.

Smart Photo Fix

The Smart Photo Fix dialog box is shown in Figure 4.13. This opens up when you choose the Adjust > Smart Photo Fix menu. I've pressed the Suggest Settings button, as I traditionally do, to see where PaintShop Photo Pro leads me. Then I tweak and adjust. I've selected three color balance points in areas of the Preview window you can't see. I've chosen the black of the screen door, the white of the house siding, and the gray of the concrete porch as the color samples Smart Photo Fix will rely on to adjust the color balance. The result is good.

Figure 4.13
Smart Photo rocks.

Color Balance

Trying to fix the overly blue cast using the Color Balance technique, as shown in Figure 4.14, doesn't work too well for this photo. It takes out the blues when I drag the Temperature slider toward the Warmer region, but the result seems lifeless.

Figure 4.14
A little lifeless.

Channel Mixer

Here again is the Channel Mixer. This time I'm showing (see Figure 4.15) the Blue Output channel. I've increased the Red source a tiny bit, the Green source by a fair amount, and the Blue source a little. I tweaked the other output channels as well. All in all, I wasn't able to get very close to what I wanted.

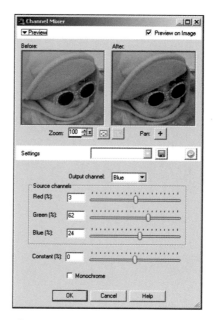

Figure 4.15
Channel Mixer doesn't work well for this photo.

Fade Correction

In the last photo, I showed you that Fade Correction could restore a yellow, faded photo. Figure 4.16 reveals that it has a certain degree of effectiveness here, too. Remember to keep trying alternative methods. If it doesn't work well for one photo, it might work for the next.

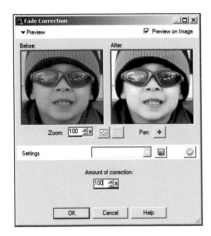

Figure 4.16
A little too much contrast.

I like what Fade Correction has done, but the result has a little too much contrast in it. I want to enhance the contrast in the final photo, but I will use a method to boost contrast that will give me greater control than this.

Adjusting Red/Green/Blue

Adjusting each component channel is the forte of Red/Green/Blue. You would think this might be the perfect solution for this problem. Too much blue? Just turn it down. I've added a lot of red (remember, adding the other components can be as effective as turning the offending one down), some green, and taken some blue out in Figure 4.17.

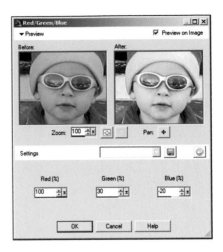

Figure 4.17
Good, but not vibrant enough.

It's not bad, but this too lacks a degree of vibrancy, which indicates a saturation problem. Can you tell what I'm doing as I go along? I'm trying to fix the problem, yes, but I'm also investigating. Contrast and saturation are on my list of things to look into after color.

Adjusting Curves

I'm going to throw you a curve ball in this study and bring back Curves. The Curves dialog box with the Red channel active is shown in Figure 4.18. The great thing about Curves, much like Histogram Adjustment, is that you can switch to each channel and therefore change the color balance. We can see from the plot that the red is too dark in this photo. There isn't enough of it because the blue has squeezed it all out. As you make these changes, look for matching colors in the photo to help you find your way. Jake's shirt is blue and he has a nice yellow stripe on his jacket. That's a good signpost. Whatever I do, that shirt should be blue and the stripe yellow. By the same token, Ben has a red shirt and Jake has a plush bug with green ears. All of these are good reference points for me to look at.

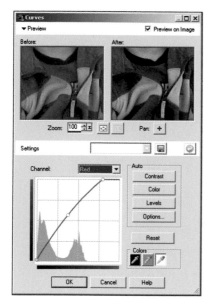

Figure 4.18
Not enough red.

Figure 4.19
Enhancing the greens.

Figure 4.19 shows that there is green, but it's a little squished down. I can help that out by adding a few dots at the correct places. I've snuck the top down and the bottom up a bit, and bowed the curve some to lessen the intensity of the green. In the Curves dialog box, a convex-shaped curve (think "outy") intensifies that component color, and a concave shape (like an "inny" belly button) turns the color component down for each pixel.

The Blue channel in the Curves dialog box is shown in Figure 4.20. There's a pretty even distribution of blue from dark to light. That figures. There's a lot of blue in this photo!

The solution? Bow the curve inward and bring the right side of the plot down to mix some blue out of the photo.

Figure 4.20
Removing too much blue.

Finishing the Photo Study

This fully restored photo, shown in Figure 4.21, is one of those "miracle" restorations. It's one that you can pull out of your portfolio and show people, and they'll all go "Wow, how did you *do that*?"

Here are the steps I took to restore this photo completely. First, I used the Smart Photo Fix as a baseline to start from. (In retrospect, I could easily have used Curves instead.) Then I fixed the contrast with a Histogram Adjustment. Next, I bumped up the saturation to make it a bit more vibrant (subtly, but you can tell if you look at Grace's pink coat). I then removed some noise, but after I did, the concrete looked funny. No matter how I tried to take out the noise, the concrete suffered. My solution? I duplicated the working photo layer and then applied Digital Camera Noise Removal to the top layer. I wanted my kids' faces to look better, so I erased everything on that layer but their faces.

I blended the two layers together by lowering the opacity of the layer with the kids' faces (the one on top, which had the noise removed). When I was satisfied, I did a Select All, Copy Merged, Paste as New Layer. Finis!

Setting Tone and Color

Improve your photography by experimenting with tone and color settings in-camera. For example, I can adjust the white balance on my Canon A480 from AWB (Auto) to Day Light, Cloudy, Tungsten, Fluorescent, Florescent H, or Custom. I can also set the colors to Vivid, Neutral, Sepia, B/W, or Custom Color. The downside to this with JPEG-only cameras is the decisions you make are locked into the photo. If you want to experiment, take and review test photos to make sure they have the tone and color you're after.

Figure 4.21
The kids are all right.

Photo Study 19: Restoring Photos Yellowed with Age

FIGURE 4.22 IS A CLASSIC POST-WAR (World War II) photo, taken sometime in July or August of 1949. It's of my mother-in-law's (Mary Anne) family. She's the baby that's being held by her mother. Her dad, Bud, was a tenant farmer at the time. He had fought in World War II as an artilleryman and had come home afterward to get married and start a family. The kids are the baby boomers you read about in the history books.

There's an odd twist to this picture. It's somewhat rare to have a casual family photo in color from this time period. It took me a while to realize this was 1949, because most of the family photos we have from this time and well into the 1950s are in black-and-white. Mary Anne says that the camera probably belonged to her grandmother and grandfather (the parents of the woman in the photo). This picture presents us with a classic case of aging and yellowing.

Deciding How

I've used the Smart Photo Fix twice now. Is that the answer? We'll see. Remember, you should try a lot of different techniques. Which one looks best will depend on each photo, your skill at using the tools, and what day of the week it is. On Saturdays, don't even try Fade Correction.

Figure 4.22
Classic Americana, but can it be rescued?

Smart Photo Fix

Figure 4.23 shows the Smart Photo Fix dialog box. It's a pretty good technique to use here. The aged yellow tint is gone, and the photo looks nice. I've chosen spot colors here, too. (You can't see them in the Preview window.) That's really crucial to getting the right color balance out of Smart Photo Fix.

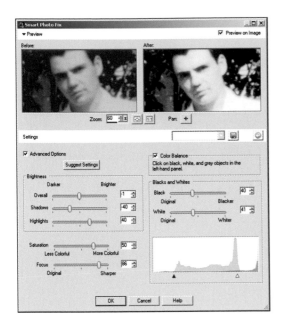

Figure 4.23
Choose spot colors for best results.

I'm not going to use this solution, even though it's pretty good. It looks too washed out. I could lower some of the settings in this dialog box to try and correct that, but then again, those settings are part of why it looks as good as it does.

Fade Correction

Fade Correction, as shown in Figure 4.24, doesn't look too hot. The yellow is gone, only to be replaced by green. To be fair, I didn't have to apply a ton of correction to this photo to take the yellow out, but the green problem got worse the more Fade Correction I applied.

I want to see if this is something I can work with. I'm going to use the results of Fade Correction and continue to alter the RGB percentages to see if I can get rid of the green. Figure 4.25 shows the Red/Green/Blue dialog box in action.

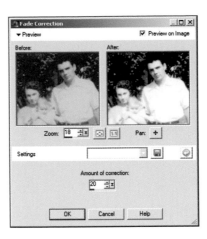

Figure 4.24
Fade Correction results in a greenish cast.

Figure 4.25
Taking the green out.

I left the Red percentage alone, cut Green, and added Blue. I'm reasonably happy with the result of this two-stage process. Notice Bud's shirt and Louise's dress. Bud's shirt is now bright and white, and Louise's dress is blue.

Histogram Adjustment

Finally, I want to try a Histogram Adjustment. Make sure to press the Colors radio button and switch between the three channels if you want to work with color. I am working on the Blue channel in Figure 4.26.

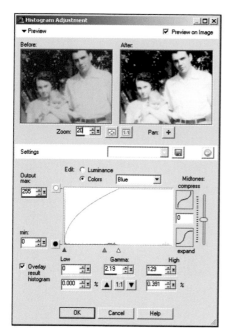

Figure 4.26
Adjusting each Histogram Color channel.

The final result for this technique is very good. It's better than the combination of Fade Correction and RGB and causes no other problems. I lowered the High slider on the Blue channel and raised the gamma to bring up the midtones. The Red channel had most of the reds in the upper mid-range. I simply dragged the Low and High sliders to match the range and tweaked the gamma to make it look good. The Green channel didn't have many highs, having mostly mid-range and dark tones. I performed the same operation on it as I did the reds.

Finishing the Photo Study

The final, finished restoration for this photo is shown in Figure 4.27. The color problems are (mostly) gone, and I spruced up the rest of the photo.

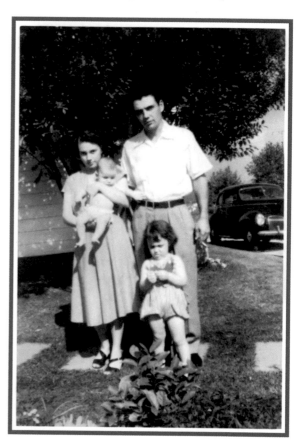

Figure 4.27
Aging process successfully reversed.

In this case, fully restoring the photo took a lot of work. The color problem was actually the easiest, least time-consuming part of the restoration. (I used the Histogram Adjustment.) Afterward, I improved the contrast and then did a lot of cloning to remove specks and scratches. I took some noise out and improved contrast; then I cloned some

more as a final touch-up (to catch problems not fixed or revealed by my prior efforts). The last thing I did was select the photo itself (sans border), invert the selection, and lighten the border to make it look as good as the rest of the photo.

Before moving on, I would like to discuss the "before" and "after" comparison briefly. I sometimes get caught up in wanting to restore the photo so that it looks "perfect." Well, that isn't possible most of the time. You could spend a year working on some of these photos and when you are finished they still wouldn't be perfect. A lot of that has to do with the original photo. Was it in focus? Was there a lot of noise? Was it developed correctly? Did it have the right exposure?

Always compare the "after" shot to the "before" shot, and if it's better, you've done your job. If it's worse, or you can tell there's been an excessive amount of retouching, then you should go back to the drawing board.

For this particular study, the end result looks a lot better, but it's not perfect. There is a somewhat greenish cast to it, the right side of the photo (a vertical swath that is aligned with the grille of the car) had some problems when it was developed, and it's just not quite in focus. But it's better than it was, and that's saying a lot.

Retail Outlet Printing

I want to return to the world of photo printing, only this time from a different angle: retail outlets. Printing your photos at retail outlets is a viable option, even for high-quality restorations. Today, you can stop by your neighborhood supermart and drop your digital photos off to be printed and picked up in an hour. Just like the old days of dropping off negatives.

There are a ton of places that develop (I mean, print) digital photos: Wal-Mart, Meijers, Walgreens, Sams Club, Target, KMart, CVS Pharmacy, and Sears (just to name a few) all offer digital photo printing services. Take your digital photos to the store on a memory card or CD-ROM and have them printed while you shop. For a pretty reasonable price, too. Most places give you the option of sending your files over the Internet and then picking them up or having them mailed to you when they're done. Talk about convenient!

We take advantage of these services quite a bit when we print a large number of digital photos. Anne loves putting together and sending photo albums, especially for my dad and other long-distance family and friends. The albums catch everyone up on what's been happening in our lives. You can also put together theme albums that cover events like birthday parties or holidays. Dare I mention scrapbooking? There's something about having a real photo album to look through that's nice.

The benefits of having someone else print your photos are obvious: fast, cheap, timely, and hassle-free. It's far cheaper for us *not* to use our own ink and photo paper for large-scale operations. The store prints are normally very good quality.

Look around at the stores you frequent and ask for their prices and printing options. Some may not be able to print .tif files. Others may. JPEGs should be universally accepted. You probably won't be able to take a .pspimage in to have it printed. Make sure to save a copy of your work in a format the store will accept.

You can decide for yourself whether or not you like sending your files over the Internet. The store doesn't even have to be in your town. Kodak has services that are entirely Internet-based, and they mail you the prints.

PaintShop Photo Pro X3 has something called the *PaintShop Photo Project Creator* (which must be installed separately) that automatically connects to a photo provider and orders prints from the photos you choose. Select *Order Online* from the main screen, and you'll be walked through the process.

I'm going to close with a few semi-random thoughts. First, there are in-store kiosks that let you "do it yourself." Whether you use a kiosk or hand things over to a person behind the counter, ask whether the prints will be glossy or matte. At some places, your options change based on how fast you want the prints or their size. Don't be surprised (like we were).

Anne has one more thing for me to add. We had an experience at one store where the overall product was very different depending on how fast we wanted the prints. If we wanted them done in an hour, they printed them in-house—without making any adjustments whatsoever to the photos. We learned that we had to tweak the lighting ourselves the next time to make the photos better. If we ordered them to be picked up in a few days, the printing was done in a different city, and they made lighting adjustments. If you've restored a photo and everything is exactly the way you want it and someone goes around automatically lightening for you, that could be a problem. Ask and test. Send some test photos to be printed and evaluate them critically. Printing is a funny thing. What you see on your monitor has to be calibrated so that you're seeing what is present in the photo, and then it has to be translated from ones and zeros to ink and paper.

And now, back to your regularly scheduled programming.

Photo Study 20: Improving Muted Colors

FIGURE 4.28 IS AN ICONIC PHOTO for me. Dad bought this 1968 Firebird when I was very young, but we only had it for a little while. (The energy crunch of the early 70s made it impractical.) To make matters worse, our family split up, and I didn't see my dad for about 30 years. We've gotten together recently, but in the interim, photos like this one came to mean quite a bit to me.

This picture looks pretty good, but needs some sprucing up. (I've always loved the red stripe on the tires and the car's green color.) The years have taken away some of the original luster, and it is a little bit out of focus. Being a physical print taken from a film camera and scanned into the computer, there are also specks and physical imperfections I want to clean up.

Examining the Options

In this photo study, I'm given a photo whose colors are basically correct (i.e., the blues are blue, and the greens are green), but they aren't strong enough. My task is to find the best way to saturate the photo.

One Step Photo Fix

Here we go. One Step Photo Fix. Figure 4.29 shows the result.

Figure 4.29
Fast One Step Photo Fix.

If this were all I had time to do, I would be pretty happy. It lightened things up and helped with the contrast.

Figure 4.28
Muted muscle car.

Smart Photo Fix

Figure 4.30 reveals our trusty Smart Photo Fix in action. I've taken care to select objects in the left-hand panel that are black, white, and gray in order to get the right color balance, and in this case it worked too well. The colors look too bright and artificial for me. I want them brighter, yes, but I'm going to keep looking for a better solution than this. If I have to, I can always come back to this and lower the saturation a bit.

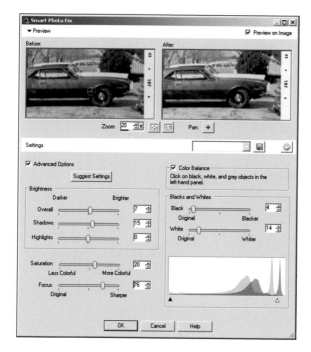

Figure 4.30
Smart Photo rocks (maybe too much).

Fade Correction

Figure 4.31 shows a Fade Correction of 20 before it is applied. The fade, seemingly imperceptible until you remove it, is gone, and the colors look brighter. They aren't so bright that they look artificial either, as compared to the last figure.

Figure 4.31
Fade Correction actually works very well here.

The thing I like most about how Fade Correction worked in this instance is that it removed the fade without compromising the colors. They still look natural, and their hue wasn't changed. However, I would like to see them more vibrant.

Vibrancy versus Saturation

Here's the point of the whole study—boosting the color intensity. Saturation is the traditional setting. Boost it when you want stronger colors. Figure 4.32 shows a moderate increase in saturation. The car, sky, and grass all look stronger.

Figure 4.32
Saturation boosts all color intensities.

Since X3, there is another setting that boosts color intensity—Vibrance (see Figure 4.33). Open the Adjust ❯ Hue and Saturation ❯ Vibrancy menu to see the effect. There's only one setting: more is more and less is less. It doesn't get much easier than that.

Figure 4.33
Vibrancy boosts muted colors.

Whereas Saturation increases the color intensity of the entire image, Vibrancy is supposed to boost only the least saturated areas. In other words, it turns up the colors that are weak while leaving the ones that are strong alone. In this case, there isn't much difference. You could probably go in either direction and be fine with an image like this. (Despite how it performs here, Vibrancy is still a cool new feature.)

Finishing the Photo Study

When all is said and done, I used Fade Correction, Vibrancy, reduced some noise, and finished with a round of moderate sharpening using Unsharp Mask. Figure 4.34 shows the final image. As you look at it, realize, of course, that I based my evaluation on a before/after paradigm rather than a "Is it perfect in every way?" matrix. It looks better—quite a bit better, but there are still flaws. That's what I'm after.

Figure 4.34
This was a great car.

Photo Study 21:
Dealing with Oversaturated Colors

FIGURE 4.35 CAPTURES ONE of my wife's happiest childhood moments. It was Christmas of 1982 at her Grandma Jo's house, and she had just opened her last present. It was a Cabbage Patch doll.

They could hear her screams of glee in the next county. You see, everyone wanted a Cabbage Patch doll that year, and you had to be on a waiting list to even get one. There were fights in stores over these dolls, because they were such a hot commodity. Anne didn't even ask for a Cabbage Patch doll because she knew they were pretty expensive, and she didn't think there was even a chance of getting it.

But miracles happen.

Her Grandma Jo (she's in several of the photo studies in this book) was able to buy one through a friend who had some extras because of a mix-up at the store. Thus, Lyndon Jock came into the family. He had a weird name (part of the appeal, Anne tells me), a birth certificate, and adoption papers. Anne calls him Josh, and says he was quite popular. She was the only one in her circle of friends to have a boy Cabbage Patch doll, so Josh got to be the "boyfriend" to all of her friends' dolls. Josh later got a "sister" Cabbage Patch doll named Emmy Aggy.

Figure 4.35
Anne with her dolly, glowing with color.

The photo that immortalizes this event is overly saturated with color. I want to explore the options I have to tone it down a bit.

Desaturation Options

There are some tough calls to make with this photo. Anne's sweater, for example, is a meltdown of saturation. There's not a lot of detail in it. Lowering its saturation will lessen the pain, but won't make the photo as a whole look much better. What will I look at to decide how to approach this? Anne's face, the couch, the doll, and the wall. When these four elements are in harmony and not overly saturated, I'll be done.

Using the Histogram Adjustment

Figure 4.36 shows the first step in adjusting the photo's histogram. There's a lot of bright red in the photo, with a couple of prominent peaks. I've brought the Low and High sliders in to match the range of the red in this photo and darkened it a bit by sliding the Gamma downward.

There's not much I can do with green, as Figure 4.37 shows. I can bring the High slider down and brighten the green by raising the Gamma slider.

Figure 4.37
A little green.

Figure 4.36
Too much red.

Blue has the same problem as green in this photo, as seen in Figure 4.38. It's pretty nonexistent! The same solution applies here.

Figure 4.38
Some blue.

The overall result of adjusting each color channel in the Histogram Adjustment dialog box is mixed. The couch and Anne look marginally better, but I'm not happy with the wall or the contrast.

Vibrancy

Vibrancy is another color desaturation option. I have entered a setting of -45 in Figure 4.39, which does a good job. Compare that to the next figure, where I lower the overall Saturation by the same amount. Vibrancy desaturates this photo more than Saturation. The differences are in the couch and her sweater.

Figure 4.39
Reducing the photo's Vibrancy.

Adjusting Hue/Saturation/Lightness

Next, I will alter the saturation directly via the Hue/Saturation/Lightness dialog box. I've desaturated by 45 in Figure 4.40. At first, I thought this took too much life out of the photo, but now I like it.

Figure 4.40
Desaturating all channels equally.

I want to try one more thing.

I made the adjustment shown in Figure 4.40 on all the channels. You can tell because the Edit drop-down light is set to Master. I can select several different colors to edit from this list: Reds, Yellows, Greens, Cyans, Blues, and Magentas. What happens if I select the most offending colors from this list and turn them down? Figure 4.41 shows the answer.

The final settings were Reds: -45 (the main problem), Yellows: -20 (brings down the couch a bit), Greens: 0, Cyans: -20 (keeps Josh's shirt under control), Blues: 0, and Magentas: -10 (to make Anne's denim skirt bluer).

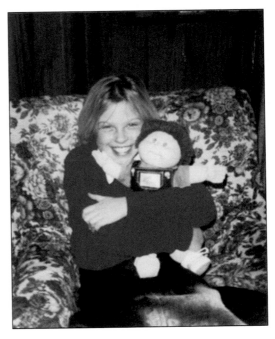

Figure 4.41
Selective desaturation is a winner here.

Finishing the Photo Study

To finish the study, I used Curves to push the tonality of Anne's skirt toward truer denim, and then I applied a very light amount of noise reduction, followed by light sharpening using Unsharp Mask. I cloned away the blemishes and called it a day.

Figure 4.42 shows the final product. Oversaturated photos often lose details that can never be recovered. Anne's sweater is devoid of detail in the original, and with the exception of the shadow of her lower arm and the cuff of her upper wrist, it looked like a red blob of color. Although the saturation has been improved dramatically, the lost details are still lost. Despite this, the restored photo looks far better and was well worth the effort. You can see the details of Anne's face without being blinded by red, and the overall photo looks much more natural. Mission accomplished.

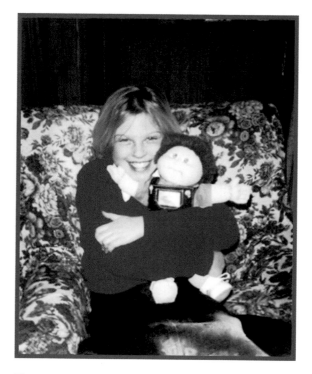

Figure 4.42
Now that's much better.

Repairing Physical Damage 5

TACKLING PHYSICAL PROBLEMS in photos suits me. One of the reasons is that I love using the Clone Brush. It's something you do with your hands, unlike a dialog box or menu choice. Whether you are using your mouse or pen tablet, *you've* actually got to do it. The computer can't. It takes skill, daring, and creative courage to go plopping down stuff where there isn't any to begin with. Follow along with me as I use the Clone Brush and other tools to retouch and restore these damaged photos:

▶ **Photo Study 22: Repairing Border Problems and Film Tearing**—It's a fact that older photos are prone to wear and tear, especially around the edges. Not a problem, because restoring a torn border is pretty easy. Film tearing is a less common problem, but I'll tackle both issues with the Clone Brush in this photo study.

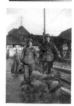

▶ **Photo Study 23: Retouching a Large Scratch**—A large scratch across my cheek ruins this photo of me from high school. I'll use the Clone Brush again and show you why the Scratch Remover isn't always the best tool for this type of job.

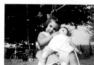

▶ **Photo Study 24: Fixing Creases**—In this old photo, I'll use the Clone Brush to erase creasing near the bottom that is the result of years of handling. In the end, however, I'll add some of the creasing back in so the photo looks improved but not overly restored.

▶ **Photo Study 25: Repairing Hairline Cracks in Film**—I could try and use the Clone Brush to erase the thousands of tiny hairline cracks in a photo, but I'm going to do something completely different (and easier). Read on.

▶ **Photo Study 26: Filling a Torn Hole**—This photo has a small hole torn in the bottom center. Watch me repair it with the Clone Brush. Aside from the obvious aesthetic reasons for fixing holes and tears, you can print the restored photo and handle it without fear of damaging the original further.

▶ **Photo Study 27: Restoring a Missing Corner**—This is a more advanced restoration project, involving re-creating a missing corner entirely from scratch (or so it would seem) and fixing a large number of creases and other damage.

Photo Study 22: Repairing Border Problems and Film Tearing

FIGURE 5.1 IS A PHOTO of Mary Anne, my mother-in-law. When I first saw it, I thought she was in college, but it turns out she was only 16 and a junior in high school. She looks more mature than 16 to me, but I think kids in old photos have a habit of looking older than they were. My mom looks 25 in her high school yearbook.

I spoke with Mary Anne about this photo recently, and she said her father took it. She is standing outside of their rented farmhouse, which is now gone. Today, the land is part of a public school.

The photo has obvious charm, but the physical damage is threatening it. The film is tearing along the border and within the body of the photo. In addition, the photo has lost some of its pizzazz and has specks and other dust problems that should be fixed along the way.

Cloning Do's and Don'ts

This is a great chapter to go over cloning dos and don'ts because the Clone Brush will be your primary tool to repair physical damage. The Clone Brush copies material from one part of the photo to another. The general workflow is as follows:

1. Select the Clone Brush from the Tools toolbar.

2. Make changes to the tool's options, such as the brush size, hardness, opacity, and whether to "Use all layers" or not. Make these changes in the Tool Options toolbar.

Figure 5.1
Vintage 1960s, complete with rough spots.

3. Identify what you want to cover. This is called the *destination*. Pay attention to the surrounding details because you will need to match them when you choose a source.

4. Move your cursor to the photo and identify the source spot; then right-click (you can also Shift+click) to set that into the brush. Pay attention to the "grain" of the details and match the source color gradient, texture, and brightness with the destination you've previously identified.

5. Paint the source material onto the destination with the Clone Brush.

6. Reselect sources frequently so that you don't create obvious duplications. Switch sides of a flaw as you clone and move at different angles so you don't create linear patterns.

Normally, I clone using a separate layer on top of the Background or current working layer. This preserves the original (or my interim working layer) image, and if I'm not happy with what I've cloned I can erase it, even well after the fact (for example, after closing and then reopening the file). It also opens up a lot of blending options. I can alter the opacity of the clone layer, soften the entire layer, or select the Soften Brush and selectively blend the cloned material with the original photo.

Choosing the correct brush size is important. There are times when you want a tiny brush to get into small areas. I've used Clone Brushes of one pixel many times to clone individual pixels. Be careful with small brushes. Cloning with a small brush tends to be more easily recognized. Larger, soft-edged brushes blend in better.

Changing Sizes

If you're cloning, and it doesn't seem to be working well, take a look at brush options like size and hardness. Change them to see if that's the problem.

I also tend to clone with the brush hardness set to 0. This helps the new material blend in because there are no hard edges. If you haven't guessed by now, blending is an important part of cloning.

There's More to a Brush than You Might Think

You can also change a brush's Thickness, Rotation, Style, and other parameters from the Tool Options toolbar. These options can come in handy if you're cloning over differently shaped and tilted areas. If that's not enough, open the Brush Variance palette and go crazy.

Working Around Edges

Using the Clone Brush near edges requires that you closely monitor where the edge is in relation to your source and destination. I've positioned my source spot (the circle with the X in it) too close to the edge of the photo in Figure 5.2. When I selected my destination, my movement upward with the Clone Brush copied the photo border. If you must select a source spot close to the edge, keep a disciplined hand when you brush and be aware of the "don't go that way" direction.

Figure 5.2
Source too close to outer border.

Figure 5.3 shows a similar problem, only reversed. Instead of transferring the outer edge of the photo, I'm transferring the boundary between the border and the picture. In this case, I've set the source spot too close to that boundary and let my brushing stray too far down.

Figure 5.4
Protect the photo with a selection if needed.

Figure 5.3
Source too close to photo edge.

If you want to protect an area of the photo from dangers like this, make a selection and clone inside it, as shown in Figure 5.4. You can make a nice, straight cloned border without fear.

If you've got a steady hand and a soft brush, you can routinely clone close to edges as you see me doing in Figure 5.5. The keys are practice, technique, the right brush hardness (softer is more forgiving and easier to blend), and a pen tablet. It doesn't take forever to learn and master. Pay attention to what you're doing, and you will learn very quickly. Developing a good technique makes you more efficient and saves time and effort.

One timesaving tool that I use to clone with is a pen tablet. A pen is more intuitive and natural to hold and use as a brush than a mouse. Additionally, the pen that I use is pressure sensitive, which means that I can press down very lightly with a larger brush and barely clone, or press harder, and the brush squishes more.

Figure 5.5
Freehand cloning with a soft brush edge and a pen tablet.

I know it sounds like I own stock in pen tablets. I don't, but I want you to realize how much help they are. If you're going to casually restore photos, you might not need one. But, if you're going to be doing this a lot, especially professionally, invest in it. Pronto.

Another cloning technique, especially on borders like that shown in Figure 5.6, is aligning the source spot exactly (either horizontally or vertically) with your destination. You might have to select a source, clone, undo, and redo several times to get the correct alignment. The material in the corner (referring to Figure 5.6), up past where the bend is, is new. I've transplanted it from the edge below. I left it undone so you could see it in progress. The key here was to precisely align the right edge of the source well below the destination. The edge looks straight and original because I've precisely aligned the source and destination vertically. Setting the source well below the destination area gives me room to move the brush up.

Figure 5.6
Start down to go up.

Cloning Areas Separated by Lines

Figure 5.7 shows the importance of good situational awareness as you clone in a busy area. Notice the tree branches that run from the top right to the lower left? They separate sky and smaller, fuzzier branches. If you break the lines of the large diagonal branches, it will be obvious.

Pay attention to these details. You can clone in the area between the diagonal lines first, or work on the branches first and return later to fill in the gaps. The point is to see how they divide the photo into regions that you need to work in. Here, the separating lines are the larger branches. In another photo, it could be power lines or a swing set or a sidewalk.

Figure 5.7
Cloning between branch lines.

I've come back and cloned the branches that run diagonally across the photo in Figure 5.8. That completes this portion of the photo. I've been careful to watch how things "flow" in this area. In fact, that dictated how I used the Clone Brush.

Figure 5.9
Some textures are hard to match.

Figure 5.8
Finish up along the branch.

In Figure 5.9, I'm cloning in the lower-right portion of the photo, along the ground. See the different textures? The split has run between different shades of grass, making it particularly hard to match things up. I clone from one side of a split like this and then go back and work on the other side. This helps balance the change in texture.

Figure 5.10 shows the border area between the far background and the sky. I've chosen a source spot along this line so that I can take care of the split in the photo along the border between the two textures (grass and sky) first. Then I'll go back and tackle the rest of the split from the top and then the bottom.

Figure 5.10
Always clone along a border between textures.

Trying Scratch Remover

There are plenty of applications where the Scratch Remover does a fantastic job, but this is pretty complex stuff. If the sky were a uniform blue and not covered with branches of different levels of detail, it would be dandy. Here, I don't expect it to work well, but I still want to show you.

Look at Figure 5.11. I've zoomed in on one of the splits and am in the process of applying a large swath of Scratch Remover.

Figure 5.12
Not for this application.

Figure 5.11
Trying the Scratch Remover.

Figure 5.12 shows the result. Bad. The blending is too much for the tool to handle.

I tried to tackle the split with the Scratch Remover in smaller chunks in Figure 5.13. I can still see the blending, however. It isn't as blatant as Figure 5.12, but you can see the pixelation that runs from the center down to the right. It looks like someone's appendix scar. If you increase the width of the Scratch Remover to something much larger, say 120 or so, the result will look much better, but you'll still have some blending issues because of the trees (whether you use short or long strokes).

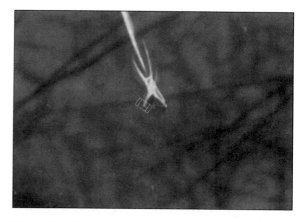

Figure 5.13
Smaller applications work better.

Fixing the Border

One viable technique for fixing border problems is to clone good parts over the damaged parts. You've seen that in some of the previous figures. I often fix all the border problems in a photo this way, especially if I want to preserve a vintage look.

If you want a bright border, you can select the photo area, invert the selection so that only the border is selected, and then use the Lighten Brush to "white out" everything. For a subtler effect, lower the opacity of the brush.

Finishing the Photo Study

In the end, I used the Clone Brush to fix all the splits, scratches, border problems, specks, dust, and dots in this photo. It's pretty straightforward, really. Find something that needs to be fixed, zoom in, select your brush, adjust the size, select the source, and clone. Although it gets routine, you've still got to pay attention to borders, textures, shades, and colors while you clone.

Figure 5.14 reveals the final, restored photo. All the tears have been mended, the other scratches and marks have been cloned out, the border looks great, and I tweaked a few other aspects of the photo. Namely, I made a histogram adjustment and fiddled with the curves to make the photo lighter and more vibrant, reduced the noise, and then sharpened the photo.

Figure 5.14
It was the Age of Aquarius.

Photo Study 23: Retouching a Large Scratch

FIGURE 5.15 IS ME, courtesy of the way-back machine we call the camera. I've spent a lot of time looking at this photo while working on it for this chapter, and I've come to the quite objective conclusion that youth has a way of making us all look pretty good.

Unfortunately, you can see a large scratch running up my cheek. It looks like this photo has been in a knife fight. I don't have many good photos of me during this time (I think this one and the drum major shot are the two best), and it would be a shame to lose this one because it's been damaged.

Removing Scanner Artifacts

There are hard-to-see artifacts created by the scanner in this photo. The most obvious one runs right across the top of my eyes and is a few pixel rows high and is reddish-purple. They sort of look like digital noise, but they run horizontally across the photo in different areas. I carefully smoothed these horizontal artifacts with the Smooth Brush to reduce their visibility.

Figure 5.15
This photo is very fixable.

Trying Scratch Remover

Once more into the scratch. Since this is a large scratch and my cheek is not as complex as the branches in the last photo study, I think it's appropriate to try the Scratch Remover again. You can see the application in progress in Figure 5.16.

Figure 5.16
Trying one large Scratch Remover.

I've chosen a rather large width to get the entire scratch under control. For this photo, that turned out to be 55 pixels. Figure 5.17 shows the result, which is not bad.

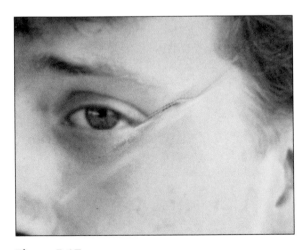

Figure 5.17
Blending problems are prominent.

I'm rather surprised at how bad this looks. I thought it would look reasonably good, but it had major problems with my eye and hair

Since I'm talking about the Scratch Remover, look what happens if I try to apply it across the scratch (see Figure 5.18).

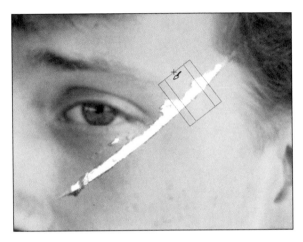

Figure 5.18
Going across a scratch is not a good idea.

Figure 5.19 shows the result. Hardly anything happens. That's because the Scratch Remover relies on blending the outer regions of the swath toward the center. Take another look at Figure 5.18. The tool has a central area that should cover what you're trying to fix. The outer border is what the tool pulls from (like a clone source) in order to blend into the center.

When you go across a scratch instead of along it, you're pulling the scratch in and blending it along its own axis of imperfection, which defeats the entire purpose.

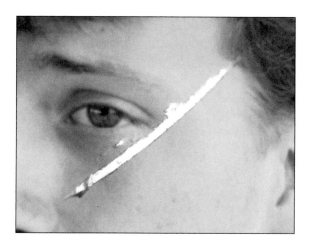

Figure 5.19
No change here.

In the previous photo study, smaller applications of the Scratch Remover seemed to work pretty well. I am using several small strokes with the Scratch Remover in Figure 5.20, and there is some improvement over the large swath of the original, but blending problems are still an issue.

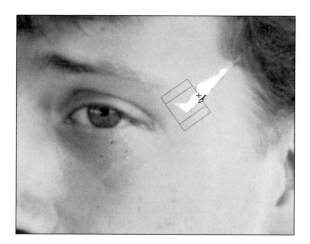

Figure 5.20
Scratch Remover in smaller applications.

I want to zoom in and take a look at the pixelation from figures shot for the previous edition of this book. This problem didn't crop up for this photo in X3, but I want to keep this material in to show you some of the bad things that can happen and how to resolve them (if possible). Figure 5.21 shows a large area of "harsh" pixels running where the scratch used to be. From a distance, this may be almost imperceptible, but it affects the hue of the area. These pixels give the appearance of dithering. Dithering is using two or more colors that can be displayed in a given medium (such as your computer monitor) to appear like a third color that cannot be produced directly. When you pull back from this shot, it looks dithered.

Figure 5.21
Close-up of pixelation.

You can select the Soften Brush, as I have in Figure 5.22, and smooth these pixels out.

Figure 5.22
Smoothing out pixelation.

One reason I prefer the Clone Brush over the Scratch Remover in photo restoration and retouching is the ability to separate what I'm doing to a new layer and blend it in later. Since you can't do that with the Scratch Remover, make sure you're using a duplicate layer so you can go back easily to prior steps if you need to.

Cloning Instead

I'm going to move on to cloning now, but I will start with a bad technique.

Figure 5.23 shows what can happen if you don't get an exact match from the source to the destination. This is the pinnacle of cloning "wrongness." Keep at it until you get it right. I might have to select a source area two or three times (maybe even more) to get the right hue and lightness at the source to match the destination. You may also have to adjust the brush size, depending on the size and shape of the source area you're pulling from.

Figure 5.23
Matching shades is very important.

I've done just that in Figure 5.24. Even though my original source was pretty close to the destination (as shown in Figure 5.23), it wasn't a good match. The source was clearly lighter than the destination area.

Figure 5.24
Clone along shade lines.

Keep Trying!

I consider myself pretty good at this stuff, but trial and error remain part of the equation. Experience and talent mean a lot, but they don't guarantee that every time I right-click to select a source area it will automatically be a perfect match with the destination area. There are times when the color gradient is so subtle that it takes getting it wrong a few times to see it.

Figure 5.25
Now from the other side.

Pay attention to subtle changes in hue and what direction gradient "flows." This will keep the trial and error phase to a reasonable minimum. Another thing to keep in mind is that this source may only be good for a very small area at the destination, meaning you need to continually move and adjust your source spot for areas of photos like this. At this magnification, this portion of my face is a very complex shape that has subtle lighting differences that result in a continually changing landscape.

I don't want you to think, though, that this is super hard or impossible to get right. It's probably harder for me to explain than it is for you to do.

I am using the correct technique in Figure 5.25. I've moved my source spot over to the other side of the scratch in order to find a good match for where I plan to clone. I will work both sides of a scratch like this to make sure I'm getting the tone right. It's even more important in this example.

Another trick is to zoom in to see some of the more microscopic cloning that you need to do. You don't need to do this on the larger elements, but in Figure 5.26 I've come much closer (600%) to get at a line of damage that runs parallel to the main scratch. You can see that it hasn't broken the surface of the film so much as it looks like something on top of it. My brush size has been scaled down to 5 pixels to fit in this area. You can also see that I've got my source selected just above the destination. This was the best area to get the right "flow" of my skin tone.

Try and develop a habit of zooming in and out to inspect your work. You will find a "sweet spot" for each level of damage you're trying to fix. If you zoom in closer, you'll feel claustrophobic, but if you zoom out you can't see the right level of detail. Whatever your current working view is, closer inspections are always a good idea to catch problems you might miss at a lower magnification. The cumulative effect of fixing a large number of very tiny problems can be dramatic.

Dabbing

Remember to alternate your technique based on the situation at hand. Sometimes, "dabbing" is better than laying down a long stroke with the Clone Brush. In fact, you should hardly ever select the Clone Brush and start painting away like you would a normal brush. Use short, small strokes and don't forget to dab.

Figure 5.26
Smaller brush for a tiny area.

I've got one final tip for you to consider. When you're done cloning, check your work by creating a temporary Levels Adjustment layer. Set the Levels Adjustment to something wacky that brings out any possible deviations in tone and delete this layer when you're done inspecting your cloning work. I'm setting this temporary layer up in Figure 5.27. I dragged the dark and middle adjustment diamonds upward, which has made the After preview window look pretty dark. That's okay. It's not supposed to look good. You're supposed to be able to see changes in tone that might have been imperceptible under normal lighting conditions.

Figure 5.27
Use a Levels Adjustment layer to check your work.

This figure needs some 'splaining. Notice where the scratch used to be? It's not there anymore. That's good. But I can see where I've cloned. That's not ideal. In fact, when I arrived at this point, I studied the photo very closely because it really bothered me. I came to the conclusion that I was seeing a couple of things. First, my cloning successfully covered the scratch. When I compare where the scratch was with the tone of my cheek elsewhere, it blends in very nicely. When the photo was scratched, the rubbing that caused the scratch also caused additional damage that wasn't as obvious. That's the reddish tone you see in Figure 5.27, which was made more visible by the temporary Levels Adjustment layer.

In my final restoration, I repaired the rub marks where I could, but I was content to leave some visible. More repair work in this case would be more visible than the original damage.

Finishing the Photo Study

My final work is revealed in Figure 5.28. I took the main scratch on my face out, but I left in some smaller scratches, especially in the lower left-center. I got the photo to the point where I really liked it, and I didn't want to overdo it.

Why didn't I fix absolutely everything? It's the real world. We've all got deadlines, other projects, a life, wife or husband, kids or pets, other interests, and finite resources. I want to make this real—not some fantasy book where I promise you the sun, the moon, the stars, but oh-by-the-way, you'll never be able to replicate what you see here in a thousand years because it's all fake!

You can and will. That's what this is about. But consider this: finish what you start. Don't get caught in the trap of working on one photo until you think it's perfect—and never finish it. That's a pipe dream anyway. Do the best job with what you have, and recognize the point when you have to stop.

Figure 5.28
Magic Bus, circa 1983.

The Expectations Game

Manage your expectations and those of others. If you are restoring photos professionally, come to terms with what you can do, how long it will take you, and what it's worth to you. Clearly communicate those terms with your clients. Sit down and have a heart-to-heart talk with them. (If yours is an Internet-based business, then have some of this information available on your Web site.) Discuss what you need from them, what they can expect from you, what the final product might look like, how long it will take, and how much it will cost. Don't over promise! If it's a terribly damaged photo and you think a light touch is about the only thing that will look good, don't let them think they're going to get a perfect photo back. As you restore the photo, make a conscious decision to remember why you take a certain approach so you can explain it to your clients. Take notes, if necessary, so you don't forget.

Photo Study 24: Fixing Creases

PART OF THE REASON I am having so much fun writing this book is that I get to share some awesome pictures with you. Figure 5.29 is a photo of my wife's grandfather during World War II. He's the younger-looking soldier on the left. The actual photo is fairly small. It only measures a few inches wide. I scanned it at 1200dpi so that I could enlarge it and get at some of the finer details.

I knew Bud later in his life. We visited, played golf together, and shared stories about being in the service. I helped him put together a sundial for his yard. Anne and I would visit during the summer and swim in their pool (he loved tending it). Our visits were always fun, and Casa Loma, as their old farmhouse was called, was always a great retreat for us.

This photo has been through a few tough times. It's lost the top-right corner and has some heavy creasing in the bottom-right corner. Throughout the photo are a large number of specks and scratches.

Figure 5.29
One of my favorite photos, heavily damaged.

Clone Wars

I won't kid you on this one. This is a hard photo to restore. Physical damage can be truly challenging to repair. Creases are not that much different from scratches or tears, but creases tend to multiply like rabbits and can overwhelm you. Therefore, I'm going to try something a little different here. I want to "repair" these creases by minimizing their impact on the overall photo but not completely removing them.

I've zoomed in to get started in the lower right-hand corner, as you can see from Figure 5.30. I'm using a tiny brush that's only 5 pixels around, and I'm starting to tackle a crease.

Try not to jump into the middle of a bunch of creases. Work from one side or the other inward. I've found a nice spot outside of those smallish corner creases to begin from in Figure 5.30. I'm going to slowly work my way down and to the right and "eat away" all of those creases.

Figure 5.30
Cloning along a crease.

I'm continuing to work on the first outer crease in Figure 5.31. Notice that I've switched sides. This is a pretty hard area because there's not much room to work in, but it's important to vary the source areas so you don't copy any recognizable features.

Figure 5.31
Switching sides to match texture.

I'm continuing to make progress down a crease in Figure 5.32. I've switched sides again to work the tone. Look carefully at this figure and tell me what it is. Can you? It's pretty hard for me, and I know the photo pretty well now. In general, the lower-right corner shows the road and where the sand-bags are laying. To the right is a fence, and on the other side is a lighter area, which may be the edge of the road. It's possible this was taken on a small road bridge. What you're seeing is shadow on the lower-right road, which is less shadowed, toward the left, the beginning of the bags at the top left, and possibly cabling or fence at the top right.

It's helpful to know what you're looking at and where you are in a photo. That can mean subtle but important differences in what you select as your source for the Clone Brush.

Figure 5.32
Finishing close to the border.

I've zoomed out a bit and am working on another crease in Figure 5.33. As in the first photo study of this chapter, I'm working between two linear elements, namely, cables. I think that's water down there in between, where my source spot is, and I am using the brush between the cables. I'll go back and repair them after I get the center done.

Figure 5.34
Clone along content lines.

Figure 5.33
Zoom out to get perspective.

I've completed the water and have moved to the cables in Figure 5.34. I've zoomed in much closer because this is a very fine level of detail. I'm cloning "with the grain" of the cable.

Figure 5.35 shows where the crease gets really nasty. This area consists of sandbags, and there are a lot of variations of detail, tone, and brightness. I'm starting from the "outside" and working my way in. It really helps to think of it like you're eating the problem away. Pac-Man, anyone?

Figure 5.35
Working a harder spot.

I've zoomed in some and am trying to get an area that's in shadow in Figure 5.36. I've switched sides of the crease to get at a good dark area.

The remainder of the creases can be repaired in like manner, which is shorthand for me saying I think you get the idea and I need to move on.

Figure 5.36
Notice the mold or mildew discolorations.

Each Photo Has a Flow

What I want to move on to has to do with flow. This photo, like all the others, had a flow of its own.

I began with the sky, which was easy, then worked on the creases for a while, and switched to the corner. I took breaks and switched things around—coming back to work on the roofs, then Bud, then back to the creases.

I vary my work between different areas and different difficulties. This keeps my mind from locking up after staring at one microscopic part of the photo for too long. This photo has so much damage that it makes repairing the entire photo almost impossible. There's not very many clean areas to use as cloning sources, aside from the sky. There are creases, scratches, and what looks like mold or mildew damage all over the photo.

Take a quick peek back at Figure 5.36. See the area on both sides of the main crease? It looks milky, doesn't it? It looks like that damage has been caused by mold or mildew. Even if I fix the crease, I would have to either clone the mildew areas to make the tone match or clone over everything to take that damage out. Neither idea sounds like a winner to me.

In cases like this, it's time to think creatively.

Most of the time, I clone to make something I want to hide invisible. I'm trying to cover it. When that's not possible, I look at changing the rules—using the Clone Brush to make things appear less obvious, but not invisible. For this photo, that means accepting the fact that I can't eliminate all the creases, but I *can* take some of their power over this photo away.

How? I can make the layer I used as a clone destination semi-transparent. Remember all those times I suggested making your clone layer separate? This is where that pays off. Figure 5.37 shows the areas where I've worked thus far side-by-side with areas that I haven't touched. The creases I've cloned over are much less obvious, and the photo has not been destroyed in the process.

Making the clone layer semi-transparent is far more forgiving than normal cloning. You can "get away" with much more, which is good for this photo. It's been terribly hard matching up all the different shadows and textures while having to work around mold and mildew damage.

Figure 5.37
A semi-transparent clone layer minimizes creases.

I should point out that I didn't make every cloned area semi-transparent. I repaired the corner, the sky, and as many scratches and specks and lines and dots as I could normally. In the process, I used more than one destination layer so that I could alter their opacities separately. In other words, I left the layer I used to clone on to correct problems in the sky opaque, but the creases I made semi-transparent. I couldn't have done this if they were on the same destination layers.

Finishing the Photo Study

Figure 5.38 shows the final result. This photo shows a fine balance between fixing some important things and leaving in some imperfections. The semi-transparent clone layer was a fantastic solution. It kept some of the cloning from being so obvious that it became a distraction, and it minimized the creases.

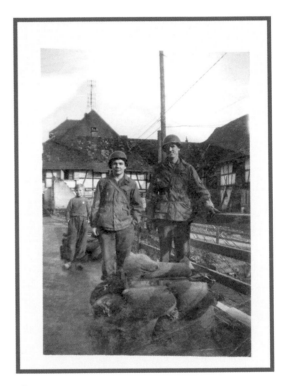

Figure 5.38
In honor of Grandpa Bud.

Photo Study 25: Repairing Hairline Cracks in Film

FIGURE 5.39 IS ANOTHER PHOTO of my mother-in-law. This was taken when she was somewhere approaching five years old. When I spoke with her about it, she instantly recognized the place and her doll. The doll's name was Bluey. She had brown hair and blue eyes. Mary Anne said the doll was a pretty new model at the time—one whose eyes closed if you laid her down.

Forming Narratives

Compare the car in this photo study with the one visible in Photo Study 19, which can be found in Chapter 4, "Making Color Corrections." They appear to be the same car. Details like this will help you tie photos together and form an interesting narrative. Look for details that might be in one photo to help you restore another.

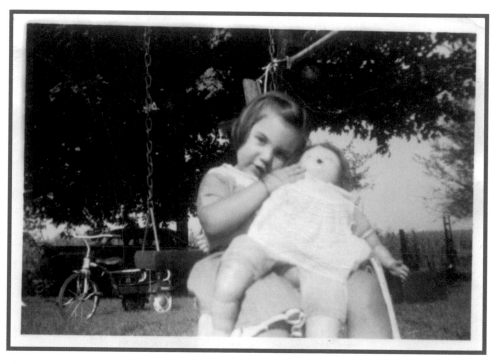

Figure 5.39
This photo has significant hairline cracks.

Traditional Approach

I'm going to remove the hairline cracks using a few different techniques. First, I'll try the Scratch Remover, as seen in Figure 5.40. I've selected a fairly small area that is cracked to see how the tool will work.

Figure 5.41
Close-up of pixelation.

Figure 5.40
Scratch Remover before.

Figure 5.41 shows a close-up of the result. You can see the pixelation. Once again, blending is a problem. The Scratch Remover leaves pixel artifacts behind.

I applied the Soften Brush with a hardness of 50 and an opacity of 34 in Figure 5.42. It took those "harsh" pixels and blended them into the rest very well, but the crack is still visible. However, this figure is zoomed in at 600%. That's pretty close.

Figure 5.42
Softening helps tremendously.

I've returned to the Clone Brush in Figure 5.43. As I expected, it looks great. I was able to select a good source area that matched the tone of my destination very well. There shouldn't be much of a problem here, except time and scale.

Figure 5.43
Cloning is the best option.

I could have spent the next fortnight cloning out all the tiny cracks, but I ended up deciding to try something a little more artistic.

Out-of-the-Box Method

This decision was made easier because this isn't a great photo to start with. Because Mary Anne and the background have very different characteristics, I want to create duplicate layers of the photo (one for Mary Anne and one for the background), perform different manipulations on them (which means I won't clone the problems out of the background), and then integrate them back together.

First, I'm going to duplicate my base (photo) layer twice. I will hide the top layer and name the bottom layer "darken-background" and then select it. I will make a histogram adjustment to the "darken-background" layer. I am working in the Histogram Adjustment dialog box in Figure 5.44 to darken the background of the photo.

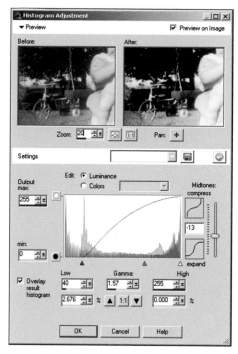

Figure 5.44
Darkening the background.

For this part of the job, I am looking at the background and ignoring Mary Anne. I've made my Low and High slider adjustments and changed the gamma. The result is a much darker background. It looks pretty cool, and it doesn't matter how this affected Mary Anne, because, well, you'll see.

Next, I need to select the top layer and unhide it. I named the top layer "Mary Anne" and will use this layer to sharpen her up. I will use the High Pass Sharpen filter, as seen in Figure 5.45. I've got a moderate to small radius (always experiment with these setting to see how they affect your photos), have maximized the strength, and set the Blend Mode to Soft Light. This combination of settings helps clarify the contrast and sharpen her without overdoing it and making the shadows on her face look too dark.

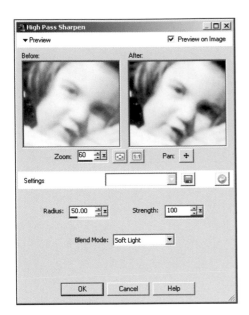

Figure 5.45
Sharpening Mary Anne.

Figure 5.46
Roughly erasing layer background.

Figure 5.47
Erasing closely.

I am erasing the background around Mary Anne on the top layer (the one named "Mary Anne") in Figure 5.46. (I could have used a mask here, but chose not to.) I've got a large square brush, and I'm erasing like crazy.

When I erase a large area, I always set my brush hardness to 100% for the first rough pass. I really want to erase in this step. When you lower the opacity of the Eraser, you end up leaving half-transparent pixels around the edges. When I move closer to Mary Anne, I'll soften the Eraser and make it smaller.

I've made my brush significantly smaller and lowered the hardness to 0 in Figure 5.47. This lets me get in closer to Mary Anne and clean up all the jagged edges left behind by the hard eraser.

For the final step, I will darken the background behind Mary Anne on her layer (see Figure 5.48). This will help her blend in with the darker layer behind her.

Figure 5.48
Darkening area behind her.

That's about it. I will merge these two layers when I copy and paste them to form a composite. Then I will use the Clone Brush to erase any specks or marks. As a last step, I will improve the overall contrast of the photo and then fix the border.

Finishing the Photo Study

The final photo is seen in Figure 5.49. I like the effect of the darker background. The whole photo looks better, too. You can clone out every crack and crevice if you like, to be sure, but there are times when you will want to reduce their negative presence another way or integrate them into the artistic presentation of your photo.

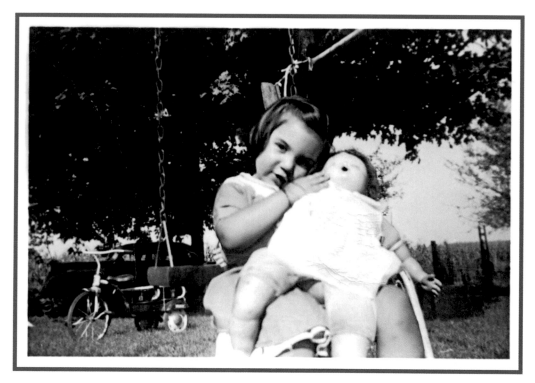

Figure 5.49
Mary Anne and her dolly artistically restored.

Photo Study 26: Filling a Torn Hole

FIGURE 5.50 IS A PHOTO of my mother-in-law's mom, Louise, and Louise's father, Dwight. Their family used to go up to Michigan for summer vacations, and as near as we can tell, this photo was taken during one of those times. Louise looks around three or so, which would date this to approximately 1928.

Somewhere along the line, a hole was torn in the bottom center of the picture. Aside from restoring this photo for aesthetic reasons, a photo with torn edges is always in danger of being torn more. Once I restore this, I'll be able to print out new copies for viewing and handling, while the original is stored safely away.

This photo is a classic example of a fairly minor touch-up that will make an enormous positive difference to the photo.

Working the Pants Leg

I'm going to walk you through a rather detailed look at fixing this, starting with the pant leg.

My first cloning operation on the pant leg can be seen in Figure 5.51. In instances like this, I generally choose to work from the inside out, which is why I've started at the top of the hole where the pant breaks from shadow to light. Borders like this, shadows and light, are just as important to nail as texture and color borders. In this case, I'm very fortunate to have a good amount of existing material to work with.

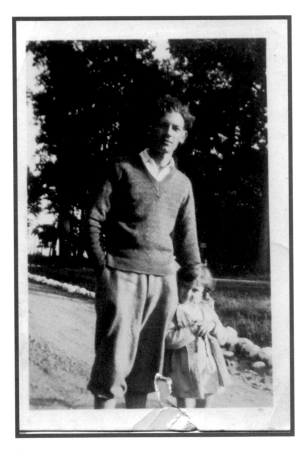

Figure 5.50
Notice the hole at the bottom?

Figure 5.51
Cloning along the pant shadow.

Now that I've got the border between light and shadow, I'm going to fill in the shaded part of the pant leg, moving carefully into the hole and filling it in. Figure 5.52 brings you up to date. It's looking really good. I'm excited!

Figure 5.52
Finishing the bottom of the pant leg.

I think in terms of pieces when I restore photos. You can break the bigger picture down and down and down—until you're left with very manageable tasks. The first task here was to fix the line of the pant leg, which bordered between shadow and light. Check. Next, the task was to fill in the shadow area and complete the bottom of the pant. Roger. Notice how each of these pieces has a border that separates it from other parts of the job? Affirmative.

Now all I need to do is finish the pant leg, and that part is done. Figure 5.53 shows the final cloning on the pant leg in the light area.

Figure 5.53
Finishing the pant leg.

Starting the Ground

I've finished Dwight's torn pant leg, so it's time to go on to another piece. I'll work on the ground a bit. I am, again, cloning along a border in Figure 5.54. This time I am working on the ground where it turns from darker to a lighter tan. I will work this area briefly so that when I turn to Louise's skirt, I can finish the ground as I finish her.

Figure 5.54
Pay attention to shading.

Now for the Skirt

I am starting to clone the bottom of her skirt in Figure 5.55. This time I am working from the outside border in. I'll grab a bit of the skirt from the right and pull it over, making sure to bring the ground along.

Next, I'll focus on another border. This time I want to get the border between Dwight's pant leg and Louise's skirt done. I may clone "over" some existing material. No matter. I'll take care not to disturb my finished pant leg, but some of the border area can be refined. I extended the shadow between the pant and the skirt down and inward in Figure 5.56.

Figure 5.55
Extending the skirt.

Figure 5.56
Bringing down the shadow.

If you want to be extra careful about things, you can consolidate your work along the way. I like working with the photo on the Background layer, and I never disturb it. I create a new raster layer on top of that to clone on, making sure that "Use all layers" is enabled when I select my Clone Brush.

Make sure you've selected this clone layer when you start to work; otherwise, you'll be putting down paint on the layer you want to protect. It's simple to consolidate. Perform a merged copy by pressing Ctrl+Shift+C, and then paste that merged copy as a new layer on top of the clone layer by pressing Ctrl+V. This is your new working layer. You've just consolidated your work, and it's protected. Create a new clone layer (an empty raster layer) once again and go back to cloning. You can do this as many times as you need, up to the amount of memory you have.

It's time for me to get back to work on that skirt. It's pretty tough in the interior. There are folds and shadows galore here. Tricky indeed. Figure 5.57 shows me starting to fill this in.

Figure 5.57
Starting to fill in.

If it doesn't look right, give it a little time. Don't start over immediately. There are times I clone tough areas like this, and it doesn't look good at first, but it comes around if I keep at it.

Figure 5.58 shows the filled-in skirt, and I'm doing some touching up. I'm working with the "grain" of the skirt, which is to say, vertically. What may have looked a little dodgy in the beginning fits right in after a little work.

Figure 5.58
Finishing the fill.

There are two final steps that are tricks of the trade and can make cloning much better. First, I'm going to push some paint around with the Push Brush (a handy tool) in Figure 5.59.

Figure 5.59
Using the Push Brush to blend.

My primary purpose is to blend my cloned work. It's still on a separate layer, but I'm pushing the paint around to blend it. I've lowered the opacity to 28, so it's a pretty light touch.

Finally, I will use the Soften Brush in Figure 5.60 to soften the work that I just completed. I turned off the photo layer so you can see what I'm doing a little better. I've turned down the opacity of this brush, too. It's set at 34.

Softening is different than pushing paint around. Soften takes the edge off of things. It smoothes the borders and creates more of a gradient between different colors.

Finishing the Photo Study

Figure 5.61 shows the finished photo. This is a photo where everything came together nicely. I want to make sure and point these out, too! I had enough time, it wasn't too badly damaged, and the final print is as nice as one could expect. The hole is gone, and I also fixed the other specks and scratches in the photo, plus I enhanced the contrast and color balance.

Figure 5.60
Softening the cloned material.

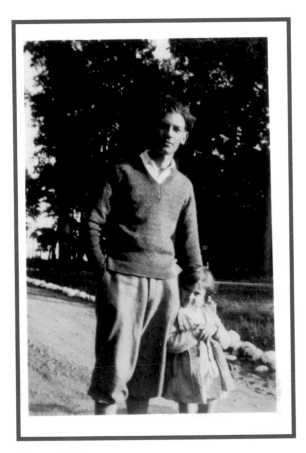

Figure 5.61
Even small repairs are very gratifying.

Photo Study 27: Restoring a Missing Corner

THIS PHOTO (SEE FIGURE 5.62), taken and developed in 1954, is another of my wife's family. Louise, the young girl in the last photo study, is back again, this time as a grown woman with a family. Bud, her husband and the young soldier in Photo Study 24, is also here. Mary Anne, the subject of Photo Studies 22 and 25, is the young girl on the left. She's got an older sister and a younger brother present in this photo.

This photo has been through some tough times. It's got a pretty good chunk missing out of the lower-left corner, and it looks like it's been wadded up, as evidenced by all the creases. This goes far beyond normal wear and tear. That makes it perfect for this chapter!

Tackle the Border First

The first thing I'm going to do is get the corner fixed. There is a pretty hefty chunk missing. I could use the Clone Brush and copy the existing borders, but it's actually much faster and easier to copy another corner and rotate it so that it fits in place.

I've selected the bottom-right corner with the Selection tool in Figure 5.63.

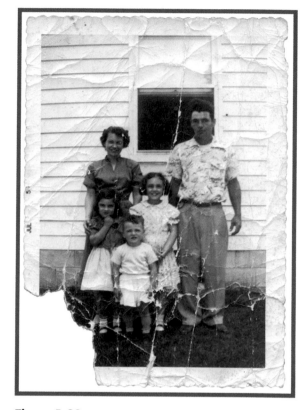

Figure 5.62
Mangled family portrait.

Figure 5.63
Copy the opposite corner.

Figure 5.64
Paste and mirror.

I pressed Ctrl+C to copy this selection and Ctrl+V to paste it as a new layer. While the corner I pasted was still selected as an object, I chose the Image ❯ Mirror menu to mirror it horizontally. After it was mirrored, I moved the new corner to cover the missing space, as shown in Figure 5.64.

You can see that the old content is still inside the "new" corner. Don't worry. It takes very little effort to delete it. It doesn't even matter that the inside border is a bit off. The important border to align here is the outer border, which will ensure that the new corner blends in. This photo has a scalloped edge, which makes it a bit trickier.

With the replacement corner aligned (it's a separate layer than the Background photo layer), I returned to the Selection tool and selected the interior of the new corner to delete it, as shown in Figure 5.65. I matched the inner border of the photo frame with what was selected in this step.

Ctrl+Shift+P

If you want to streamline the process, make your selection and press Ctrl+Shift+P to promote it to a new layer. You don't have to copy and paste it that way. You can then deselect it, mirror, and move the material.

After I selected the proper area, I pressed the Delete key to send it to oblivion.

Figure 5.65
Select and delete unwanted material.

All I need to do now is touch up the "joints" where the new corner and existing border overlap. I am using the Clone Brush to remove the obvious signs that this corner was pasted in Figure 5.66. I'm not worried about restoring the corner fully. That will come later.

Figure 5.66
Touching up.

Filling In

The outer border is complete. Now for the hard part—filling in the missing area of the picture.

There will be times when this will be impossible. In some of these cases, restore the border and the rest of the photo but do not re-create the missing material. Fill the area with a neutral shade of gray. This is similar to the way some architectural restorations (like the Coliseum in Rome) are handled. New material is clearly new. People can see there was a missing corner, it's not distracting, and you can handle the restored photo without fear of damaging the original any further.

For this book, I will put grass in the missing corner. I am beginning the process in Figure 5.67.

Figure 5.67
Cloning grass.

I have to take grass from the other side of the photo, as seen in Figure 5.68, to fill in the missing area.

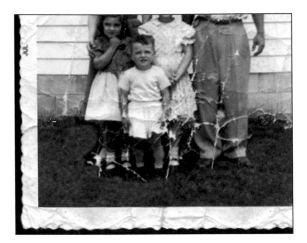

Figure 5.68
Taking material from the other side.

After the new grass is planted, I will use the Burn Brush to create a shadow behind Louise, as seen in Figure 5.69. This will make the cloned area look more realistic. I lowered the opacity of the Burn Brush to 10 to blend it in naturally.

Figure 5.69
Using the Burn Brush to create a shadow.

Finishing the Photo Study

The fully restored photo can be seen in Figure 5.70. This was a tough one, and the corner was only the tip of the iceberg. After fixing the corner, I made as many other repairs as I could. I retouched the siding of the house, the window, the grass, everyone's faces and hair, and other areas. I also made contrast and color adjustments, plus worked on the border.

I want to conclude this chapter by making the point that whether the job is very large or relatively minor, restoring and retouching photos should be fun and rewarding. Although photo restoration will challenge you as a creative artist and push your technological limits, PaintShop Photo Pro is an economical and powerful tool. Be positive and don't get down on yourself.

Figure 5.70
Large jobs are great, too.

Erasing Writing and Other Marks

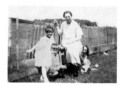

DO YOU HAVE A LOT OF PHOTOS in your collection where your mom, or your aunt, or your grandmother decided to write on them? She was undoubtedly being helpful at the time. Maybe you decided to do some creative coloring when you were young. Regardless of how it got there, removing writing (and other types of marks) is a challenging endeavor and the subject of this chapter. I'm going to restore several photos that have pen, marker, tape, some icky gunk, and spots on them.

I'll use a combination of the superstar Clone Brush and a technique that may surprise you—separating a photo into its hue, saturation, and lightness channels, using the Clone Brush on each of these separate images, then combining them back together again. Here are the studies:

▶ **Photo Study 28: Erasing Colored Pen**—Here's an old photo with a combination of different pen markings that is an excellent way to start the chapter. I'll use the Color Changer and the Change to Target Brush before splitting the HSL channels in an effort to take the markings out.

▶ **Photo Study 29: Taking Out Notations**—This is a straightforward Clone Brush operation. The hard part is that there are a lot of numbers above and on people's heads. It's a great exercise in cloning, and I'll have to use a lot of different cloning techniques.

▶ **Photo Study 30: Removing Marker**—I'm going to separate the photo into HSL channels in order to make the marker stand out much more clearly than in the original photo, then send in the clones.

▶ **Photo Study 31: Hiding Tape**—This photo has been torn in half and taped back together. I'll put it back together and hide the tape so the photo looks like it was never torn. Bonus!

▶ **Photo Study 32: Hiding Discolored Spots**—This study features a photo of my wife's grandfather during World War II. It's a posed shot that has suffered from spotty discoloration over the years. I'll use a mask to create a new background, then separate the channels and use the Clone Brush to out those darned spots.

Photo Study 28: Erasing Colored Pen

FIGURE 6.1 IS A PHOTO of my father-in-law's mother, Grace, and her siblings, taken in (as the writing shows), 1919. Grace is the woman in this photo, and the namesake of our daughter. She is about 24 here. The playful young girl on the right is Grandma Jo. Once again, history is right before our eyes. This photo was taken before the roaring twenties, before the great depression, before women had the right to vote. The people in this photo were alive before television, during the birth of the automobile and airplane, before spaceflight of any kind, before microwaves and cell phones and computers and most of what we have around us today. They didn't have to decide between cable and satellite TV or between Windows and Macs.

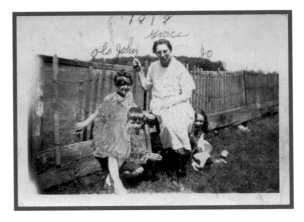

Figure 6.1
Colored ink mars a classic old-time photo.

Technique Bonanza

PaintShop Photo Pro has a plethora of options when it comes to removing ink and writing on photos. I'm going to explore a few of the more direct varieties before moving on to splitting the HSL channels. I'll first show the Color Changer tool (organized with the Flood Fill tool on the Tools toolbar) and then move on to Change to Target Brush.

Color Changer

The Color Changer tool made its appearance with the release of Paint Shop Pro Photo XI. Older color replacement tools like the Flood Fill tool (which admittedly, isn't the only way to change colors, and itself has gotten better) were designed to operate simply: See blue (within a certain tolerance), replace blue. Only one replacement shade of blue per customer, please. They were great for changing a color range to a specific color, but not so great at replacing a color range with a color range.

The Color Changer tool is optimized to replace a range of similar colors. You specify a tolerance and edge softness from the Tool Options toolbar. That's nifty.

It's easy to use this tool. I've selected the tool from the Tools toolbar in Figure 6.2 and pressed Ctrl to change the tool to the dropper. I'm hovering my pen over the color I want to replace with. That's right. First, I'm selecting the color I want to use as the replacement—not the color I want to get rid of. I want to change the red dots to an off-white, so I am clicking on the off-white in Grace's dress to load that color into the Materials palette. The RGB values pop up when you have Ctrl pressed. This is a great shortcut so you don't have to switch tools.

Figure 6.2
Sampling the color to replace with.

The next step is to let go of Ctrl (the tool cursor will change to a bucket) and left-click (right-clicking changes the color to the Background color of the Materials palette) on the color you want to replace; in this case, the red in Grace's dress. I have just clicked to change the color in Figure 6.3.

Figure 6.3
Washing those reds away.

Notice a few things from Figure 6.3. First, the areas of color that get changed do not have to be adjacent, providing they are connected by pixels within the color tolerance. They can be on opposite sides of the photo, and the Color Changer will replace them. The red in the young girl's dress was changed to off-white (roughly, I will get to that), even though I clicked in Grace's dress. This has benefits but also drawbacks. If you're working in a photo where the colors are very similar (as this one), you will get more color replacement than you may want. Try lowering the tolerance in those cases.

Second, the off-white color that replaced the red did so reasonably intelligently. It's not just a blob of solid color. The bad thing is that it didn't completely eliminate the red from this photo.

I Know What You're Thinking

Why don't I just change this photo to grayscale and get rid of the color that way? I could, but I would still be left with the different lightness values of the colored regions that would be different than the surrounding fabric. In other words, the red dots on Grace's dress would be gray, not white, and you could still see them as dots. The other reason is that I don't find a pure transformation into grayscale very attractive. I realize this is technically a black-and-white photo, but I like preserving some of the color.

It made the spots much less obvious, but I will still have to use the Clone Brush, as seen in Figure 6.4, to completely remove them.

Figure 6.4
Cloning to finish.

Learning Center

There are times when I forget how to use something in PaintShop Photo Pro, especially when it comes to brushes that I don't use as often as others, like the Change to Target Brush. That makes for a great opportunity to promote the Learning Center palette. I normally work with this feature hidden, but it's always within easy reach if I need it. The point is to be able to use all the features of the program and get the job done, isn't it? If you need a quick reminder on how to use something, turn on the Learning Center and read along. It's faster than consulting the help file and smart enough to know what tool you have selected and show you how to get help with that.

Change to Target

I want to try a different technique on John's shirt. It's been pretty well inked over, with globs of thick color interspersed with patches of less dense blue. This time I will use the Change to Target Brush.

Set the foreground color in the Materials palette to the color you want to change to with the Dropper tool, as I'm doing in Figure 6.5. I'm looking for something in the photo that has the same tone I would like to change John's shirt to. The area on that wooden post will do.

Figure 6.5
Taking another sample.

I've selected the Change to Target Brush and changed the size and hardness to fit the task at hand, and am brushing in the area I want to recolor in Figure 6.6.

Figure 6.6
Using the Change to Target Brush.

Be careful when you paint with the Change to Target Brush, because it's not a "smart" tool. In other words, some tools analyze what you click on and then change a range of similar pixels within a certain tolerance, like the Color Changer tool. The Change to Target Brush doesn't work like that. With it, your brush covers whatever you're painting over with the target color.

In "Color" mode, Change to Target Brush modifies the color (a combination of hue and saturation in this instance), but not other properties (like lightness, which is where much of the detail is). Normally, that's nice. In this instance, it's not so good. After changing the color of John's shirt, it still looks like someone has drawn on it. I'm softening the leftover texture with the Soften Brush at a fairly low opacity in Figure 6.7 to correct that.

Figure 6.7
Softening to smooth the effect.

Splitting HSL Channels

I wrote a description of color and HSL in the section entitled "Technique Smorgasbord" in Chapter 4, "Making Color Corrections." I'll recap here briefly to get this section started.

HSL stands for Hue, Saturation, and Lightness. These are three "channels" that store information about a picture. They work like the Red, Green, and Blue channels, which you're probably more familiar with. RGB is purely color information, whereas HSL is more. Here's how it breaks down in simplified terms:

- ▶ **Hue**—the color of the pixel

- ▶ **Saturation**—the intensity of that color from gray to the pure color

- ▶ **Lightness**—the lightness of the pixel

If you could alter these channels independently of each another, you could change the color of something in the photo without compromising its intensity or lightness. Or you could use other combinations. You could change lightness without altering saturation, or saturation without altering hue, and so forth.

CMY What and RG Who?

CMYK stands for cyan, magenta, yellow, and black, and is used mainly in professional printing. These printers use four colors of ink to create a full-color product. When you hear someone talk about four-color printing, they are referring to the number of inks used and not the color depth of the printed material.

RGB stands for red, green, and blue. Color television screens and computer monitors (older style CRTs, anyway) use three electron guns (one of each of the RGB colors) to shoot electrons onto a cathode ray tube, which is coated with red, green, and blue emitting phosphors. (They emit that color when excited by the electron beam.) The RGB guns and RGB phosphors are why computer colors are so RGB-centric.

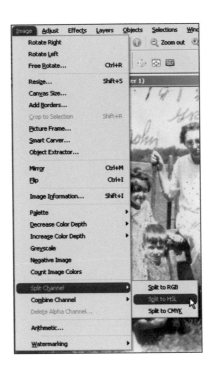

Figure 6.8
Splitting to HSL channels.

I'm going to show you how to do exactly that.

I'm choosing the menu item that splits the channels to HSL in Figure 6.8. You can also split to RGB (Red, Green, and Blue) or CMYK (Cyan, Magenta, Yellow, and Black), but those techniques don't isolate hue, saturation, and lightness like HSL does. It's very important to note that if you have more than one layer in a file, the currently selected layer is split, not every layer. If you must, perform a merged copy (let's say of a cloned layer and the original background), paste that as a new layer, and then split it.

When you select the menu item, PaintShop Photo Pro splits the photo in the H, S, and L channels and opens up three new images, entitled appropriately. Hue1 is the hue channel, Saturation1 is the saturation channel, and so on. If you split more images (or the same image multiple times), the numbers keep going up.

This is going to look freaky if you've never done it before, but it's kind of fun to work with HSL channels. I'm going to do it a lot in this chapter, so you'll get a lot of experience seeing what it's like.

Careful, You're Using Indexed Color Now

The HSL channels split into palette-indexed grayscale files, not your typical 8-bit-per-channel RGB format. When you look over at the Materials palette (Rainbow tab), you'll see the color wheel has been replaced by discreet chunks of gray, ranging from white to black. These are the indexed colors. If you change this, or increase the color depth, you'll have an impossible time remapping the grays to what they were before. Some tools, like the Change to Target Brush, change the color depth when you use them. Stick with the Clone Brush (it's one tool that doesn't change the indexed colors), and you'll be fine.

One other thing: It's important to keep all three images open, so you'll have them to combine together at the end of this process.

Figure 6.9 shows the Hue channel. I've selected the Clone Brush and am working the writing out of the sky. Remember, this is hue, which is color information. It won't affect the detail (lightness) of this photo. For example, I could select this entire image (in this or in the Saturation channel), delete the current content, and fill it with a randomly chosen swatch of gray from the Materials palette and not lose any of the details. I would just be changing the hue of the entire photo to one value. This is basically what happens behind the scenes when you use the Image > Grayscale menu to turn a color photo into black-and-white; only instead of a shade of gray, the Hue and Saturation channels will be black. Go ahead and try it out for yourself. Take a color photo, change it to grayscale, and then split to HSL and check the different channels out.

The writing really stands out well on the photo when you look at it from the HSL channels. That's one great advantage of splitting them.

Figure 6.9
Cloning the Hue layer.

I should discuss this a bit more before moving on. When you're looking at Figure 6.9 and you see something that's mainly unrecognizable, you're looking at a scale. White is at one end of the scale and black is at the other end. For saturation and lightness, think of white as "full on" and black as "full off." Gray is somewhere in the middle. The specific shades of gray you see on-screen in this channel are meaningless, except as a stepped measure of intensity. In other words, you could be looking at shades of pink, purple, orange, green, or blue instead of gray. The color doesn't matter; it's the shade that matters. You'll get used to being able to interpret different shades of gray as a measure of hue and saturation. The lightness part is easy.

Full-Color Photos and HSL

Manipulating HSL channels isn't as easy with a color scan of a color photo (or a color digital photo). Try it yourself. It's much harder to spot things that are wrong and successfully alter the Hue or Saturation channels of color photos without throwing things completely out of whack.

Compare Figure 6.10 with Figure 6.2 and look at the spots on Grace's dress. I can clearly see what I need to fix in the Hue channel. I'll use a hue from Grace's dress to cover the dark spots with the Clone Brush.

Figure 6.10
The spots really stand out.

I'm going to switch gears and move on to the Saturation channel. Remember, this is a separate image in the workspace that got created when I split the channels. Since this is the first split, this image is called Saturation1, and is shown in Figure 6.11. Once more, I am cloning out the writing.

There is quite a bit of detail in this channel, which would, of course, not be present in a true black-and-white photo. I can clearly discern the differences between the sky and the woods and between the writing and everything else. The writing is easily cloned out.

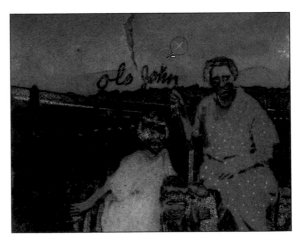

Figure 6.11
The names stand out in the Saturation channel.

Finally, I'm going to move on to the Lightness channel, as seen in Figure 6.12. This channel most closely approximates the actual photo, because the photo was originally black-and-white. You'll find this is the case even for color photos. The Lightness channel looks most like what we see.

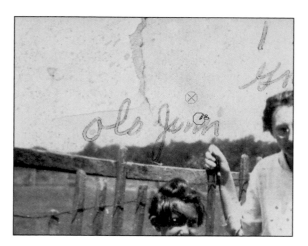

Figure 6.12
Cloning the Lightness channel.

This technique can triple the amount of work you do on a photo. For the most part, instead of cloning once on the composite photo, you're cloning over the same thing three times, once in each channel. Yeah, that stinks.

Why would I even suggest such a thing? Because there will be photos where you need this level of control over the different channels, and perhaps the best way to see the damage is to split the channels out. In other words, you may want the option to preserve the original tinting or discoloration as you correct the photo or selectively remove the tinting without affecting the other channels, and damage is sometimes easier to spot in the Hue or Saturation channel compared to the original photo or Lightness channel. I don't think I could have done the same job in this and some of the other studies without looking at and working in the other channels.

Two last things before I combine the channels back together into one image.

First, I'm going to use the Dodge Brush to lighten up John's shirt (see Figure 6.13) on the Lightness channel. The Dodge Brush, as with the Soften Brush below, can be successfully used on the channel images without altering the color depth.

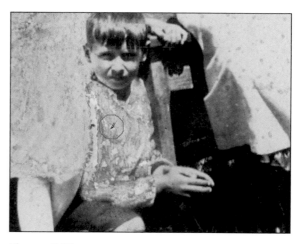

Figure 6.13
Using the Dodge Brush to lighten the shirt.

Finally, I want to soften the clumps of color on Olo's dress. I'll use the trusty Soften Brush for this, as seen in Figure 6.14.

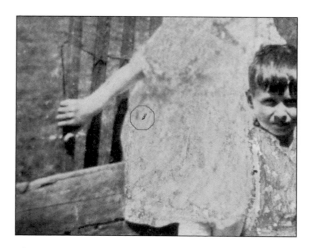

Figure 6.14
Softening the dress.

After you've done all the work you need to do on each separate channel, it's time to combine them back together.

Checking Your Work

You can combine the channels in interim stages to check your work. After you combine them, don't close the individual channel images. (You still need them.) You can close the merged image without saving it when you're done with your inspection.

Figure 6.15 reveals the correct menu, Image ❯ Combine Channel ❯ Combine from HSL. I've got all three channels arranged, and the original working copy of the photo study is minimized. What I'm going to do is combine these channels, copy the result, and paste it back as a new layer into my working study file, which is a .pspimage.

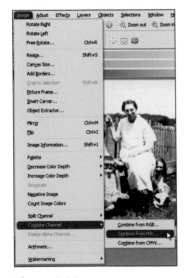

Figure 6.15
Combining from HSL.

When combining channels, you're presented with the Combine HSL dialog box, as shown in Figure 6.16. Select the correct channel sources from the drop-down menus. Check "Sync hue, sat, and light if possible" to make it easy on yourself. When this is checked, select one source (which sets the correct numbering), and the other channels automatically look for and select their appropriately named source image. If you deselect the Sync option, you will have to manually identify your channels.

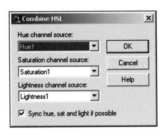

Figure 6.16
Choosing the HSL Channel sources.

Figure 6.17 shows the combined result. Splitting the channels out and working on them separately proved to be a pretty good idea. This photo combines easy stuff with "pert-near impossible" stuff. The writing in the sky and Grace's dress were really easy to fix. John's shirt and Olo's dress are much tougher problems.

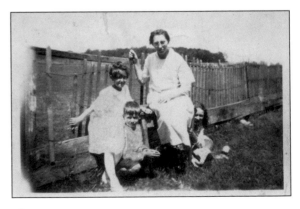

Figure 6.17
Good result, although a bit yellow.

In the end, I wasn't completely happy with John and Olo, so I created a layer over them set to Color Blend mode. Then I painted an off-white color over their clothes and turned the Saturation down on that layer by -20 (see Figure 6.18). This seemed to work better than anything else to get rid of most of the color from those areas of the photo and yet have them fit in.

Figure 6.18
An alternate solution.

Finishing the Photo Study

Figure 6.19 shows the final photo. I ended up working on this beyond removing the writing. After the adjustment in Figure 6.17, I enhanced contrast with Curves, sharpened with Unsharp Mask, smoothed with Edge Preserving Smooth, and then desaturated the photo a bit. I ended up leaving some yellow in the photo, in addition to a good number of blemishes, because I thought it added to the character.

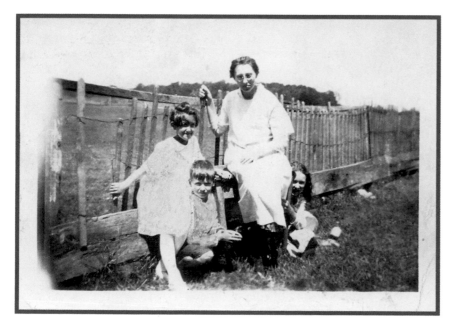

Figure 6.19
Attractively restored.

Photo Study 29: Taking Out Notations

FIGURE 6.20 IS ANOTHER example of someone writing on a photo to give us an idea of who is in it. This time, there are no names, but numbers are above and on everyone's head. There's also a pretty long tear in the photo, which runs from the right side clear past the center of the picture.

It amazes me how these photos tie together. I think you'll run into the same thing when you start restoring your own family photos. Take a closer look at the women numbered 3 and 4 in Figure 6.20.

We just saw them in Figure 6.19, only this is somewhere between 15 and 20 years later. Number 3 is Grace, the woman in Figure 6.19. Jo, the playful girl in Figure 6.19, is now a woman (number 4).

I am struck again by the feeling I'm looking back in time. The man and woman on the far right are John and Clara Wissler, my wife's great-grandparents on her father's side. John was born in 1860 and lived until 1946. Clara was born in 1869 and died in 1962. John's lineage can be traced with a pretty

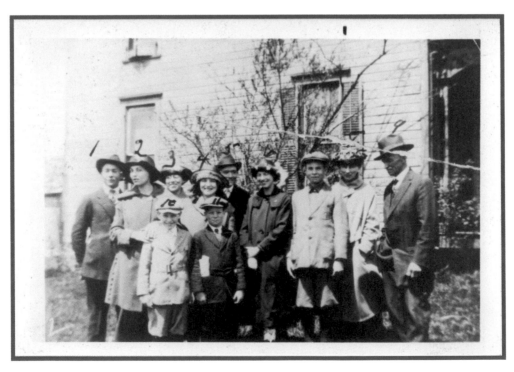

Figure 6.20
An impressive family photo, complete with notations.

good degree of certainty back to Heinrich Wissler, who was born in 1689 in Langnau, Canton Baselland, Swizerland, and was the original immigrant of the Wissler line to America. Clara was descended from the Rasors, who emigrated from Germany and can be traced back to the 1500s.

This type of genealogical information makes this photo especially significant. I am sure you will have the same opportunities, and it may even prompt you to begin researching your own (or your spouse's) family tree. If you are restoring photos professionally, you will probably not be dealing with your family, but keep in mind that these photos often have special emotional and historical significance to their owners. You can be a part of preserving their family treasures.

I'm going to treat this as a fairly straightforward cloning operation since there are so many marks. If I separated out the channels, it would take a long time to clone away so many marks and imperfections in triplicate. Besides, this photo makes a great cloning exercise. The markings cover a lot of different textures. There is marking on the siding of the house, on windows, shutters, hats, and branches.

Creating an Adjustment Layer

I want to work it with a twist, however. Since this is such a bright photo, I will create an Adjustment layer to darken the photo to see what's going on. I've called up a Levels Adjustment layer in Figure 6.21 and have tweaked the sliders to give the photo better definition. The point here is to bring out the problems, not to make the photo look good. I'll hide or delete this layer at the end of the restoration.

Figure 6.21
Creating a Levels Adjustment layer.

Cloning the Problems Away

Once again, I'm working in an environment where I have a background photo (as shown in Figure 6.22), a clone layer (for the advantages of protecting the original photo and giving us more blending options), and an Adjustment layer, which shows us things we can't see well in the original.

I'll begin with number 1. It's pretty straightforward. I will clone with the siding of the house, which is made more prominent because of the Adjustment layer.

Figure 6.22
Cloning along the siding.

The key, when you work with an Adjustment layer like this, is always to look at the Layers palette and know where you're drawing your source from and where you're cloning to (similar to Photo Study 4 in Chapter 2). If you get caught up in going too fast, you'll make mistakes. Select the photo layer and right-click the source into the brush, and then select the clone layer to apply the paint. For this technique to work, you must turn off the Clone Brush's "Use all layers" option on the Tool Options palette.

I'm cloning in the window above a woman's head in Figure 6.23. You can faintly tell where the window frame tone is different than the window. These are the things that will separate you from a beginner. Find those changes in tone as you clone and work *with* them, not against (or oblivious to) them.

Figure 6.23
Cloning with the window.

This one's pretty simple in the window. It gets much harder as I move down to the hat. I will zoom in and make the brush smaller, picking up material from below the bottom of the number 2.

I've moved on to Grace in Figure 6.24. Here, the challenge is to move with the grain of the siding and pick up branches from another part of the photo. If I just clone the whiteness of the siding here, it will look out of place.

Figure 6.24
Cloning siding with leaves.

Ah, now for a real tricky part. In Figure 6.25, I'm cloning a number out of a window shutter. This is harder because of the fine details, but not impossible. I will pick up details from above and to the side, while paying attention to where all the lines are (that's the tricky part). I'm pulling detail from the central vertical frame down, but it also has to match the horizontal shutter shadow. The outer frame is easier, but it also needs to match the siding on the house.

Figure 6.26
Follow the shadow lines.

Figure 6.25
Extra care is required for the shutters.

I've moved on to a young boy's hat in Figure 6.26. We're not completely sure who this is, but he's got a dapper hat on. His hat has a lot of subtle shading so I can't just plop material down. I've got to examine the hat closely and see where the best match is; then try it out and see if it works. I'm cloning in an arc here, from near the brim of the hat up and toward the center. That matches the shape and tone of the hat where you can see my source spot.

If you can't match the tone perfectly, return with the Soften Brush. That helps tremendously. I'm working with a pretty light touch (opacity of 50) in Figure 6.27. I've found that the Soften Brush (remember, this is on the clone layer, not the photo layer) can lighten cloned material, and if I work at it too much I can start to see the original photo through the clone layer. If that happens, undo and come back a little softer. If I need to, I'll clone a darker patch and then come back with the Soften Brush.

Figure 6.27
Softening the cloned area.

Finishing the Photo Study

This was a fun photo. It had a good deal of cloning, which is always very rewarding when you look at it afterward. When there's a lot of work to be done, tackle things in stages and break the stages down into steps. For example, I normally start with easy things and then move to harder tasks. I get on a roll accomplishing things, which boosts my enthusiasm and confidence. In this photo, that meant I started with a few easy numbers before switching to the background. I came back to the harder numbers a bit later and then worked the tear. I finished by scouring every inch of the photo at a high magnification, looking for any imperfections I could fix.

Afterward, I performed a merged copy and pasted that to a new layer from which to work on the brightness and contrast. I used the Smart Photo Fix, followed by an Unsharp Mask, to finish the restoration.

Just because I chose to remove the writing in this photo doesn't mean you have to remove everything you ever come across. You can restore a photo like this a few different ways and preserve the numbering as an alternate version. That's the convenience of having a digital file to worth with and the advantage of keeping track of what you're doing in the file by using layers and saving tool presets (like a Levels or Curves Adjustment).

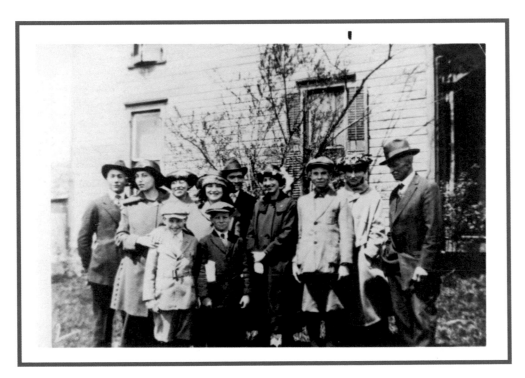

Figure 6.28
Completely restored family lineup.

Photo Study 30: Removing Marker

FIGURE 6.29 IS ANOTHER PHOTO of me from high school. I was a drum major of our marching band, which explains my white uniform when the others are in green. I am playing my alto saxophone on this song. One of the highlights of my marching band experience was participating in the 1982 Macy's Thanksgiving Day Parade in New York City.

Leadership

I thought being a marching band drum major was cool at the time, but I didn't realize that it was developing important leadership qualities in me. That helped me in the United States Air Force Academy, and later, as a commissioned officer in the Air Force (not to mention being a parent, which is the hardest job by far).

This photo was taken by one of the photographers of our local newspaper. Some years later I was able to scan it and have a digital copy—thankfully, because the original photo seems to have been lost.

I like the composition of this photo and the fact that the farther you look into the background, the more out of focus everything is. (That's called a shallow depth of field, which you can simulate in PaintShop Photo Pro if the photo doesn't have it.) The challenge with this photo is to remove the marker and what looks like smudged ink, without taking anything away from such a good photo.

Figure 6.29
Smudged marker has damaged this photo of me.

Splitting HSL Channels

For this photo study, I want to split the channels to HSL, just like Photo Study 28. If you look at the original photo in Figure 6.29, it is very bright. The H, S, and L channels give me a much better chance of seeing the imperfections I want to clone out, and give me a little more room for error when correcting the damage.

Remember, there are a few reasons you might want to do this. First, it may be easier to repair the damage to a photo using the H, S, and L channels as opposed to the normal photo. This was the case in the study above, which had writing on the photo. Secondly, splitting the channels is often the best way to see the damage in the first place (and may be the best way to repair it once you see it). That's the case here. You always have the option to experiment and discover which method works for you on a specific photo.

Channel Images

Don't forget that the H, S, and L channels I am editing are separate images, not layers within my working photo. When I switch channels, I am selecting a different image in the PaintShop Photo Pro workspace, not just clicking on another layer.

Figure 6.30 illustrates what I mean. I'm working on the Hue channel in a sea of gray that is the majority of the right side of my chest area. The little white spots are what I need to clone out. They stand out like sore thumbs!

Figure 6.30
Cloning away easy-to-spot imperfections in the Hue channel.

I am still in the Hue channel in Figure 6.31, but I've moved down to my hand. This is another area where there are heavy markings, but using the Hue channel makes it far, far easier to spot them and clone them out. This particular area is harder to fix than my chest, but it's still very practical.

Figure 6.31
The more difficult hand area is still easier using Channels.

Let's look at my chest area again (see Figure 6.32). Although this channel is very uniform, you can still tell there are differences in tone and texture. Above my Clone Brush, you can see an area I haven't fixed yet. You can see the shadows of my uniform, even in the Hue channel. It's almost imperceptible, so you have to pay really close attention. I mention this because I always try to stay within the same range of tones. I can see the difference in the shadow of my uniform, so when I clone, I'm going to go with that "grain." My source spot is within this region, and I am moving down and to the right, following the fold of the shirt.

Figure 6.33
Carefully working in small areas.

Figure 6.34 shows my right shoulder and arm in the Saturation channel. The marker is visible as dark lines. I am cloning it out carefully, following the folds of my garment where the shadow lies.

Figure 6.32
The texture is almost imperceptible.

Figure 6.33 shows the center of my uniform, still looking at the Hue channel. My neck strap travels from the bottom right to the top center. You can tell the difference in hue between my white uniform (the left center of this figure), the black markings on the uniform (the X), and the marker that I am cloning out, which stands out as a bright white.

Figure 6.34
Marker is easy to spot in the Saturation channel.

I've zoomed in closer and am working in a more deeply shadowed area in Figure 6.35. I am careful to match source and destination areas.

Figure 6.35
Working along shaded areas.

I return to my hand in Figure 6.36, this time in the Saturation channel. You can see more detail here than in the Hue channel, which complicates matters a bit, but because this is saturation (and not lightness detail) of a nominally black-and-white photo, I can get away with some duplication. In other words, if I wanted to "paint" this area one shade of gray, it would work just fine. The glove would be saturated equally, and in this case wouldn't look strange or out of place. The important thing is to get rid of the marker.

Some of the flexibility I had while working in the Saturation channel is unique to the area I am working on in this photo. It's black and white, essentially, and the glove is fairly uniformly saturated (or unsaturated). The damage stands out while the glove blends in and almost disappears in itself. I could have removed all saturation information from the photo, but I don't like throwing information away, even if it seems pointless to keep it. Remember, black-and-white photo prints may not be true grayscale, and they may contain very subtle tints and coloration that can add to the character of the photo.

Figure 6.36
Smaller brush for the hand.

Finally, I want to show you a Lightness channel example.

Splitting and Combining

You can split and combine channels as many times as you need. If you're working, and all of a sudden you remember that you have to go run an errand, combine the channels and copy (you don't even have to select all, just press Ctrl+C without an active selection) and paste the combined image as a new layer in your working .pspimage file. When you come back, split that new layer and continue working.

Figure 6.37, the Lightness channel image, looks essentially like the unsplit photo. I will clone in this channel as I would normally do. I'll have to remember where I've cloned away the markings in the other channels and check those spots here to see if I need to work them in this channel.

Figure 6.37
The Lightness channel completes the trifecta.

Finishing the Photo Study

Figure 6.38 shows the final result, which included noise reduction and contrast adjustments in addition to cloning away the marker.

Figure 6.38
The spots are gone.

Professional Printing

Had I not been an independent contractor for a marketing and design company, I might never have realized how easy it is to send work out to be professionally printed.

Even if you've got a fantastic setup at home, I doubt you'll be able to match the equipment a professional print company has. I think the professional printing avenue is the solution that will achieve the highest quality printouts, given the quality of your originals and the DPI you've been working in.

Yes, it costs money, but even if the per-page printing costs are more than what you would pay at your local supermart, it's more than offset by two factors. You're going to have a reasonably low volume, which means you should be able to afford to pay more per copy. Secondly, the quality and features a print and copy business have are astounding. This is what they do, full-time.

Here are a few of the products and services available from the print and copy company I use:

- Booklets
- Brochures
- Calendars
- Catalogs
- Digital Copies
- Note Pads
- Binding
- Cutting
- Folding
- Lamination
- Offset Printing
- Pickup and Delivery
- Shrink wrapping

Call a marketing or design agency (whoever you think needs a good printer) in town and see where they get their printing done. Ask around. Talk to people.

Visit them on the Web first and then call them. Tell them what you're doing and what sort of production you'll need (numbers, sizes, format). Ask them for a price list or quote. Before you send anything in, make sure you've asked what format they require and be clear on what sort of output you want (mainly size, but also paper, cutting or folding, and finish).

I hope you can develop a good relationship with someone. These people know a lot about printing. They may even have some suggestions that you can use to prepare your work to be printed.

Send them a file and try them out. Evaluate the product and your experience, and then go from there.

Photo Study 31: Hiding Tape

MOST PHOTOS IN THIS BOOK have reasonably interesting stories behind them, but this one (see Figure 6.39) is an exception.

The one somewhat interesting factoid I have to share is that the flowers next to the house are orange "Ditch Lilies" (aka Tiger or Orange Lilies). There you have it.

This photo has been torn in half and taped back together. I propose to fix that, without taking the halves apart prior to scanning (which could damage the photo further). I'll scan it in "as is" and repair it digitally.

Prepping the Patient

Before I move on to fixing the tape, contrast, sharpness, color, and other problems, I will stitch the photo back together.

To make repairs such as this, follow these steps:

1. Choose the Freehand Selection tool from the Tools toolbar and change the type to "Point to point" in the Tool Options palette. I'll use the selection tool to select the top and bottom of the photo separately.

2. Select the top or the bottom of the photo. I'm starting with the bottom in Figure 6.40. Make sure to select an area well on the other side of the taped border. You'll erase this extra area later.

3. Copy this selection.

Figure 6.39
Old, yellowed, torn, taped, and wonderful.

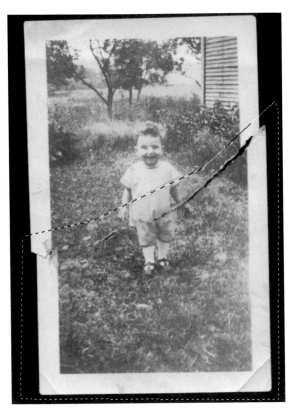

Figure 6.40
Select the bottom.

Figure 6.41
Paste as new image.

4. Paste the selection into a *new image* using Ctrl+Shift+V, as shown in Figure 6.41.

5. Enlarge the canvas since this new image contains roughly half of the overall photo. Go to the Image ❯ Canvas Size menu and double the vertical size of this file to make room for the other half of the photo. Make sure the "Lock aspect ratio" setting in the Canvas Size dialog box is off so you'll be able to enlarge the canvas significantly more in one dimension than another. Don't worry if the canvas ends up being too large (which is better than too small). You'll crop out the unneeded space later.

6. Go back to your original file and select the top half (or the opposite of what you just did) of the photo this time, as shown in Figure 6.42.

7. Copy the selection.

8. Switch to your new image and paste this as a new layer, as shown in Figure 6.43. I've pasted this as the top layer and moved the two layers in a rough approximation of where they will end up.

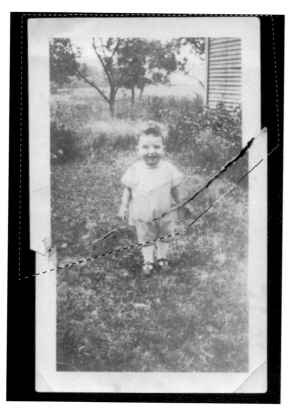

Figure 6.42
Select and copy the top.

Figure 6.43
Paste as New Layer in New Image.

9. Now I need to straighten my two layers. I'm going to use the long vertical side to straighten the bottom of the photo, as seen in Figure 6.44. Select the Straighten tool from the Tools toolbar and line the two end points up. Make sure "Rotate all layers" and "Crop image" are off. I've hidden the top layer to make it easier to see what I'm doing. Make sure that you've got the right layer selected when you apply the Straighten tool.

Figure 6.44
Straighten the bottom.

10. Now for the top. If you hid the top, unhide it now and hide the lower layer; then select the Straighten tool, as shown in Figure 6.45. I'm using the opposite side as a reference this time, but it's still a long side. You'll get better results if you can choose the longest edge you have. Make sure that your Straighten tool options stayed the same; then apply.

11. Save your work in the appropriate location on your hard drive with a proper name. Make sure that you save it as a .pspimage so the layers are preserved.

Figure 6.45
Straighten the top.

That's it, doctor. The patient is prepped for restoration!

Joining the Pieces

Let's set the stage. A torn photo has been taped back together, and you're going to restore it. You've scanned it in and then digitally separated the two torn pieces with the power and majesty of PaintShop Photo Pro. They've been straightened, and now you're ready to begin joining the pieces, which is the second phase of this three-phase operation.

1. Hide one of the layers; then select the other layer to work on. Doesn't matter which one.

2. Select the Eraser and choose a size and hardness appropriate to the area you want to erase (which, in this case, is on the opposite side of the tear). When I'm erasing a lot of material, I start out with a large eraser that's 100% hard and then move smaller and softer the closer I get to the edge. I may take two or three passes to get close to the edge. In this case, I can go right to a smaller, softer brush.

3. Begin erasing material from the opposite side of the tape, as shown in Figure 6.46. Work your way carefully across, trying not to erase anything from the "keeper" side. Don't worry about the rough edge of the torn paper border. You'll clone this out eventually.

4. When you're done with this layer, hide it, show the other, and repeat the process, as shown in Figure 6.47. I'm working on the top of the photo by erasing everything from below the tape and tear line. This is cool stuff!

Occasionally, show the other layer (in step 3 as well as 4) to make sure that you're not overerasing.

Figure 6.46
Erase extra bottom area.

Figure 6.47
Erase extra top area.

5. Now for some magic. Show both layers and then select the content of the top layer with the Pick tool and move it into position, matching the edge of the bottom layer, as seen in Figure 6.48. If you get it close and want to verify its position, zoom in. You can also use your arrow keys to nudge the selection in any direction you choose. In particular, look to match the subject of the photo first; then check out the border. Never choose a straight border over your subject.

There are many ways to fix borders that don't match perfectly after the fact. For example, you could clone new material, create a rectangular selection and lighten the outside to form a new border, or crop the photo. If your subject doesn't line up, then you're toast. You'll do more damage trying to fix that (self-created) problem than you would ever do fixing a border.

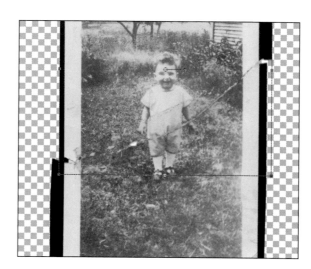

Figure 6.48
Align the two layers.

6. Now it's time to stitch them together. Create a layer to clone with on top of the two content layers.

7. Make this clone layer active; then select the Clone Brush and clone the edges of the photo together along one side of the photo, as seen in Figure 6.49.

Figure 6.50
Getting the other side.

Figure 6.49
Clone them together.

8. Repeat on the other side, as seen in Figure 6.50.

With the pieces fit together, the subject successfully lined up, and the photo border fixed with the Clone Brush, I'm ready to move to the center of the photo.

Continuing to Clone

This is the third phase of restoring this photo and hiding the tape. I will hide the tape with the judicious use of the Clone Brush. I am cloning grass over the taped area to the left of the young boy in Figure 6.51.

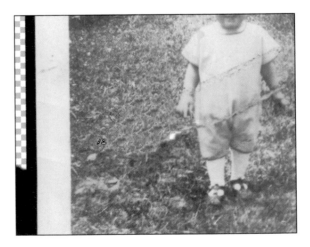

Figure 6.51
Working the middle.

I am continuing to clone, and have moved on to his wrist in Figure 6.52. I need to be very careful here because there is little room to work, and the gradient of his wrist needs to match perfectly.

Figure 6.52
Careful along the arm.

If cloning tape away is problematic in a portion of the photo, desaturate the area with the Saturation Up/Down Brush. This takes the color out of the tape and leaves the detail of the clothes behind, as seen in Figure 6.53.

Figure 6.53
You can also desaturate.

Finishing the Photo Study

This was another very rewarding photo to restore. The difference between the before and after (see Figure 6.54) shots is amazing. When you can put together a photo that has been torn in half and then taped back together, you start to see the world of possibilities that are open to you.

After I got the photo together and cloned much of the tape and other problems away, I worked on the brightness, contrast, and color with histogram adjustments, fade corrections, and some desaturation.

Figure 6.54
Smiling child recovered.

Photo Study 32: Hiding Discolored Spots

FIGURE 6.55 IS A PHOTO of my wife's grandfather taken in 1944, when Bud was 19-years-old. He'd already seen a lot of combat in Africa, Italy, and France. Bud was in France at the time and was able to sit for a photographic portrait to send home to his family. He was engaged at the time, and I am sure Louise loved getting photos and letters from him.

There are several spots on his sweater, shirt, and background. The photo has been bent or creased in a few spots. I will use the HSL technique again to split the image and do some of the repair work (the spots on his sweater) in the separate channels. The reason that makes sense with this photo is the texture of Bud's sweater and the folds of his shirt. It's incredibly hard to clone these areas without making it obvious. Cloning on the Hue channel is much easier.

Initial Fix-Ups

Rather than immediately breaking the photo into channels, it is better to fix what I can first, then split, clone, and rejoin toward the end. I am going to rapidly move through these steps with little explanation to get to the more unique restoration work at the end of the study.

Figure 6.55
Marvelous photo lessened by discoloration.

First, I corrected brightness and contrast with a Histogram Adjustment, as shown in Figure 6.56. This, along with removing the yellow color, contributes most noticeably to the end result.

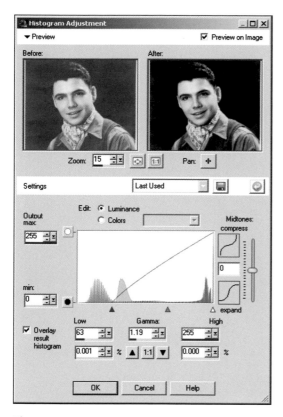

Figure 6.56
Correcting brightness and contrast first.

Figure 6.57
Desaturating to correct the color problem.

Next, I used the Hue/Lightness/Saturation routine (see Figure 6.57) to desaturate the photo in order to reduce the yellow tint. I tried Fade Reduction, but this increased the contrast when I didn't want it to. Notice that I haven't completely desaturated the photo. I left some age in because I really like the look of subtly tinted black-and-white photos.

After this, I sharpened the photo with High Pass Sharpen, as shown in Figure 6.58. I compared this to Unsharp Mask and felt High Pass Sharpen (lightly applied in Overlay mode) created fewer sharpening artifacts. I wasn't going for super-sharp here. I wanted to crisp up the photo.

Figure 6.58
Subtle sharpening.

Figure 6.59
Smoothing.

Following sharpening, I smoothed the photo just a little with Edge Preserving Smooth, as shown in Figure 6.59. I wanted to preserve the edges I just sharpened, so didn't apply this strongly. Compared to One Step Noise Reduction, this left the most detail.

Finally, I corrected the final contrast and lightness issues with Curves, as shown in Figure 6.60. Again, there are times when I make more than one adjustment that corrects the same thing. That may seem odd, but I find that I have better success tackling some problems incrementally. In other words, I don't try to push it all the way sometimes.

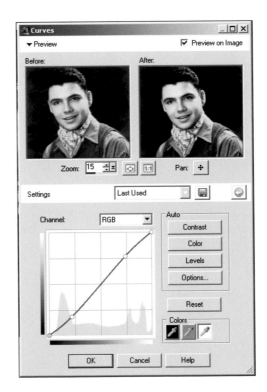

Figure 6.60
Touching up brightness and contrast.

Creating a Mask and New Background

With the photo looking pretty good, I was ready to tackle the background. Rather than cloning over the creases in the photo (look at the bottom left), I decided to mask out the original background and replace that with a solid color.

First, I duplicated my Curves working layer, renamed it, and created the mask. I am "painting" the mask over the background in Figure 6.61.

Figure 6.62
Masking out the frame.

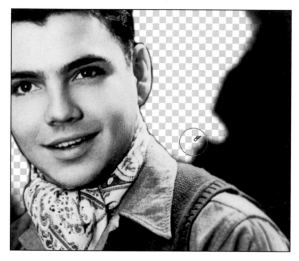

Figure 6.61
Masking out Bud.

I also needed to mask out the photo frame, as shown in Figure 6.62. If you want to crop the frame out, you can ignore this part. I used the Freehand Selection tool in Point-to-point mode to select the inner frame border and then used the Selections ❯ Invert menu to select outside this area, which I "deleted" with white. After deleting this material from the mask, I softened the interior corners a bit with a soft eraser.

Next, I created a new Raster layer and positioned it below the Mask group and filled it with a color that I sampled from the actual background (see Figure 6.63). It's a nice, dark color. To preserve some realism, I chose to lower its opacity so the background of the Curves layer would peek through and keep it from looking computer-generated. When you get to the end of the study and can still see some creasing in the left side of the photo, that's why. It preserves the illusion that no one worked on this photo, which is how I like it.

Finally, I copy-merged (Ctrl+Shift+C) and pasted that as a new layer to lock all these changes in.

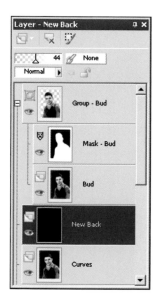

Figure 6.63
Blending the new solid background.

Splitting Channels

Time to split the channels. I have to say, this is optional and not always necessary. It's a technique to use when you can't see the problems in a photo very well or when you are having trouble repairing them (mostly clone work) normally.

In this case, I tried to clone over the spots on Bud's uniform but had trouble getting the tone and texture to match as well as I wanted for the larger spot on his right arm. I decided to split the channels and see if it would be easier to edit them directly, and the answer for me was yes.

Split a photo into separate channels from the Image > Split Channel menu. Since I split into HSL channels, I used Image > Split Channel > Split to HSL. Figure 6.64 shows the area at the bottom of the photo where there are several spots in each of the channels and the composite. The three large spots stand out very well in the Saturation channel but are less visible (to one degree or another) in the other channels. You can see them in the normal photo and the Hue channel, but not quite as well.

If all you need to do is to split the channels to spot the problems, you can close them without saving at some point and without working on them. If you want to edit on those channel images, select the Clone Brush and have at it, as shown in Figure 6.65.

I kept working on each of the three channels, cloning out the major problems that had to do with discoloration, knowing I would have a chance to further correct problems after I joined the channels back together. I didn't waste my time cloning out every speck on these three channels. That I saved for when they were combined and back in my working file.

Figure 6.64
Comparing the channels versus the photo.

Figure 6.65
Spot removal in the Saturation channel.

When I was done editing the separate channels, I selected the Image ❯ Combine Channels ❯ Combine from HSL menu. Figure 6.66 shows the dialog box. With the image combined, I selected all, copied, and pasted that as a new layer in my working .pspimage file. I then went back to the Clone Brush and cleaned the rest of the photo up.

Figure 6.66
Combining the channels.

Finishing the Photo Study

The final photo is shown in Figure 6.67. The problems weren't huge, but they definitely had a negative impact on how the photo looked. The solution was to use several techniques to spruce up the photo and then work on the spots separately. Splitting the channels enabled me to find the discolorations and clone them out effectively. All in all a very satisfying photo study!

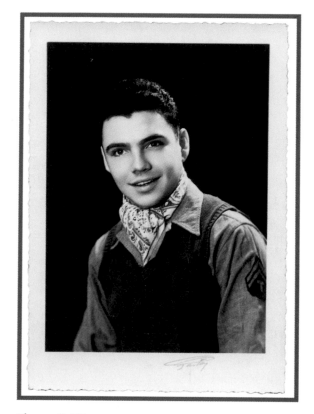

Figure 6.67
Young, vibrant, and spot-free.

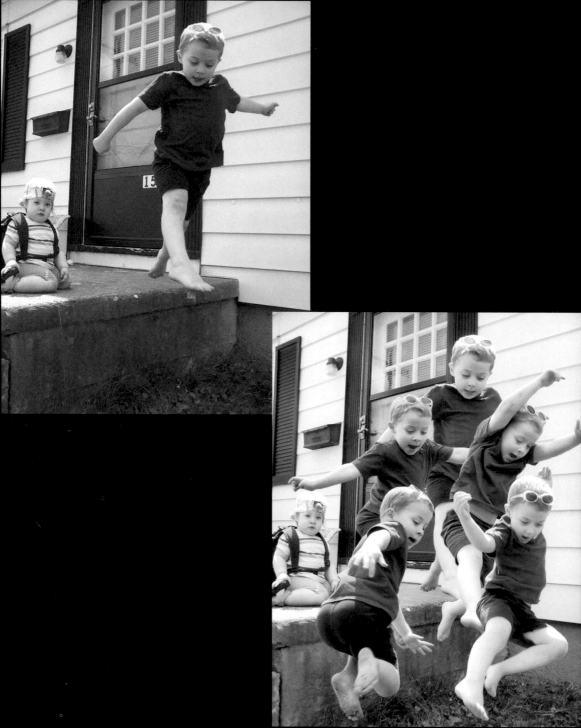

Moving, Adding, or Removing Objects

<div style="float:right">**7**</div>

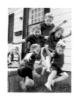

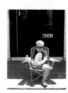

REMOVING OBJECTS IS VERY MUCH like fixing damaged photos, but instead of covering up a scratch, you're covering up your thumb, camera strap, or a reflection. Therefore, you'll use many of the same skills in this chapter that you've honed thus far. Namely, most studies in this chapter showcase copying, pasting, and erasing in some way. If you master these skills, which are important if you want to move things around or add them to other pictures, you'll do well.

▶ **Photo Study 33: Moving a Teddy Bear**—This is an older photo of my son sleeping on the couch with one of his teddy bears. She's tucked up under his pillow and looks a little out of place. I'm going to move the bear so it looks more natural and cover up the original.

▶ **Photo Study 34: Removing Odds and Ends**—This photo of my family (taken in 2009) has some toys strewn around the floor. I'll remove them from the picture with a few different techniques as I retouch and recompose the picture to make it better.

▶ **Photo Study 35: Adding a Person to a Photo**—Do you want or need to add someone to a photo? I'll show you how to take content from more than one picture and composite it together. The process is very similar to moving an object because you're moving someone or something from one photo to another.

▶ **Photo Study 36: Cleaning Up a Photo**—This photo of a laughing hyena needs to be cleaned up. I'll remove spots and smudges from the glass and someone's arm from the corner of the photo, and then take the glare out of the grass and sky.

▶ **Photo Study 37: Reflections and House Numbers**—I'll use a combination of techniques in this study to remove my wife's reflection from the front storm door and change the house numbers around.

▶ **Photo Study 38: Improving Photo Composition**—You can improve a photo's composition by removing distracting objects. I will use the Clone Brush and the Object Remover in this photo and then follow the Rule of Thirds as I reposition the scene and crop it.

▶ **Photo Study 39: Creating Montages**—I love making montages, and could easily fill a good-size chapter with montages I've made over the years of our family's faces, of us sticking our tongues out, of our kids, and of our pets. If you can copy, paste, and erase, you can montage.

Photo Study 33: Moving a Teddy Bear

OUR KIDS LOVE THEIR teddy bears and pillows. In this photo from 2006 (see Figure 7.1), my oldest son, Benjamin, is napping on the couch with his pillow and one of his smaller bears, Baby Grace.

Baby Grace is fine where she is, but would look cuter if she were under the blanket with Ben. With that in mind, I'll show you how to move something around in a photo.

Getting Started

First, I duplicated the Background layer so I wouldn't accidentally clone on it or otherwise change it. I used that working layer as my new background. Next, I had to copy the bear. I use the Freehand Selection tool in "Point to point" mode for selection operations like this. (Modes are accessible in the Tool Options palette at the top of the screen.) The Freehand Selection tool in "Freehand" mode takes more effort to use quickly, and the extra around the edges will be erased anyway. There is no need to be fancy with selections like this as long as you get the entire subject. I've made my selection of the bear in Figure 7.2 with the Freehand Selection tool in "Point to point" mode. This mode lets me click at each point of the selection polygon so I can go rapido. Comprende?

I copied the bear using the standard keyboard shortcut (I'm a sucker for Ctrl+C) and then pasted it as a new layer (Ctrl+V). This is the working layer for the bear. Next, I had to erase around it.

Figure 7.1
Cute, but could be composed better.

Figure 7.2
Lasso that bear.

Freehand Conventions

From this point forward, I will write "Freehand Selection tool in 'Freehand' mode" as *Freehand Selection tool (Freehand mode)*. I will shorten "Freehand Selection tool in 'Point to point' mode" to *Freehand Selection tool (Point mode)*.

Ctrl+V and Paste

Some older versions of Paint Shop Pro had Ctrl+V as a shortcut for Paste as New Image. This always tripped me up because in most other programs Ctrl+V pastes what you've copied into the same document.

That behavior has been changed in X3. Use Ctrl+V to paste what you've copied into a new layer.

I've hidden the Background layer in Figure 7.3 so I can see the bear and where I was erasing. I centered the bear in the image so I could zoom in and see all the edges. If I need to erase a lot, I'll start with a large eraser and set the hardness to 100%, and then work my way down to a small brush at 0% hardness for the final pass. There wasn't much to erase here, so I used a soft eraser from the outset.

Erasing is one of the most important aspects of this exercise. If you don't get a good clean border (not sharp—sharp will stick out like a sore thumb) around your subject, it will be obvious when you position it. Use short strokes as you erase so you don't lose a lot of work if you have to undo. Notice that I haven't rotated the bear or positioned it yet. I'm concentrating on erasing the border. That's it.

Covering Up

With the subject prepped and ready to position (remember, it's been copied and pasted to a new layer), I put it aside and started covering the original. For this photo, that involved extending the couch material to cover the original bear. I could have used the Clone Brush, but I decided to copy and paste a section of the couch instead. The texture of the couch made it hard to clone without being obviously repetitive. First, I hid the new bear layer and showed the working layer.

Figure 7.3
Don't wake her while you erase.

Having done that, I selected the trusty Freehand Selection tool (Point mode) in Figure 7.4 and completed a selection of the couch to copy. Thankfully, there was a patch of couch that was a good match to repeatedly paste and blend. There are some shadow problems, but I planned to minimize that later by applying an overall shadow to the area. I went for "ballpark" tone but a more precise texture and pattern alignment. Had I not been able to grab this area, I would have looked for another photo that had the couch in it, or walked out of the computer room and into the living room and taken another photo for that express purpose. You can do that too!

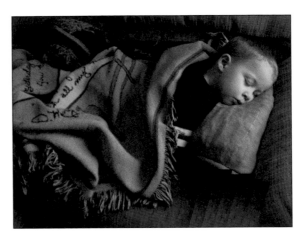

Figure 7.5
Transplanting couch texture.

Figure 7.4
Carefully selecting along the lines.

After making the selection, I copied and pasted it as a new layer. You can paste it several times or just paste it once and then duplicate that layer several times. It's your call. I pasted the couch material about eight times, and I arranged the pieces to fit the area in Figure 7.5. I wasn't worried about the border yet. This was just to align and get the pattern set.

After I aligned the multiple pasted strips, I selected the top one from the Layers palette and chose Merge Down (right-click over the layer in the palette, choose Merge, and then Merge Down). I kept doing this until all the couch strips were merged. When you are merging layers, take special care. It is very important not to merge this layer with the Background layer.

The reason I merged these couch texture layers together was to be able to manipulate the extra couch layer separately from the main photo layer. For starters, I needed to erase all the ragged edges (see Figure 7.6). First, I moved along the arm of the couch and then next to the pillow. It's important to remember that this "patch" is on a separate layer above the couch. As I erased the border of the patch, it "sunk" in and blended with the couch.

Figure 7.6
Erase to fit.

Next, I got rid of the straight edges that formed the border between the pasted patches. This was easily done with the Clone Brush (see Figure 7.7). I was careful to match tones (colors, shadows, and lightness) and patterns.

Figure 7.7
Couches sans borders.

With the cloning done and the original bear covered, it was time to put the copy of Baby Grace into position.

Fitting In

I kept the new Baby Grace layer hidden while I was covering up the original area. This kept things visually simple. With that completed, I was ready to make Baby Grace look like she was tucked under the blanket as opposed to the pillow.

It was a simple matter to grab the Pick tool and drag Baby Grace over to the blanket and rotate her to match the orientation of the new scene I wanted her in (see Figure 7.8). After positioning her, I blended her in with the Eraser. While it looks like I'm erasing the blanket in the figure, I was actually erasing around the bear on a layer above the blanket's fringe. It's funny how perception works sometimes.

During the blending stage, I was careful to observe how she blended in. I zoomed in and out to get a fresh perspective.

Almost done.

Figure 7.8
Erase border of Baby Grace to create the illusion.

Shadows are an important aspect of getting things to blend and match. They can also cover up things that you can't get to look right. For this photo, I darkened a few areas to help cement the illusion. First, I used the Burn Brush (at a pretty light setting: opacity 10) and stroked around Baby Grace (see Figure 7.9). This gave her a sense of belonging in her new position. I also darkened the couch below her to make it look as if she were casting a shadow. I also darkened the area of the couch she came from to hide some texture and tone mismatches.

Figure 7.9
Burn shadow on the couch.

That completed the reposition. I selected everything, performed a merged copy, and pasted that to a new layer on top of everything else to be able to make global adjustments to a single layer.

Final Adjustments

Always remember to tweak things. Although the main point of this restoration was moving the bear, that's only one part of the overall retouching job. In this case, I consulted Smart Photo Fix. With minor alterations (see Figure 7.10), the result was a bit livelier than the original.

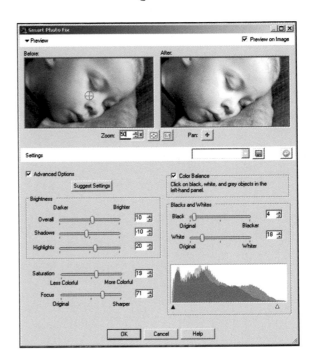

Figure 7.10
Tweaking merged layer.

After this, I smoothed things out a touch using Adjust ❯ Add/Remove Noise ❯ Texture Preserving Smooth. Dark or poorly lit digital photos often have more noise than well-lit photos, especially if the ISO is raised to brighten the exposure. This photo has an ISO of 50, so that wasn't causing the noise. More than likely, it was the camera's noisy sensor, whose internal noise characteristics were more evident when it captured dark regions.

Finishing the Photo Study

Figure 7.11 shows the final result. Baby Grace looks better under the blanket than where she was originally. Before I moved her, she was aligned vertically and was at odds with everything else in the photo.

Restoration and Retouching Ethics

Danger! You could write a lot of damaging things with this word processing program! Use this program wisely!

That's silly, of course, and you wouldn't see a note like this in a word processing book. Pictures are powerful things, however, and PaintShop Photo Pro gives you the ability to alter them quite a bit.

I trust you to know where the ethical lines of photo retouching are and not to cross them. Something to think about.

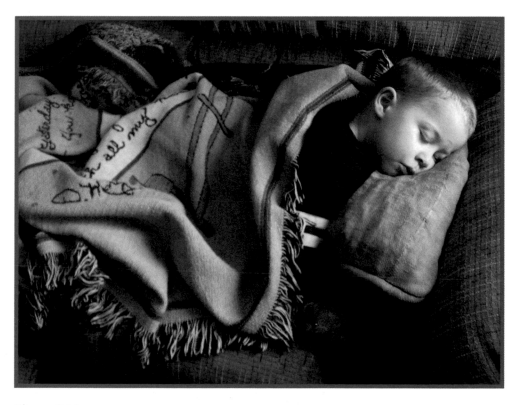

Figure 7.11
Ben and Baby Grace hibernating one afternoon.

Photo Study 34: Removing Odds and Ends

FIGURE 7.12 SHOWS A LIGHTHEARTED family portrait (sans the photographer, me) taken in 2009. Anne and the kids were playing, and everyone fell down on the floor. I had my camera at the ready because I was experimenting with white balance bracketing down in the (very yellowish) basement, taking pictures under the fluorescent lights.

It's got some odds and ends I can use to show you how to remove odds and ends. There's a green square stacking toy by Ben's head, a Hot Wheels toy (where you rev up motorcycles and let them fly) next to Sam, and some stuff on the couch to the top left. There are also spots on the rug I can remove.

Sounds like a perfect fit for this chapter.

Stay Flexible

In the process of experimenting with the photo's framing, I realized I could crop out a lot of the distractions and focus more tightly on everyone's faces. Figure 7.13 shows where I planned to crop the photo.

That meant my initial plans had to change. I went back and carefully reviewed the things I was going to work on. The Hot Wheels toy was outside the crop so I could ignore it. The green cube was still in the shot, as were the couch and the spots on the rug. No changes there. I realized, though, that the crop would make everyone more prominent in the photo. In other words, cropping out their legs and floor meant faces and upper bodies were visually more dominant and important to the photo.

Figure 7.12
Lots of extras to remove from this photo.

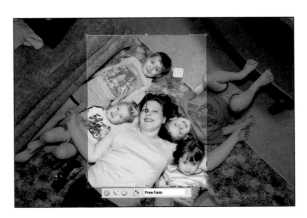

Figure 7.13
The planned crop.

Therefore, I decided to remove the cuts and scrapes on everyone, remove Jake's knee by replacing his arm, completely exchange Grace, and take the couch out.

If you rotate and enlarge the photo layer with the Pick tool instead of rotating and cropping the entire image, take note of the Scale percentage if you think you might copy and paste material in from another photo (this was 174.54). Having that number makes scaling new material easier because you can enter it in the Pick Tool Options toolbar. You still might have to tweak things to match scales from different photos (like I did here), but you'll be in the ballpark to start with.

Standard Cloning

For this photo, I cloned out the green cube and the couch. Both had a few tricky spots worth mentioning. The green cube overlays the edge of a rug, which is angled. Cloning along this angle resulted in a mismatch between the sides, as shown in Figure 7.14.

Figure 7.15
Matching the angle carefully.

The couch posed a different problem. Namely, my first attempt to clone it out was too obvious (see Figure 7.16). I made the mistake of not cloning any of the lighter spots on the carpet.

Figure 7.14
Cloning mismatch on an angle.

Figure 7.16
Pay attention to textures and patterns.

In cases like this, don't worry about cloning from either side and meeting in the middle. Clone from one side all the way over. I cloned a new border from the cube all the way to Ben, as shown in Figure 7.15.

I started over and took special care to randomize my source selections, making sure to pick up light and dark areas. Likewise, don't neglect things like shadows. The couch cast a darker shadow on the carpet close to Ben's arm. I was careful to clone over this with lighter material so it didn't look like a shadow was being cast from nothing. Figure 7.17 shows the result.

Figure 7.17
Much better match the second time around.

Removing Blemishes

I often use the Blemish Remover to take out spots, scrapes, and cuts on people. Pay attention to how the tool blends. Figure 7.18 shows a blend problem, probably caused by the image scale. (I scaled instead of cropped.) In this case, I would undo and go for the Clone Brush.

Figure 7.18
Watch carefully how the Blemish Remover blends.

Replacement Material

Jacob's arm and knee bothered me, so I decided to make it look like his left arm went straight and to remove the knee. I tried cloning his arm to extend it, but it never looked right. I realized I had a few other photos I took at the same time to choose from, so I looked them over to see if I could copy his arm from a different photo and transplant it here.

I did, and it worked. I drew a rough, freehand selection around his left arm in another photo and copied and pasted it into my working file. After rotating and scaling the new arm, I still had to resize it slightly to match the scale of this photo. Next, I erased what I didn't need and blended it in. In the end, it worked perfectly.

In Figure 7.19, I have placed the rotated and scaled new arm next to the original so you can clearly see they aren't the same.

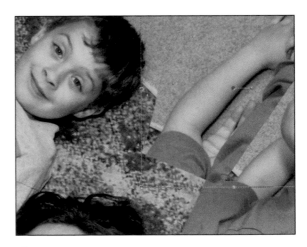

Figure 7.19
Matching Jake's new arm.

The other transplant involved Grace. She has an odd expression in the original photo. Having looked at the photo that I copied Jake's arm out of, I realized I preferred her expression in that one, as opposed to the original. I applied the same technique to selecting and transplanting her as I did to Jake, although hers was a bit more complicated.

For starters, I could have tried to copy and paste her face or her head and replace her expression. Well, I did try, and it never looked right. Faces are connected to heads, and heads are connected to bodies. Mixing and matching faces or heads is pretty hard. It's far easier to replace an entire body.

Therefore, I made sure to get Anne's green shirt in the selection (knowing I would need that to blend) and all of Grace. After copying and pasting it into the working file, I used the Pick tool to scale her upward (make the layer you're enlarging semitransparent so you can see what you're doing), and then I positioned her in the right spot.

I erased around her (see Figure 7.20) to blend her in, which is to say that I was mostly erasing Jake and Anne's shirt. It's not perfect (you can tell when you toggle the new layer on and off), but you really can't tell from looking at the new material that anything is wrong.

Finishing the Photo Study

I finished the photo study by running the photo through Levels to brighten it and improve contrast, and then I whitened everyone's teeth and performed One Step Noise Reduction. I save these adjustments for last when working with photos like this. Otherwise, it's too hard to match new material to the original. Figure 7.21 shows the final result. This photo went from a slightly cluttered family shot into a tightly focused and yet fun family portrait.

Figure 7.20
Erasing to blend Grace in.

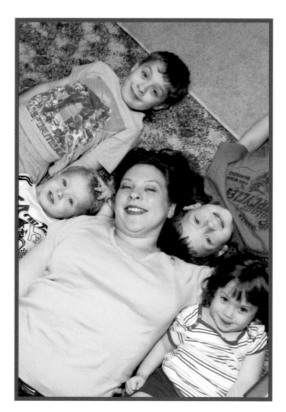

Figure 7.21
The slightly altered family portrait.

Photo Study 35: Adding a Person to a Photo

FIGURE 7.22 IS A PHOTO from 2002 of my son Benjamin sitting in his car seat on the kitchen table. I'm the proud papa beside him. Where's Mommy? She's taking the picture. This happens to us all the time. She's not in the pictures she takes. I'm not in the pictures I take. These photos stood out from the very beginning as good candidates for moving one of us to the other photo. They were taken at the same time, with the same lighting, and from basically the same vantage point.

I used one of the photos as a "base" layer and copied the other person in to blend them together.

Adding Anne

First, I took Anne from her photo (see Figure 7.23) and added her to my "base" photo. I used the Freehand Selection tool (Point mode) to select her. I decided to move her (rather than move me into her photo) because she was sitting off to the side, and there was less of her covered up by the car sear. That meant it would take less effort to put her in a new photo. If you look at my chest (see Figure 7.22), much of it is covered by the car seat. If I were to move myself, I would have to create a large area from out of thin air or try to put myself behind something to cover that missing area up. Those are tricky operations.

I was fairly liberal with the amount of wall and pantry door I included with Anne in the selection. This is about moving her over, not making a perfect selection on the front end. Don't waste your time with that. I also saw that I could use the extra space. First, when I started erasing around her, the extra border width (in general, not the wall just yet)

Figure 7.22
We needed someone to take our photo together.

gave me a chance to get the right eraser size and hardness, which helped when I blended her in. Second, I used some of the extra material to match her size and perspective to mine, because the photos were not taken from exactly the same vantage point. (That means we weren't scaled exactly the same.) They were close, which makes this possible, but not exact.

Figure 7.23
Select and copy the subject from the other photo.

I copied her and pasted that image into a new layer in my photo, as shown in Figure 7.24. You see the extra wall and door space that I have included with her in this figure. Those linear features are perfect for aligning and scaling the two parts of the photos.

Next, I lowered the opacity of Anne's layer to about 80% and used the Pick tool to align (move), size (using the outer handles), and rotate (matching the tile on the wall) Anne's layer to match mine.

Figure 7.24
Paste her in the "keeper" photo.

I'm rotating and scaling her layer to match mine in Figure 7.25. Can you see the door hinges? I've got hers to the left of mine. Although her layer is less opaque, it looks stronger than mine because she is on the top layer. I used the hinge and the doorjamb to get the vertical alignment, and the tile lines and size to get the rotation and scale. The tile sizes matched near the top, but they didn't line up as well near the bottom. That's proof that the scales of her photo and mine are a slight mismatch.

Figure 7.25
Adjust using reference points for scale and perspective.

The reason I went to this extreme to figure out our scale is to make sure we looked good together. It would look weird for her head to be out of proportion with mine. They don't need to match perfectly, but I wanted them to be close.

Erasing and Positioning

Next, I erased around and positioned Anne in the context of the photo. I started erasing the border around her in Figure 7.26 with the Eraser. I'll make a few passes with the Eraser, and on each pass I'll zoom in closer to catch more details.

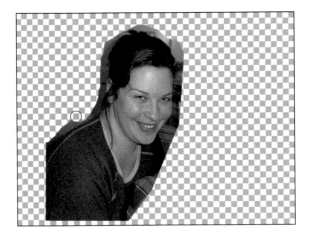

Figure 7.26
Erasing is critical.

Hair is hard to erase well, so I will share a little trick I use in these situations. First, don't worry about erasing a few straggling hairs. Just erase them. They aren't worth the trouble of trying to save. Second, you want to have a fuzzy border around the hair. That's what natural hair looks like anyway. The trick is to take a large Eraser that is 100% soft and lightly touch it outside of the area you are erasing to gently eat away at some of the opacity of the pixels that border the hair.

I moved Anne into position in Figure 7.27 with the Move tool. Remember, you should finish any changes to perspective and scale before you position.

Figure 7.27
Position before making final adjustments.

The big stuff is done, but there are still some important things to fix. Anne's shirt is missing material that makes it obvious she doesn't belong in this photo. I need to add it to finish her.

Adding New Material

I've got another photo taken at the same time with Anne sitting at a slightly different angle to the camera which picks up the front of her shirt better. This creates valuable source material for me to copy and paste. I selected an appropriate section of the shirt to copy and paste as a new layer in the base photo in Figure 7.28.

I'm aligning the new layer in Figure 7.29 by making it semi-transparent and moving it around with the Pick tool.

Figure 7.28
Copying extra material from another photo.

Figure 7.29
Go semi-transparent when positioning.

The orientation of the new material was different
enough from where I wanted to place it that I had
to choose what to align. In this case, the neckline
and the seam on her left shoulder were the best
choices. They formed the border of what I wanted
to replace. I aligned the new shirt material and am
erasing what I don't need in Figure 7.30.

Figure 7.30
Erase unneeded material.

Next, I had to do some retouching to make the
new layer match her neckline. I am just starting to
use the Clone Brush in Figure 7.31 to line up the
seam by cloning gray material over the mismatch.

Figure 7.31
Getting ready to clone.

Figure 7.32 shows the result. You cannot tell that this neckline and shirt were from two different photos.

Figure 7.32
Now it matches perfectly.

Final Adjustments

I'll finish with my usual flourish. I selected all, copy merged, and pasted as a new layer. This locked in all the changes to a single layer that I used to make global adjustments to.

Next, I carefully softened the bright spots on our faces and removed a few blemishes. Then I did some minor noise reduction. Finally, I used Levels (as shown in Figure 7.33) to get better contrast.

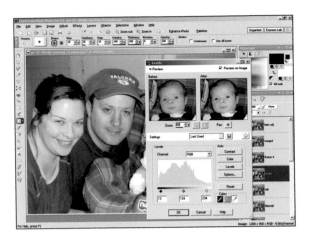

Figure 7.33
Don't forget to check Levels.

Finishing the Photo Study

This one's done (see Figure 7.34). I didn't use more than a handful of tools for this entire photo study, but the result is dramatic. We were in two photos, and now we are in one photo. It's not about how many tools you use or how easy or hard they are, it's about the photos and the results.

Figure 7.34
A successful operation, doctor!

Photo Study 36: Cleaning Up a Photo

ANNE TOOK THIS PHOTO (see Figure 7.35) during a trip to the zoo in 2009. The zoo had just opened a new exhibit called African Journey, and she caught a Spotted (aka Laughing) Hyena at rest. It's quite close, and you can barely tell there is a window separating the Hyena from the observers.

That makes it a great photo to work with because I can make it look like it was taken in the wild by removing a few small details. I'll take out the smudges and dust on the glass and the person that got into the bottom-right corner of the picture.

Pay attention to the depth you are working at with photos like this one because there are three levels that shouldn't be mixed. In front, there is the child's elbow in the bottom-right corner. Next comes the glass, with dirt and smudges on it. Finally, there is the landscape in the background. The only thing the background needs is a bit of a brightness adjustment.

From Front to Back

First, I erased the arm in the corner of the photo with the Clone Brush. This was a simple, straightforward operation, but I did have to make sure not to clone smudges. There was a small smudge-free area to the left of the arm that was a good source for the Clone Brush (see Figure 7.36).

Figure 7.35
Great shot from behind the glass.

Figure 7.36
Cloning to clean a corner.

The next step was to clean the glass. There are a lot of different ways to remove the smudges. First, the Scratch Remover did a pretty good job of removing the linear smudge. I kept the strokes short and the width wide to try and hide the blending (see Figure 7.37).

Figure 7.37
Trying Scratch Remover.

If that doesn't work or you think you can do better, switch to the Clone Brush. Figure 7.38 shows the difference.

Figure 7.38
Cloning gives you total authority.

You can use the Clone Brush on the other smudges or switch to the Blemish Remover to zap the specks (see Figure 7.39).

Figure 7.39
I love zapping blemishes.

Fixing the Exposure Problem

The next stage of retouching the photo was to deal with the exposure problem. The top-left corner of the photo is obviously too bright, and the rest is a tad dark. This imbalance hurts the photo. As usual, there are many ways to correct this. I settled on a targeted mask-based solution where I could darken the brighter areas on one layer and brighten the darker areas on a separate layer. Then I performed a merged copy to combine the two.

The Foreground

To fix the foreground, I created two duplicate working layers and then applied a Levels adjustment, as shown in Figure 7.40, to the bottom one (after hiding the top layer). My goal here was to make the Hyena look as good as possible while ignoring the background. In this case, the contrast and brightness were both improved.

Notice that the histogram doesn't really look out of whack. That makes your analysis of the photo important since the histogram doesn't always give you an easy answer. You can spin your wheels if you spend too much time trying to make the histogram look "right" or miss an important adjustment if you think the graph (as opposed to the photo) looks pretty.

Figure 7.40
Making an initial Levels adjustment.

This adjustment took place on the bottom working layer, reserved for the foreground. The upper working layer will have the background adjustment and will have the foreground masked out.

Now for a twist. This didn't look bad, but it didn't really interest me. That happens sometimes when you're retouching a photo. Don't lock yourself into a specific solution and refuse to change. Remember, this is about making the photo look the way you want it to. That involves a combination of accentuating positives, removing negatives, and boosting or reducing realism or artistry. It doesn't involve using Levels or Curves or a particular tool.

I realized I wanted more contrast, so I decided to give Local Tone Mapping a try. I created another foreground working layer (again called "Near," but I renamed my first try). Then I hid the one I just performed the Levels adjustment on to keep, just in case I wanted to go back to it. I began by applying Smart Photo Fix to the new working layer, as shown in Figure 7.41.

No, it doesn't make a whole lot of sense, but this path seemed to work the best. I then opened up the Local Tone Mapping dialog box, as shown in Figure 7.42, and experimented with the strength to get more contrast. I tried to go back and remove Smart Photo from the equation, but nothing I did was able to match the combination of Smart Photo and Local Tone Mapping. When that happens, I don't argue. I go with what I like.

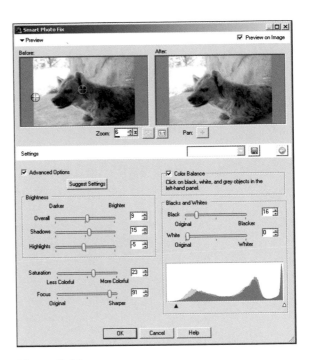

Figure 7.41
Making a Levels adjustment on the near scene.

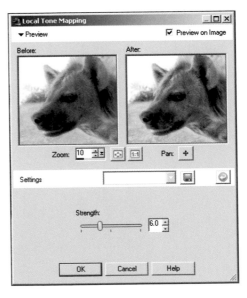

Figure 7.42
Local Tone Mapping adds pizzazz.

The Background

Fixing the background was a two-step process. First, I created a mask layer grouped with the top working layer and masked out everything but the bright corner (see Figure 7.43).

Then I selected the photo layer within the group and performed a Curves adjustment on it (see Figure 7.44).

I ended up making a relatively subtle adjustment because I didn't want the corner to look completely artificial. This way it blended in with the foreground best.

Figure 7.43
The Layers palette showing the mask.

Figure 7.44
Adjusting the brighter area.

One Other Thing

After finishing the exposure fix, I experimented with different film filters (Effects > Photo Effects > Film and Filters) and black-and-white treatments. After performing a merged copy and paste, I created a black-and-white layer with the Adjust > Color > Channel Mixer menu, whose dialog box is shown in Figure 7.45.

Figure 7.45
Converting a layer to black and white for an exposure trick.

After converting the layer to black and white, I changed the Blend mode to Luminance (L). When I realized it made the exposure better, I kept it.

Finishing the Photo Study

In the end, I made a slight Vibrancy enhancement. Although I wanted to sharpen the image a bit, that exaggerated blemishes from the glass I couldn't quite eliminate. I would have used noise reduction to smooth, but that took too much texture away from the Hyena and rock. So, that's it. Figure 7.46 shows the result.

Figure 7.46
Retouched to look au naturale.

Photo Study 37: Reflections and House Numbers

ANNE IS STANDING OUTSIDE the front door in 2006 (see Figure 7.47), taking a picture of Ben, who is sitting on the front porch watching construction on our street. He's got quite the setup and is fully equipped to relax and stay refreshed with his water!

Notice the problems? You can see Anne in the glass of the storm door. The other main issue is the house number on the door. You probably have pictures like this that have these sorts of things you want to remove from them.

Erasing the Reflection

First of all, I will take care of Anne's reflection in the screen door.

The details are small enough that the Clone Brush works best. I tried the Object Remover, but I couldn't find the right combination of size and source area to make it look good. Figure 7.48 shows my progress as I cloned her away. Like always, I created a transparent layer to clone on.

The key here was to pay attention to things around her reflection that I didn't want to clone out. That included a tray beside the TV inside the living room that looks like a brown box to the right of Anne. I was also careful not to mix the dark area around Anne with the lighter area, which leads into the kitchen. Remember, what you're cloning out has a context that you don't want to disturb. If you do, it makes it obvious you've worked on the photo.

Figure 7.47
I spy someone reflecting in the door.

Figure 7.48
Cloning is very easy here.

House Number Techniques

There are several ways to remove the house numbers. To review, they are:

▶ **Object Remover:** This works well depending on the situation. This is the "automated" way to remove something.

▶ **Cloning:** The Master of Disaster, the Tool of Power, Ms. Congeniality, and Send in the Clones all wrapped up into one. This is "Da Tool." Want to know what the Object Remover is emulating? This. There are things this tool can't do, but there's a whole lot more it can. If I'm in a pinch, I know I can trust it.

▶ **The Switcheroo:** More commonly known as Copy and Paste, this is another hallmark of photo retouching and restoring. Copy something and paste it to move it around.

▶ **New Text:** This represents another way around this problem. We'll cover over the old number and enter new text with the Text tool. Maximus Flexibilitus. You can add whatever font face you choose. The new numbers don't have to match the original numbers at all.

▶ **Smart Carver:** New to X3, this tool promises to carve your photos up and spit them out better than before. The house numbers promise to challenge this tool, but I'm interested to see how it goes.

Enough jabber. Time to get this shootout going down.

Object Remover

Duplicate the Background layer (to protect it) and select the Object Remover tool on the working layer. I've selected the numbers I want to remove and have placed the source rectangle in Figure 7.49.

Figure 7.49
Trying Object Remover on house numbers.

Figure 7.50 shows the result of the Object Remover. I'm fairly surprised it worked this well, which again goes to show you that you can never write a tool off without trying it first. It wasn't perfect, however, so I decided to touch up the borders with the Clone Brush to make it better.

Figure 7.50
Worked well, but cloning still required.

Use Your Selection Tools!

I've been waiting for this tip since I retouched this photo a few days ago. I was using the Object Remover, and I kept trying to select a straight line with the Selection tool, but couldn't. Freehand selection meets the impossible-to-draw straight line. I dumped out of the Object Remover, selected the Freehand Selection tool, chose "Point to point" mode, and then made my selection. Guess what? When I kept the selection selected and immediately went back to the Object Remover, the selection stayed chosen, and all I had to do was press the Source mode button to finish up. So, for touch photos, make your selections before you start the Object Removal. You can also create selections from masks, load selections from the Alpha channel, or load them from disk before switching to the Object Remover.

Cloning

The next technique is to clone the whole thing out. Clone Brush, do your thing (see Figure 7.51).

Figure 7.51
Cloning to remove all numbers.

The Clone Brush is effective, and you're left without any numbers at all.

The Switcheroo

This is the copy and paste method of changing the house numbers. You could copy and paste the black part of the door over the numbers to erase them or copy the numbers and switch them around. I selected the first number in Figure 7.52 to switch it around.

Figure 7.52
Select numbers to copy.

I pasted that number in Figure 7.53 to a new layer (not absolutely necessary, but I like keeping my creative possibilities open until I'm finished) and then used the Pick tool to position and slightly rotate the number.

Figure 7.53
Paste and arrange.

I like this technique, but can you see the problem? You're stuck with whatever numbers you have to begin with. You can rearrange them to your heart's content, but if you want to be really creative and change the numbers to something completely different, you'll need something else.

New Text

For this technique, I removed the existing numbers with the Object Remover and then created my own text with the Text tool.

First, I replaced the black numbers with the shiny silver backing. I've got things set up and ready to apply in Figure 7.54.

Figure 7.54
Preparing to use Object Remover.

Figure 7.55 shows the result. Pretty good. If I were going to be ultra-realistic, I would add a little noise to that selection from the Adjust ❯ Add/Remove Noise menu because the actual silver backing is not perfectly uniform like the replacement.

Figure 7.55
Zap—there goes the number.

Next, I selected the Text tool and entered a new house number in Figure 7.56. You have to choose the right font and size so the numbers fit vertically where you want them, and you might have to fiddle with the kerning or tracking (these options are on the Tool Options palette) for the new numbers to fit horizontally to your chosen space.

Figure 7.56
Enter a new number or message.

Convert the type layer to a raster layer and add more noise to make it as realistic as you like.

Smart Carver

The Smart Carver is supposed to make removing things from photos easier because the routine positions what you leave in "smartly" as it carves out what you want to remove. Will it work here?

I have the dialog box open in Figure 7.57 and have colored the hour numbers red. They are what I want to remove. I wasn't particularly exact about it because I didn't want any of the silver backing in the shot.

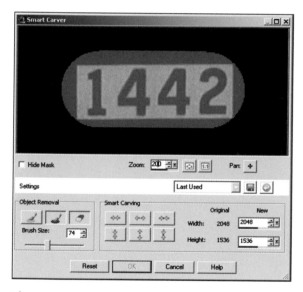

Figure 7.57
Prepping Smart Carver.

Figure 7.58 shows the result after I hit the "Auto-contract vertically to remove red-painted area" option. The result is fairly impressive. The one downside to this application is that if you look carefully, you can tell the house has shrunk. Not by much, though! This tool works best if you need to remove an entire swath, either horizontally or vertically.

Figure 7.58
Results of the Smart Carver.

Final Adjustments

I'm in the home stretch. I used the switcheroo technique to change the house numbers and then copied everything as a merged copy and pasted that as a new layer.

Next (see Figure 7.59) I used Histogram Adjustment to bring the Low end of luminance up slightly and the High end down. When you drag the other sliders, the Gamma slider will stay in the middle of the two (as opposed to the middle of the graph) and remain at 1.00.

Figure 7.59
Subtly improving brightness and contrast.

Next, I opened up the Hue/Saturation/Lightness dialog box and increased the saturation by 5. That made the photo just a wee bit more vibrant. Finally, I performed minor noise reduction to smooth the photo.

Finishing the Photo Study

I made two substantive changes to this photo (see Figure 7.60) before rotating and recomposing the shot in portrait rather than landscape orientation. I removed something (Anne's reflection) and changed something (the house numbers). That's something!

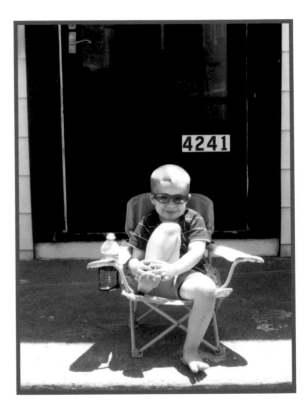

Figure 7.60
Good photo without distractions.

Photo Study 38: Improving Photo Composition

I TOOK THIS PHOTO (see Figure 7.61) in my brother-in-law's back yard in 2009. We were over for a birthday party, and I naturally had my camera. I took a break from the party and was scouting the area for potential High Dynamic Range shots when I came across this woodpile and decided to take its photo.

It's a good picture that I don't have to mess with, but there are a few subtle things I want to do to see if I can make it better. I will clone the leaves and stuff out of the yard to make the grass more uniform, take a power line out of the trees in the far background, remove some dust spots in the sky, and then recompose the photo. All these things will help the overall composition of the photo.

Figure 7.61
Woodpile in the country.

Cleaning Things Up

By now, this should be easy. There are three things to clean up in this photo: the grass, the power line, and dust in the sky. Each type of object calls for a different tool: the Clone Brush, the Scratch Remover, and the Blemish Remover.

I am removing the leaves from the grass in Figure 7.62, albeit poorly. Grass can be a challenge to clone around, especially in a photo like this. Pay extra attention to the "grain" of the grass, the texture in the general area, the color, and the size of the blades. All should match from source to destination.

Figure 7.62
Not thinking of texture and scale.

The other issue when cloning at different depths in a photo is to match the focus caused by the depth of field. If you're using a wide aperture, the photo will have a shallower depth of field (what looks sharp) than a smaller aperture. Cloning a blurry area to a sharp area stands out like a sore thumb.

Apertures and Depth of Field

Although the phrase *wide aperture* is relative, at f/5.6 or larger you will have a noticeably shallower depth of field than f/8 or smaller. Depth of field is the area in the photo that is sharp and in focus. It extends away from the camera. At close ranges and with wide open apertures, the depth of field can be as small as a few millimeters. Focusing further away and using a smaller aperture increases the depth of field upward until it is essentially infinite.

Remember, f/numbers are inversely proportional to aperture sizes, which means f/8, f/11, f/22, and larger f/numbers indicate ever-decreasing aperture sizes. A small f/number, such as f/2.8, indicates a pretty large aperture.

Figure 7.63
Cloning to match.

Figure 7.64
Blending causes the problem.

Figure 7.63 shows me doing a better job.

The power line calls for the Scratch Remover. Or does it? I applied the Scratch Remover over the power line in front of the tree line in Figure 7.64. Notice the fact that the blending makes a mess of the trees. Remember, the Scratch Remover works best in areas of similar tone and texture. A better place to use it on this photo would be on the power lines in the sky to the right.

The best solution, then, is to use the Clone Brush on the power lines in front of the trees, right? Figure 7.65 shows that this isn't always the case, either. I thought it would be a breeze to clone these cables out, but when I tried, the Clone Brush left unmistakable tracks that make the fact that I was using it obvious.

Figure 7.65
Cloning can be obvious here, too.

I resolved this by keeping the Clone Brush very small and lightly "dabbing" from above and below the power lines to avoid making it obvious.

Finally, there are a few small dust spots in the sky. They could have been birds, but I took them out anyway. For this, the Blemish Remover was the perfect tool, as shown in Figure 7.66.

Figure 7.66
Using the Blemish Remover on dust (or the occasional bird).

Remember to clean your monitor. I have several dust spots on mine that made me think there was more dust in this photo than there was. I have since cleaned my monitor to avoid the confusion. The way to tell whether something is in the photo or not is this: If the dust spot moves with the photo when you scroll around, it's in the photo. If it stays where it is on the screen, it's on the screen.

Recomposing

I can focus this photo more on the wood pile by recomposing it according to the Rule of Thirds. It wasn't shot badly. In fact, I did a pretty good job of composing it according to the Rule of Thirds. Despite this, the orientation of the wood pile pulls your eyes off to the right and into the distance, dissipating the energy of the photo.

Divide the photo into thirds (think "Tic-tac-toe"). Try to line up horizontal and vertical features on or near a dividing line. Put something in the squares. Either or both methods work. I have created a helper layer on top of the photo layer to make this easier to spot, and am using the Pick tool in Figure 7.67 to enlarge the photo.

Figure 7.67
Using the Rule of Thirds.

Don't Be Slavish About It

I try to follow the Rule of Thirds without being obsessive about it. If you align all of your photos too precisely, people may think they look artificially composed. Go for a natural look that fits within the spirit of the rule. You'll have some photos where you line things up right on the lines (or in the boxes), others where you fudge it a bit, and still others where you completely ignore the rule.

Finishing the Photo Study

Figure 7.68 shows the finished result. Some of the objects I removed were taken off-screen when I recomposed the photo, but it's often a good idea to take them out anyway because you never know when you'll want the entire canvas (unlike the earlier example in this chapter where I cropped first and knew I wouldn't want the rest).

I also made brightness and contrast adjustments with Levels. I thought about sharpening the photo a little with Unsharp Mask, but decided against it because it accentuated noise in the vine to the left and didn't add all that much to the other parts of the photo. This is an example of leaving something alone that could have gone either way. All-in-all, it's a very nice photo.

Figure 7.68
Good made better by removing and recomposing.

Photo Study 39: Creating Montages

FIGURE 7.69 SHOWS MY SON Ben leaping off the front porch in 2007. Anne was taking pictures of the kids while I was mowing, and Ben decided that he wanted to show her his "tricks" and started catapulting himself into the yard.

Having one photo is awesome, but when I've got five pictures of Ben performing different moves, how do I decide which one to use? I don't always have to. I'm going to take Ben's tricks out of several shots and create a single photo montage.

Workload and Time

Let me say right up front: This is a lot of work. It's not that difficult once you get the hang of it, but the more pieces of photos you use in your montage and the more you need to erase around objects to blend them in, the more work you're asking for. I got a little carried away and selected five photos to work with, four of which I was copying material out of.

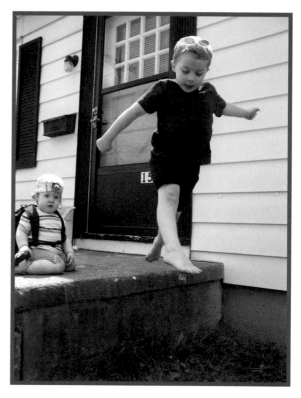

Figure 7.69
Ben leaping off the porch.

Prep

First, I needed to get my photos together and decide which ones I was going to use. Then I decided which one would serve as the background. I chose the one with Grace sitting on the porch for the background photo because it stood out. Next, I opened them all up in PaintShop Photo Pro and evaluated their color, brightness, and contrast. I was looking to see if they were all pretty close to each other or if I needed to make adjustments on them.

Thankfully, they all had fairly similar characteristics, so I only had to make adjustments to two of the five photos. For one, I performed a Histogram Adjustment to brighten it up, and for the other, I warmed it up a tiny amount (Adjust ❯ Color Balance) and brightened it.

Copy

With the prep work completed, I started copying Ben out of the source photos. I used the trusty Freehand Selection tool (Point mode) for this, as shown in Figure 7.70. I gave myself a good border around Ben (each time I copied him) to erase later.

Figure 7.70
Within each source image, select the subject to copy.

Paste and Erase

It starts getting harder and more time consuming here. I pasted each instance of Ben that I was going to use into the background photo as a new layer and prepared to erase the extra material. Before you erase, make sure that you have selected the right layer. To make things easier to see, I hide everything but the layer I am working on for these first few passes.

Erasing is a skill you should develop if you want to create montages like this. I make three main passes, each with a differently sized Eraser. I make the first pass (as shown in Figure 7.71) with a relatively large brush at 100% hardness. I eat away at the outer border, and am careful not to get too close to the subject. The hard Eraser ensures I fully erase whatever I brush over.

Figure 7.71
After pasting, start erasing.

For my second pass (see Figure 7.72), I zoom in, shrink the Eraser (or brush—I am using both names to mean the same thing in this context), and lower the hardness to 0%. I get close to the edge of the subject and erase very carefully. The soft brush helps blend the pixels from totally opaque to transparent.

Size Is Relative

When I say "large brush," as opposed to medium or small, the actual size (in pixels) of the brush can vary, depending on the context of the photo and its resolution.

Figure 7.72
Magnify and continue with the smaller Eraser.

Finally, I make a third pass around each object with a very small Eraser. On this pass, I get into the nooks and crannies of fingers, corners, and between things. I'm working on the area where Ben's hand passes beside his head in Figure 7.73.

Figure 7.73
Third pass with smallest Eraser.

Montage

When the prep work is finished, you can move the montage pieces into position. Figure 7.74 shows my final layout. I played around with different locations and orientations before settling on this one.

Figure 7.74
Arranging the montage.

It looks finished, but it's not. I'm almost there, though!

Erase in Context

These next steps are critically important. You can be very skilled with the Eraser, but it is still important to check whether or not you've missed pixels and how they relate in context to what is in front or behind. I do this in three steps:

1. Check each layer against a white background.

2. Check each layer against a black background.

3. Show all layers and check against each other.

I create two new raster layers (they are temporary) for my initial checks. I fill one with white and the other with black and arrange them so they are above the Background layer but below all the montage layers. Choose one photo montage layer to start with and hide everything else but it and the white layer.

Figure 7.75 shows why I do this. I've zoomed in on Ben's hand, and you can see there are dark pixels that didn't get fully erased. Change your Eraser hardness to 100% and zap them. Check each montage layer against the white layer. Next, hide the white layer and show the black layer. This time you're looking for light pixels that you missed. When you find them, erase them from each object layer (see Figure 7.76).

Finally, hide (or delete) both the black and white helper layers and show everything else. Then check edges against the photo montage. I am checking every edge that rests on another in Figure 7.77 to see how they blend. I moved closer and erased the border that looked lighter. These pixels were lighter because they were on top of a darker blue.

Figure 7.75
White background layer helps show dark leftovers.

Figure 7.76
Black background layer helps show light leftovers.

Figure 7.77
Next, check edges in context.

When they were on top of the white layer, I couldn't tell if this area needed erasing. Likewise, when they were on top of the black layer it was not apparent that this border was too light. I had to check it in this configuration to see if I missed it.

Final Points

You can see why this turns into a lot of work. For this montage, the first three erasing passes covered four objects, making 12 passes. The next two passes with the white and black backgrounds amounted to eight more. The final pass attended to four objects. That makes 24 total times around, carefully erasing each time.

I then selected all, performed a merged copy, and pasted that as a new layer. I made a contrast tweak with Local Tone Mapping (see Figure 7.78).

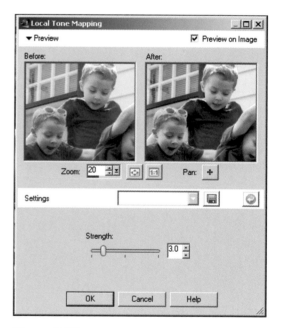

Figure 7.78
Boosting contrast with Local Tone Mapping.

After that, I ran it through Highlight/Midtone/Shadow to brighten the midtones in the photo. I liked what I saw (see Figure 7.79), so I decided to keep it.

Finally, I applied very modest noise reduction to smooth Ben's features and warmed the photo up a notch. That finished the photo.

Figure 7.79
Brightening midtones.

Finishing the Photo Study

This is it. This is the final study of this chapter (see Figure 7.80). Photo restoration and retouching isn't always about taking scratches out or covering up imperfections in a photo. This study showed you that it can be a fun exercise in creating a montage from five different digital pictures.

Figure 7.80
Ben, one of our brave and adventurous sons.

Retouching People

A S I WORKED THROUGH THE SERIES of photo studies in this chapter, I came to the unavoidable conclusion that you're going to see us at our worst. I've got pictures that show off our blemishes, dandruff, yellow teeth, nose hair, mucus, weight, and thinning hair. You, the discriminating reader, are going to benefit from our imperfections as you learn how to retouch these problem areas.

Do you know what? It's worth it. These photos, of myself and other members of my family, are exactly the type of photos you're going to have. They're real—real people engaging in real life. They have the type of actual problems that would probably keep you from showing yours off, too. The point of this chapter is to enable you to pull out that photo of yourself with dandruff, the precious one of your kids where they all have red eye, quickly fix the problems, and then enjoy them without cringing all the time.

Aside from feeling good about that, it's fun working with people. It was fun for me to give myself a makeover. Err, well, a makeover in PaintShop Photo Pro. I'm not ready to go spend the day at the spa with cucumbers on my eyes and mud on my face!

▶ **Photo Study 40: Removing Red Eye**—Red eyes are terrible to behold and can easily ruin a good photo. I'll walk through the standard technique for taking the red out of eyes and then introduce you to my own solution.

▶ **Photo Study 41: More Red-Eye Techniques**—In this photo, I'll show you the "hidden" Red Eye Removal tool, which is both powerful and useful. After that, I'll compare it to my technique.

▶ **Photo Study 42: Whitening Teeth**—Teeth that aren't gleaming white can be painfully exposed by photography. Follow along as I fix my yellowish teeth and touch up a few other things in this photo study.

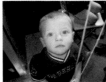

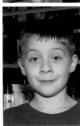

▶ **Photo Study 43: Teeth, Eye, and Skin Touch-Ups**—I'm going to perform the retouching trifecta in this photo: teeth, eyes, and skin. I'll polish my wife's teeth, intensify her eye color, and use the default skin smoother.

▶ **Photo Study 44: Covering Cuts and Scrapes**—I'll use many of the same techniques I've used to repair other problems in other photos to cover a large scratch on my son. You'll learn to use whatever tool you want, no matter what it's named.

▶ **Photo Study 45: Glamorous Skin Smoothing**—I'm going to show you how to smooth and glamorize normal, everyday skin in this study involving a cute photo of my wife Anne.

▶ **Photo Study 46: Complete Body Makeover**—This is an astounding example of what you can do with PaintShop Photo Pro and a little ingenuity. I'll show you how to lose weight, put on muscles, and get a tan in one photo.

▶ **Photo Study 47: Trimming Nose Hair**—Did you ever think you would buy a book, especially a book on a computer application, which had "Trimming Nose Hair" as a section title? I leave no unattractive stone unturned for you, my reader.

▶ **Photo Study 48: Removing Mucus**—This study continues the nasal theme, only this time with my son, Ben, who needs a touch-up under his nose (a more common problem with photos of kids than you might think).

▶ **Photo Study 49: Hiding Hair Loss**—This study shows you one technique to cover hair loss: applying new hair. I will attempt (I sound like a magician) to transplant some of my son's hair onto my head. Will I be successful?

▶ **Photo Study 50: Softening Shadows**—Flash photography is great at times and stinky at others. When it's stinky, it normally produces harsh shadows. Watch me soften them using this photo of Ben and Jake as an example.

Photo Study 40: Removing Red Eye

FIGURE 8.1 IS A PHOTO of my youngest child, Samuel, from 2007. Anne was holding him over her shoulder, and he's looking past me as I took the picture. It was dark enough in the room that the flash went off, and sure enough, it caught him with red eyes. If you don't know, red eye is caused by the eye not reacting fast enough to the flash, which allows light to reflect off the blood-filled retina at the back of the eye. Animals aren't immune to this effect, and certain animals (cats, for instance) have a reflecting layer on the back of their eyes, which increases the problem. This layer is why a cat's eyes appear to glow in the dark.

There are a number of ways to get rid of red eyes in PaintShop Photo Pro. I'll start by showing the Red Eye tool and then my own technique.

Figure 8.1
Attack of the serious red eye.

Using the Red Eye Tool

The standard method for removing red eyes in PaintShop Photo Pro is to grab for the Red Eye tool, which is located on the Tools toolbar. There is only one option to choose: the tool's size. I've selected the tool in Figure 8.2, sized it to cover the entire red portion of Sam's eye, and clicked on the red eye to apply. It did a pretty good job in the center, but there is still a red ring around his pupil.

Duplicate Layers

This photo study, and many that follow, use my technique of duplicating the Background layer and applying changes, such as the Red Eye tool, to that duplicate working layer. This preserves a copy of the original photo within the working .pspimage file. If I hide all the intervening layers, I can quickly compare the top "after" layer to the bottom "before" layer and see the overall transformation.

Figure 8.2
Red Eye tool does well, but not completely.

I kept clicking in the red area that was left behind in Figure 8.3 to see if I could complete the repair. I was able to make it better, but couldn't completely eliminate a red tinge.

Figure 8.3
Further application is better.

You might think that if I made the tool larger, much larger than the red pupil, that it would take care of all the red. Unfortunately, this is not always the case. I enlarged the Red Eye tool to a diameter of 99 pixels in Figure 8.4 and applied it to the same eye as before. The result is essentially identical.

Figure 8.4
Larger tool does about the same.

An Alternate Technique

I'm not saying the Red Eye tool is useless or that you should never use it, but I want to extend beyond the simple basics of "click here" for portions of this book. There are times the Red Eye tool doesn't work the way you want it to, and you have to figure out a way to get the job done. This section shows you a technique that I came up with and use when I absolutely have to get the red eye out.

First, duplicate the Background or working layer in case you want to erase around the effect and blend it in with the layer below. Then choose the Selection tool from the Tools toolbar and change the Selection type from Rectangle (which is the default) to Circle.

Using Different Selection Types

You don't have to use Circle if you don't want to. Some pupils appear elliptical, and you may need to draw around the pupil of someone's eye with the Freehand Selection tool. Use the type of tool that best fits your situation.

Figure 8.6 shows the settings that I use most of the time. You might think you should just be able to pull the red percentage down and be done with it, but you can't. When I took red from 100% to 0% in this photo, the pupil looked too blue, and the glint was more cyan than white. I had to keep searching for the right combination, but I think I eventually found it. Leave the Green and Blue channels alone and set the Red, Green, and Blue percentages for the Red channel to 0, 125, and -15, respectively. (These numbers should work for most eye colors because you're taking the red out of the pupil, not altering the iris.) Be patient and keep fine-tuning if you need to. You can match the pupil's color to what it should be very precisely. By the way, if you take all the color out and make the pupil or iris absolutely black, you'll make people look like aliens.

Then select the area around the red portion of the eye, as I have done in Figure 8.5. Get all the red, but don't stray too far outside of this area.

Figure 8.5
Select the red eye.

Now for the fun part. Take the red out of the eye with the Channel Mixer (Adjust > Color > Channel Mixer). Uncheck the Monochrome box at the bottom of the dialog box and select different Output channels to edit. Since this is a case of too much red, the Red channel is a great place to start.

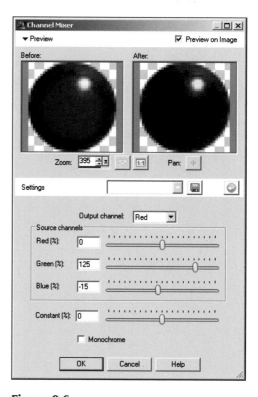

Figure 8.6
Tweak the Red channel.

I've accepted my Color Mixer settings, and the result appears in Figure 8.7.

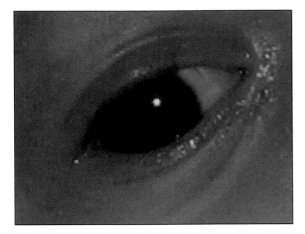

Figure 8.7
Red eye is really gone this time.

When I first removed red eye using this technique, I was astounded. I still am, really. The red is gone, and the pupil matches the rest of the eye. Notice that there's a light area on the inside of the iris, next to the pupil. That's the glint in someone's eye. Take a look at some good close-ups of eyes without red eye, and you'll see that this is the way an eye should look. Don't try to take that out of a person's eyes.

Finishing the Photo Study

Sam's red eyes were about the only dramatic thing wrong with this photo. I removed them with my technique and performed a Histogram Adjustment to improve the brightness and contrast. Finally, I smoothed Sam's skin with Skin Smoothing (50). The finished study is shown in Figure 8.8. You should be able to complete retouching work like this quickly.

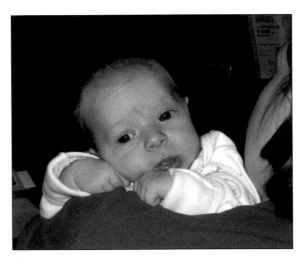

Figure 8.8
Ahh, that's better.

Photo Study 41: More Red-Eye Techniques

MY SON, JACOB, IS HAVING FUN at the table in Figure 8.9. He's got a funny, open-mouthed expression on his face, like I caught him in mid-exclamation. Jake's red eyes are looking off obliquely to the camera, and his pupils appear elliptical. Red eyes that aren't perfectly circular can be more difficult to retouch.

What you can't see from this photo is that we were having a dinner in celebration of my wife's Grandma Jo, who would have been 100 years old that day (in 2007). We celebrated by fixing some of her favorite foods and sharing stories about her.

More Techniques

In this photo study, I will show you four red-eye removal techniques one after another. The first uses the Red Eye tool, the second the Red Eye Removal tool, the third a variation of the Red Eye Removal tool, and the fourth is my own technique.

Red Eye Tool

I selected the Red Eye tool from the Tools toolbar and applied it to Jake's eye in Figure 8.10. It has about the same effect as the previous photo study. Namely, it gets the red out of the center but leaves a red margin around the outside. In cases like this, enlarge the tool and try again. There are times you'll hit the jackpot, and it'll look great.

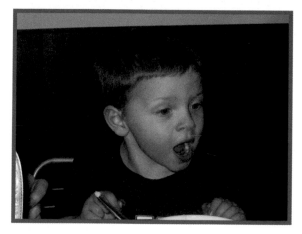

Figure 8.9
Cute photo marred by red eye.

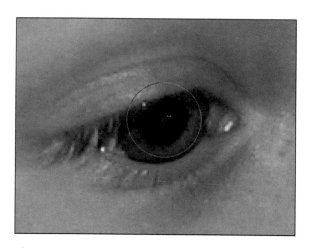

Figure 8.10
Red Eye tool on elliptical pupil.

The Red Eye Removal Thingy

There's an alternate method of removing red eye tucked in a place you may not think to look. It's called Red Eye Removal and is located in the Adjust menu. Figure 8.11 shows the Red Eye Removal dialog box. It's pretty intense, and there are a lot of settings that affect how it works. You can spend a lot of time practicing with this one.

I'll run through a series of steps to show you how to use Red Eye Removal. Many of the steps aren't sequential. In other words, you can follow most of these in sequence, or not, or find a sequence you prefer to use instead of this one. It's your call.

1. Choose a method. The options are Auto Human Eye, Auto Animal Eye, Freehand Pupil Outline, or Point-to-Point Pupil Outline. With the Auto methods, you have only limited ability to adjust the edges of the iris shape. With the Outline methods, you have more control since you manually draw around the pupil. If the eye is fairly circular, the Auto methods are more effective. For this example, I've chosen Auto Human Eye. I'll cover another method later.

2. Select an eye in the left windowpane. You'll see a circle, just like the Circular Selection tool, appear as you click and drag. The center point is where you click. Drag until it looks to be the right size and then let go. When you release the mouse button, the circle appears inside a box, as shown in Figure 8.11.

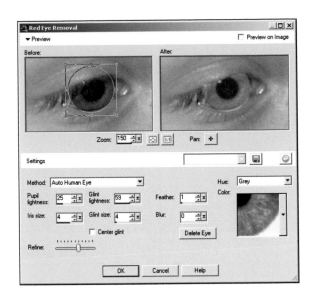

Figure 8.11
Draw box around eye.

You can resize the circle (which represents the eye's iris) by clicking and dragging the box around the eye's iris. You can move this box around by clicking on the inside and dragging. If you click outside this eye's iris, you'll draw more circles, enabling you to perform multiple red-eye removals at once. (You'll either have to zoom out or move the Preview window view to the other eye.) If you want to delete a selection, select the square and click the Delete Eye button.

The trick here is to get the selection box sized just right and the circle positioned directly over the eye. You'll see a preview of the effect in the right windowpane.

3. Now it's time to size the pupil (where the red is). Do this with the Iris size control. Note that increasing or decreasing the value of the Iris size control doesn't change the outer diameter of the iris. It changes the pupil's size within the iris. You'll want this to be as exact as you can get it. Make sure to look at the right windowpane as you change the numbers. That's where the iris size preview shows up.

4. At this point, take a look at the glint settings. Check Center glint if the glint is in the center of the eye, or uncheck it if the glint is offset, as it is in this case. You can also modify its lightness.

5. Next, change the Pupil lightness up or down. This has a dramatic effect, moving from black to a light gray.

6. You can also change the Feather and Blur settings. Feather affects the blend between the iris and pupil, and Blur takes the entire eye out of focus.

7. Next, drag the Refine slider left or right to match the overall shape of the eye and "completeness" of the iris. PaintShop Photo Pro will change how much of the iris and pupil to display. I've done this in Figure 8.14, and you can see the top and bottom of the eye in the right windowpane match Jake's actual eye more closely now.

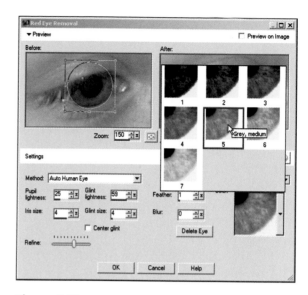

Figure 8.12
Choosing an iris hue and color.

8. Gray is the default color that the Red Eye Removal tool will apply. You can change what shade of gray from the Color list box (see Figure 8.12). Click on an iris that matches your subject most closely. You can also choose a different color entirely, like green or blue.

9. Finally, click OK.

Most of the time, the Refine control gets you pretty close to the overall shape of the eye, but it isn't always perfect. This is another reason why I duplicate the Background layer. I can erase the outer portion of the eye, the part the Refine control didn't remove, as shown in Figure 8.13. Jake's normal eye appears from underneath.

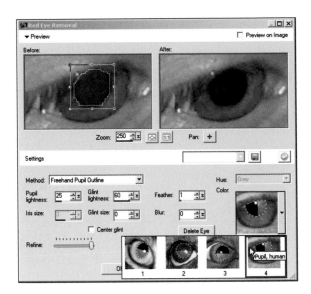

Figure 8.14
Using Freehand Pupil Outline.

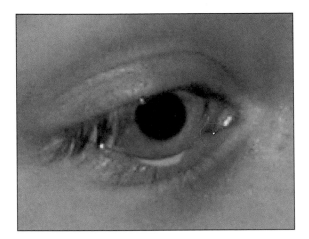

Figure 8.13
Trim away excess.

Freehand Pupil Outline

Now that you've seen how to use Red Eye Removal in Auto mode, the Freehand Pupil Outline mode will be easier to follow. I'll dispense with the steps and refer you to Figure 8.14.

Rather than selecting the eye's iris, the Outline mode prompts you to outline the pupil. This technique is best suited for pupils that aren't perfectly circular, as in this case. How you choose to outline the pupil is up to you. The difference is that in Freehand, you're drawing around the pupil just like you would use the Freehand Selection tool in Freehand mode. For Point-to-Point, click at points outside the pupil to draw around it.

The other options are mostly the same between this mode and the Auto modes. The differences are that you don't need to select an Iris size or Hue, and you will need to select what type of eye you're working on. You'll make this selection in the Color section. The choices there are Pupil, cat; Brown Pupil, dog; Black Pupil, dog; and Pupil, human.

I've made a Freehand selection in Figure 8.14 and am changing the color to a human pupil. You can see the preview in the right side of the window. Not too shabby!

The Channel Mixer

I've selected Jake's pupil in Figure 8.15 with the Selection tool. I left the selection type as Circle, even though the pupil is not quite round. That's okay. You can change the type to Elliptical or even switch to the Freehand Selection tool if you like. The important thing is to get all the red out and be working on a duplicate layer.

Figure 8.15
Select the pupil.

You can see that a portion of his eyelid is in the selection. Depending on their race (and other factors such as skin type and lighting), a person's skin will have different amounts of red. Jake's skin in this photo is pretty pink. That will cause a little problem after I apply my color change. The eyelid I've included will lose much of its red, and I'll have to erase that and rely on the Background layer to pick up the correct color of his eyelid.

Next, I selected the Adjust ❯ Color ❯ Channel Mixer menu to open up the Channel Mixer dialog box, as shown in Figure 8.16. I altered the amount of red in the Red Output channel as shown. You may need to tweak this, depending on the red in the red eye and the overall color balance in the photo.

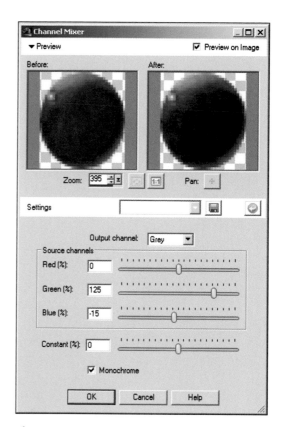

Figure 8.16
Alter red output.

If it doesn't look right, check the other channels to make sure that the Green and Blue channels are at their default. If it looks wacky, you may have left-over settings. To correct that, choose the Default preset from the Settings menu (this corrects the other channels) and enter new percentages in the Red channel for Red, Green, and Blue.

The result is shown in Figure 8.17. I deleted the portion of Jake's eyelid that was altered by the Channel Mixer so all you see is a perfectly retouched red eye and normal pink eyelid.

Figure 8.17
Great results.

Finishing the Photo Study

Figure 8.18 shows the final result. I've completed the red-eye removal in both of Jake's eyes on a separate layer than the Background, erased the portions of his eyelids that were changed, selected everything and performed a merged copy, and then pasted the result as a new layer. Afterward, I used that merged layer as a basis to perform other brightness and contrast adjustments. For this particular photo, a Fade Correction of 20 was just the right trick to make the colors stand out more and give me better contrast. Finally, I lightened the photo with Curves and then smoothed Jacob's skin with Skin Smoothing (20). All in all, it was a very successful retouching job.

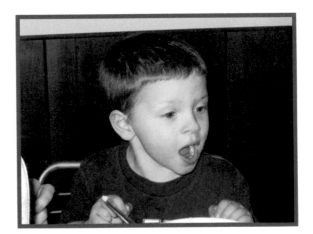

Figure 8.18
Those blue eyes are sparkling now.

Photo Study 42: Whitening Teeth

THIS IS A HILARIOUS PICTURE of me and my daughter, Grace (see Figure 8.19), from 2006. She's wearing lots of pink, which is common for her. She's got pink glamour shades, a pink jacket, pink pants, and I think that's a light pink top she has on. The furry thing around her neck isn't a cat (although when it's on the floor at night it sometimes freaks me out because it looks just like our predominately black cats). It's a detachable faux fur neck that goes on an old coat. We keep it around to play with, and she's hamming it up as I hold her.

My teeth are really yellow in this photo. I don't want to resign this nice picture to the stack that we never show anybody, however, so I will whiten my teeth as I enhance this photo.

Figure 8.19
Daddy with his princess.

Whitening Teeth

Whitening teeth is another retouching job that can go a long way toward making a photo better. The simplest method is to choose the Makeover tools from the Tools toolbar and then choose the Toothbrush from the Tool Options palette (that's just below the Standard toolbar). Enter a strength and click on the yellow teeth.

Easy does it. Most of us don't have absolutely white teeth, and teeth that look too white can appear unnatural. To prove my point, look at Figure 8.20. I've applied the Toothbrush to my teeth and put the strength up to 100. That's overkill!

Figure 8.20
Overdoing it.

A better technique is to tone down the Toothbrush and apply multiple levels of whitening until you get the desired result. I've chosen a strength of 30 for my teeth in Figure 8.21 and the result is more realistic. You'll notice that I pulled back the zoom quite a bit when compared to Figure 8.20. I get a better sense for how the whiter teeth will blend in with the rest of my face that way. Too much will stand out like a sore thumb, and too little is rather pointless.

Figure 8.21
Realistic is better.

Teeth and Gums

If a person's teeth aren't touching (that sounds odd, but the gums may be separating the teeth), you may have to click multiple times on teeth in different areas to apply the Toothbrush successfully. The Toothbrush works partly like the Flood Fill tool.

Handling Blemishes and Skin Tone

If you look carefully in Figure 8.22, you can see that I've applied the Blemish Remover to a spot in my eyebrow. That's a bad thing. You shouldn't be able to see it. The problem is that the tool can blend the area around the blemish too much. In this case, that surrounding texture is my eyebrow hair, which makes blending obvious. It would be better to use the Clone Brush in this area.

Figure 8.22
Blemish Remover softens focus on brow.

The next few figures illustrate my efforts to even my skin tones. I've got some red areas (probably dry skin) on the bridge of my nose and other parts of my face. There are several possible ways to fix this problem.

I could use the Hue Up/Down Brush to change the hue. I could use the Saturation Up/Down Brush to lower the intensity of the red color in those areas. I could even try to use the Clone Brush to clone areas of my skin that are a more pink color over the red areas. If you're thinking along those lines, that's great. Those are all good ideas.

I tried them, however, and wasn't happy with any of them. It was after I switched to the Change to Target Brush that I got the result I was after. I used the Change to Target Brush in Hue mode to change the hue of the red areas of my face to match that of another, less red, patch of skin. If you ever wonder why there are tools like this in PaintShop Photo Pro, and why they have all these different modes, this should help answer that question. This tool and this mode make this problem easily fixed.

I chose the tool first (the Change to Target Brush, in this case). Then I pressed Ctrl while I hovered my mouse over an appropriate color (see Figure 8.23) to load a color into the Foreground and Stroke Properties box on the Materials palette. That changed the cursor to the dropper, which I clicked to load the color. I went for a nice pink that wasn't too red.

Figure 8.23
Select color for replacing hue.

Next, and this is pretty important, I made sure the Mode (seen on the Tool Options palette) was in Hue. My goal was to match hues with another area, not lightness or saturation. With a more muted pink loaded into the right-sized brush, I started brushing away the red, as shown in Figure 8.24. If you're doing this and it looks terrible, Undo and find another shade of skin tone from your face and try it again. Trial and error are important elements of finding the right color sometimes.

Figure 8.24
Taking the red out.

Other Touch-Ups

Before I close this photo study, I have a few more touch-ups to show.

First, as seen in Figure 8.25, I softened Grace's sunglasses. They were smudged, and the softening effect reduced the smudginess and kept it from being too obvious. Look to make touch-ups like this in your photos. It wasn't a big deal, but it was, if you know what I mean. If you're going to retouch photos, use all the powers of your perception and imagination to make them better!

Figure 8.25
Softening smudged shades.

Finally, I liked the levels of the subjects, but I wasn't happy with the background. I isolated us from the background by performing a merged copy (remember, I did some cloning on my eyebrow, and when I clone I use a separate layer), and pasting that as a new layer. Then I duplicated the merged copy layer. One of the duplicate layers served as the background layer (that I lightened) and the other held us. I am erasing us out of the background layer in Figure 8.26 (a mask would work, too).

With that done, I could apply whatever color, brightness, or contrast change to the background layer (the one I erased us out of) I wanted, and the foreground layer (myself and Grace) was left unchanged.

Finishing the Photo Study

To finish this photo, I applied a Histogram Adjustment to lighten up the background (the layer without us), and then I copied the merged photo, pasted that as a new layer, and made an overall levels adjustment. There's a subtle sheen to the background (look at the paneling) that wasn't there, and the contrast is much better. I made a Curves adjustment to brighten us up, masked Grace's clothes out so they wouldn't get too bright, and finished off with Skin Smoothing. The final photo is shown in Figure 8.27.

I almost forgot to tell you. I cloned my thumb out. It's not a huge difference, but I think it makes the photo better without the distraction.

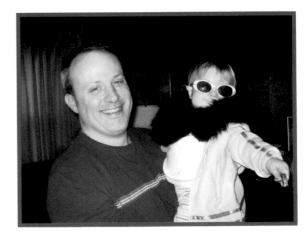

Figure 8.27
Daddy looks better now.

Figure 8.26
Preparing to adjust background only.

Photo Study 43: Teeth, Eye, and Skin Touch-ups

Figure 8.28 is another photo of my wife, Anne, and son, Sam, from 2007. If you've got a digital camera and newborn children, you can relate to this. We carried around the camera constantly, looking for opportunities to take more pictures. The great thing about digital photography is being able to take thousands of digital pictures and keeping the best. If you take more pictures than you need, you're bound to capture the right moment.

I will use this photo to polish Anne's teeth a little differently than if I were to whiten them with the Toothbrush. I also want to show you a technique to brighten someone's eyes and use the Skin smoother. She's in for a day at the spa!

Figure 8.28
Looking good, but worth touching up.

Whitening Teeth

In this photo of Anne, I just want to polish her teeth up a bit. It's more of a subtle approach than using the Toothbrush, but it makes teeth glow with a healthy radiance when you finish instead of just being whiter.

To begin polishing, select the Lighten/Darken Brush from the Tools toolbar and select an appropriate size. I like to make mine smaller than the tooth, but not by much. If it gets too small, you'll see all the little brush lines. I also set the Hardness to 0%. For 99% of the time, you'll make your opacity something less than 100%. I am gently polishing Anne's teeth in Figure 8.29 and have completed one of her incisors and moved on to another.

Figure 8.29
Lightening teeth.

I'll polish each tooth separately, changing my brush size if I need to. Do I need to mention that you should be doing all this on a duplicated background (or otherwise copy-merged and pasted as a new layer) layer? I didn't think so.

Now that her teeth are whiter, there are yellowish areas between Anne's teeth in her gum line that should be pinker. I will use the same technique on her gums that I used in the previous photo study where I evened my skin tone.

I've selected the Change to Target Brush, made sure it's in Hue mode, adjusted the size to very small (4 pixels), pressed Ctrl to grab a good pink color from somewhere else on her gums, and changed the hue from yellow to pink, as shown in Figure 8.30.

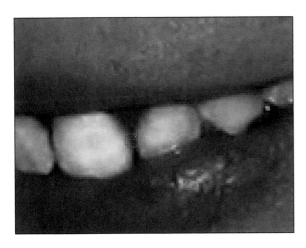

Figure 8.30
Changing hue of gums.

Retouching Eyes

People don't have to have red eyes for you to retouch them. You can use this technique to change their eye color or strengthen the existing shade. In this case, I reinforced the existing green color.

Select Red Eye Removal from the Adjust menu to get started. Draw the eye selection and then choose your settings. Essentially, I pretended she had red eye and added a green color over her iris, as shown in Figure 8.31.

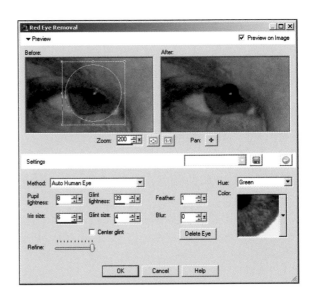

Figure 8.31
Deepening green eyes.

I used the Auto Human Eye Method because I could select a different Hue and Color to apply over her eye. There are a number of different shades and intensities of green to choose from. I tried to get a pretty good match to her original eye color.

Since I applied her "new" eyes on a duplicate layer and erased the extra (see Figure 8.32), I didn't need to use the Refine control. Erasing, rather than using Refine, gives you more control over the area that is retouched.

Figure 8.33
Lowering layer opacity to blend.

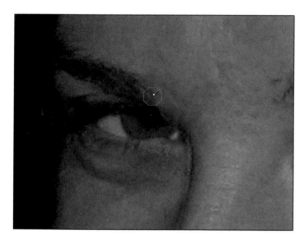

Figure 8.32
Erasing extra.

Finally, I lowered the opacity of the new eyes layer to 30 to preserve most of the original hue (see Figure 8.33).

Skin Smoothing

This is turning into a real makeover. Anne has beautiful skin, and she takes good care of it. But she's human, and this is the real world. Unless you're a full-time supermodel with your own personal skin smoother, you're not going to have perfect skin. Besides that, models rely on digital artists to retouch their photos. Did you think those magazine close-ups were unretouched?

Figure 8.34 shows the Skin Smoothing dialog box. Select the person's face or skin you want to smooth and choose the Adjust ❯ Skin Smoothing menu. Choose a strength that looks good in the preview window and apply the filter.

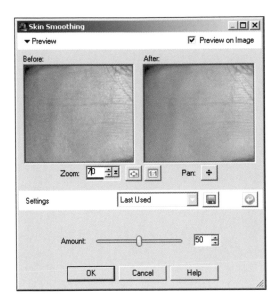

Figure 8.34
Smoothing Anne.

For some photos (this is a good example of one), select the area you want to smooth before you start the process, rather than apply the effect to the entire photo. Sam's skin doesn't need any smoothing, so there's no point in applying it to him. He's only a few months old and his skin is about as smooth as humanly possible.

If you need to be more precise than using a rough selection, use a mask and mask out what you don't want smoothed.

Finishing the Photo Study

I finished the photo study by increasing the brightness by 15 and the contrast by 10 through the Adjust ➤ Brightness and Contrast ➤ Brightness/ Contrast menu; then I bumped up the saturation by 5 through the Adjust ➤ Hue and Saturation ➤ Hue/Saturation/Lightness menu. The photo was a little dark and had a gray sheen to it. The brightness and contrast adjustment took care of that, and then the saturation gave more vibrancy to Anne's face. After looking at it closely for a while, I realized I could still improve the photo by cloning some imperfections from Anne's face and using the Smudge Brush very lightly on the brighter areas to tone them down. After this, I finished with another brightness adjustment. This time: Curves.

This is one of those photos with bright subjects and a dark background. I could have separated Anne and Sam from the background and adjusted their layer differently than the background. I decided against that, as I liked the dark background in this instance. Figure 8.35 is the final photo.

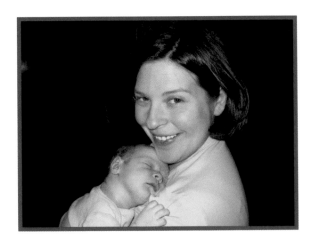

Figure 8.35
Much better.

Photo Study 44: Covering Cuts and Scrapes

FIGURE 8.36 IS A PICTURE from 2006 that shows my son, Jake, with a good-sized cut on his forehead. This is a great photo for me to illustrate how to remove cuts and scrapes from people in photos. Now, I'm not proposing you "sanitize" every person in every photo. Cuts and scrapes often tell a compelling story. However, when you need to, you'll need to know how to do so.

Figure 8.36
That's a doozy.

Technique Bonanza

This operation couldn't be simpler. Really. I'm going to take advantage of that and show you a number of different ways to take this cut out. Each one is going to do an outstanding job. The hardest part will be deciding which technique you want to use.

Blemish Remover

Now that you know how to use the Blemish Remover, pull it out at every opportunity and try to zap things with it. It's therapeutic. This one, however, may be a bit of a stretch because of the size of the scrape.

I made the Blemish Remover 175 pixels large, as you can see from Figure 8.37, to cover the scrape. The problem is, the tool is so large that it covers most of Jake's forehead, including areas of his hair, eyebrows, and eyes. In general, this is a Blemish Remover no-no, because you want textures from the outer circle to match and blend as they cover the blemish.

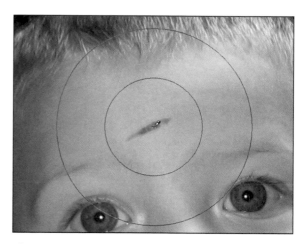

Figure 8.37
Big-time Blemish Remover.

Figure 8.38 shows the result, which surprises me. My one criticism is that the new area looks a little too uniform, which is a clue that something has been covered up. Remember, you're trying to hide your work, not show it off.

Figure 8.39
Trying Scratch Remover.

Figure 8.38
Worked pretty well, but is a bit obvious.

Scratch Remover

The Scratch Remover is a more obvious choice to remove this scratch because it's a scratch and not a blemish. Scratches tend to be linear while blemishes are more circular, which is exactly how the different tools work. You apply the Scratch Remover along the axis of the scratch (see Figure 8.39), whereas with the Blemish Remover, you pick a center point and size the tool outward. The trick here is to make sure the tool is wide enough and applied to the entire length of the scratch.

Figure 8.40 shows the result. The scratch is gone. If you zoom in ultra-close, you might be able to tell where the pixels were blended, but this is the Scratch Remover's element, and it has done its job well.

Figure 8.40
Another fine job.

Object Remover

Two down, two to go.

Now it's time to try the Object Remover. Don't fall into the trap of using tools only as they were intended or how they are named. Yes, you read that right. You're the boss. Use the tools you want to use, even if they were meant for or are called something different than what you're doing. If there is a tool called the "Don't Even Think About Using Me on Pimples" (my sources tell me they're going to unveil that tool in version X14, due out sometime in 2032), and it works on pimples, *use* it!

Call me crazy, but I do this all the time. I make color adjustments with whatever dialog works best in the given context. I use the Blemish Remover on dandruff. I use the Lighten/Darken Brush to whiten teeth. Get the picture?

The Object Remover is lined up and ready to rock in Figure 8.41. I selected the scratch with the lasso and then moved the Source rectangle to a clean spot on Jake's forehead and resized it so that it was small enough to fit. I made sure (or at least tried to) that the source area matched the skin around the scratch that I'm trying to cover. If it doesn't, I can always undo and try another spot.

Figure 8.42 shows the result. It works, and works well.

Figure 8.41
Try the Object Remover.

Figure 8.42
Outstanding.

Clone Brush

Now for my favorite, the Clone Brush, as shown in Figure 8.43. There's not really much to say here. Make sure that the brush is large enough to cover what you're working on but not too large to pick up extraneous material. Soften the brush so that it blends better. It works.

Figure 8.43
Cloning works, too.

Finishing the Photo Study

Figure 8.44 shows the final result. The scratch is gone, and I've increased the saturation by 15 to make Jake's skin a little more vibrant. Then I cleaned up his nose, brightened the photo, and applied some light Digital Camera Noise Reduction to smooth the photo a bit.

Can you tell which technique I used to take the scratch out? I didn't think so. I can't either. The people who look at the photos you restore and retouch aren't going to be able to tell whether you used the Blemish Remover or the Object Remover either. Use the tools you want. Use the ones that achieve the effect you want.

Figure 8.44
Boo boo be gone.

Photo Study 45: Glamorous Skin Smoothing

I TOOK THIS PHOTO (see Figure 8.45) of my wife, Anne, in 2009. Looking at the EXIF data, it says I took it on my birthday. It's a great shot of her being playful, but when you look closely, her skin looks a little rough. That's the problem with good cameras and lenses—they show everything, whether complimentary or not, with 10 or more million pixels of detail.

I'm going to give her a glamorous skin-smoothing makeover for this photo study. It's actually not as hard as you might think, especially when the photo is great to start out with.

Figure 8.45
Lookin' sassy.

The Treatment

Skin smoothing is a challenging endeavor to undertake because you risk smoothing away important details that make up a person, to say nothing about the rest of the photo. In that way, it's very similar to being on the horns of the noise-reduction dilemma. The two horns are: detail versus smoothness. You can smooth details you don't like away and be happy with smooth skin, or you can smooth details you do like away and be unhappy with losing crispness. See what I mean?

Thankfully, there is a specific skin smoothing adjustment in PaintShop Photo Pro that targets skin. How well it does this in every circumstance is up for you to decide, but in general, the answer is very good. The trick is to only apply what you need, and if the going gets rough, mask out a person's skin so you don't blur the entire photo.

Testing on Other Areas

To get a sense of how much skin smoothing affects the parts of the photo that aren't skin, perform a "Max Effort Skin Smoothing" test. Here's how I do it:

1. Duplicate the Background layer or the last fully opaque working layer you have so there are two identical layers you can use to compare.

2. Select the top layer and then choose Adjust > Skin Smoothing. This launches the Skin Smoothing dialog box, which is so simple I don't need to show it here. You only have to set the Amount.

3. Max the Amount and choose OK. No sense in playing around. You want to see where details are going to be lost the most.

 The result is a layer with the most skin smoothing you can get from this tool on top of a layer without any.

4. Zoom in and out, pan around, and toggle the skin smoothing layer on and off to compare with the unsmoothed layer beneath it. Pay attention to where you lose the most detail outside of the skin and note these areas in case you need to return later to mask them out.

Figure 8.46 shows one side-by-side comparison of an area with lots of edge detail—Anne's hair. Remember, I applied the maximum amount of skin smoothing to the photo. The result is a loss of detail, but not as much as you might expect. It looks like some of the highlights were smoothed.

No Skin Smoothing *Maximum Skin Smoothing*

Figure 8.46
Comparing maximum skin smoothing.

I find that toggling layers on and off is a very effective way of comparing results, even though it isn't as convenient as looking at the Preview windows in most adjustment dialog boxes. That's one reason why I don't conduct this test for every photo. Knowing the right questions to ask and how to conduct tests to provide your own answers is pretty important, though.

Finding the Right Amount

Finding the right amount of skin smoothing for each photo is pretty simple. Just open up the Skin Smoothing dialog box and either use the Preview window or the main image window. The things you want to look for here are the following:

▶ **Skin:** The main effect. Look at areas of the skin to see how smooth they are and increase or decrease the Amount accordingly. Figure 8.47 shows her cheek with too little Skin Smoothing applied to make much of a difference. The Amount was 20.

No Skin Smoothing *Too Little Skin Smoothing*

Figure 8.47
Comparing too little smoothing on skin.

▶ **Facial Hair:** Examine areas where there is facial hair, such as mustaches, beards, sideburns, eyelashes, and eyebrows. Figure 8.48 shows the area around one of Anne's eyes with the Amount at 100. This is too strong. Note the loss of detail in and around the hair follicles.

Figure 8.48
Oversmoothing eyelashes and brows.

▶ **Hair Boundaries:** Check out parts, cowlicks, and other areas where the hairline begins. Pay attention to where wispy hair extends over the skin, as you will likely lose it there. Figure 8.49 shows a close-up of where some hair is covering Anne's nose. In these cases, the amount of Skin Smoothing to use can be a tough judgment call. If you're going for a glamorous effect, I wouldn't worry about losing it.

Figure 8.49
Oversmoothing here doesn't really matter.

At this point, you should have looked around and increased or decreased the amount of skin smoothing to suit your artistic purpose and not taken away the details you want preserved. If you have a tough time balancing things out, create a mask and apply skin smoothing to the photo layer in the Mask group; then mask out overly smooth areas. Don't forget, you can also lower the opacity of the smoothed photo layer and blend it with the unsmoothed layers below.

Smudging

I settled on a final strength of 75, which sounds pretty strong, but was a bit undersmoothed for this image. I wanted a definite glamour look, but didn't want it to look too airbrushed.

I wasn't done, though. After applying skin smoothing to the working layer, I duplicated it and hid the original. I then chose the Smudge Brush, made it reasonably large, lowered the Hardness to 0 and Opacity to 50, and smoothed the rest of Anne's face manually using gentle, circular brush strokes. (Hint: The larger the brush, the lighter your touch needs to be.) Figure 8.50 shows this in action.

Figure 8.50
Smoothing by smudging.

I tried using the Soften Brush, but it didn't actually smooth away the details. The Soften Brush softened edges but didn't make her skin look smooth. The key is to choose the Smudge Brush and lower the Opacity to get a good smooth look. I varied the size of the brush and worked it over any areas that I thought could use more smoothing.

Next, I lowered the opacity of the "smoothed and smudged" layer to blend it with the normal layer beneath, as shown in Figure 8.51. Use your judgment here. The key is to balance realism with glamour.

Figure 8.51
Blending the extra smoothing.

Next, I performed a copy merged to lock all the changes into a single layer. (This is important when you're working with semi-transparent layers that blend together, and you want a single opaque working layer to continue with.) Then I used the Clone Brush and Blemish Remover to remove any remaining imperfections in her skin.

Finishing the Photo Study

After all that, I corrected the photo's brightness and contrast problems with Levels and boosted the Vibrancy a bit. I then experimented with the Glamour effect in Effects ❯ Photo Effects ❯ Film and Filters. This gave Anne a healthy glow about her that I liked. I also experimented going the opposite direction and tried sharpening the photo with Unsharp Mask.

Figure 8.52 shows the final result. I'm happy with the balance of skin smoothing that resulted in a glamorous effect and yet doesn't look overly done. I ended up using the Glamour filter, but toned it down some by lowering that layer's opacity and blending it with the next working layer.

Figure 8.52
Glamorously smooth but not fake skin.

Photo Study 46: Complete Body Makeover

I'M HAPPILY MOWING THE LAWN in Figure 8.53, dressed in my lawn-mowing sneakers and shorts. I like getting air and sun while I mow, so I dress minimally. It's an hour or so that I get to be outside doing something physical.

I've been an outdoor person and athlete most of my life, although it's been much harder to find the time the last few years. When I was at the Air Force Academy, physical fitness was regular and intense. Mandatory gym classes ranged from wrestling, boxing, judo, and unarmed combat, to water survival, which included a jump off a 10-meter platform in fatigues like you were bailing out of an airplane into the water.

Well, that was some time ago. I'm pale and flabby in this photo. But, that makes it the perfect candidate to give myself a complete body makeover with the Warp Brush.

Tummy Tucking

Conceptually, once you get the hang of what's going on here, it becomes a matter of execution.

First, I duplicated my Background layer so that I had a working layer to manipulate. Next, I started on the most obvious feature in need of repair, my tummy. (You talk funny when you've got four children under eight years of age—I would have never called this my "tummy" before I had kids.)

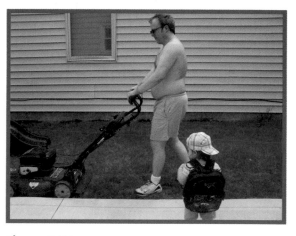

Figure 8.53
You don't have to say a thing.

I tried to warp it in, but after several tries I realized it wasn't going to work. I needed to think outside the box. The solution was to copy and paste my stomach, rotate it to a new orientation, and then flatten it.

I selected it in Figure 8.54 with the Freehand Selection tool (Point mode). I made a rough selection with a little more than I needed because I will erase the extra and blend it in later.

Figure 8.54
Select the offending bulge.

I copied and pasted it as a new layer, and am rotating it to a more vertical orientation in Figure 8.55. I hid the other layers so you could see the rotation. When you do this, make whatever you're transplanting semi-transparent so you can judge the rotation in relation to the background.

Figure 8.55
Rotate to desired angle.

I used the Warp Brush in Push mode to flatten the bulge, as seen in Figure 8.56. Take your time with these warps. They are very important. Don't get tripped up by selecting too small a brush. Sometimes, a smaller brush works worse than a larger brush. In this case, a good large brush size (150) allowed me to push the center of my stomach in as a cohesive whole, rather than making several small, disjointed pushes.

Figure 8.56
Flatten with the Warp Brush.

With the new tummy prepped and ready, I moved on to erase the bulging original. I used the Clone Brush (see Figure 8.57) to push my stomach in and make it flat. I'm not worried about the outer border of the original stomach not looking perfect because the flattened version will serve that purpose. I just need to get enough of the old tummy out of the way so that it doesn't stick out from under the new, flatter one.

Figure 8.57
Clone away excess original tummy.

Figure 8.58
Warping those love handles.

I placed the rotated and warped tummy in position and toggled it on and off so that I could judge the right amount of cloning I needed to do. You will see the flatter, composite stomach in the next figure.

More Cosmetic Warping

With the new stomach in place, it's time for more cosmetic warping. I kept with the Warp Brush in Push mode and alternated the size so that I picked up enough material in my warps to make steady, integrated pushes.

I am warping my "love handles" and pushing my back inward in Figure 8.58. This accentuates the curve of my back and will round the top of my buttocks. If you're still looking at my back, notice the shadow between the hair on my back and where I am pushing in. That's a good candidate to use the Lighten/Darken Brush to take out some of the shadow (i.e., lighten it) to reduce its visual dominance.

Next, I worked my way up to my arms. First, I added some muscle to the back of my arm, or triceps, as seen in Figure 8.59. I'm clicking and dragging the arm toward my back to get the right bulge. Be careful with Undo and the Warp Brush. Take one area at a time (like I'm doing here) and then apply the warp. After you apply, move on to another area. That way, if you have to undo something, you won't lose all your warps.

Figure 8.59
Adding triceps.

To balance my arms, I decided to add mass to my biceps. It's a simple operation of clicking and dragging toward the front, as seen in Figure 8.60.

Figure 8.60
Bulging biceps.

Warping my biceps out had the side effect of increasing my chest, and I didn't like that, so I decided to push the chest (not the arms) back in, as shown in Figure 8.61. I also accentuated the biceps by making my elbow look a little tighter. Pay attention to things like the siding on the house behind me. Those lines and shadows forced me to push material in line with them (or clone out problems later). If I weren't careful, you would see a bunch of wavy siding around me, giving something away.

Figure 8.61
Accentuating biceps.

I said that once you got the concept down, this was easy. As you can see from Figure 8.62, I continued finding different parts of my body that needed to be enhanced or minimized, and then applied the desired warp effect.

Figure 8.62
Boosting calves.

Finally, I tightened up my neck and chin in Figure 8.63. There is less margin for error working around the face and chin, and I had to be careful here because the facial hair complicated the texture of my neck. If I just squished it in without thinking, I would make myself look much worse. To avoid that, I used smaller brushes and strokes.

Figure 8.63
Tucking chin.

Tanning

Last, but not least, I need a tan. The greatest challenge with the Tanning tool is to tan what you want without darkening your clothes or anything else. In cases like this, use a mask to mask out what you don't want to tan.

First, I copy merged and pasted that as a new layer. I then duplicated that merged layer to work with my mask. Then I moved on to creating the mask.

I created a "Show All" mask in Figure 8.64 and hid everything but the skin I wanted to tan. I also set up a white layer and a black layer underneath so that I could see where the borders were. I used those layers to help me see what I needed to mask. Without those helper layers, I would see either one of my merged layers underneath (which would make it impossible to tell where I was masking) or, if they were hidden, transparency.

This is like painting or erasing. Modify the size and hardness of your brush and make a few passes around your subject. You're not adding to or erasing anything but the mask. You can paint the mask right back (or erase it, as the case may be) if you make a mistake. The important point is to make sure that you're working on the mask layer, not a photo layer.

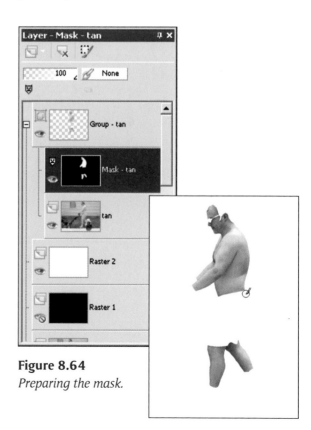

Figure 8.64
Preparing the mask.

The purpose of the mask is to set up a complicated selection—namely, my skin, and *not* to include my hair, sunglasses, clothes, or any other background. Here's how to make that selection and apply the tan.

1. Finish the mask.

2. Duplicate the photo layer and put it above the mask. This isn't absolutely necessary, but it's how I like to work. This is the layer that I applied the tan on.

3. Select the Mask layer (this is very important). It is contained in the layer group that gets created when you first create the mask and has a little mask icon next to its thumbnail in the Layers palette. In my case, the Mask layer is mostly black because I'm hiding most of the photo.

4. Next, choose the Selections ❯ From Mask menu. This will be active only if you've got the Mask layer selected in the Layers palette. This makes a selection based on the mask you created, and in this case is the purpose for creating the mask in the first place. With my skin selected, I can apply the tan liberally and not worry about it bleeding into other areas of the photo.

5. Now, click on the layer in the Layers palette where you want to apply the suntan. In my case, it was the layer I put above the mask group.

6. Finally, select the Makeover tool, choose the Suntan mode, resize it if necessary, and apply the suntan, as seen in Figure 8.65.

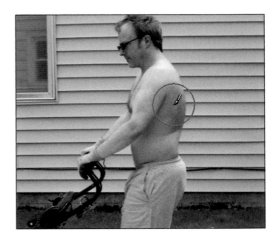

Figure 8.65
Applying suntan.

The suntan was a little dark on me, so I took that layer and lowered its opacity to blend it with an untanned layer beneath. This allowed me to set the tan's strength exactly where I wanted it to be.

There Are Always Alternatives

I chose to use a mask to make a selection in this photo study and then apply a tan to the area within the selection on a separate photo layer. That "tanning" layer wasn't a part of the mask group. An alternate method is to apply the tan to the photo layer in the mask group and let the background show through from beneath. I did it this way mostly to show (or remind you) how to make a selection from a mask.

Finishing the Photo Study

That's really all there is to it. I copied and pasted a few areas (my tummy and one small area of my waistband that I didn't have room to show you), warped them, and blended them in with the Clone Brush. I used the Warp Brush again to give myself some extra bulk in the muscle department and minimize my chest and chin. Then I created a mask of my skin so that I could apply the Suntan tool and blended that layer with an untanned layer to get the right strength.

To wrap it up, I made some brightness and contrast adjustments and ran the photo through the Smart Photo Fix. The finished product is Figure 8.66.

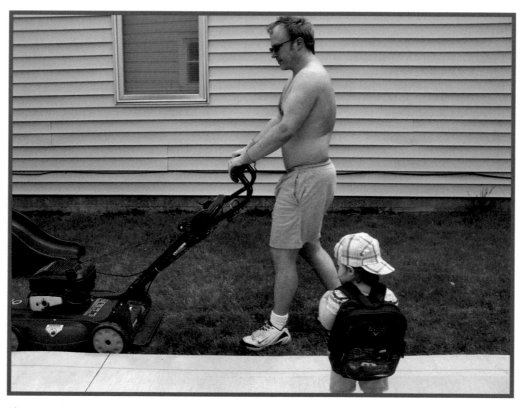

Figure 8.66
This is what I should look like.

Photo Study 47: Trimming Nose Hair

I'M HOLDING MY SON, BEN, in Figure 8.67. It was in the spring of 2003, so we had our jackets on.

Figure 8.67
Funniest photo study title ever.

What's the first thing you notice when you look at this picture? Is it Ben, his smile, his eyes, his monkey, or is it the hairs coming out of his Daddy's nose? Once you spot them, you can't stop looking at them. One relatively minor blemish in a photo can overwhelm the positive things that are present.

To fix this, I first cloned away the nose hairs on the outside of my nose, as seen in Figure 8.68.

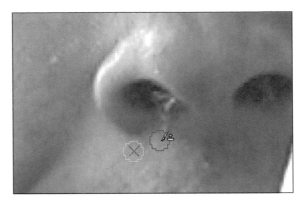

Figure 8.68
Clone hairs outside of nose.

Since there wasn't enough darkness in my nostrils to clone over the hair that was still visible, I used the Burn Brush to darken the light pixels (which is the hair), as shown in Figure 8.69. I switched the Limit parameter (look to the Tool Options palette to find it) to Highlights to burn only the brighter values.

Figure 8.69
Burning nostril to darken.

When I got one good, dark nostril, I cloned that over to the other side, as seen in Figure 8.70.

Figure 8.70
Cloning dark nostril to the other.

I wanted this to be an unobtrusive part of the photo, so I used the Soften Brush to ensure that there were no sharp pixel borders to draw anyone's eyes to. I was careful to gently soften the nostril, as seen in Figure 8.71.

Figure 8.71
Soften to blend.

Finally, I tackled some extra blemishes on my neck and on Ben's nose, as shown in Figure 8.72. Always be on the lookout for things like this to fix. Even small improvements can make a difference.

Figure 8.72
Taking out extra blemishes.

Finishing the Photo Study

This is an example of a photo that didn't take me more than 15 minutes to retouch from start to finish. I spent the most time at the end, deciding on which method to use to enhance the brightness and contrast. In the end, I used Smart Photo Fix and then altered the levels. The final result, as seen in Figure 8.73, is free of extraneous nose hairs and blemishes.

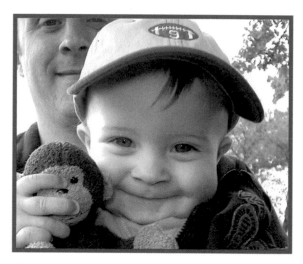

Figure 8.73
Nose hairs safely trimmed.

Photo Study 48: Removing Mucus

BEN, OUR OLDEST, just finished getting a haircut in this 2010 photo (see Figure 8.74). I had him stand over by the product shelves so I could get a good shot from his level. Unfortunately, when I stooped to take his photo, I got a straight shot right up his nostrils. (It looks like he was flaring them, too, at just the wrong time.) The result is, well, a bit unsightly.

It's sad that a picture like this gets neglected because I just happened to be at the perfect angle to see up his nose when he was getting over a cold. If you have kids, you're probably used to seeing these sorts of things in your casual photos. Thankfully, you can do something about it.

Clone, Soften, Smudge

The problem with noses, at least inside nostrils, is that there's precious little space to work with. What good skin there is normally is shaded so that the gradient is highly variable and complex. It's not as simple as cloning grass or the sky, or even most areas on a person's face. You've got to zoom in and be very, very careful (read that like Elmer Fudd). In cases like this, I resort to a three-part operation to get the main effect: cloning, softening, and smudging.

I cloned inside the left nostril in Figure 8.75. This one was a bit easier than the other side, which wasn't as uniform. With this technique, I try to get the tone as even as I can without worrying too much about perfection.

Figure 8.74
Freshly shorn.

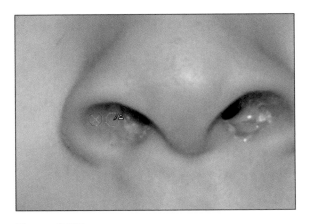

Figure 8.75
Cloning to set the stage.

The next step is to soften what you just cloned. I selected the Soften Brush, sized it appropriately, reduced hardness, and brushed gently over the new material to soften the edges, as shown in Figure 8.76.

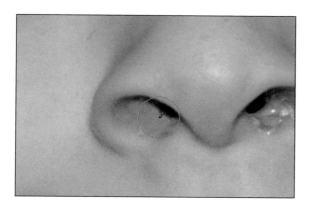

Figure 8.76
Softening the edges.

After that, I smudged. If you cloned the new material on a separate layer, perform a merged copy to consolidate and lock in your changes. You'll need to smudge on a single layer.

I sized my Smudge Brush so it was small enough to fit in the nostril but covered most of the skin within and reduced the opacity of the brush to 50 or less. I then dabbed the brush over the nostril area to smooth the skin, as shown in Figure 8.77. Don't brush (or if you do, keep the strokes very short). Dab carefully.

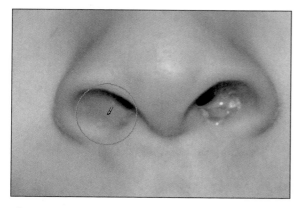

Figure 8.77
Smudging to blend.

This blends the softened, cloned material in with the original and leaves you with a pretty natural look. I continued to refine this by burning and blending.

Burn and Blend

For the most part, nostrils are in shadow. Pay attention to this and use it to your advantage. After the nose was cleaned up, I duplicated the working layer to create a special "Burn and Blend" layer. I then switched to the Burn Brush, set the Opacity to around 50, and darkened within each nostril, as shown in Figure 8.78.

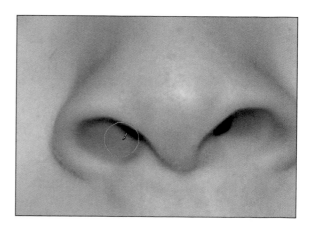

Figure 8.78
Darkening in the nostrils.

Don't worry about getting things perfect. The point of this layer is to have a dark working layer to blend in with the normal layer using either a mask or the eraser. For this type of operation, I normally use the eraser because I can make the eraser large and soft (and even less than fully opaque) and erase to create a nice gradient effect, as shown in Figure 8.79.

Figure 8.79
Erasing to blend.

After this, you can even lower this layer's opacity to further blend the darker areas in with the rest of the nose.

If the new material looks fake, then add some texture to it by copying skin from above the upper lip and pasting it over the skin inside each nostril. Change the Blend Mode of the new layer to Soft Light and erase around the pasted skin to blend it in. Lower that layer's opacity to get the right lightness.

Finishing the Photo Study

To finish the study, I brightened Ben up with a Levels adjustment and increased the Vibrancy. I also used Color Balance to warm Ben's skin tone up slightly. It was either that or use the Suntan mode of the Makeover tool. I tried both (don't forget to always do that yourself), and Warming looked a bit better.

In the end, I decided to change the orientation of the photo from landscape to portrait. This had the effect of reducing some of the clutter and making Ben the center of attention. The result, as shown in Figure 8.80, is a nice portrait.

Figure 8.80
A clean nose always helps.

Photo Study 49: Hiding Hair Loss

CAMPING IS FUN, and camping with your kids is even more fun. Ben, Jake, and I are setting up our tent in the backyard in Figure 8.81. (This was in the summer of 2006, about six months before Sam was born and while Grace was still just a wee babe.) I'm giving Ben a turn hammering the tent stake in, while Jake watches intently, ready for his turn to come next.

And, there's my head. You can clearly see my thinning hair and balding spot. Rather than try to darken my scalp or thicken the existing hair, I want to show you how to perform a hair transplant.

First, I needed to find a suitable hair replacement. I scoured our digital photo collection and found a decent photo of my son Jacob from the back. He was looking out the front door (see Figure 8.82), and his hair looks great. I made a selection of the hair I wanted to take and copied it.

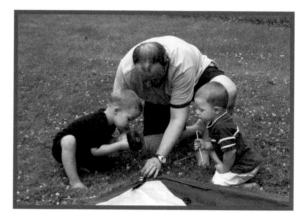

Figure 8.81
Remind me not to look down again.

Figure 8.82
Copying Jake's hair.

Next, I pasted that hair as a new layer into the photo I wanted to modify, as seen in Figure 8.83. I used the Pick tool to shrink it down to the right size and match the two hair textures. It wouldn't look right if I had hair that was as thick as ropes!

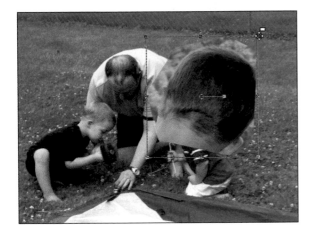

Figure 8.83
Paste, resize, and position.

After resizing it, I positioned it over my head and trimmed it down to fit (see Figure 8.84). Because Jake's hair is lighter than mine, I had to use the Burn Brush (Link set to Highlights) to darken his hair to match mine.

Figure 8.84
Burn to match darkness.

Because I didn't want it looking like a toupee, I trimmed Jacob's hair transplant to match my basic hairline in Figure 8.85.

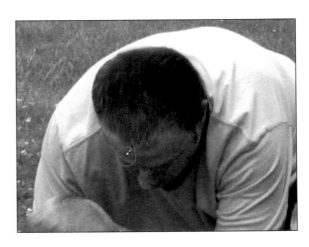

Figure 8.85
Trim to desired hairline.

For the same reason, I reduced the opacity of the hair transplant layer to 57. This blended it with my balding head and made it look more natural, as shown in Figure 8.86.

Figure 8.86
*Blend using
Layer Opacity.*

Finishing the Photo Study

This study has surprised me by how natural the new hair looks. After selecting all, copy merged, and pasting as a new layer, I increased the contrast and ran the photo though a filter. I used the Effects > Photo Effects > Film and Filters menu to access the film filter effects and applied the Vibrant Foliage (because there's a lot of nice green grass in this photo) filter to get the final effect. Figure 8.87 shows the result.

I want to point out that I didn't just copy and paste someone else's hair on my head. I worked it. I chose someone I'm related to, carefully burned the transplanted hair color, erased it to fit a realistic hairline, and then blended it into the photo by making it more transparent. This approach is very effective.

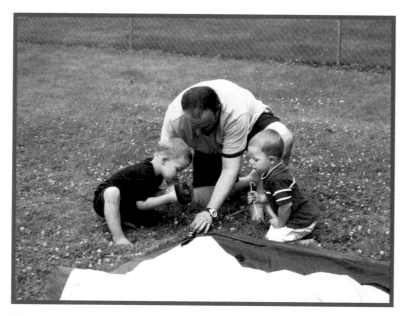

Figure 8.87
One of my best jobs.

Photo Study 50: Softening Shadows

I TOOK THIS PHOTO (see Figure 8.88) in 2009 at Ben and Jake's Awana graduation ceremony (Awana is a Christian youth program). They have a blast and meet a lot of new friends over the course of the school year. Their favorite part is undoubtedly the Awana Grand Prix, where they get to build, paint, and race pinewood derby cars.

I caught them on the stage as things were breaking up and asked them to quickly pose for me. I had the flash, but it was overpowered by the strong overhead spotlights shining down on them. Those caused strong shadows to appear on the sides of their faces and necks. I'm going to reduce the strength of those shadows in this study so they don't dominate Ben and Jake's faces.

Figure 8.88
Harsh lighting casts harsh shadows.

Contrast Masking

I will dispense with a technique shootout and concentrate on a single, more advanced technique than dodging shadows or using the Highlight/Midtone/Shadow menu. It's called Contrast Masking, and it requires several steps to complete.

The gist of it is that you're creating a blurred, inverted grayscale layer of the photo and changing the Blend mode to Overlay so what is light on the contrast mask layer darkens the photo and what is dark on the contrast mask layer lightens the photo.

This technique works best (with people, anyway) if you target the application by masking or erasing what you don't want changed from the contrast mask layer. Here are the steps:

1. Duplicate the Background layer to give yourself a working layer.

2. Open the Levels dialog box and adjust the settings to darken the shadows, as shown in Figure 8.89. This is an optional step that I sometimes do to accentuate the opposites, which is how this technique works. You turn darks in the original photo to lights and lights to darks in order to overlay them on the photo and turn those darks to light and vice versa. Got it?

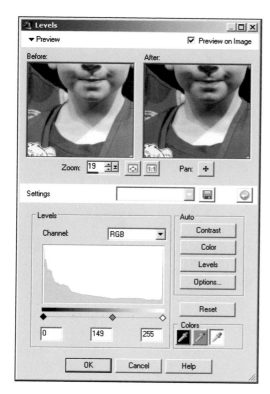

Figure 8.89
Darkening shadows to lighten them later.

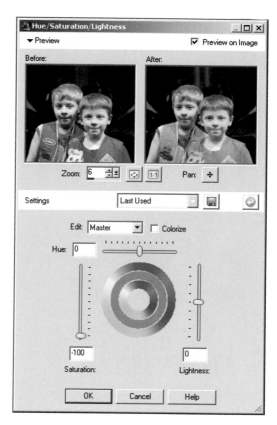

Figure 8.90
Convert working layer to black and white.

3. Convert this layer to black and white using your favorite technique (Adjust ❯ Color ❯ Channel Mixer, Hue/Saturation/Lightness, or Effects ❯ Photo Effects ❯ Black and White film), as shown in Figure 8.90. I have noticed differences in how the end result looks, but honestly, I don't know whether one of these is better to use than another. Simple desaturation seems adequate enough in most cases.

4. Use the Image ❯ Negative Image menu to create a negative, as shown in Figure 8.91. This step turns those darks to lights and lights to darks.

Figure 8.91
Creating a negative.

5. Change the Blend Mode to Overlay, as shown in Figure 8.92. Here is where the magic happens. By using Overlay mode, the dark shadows in the photo are lightened by, paradoxically, the dark shadows in the negative black-and-white layer that have been turned white.

Figure 8.93
Blurring to keep details from being lost.

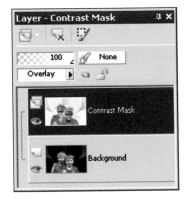

Figure 8.92
Changing to Overlay mode.

6. Use the Adjust ❯ Blur ❯ Gaussian Blur menu to blur the layer, as shown in Figure 8.93. This is so the details of the photo aren't erased by their opposite. Make sure that "Preview on image" is checked and look at the photo to see how much blur you need. Use enough to preserve clarity.

7. Mask or erase areas that aren't in shadow, as shown in Figure 8.94. In this case, I masked out everything but the shadows on their necks.

8. Lower the layer's opacity to blend. In my case, I erred on the side of realism. I could have created a cartoonish Contrast Mask to prove to you that it's doing something, but I would rather show you how to use this technique in real-world applications. It's valuable, yes, but can be taken to an extreme.

Figure 8.94
Masking out areas I don't want altered.

9. Perform a merged copy to lock things in.

Finishing the Photo Study

The final image is shown in Figure 8.95. I realize it's not perfect, but this is still the real world. I wasn't trying to remove every trace of a shadow or contrast in the photo. What I wanted was to reduce the dominance of the shadows and lines on their necks a small amount. (Jake's neck is a bit more obvious.) That makes the photo look better.

Aside from that, I adjusted the brightness and contrast with Levels, sharpened with Unsharp Mask, and brightened the background separately with Curves. I used a mask to hide Ben and Jake and keep them from becoming too bright. I finished with moderate noise reduction.

Figure 8.95
Softened shadows make a photo easier on the eyes.

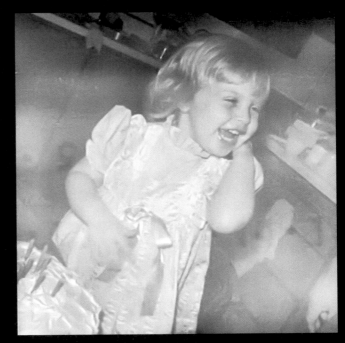

Prognosis Negative

<div style="float:right">9</div>

IF YOU'RE LIKE ME, YOU'VE GOT A BUNCH of photos either in albums, in shoeboxes, or on your hard drive that you can't bear to throw away or delete. There's something about them that you love and don't want to part with. The problem is, they're "Prognosis Negative." By that I mean there's something so wrong with them that you can't bring yourself to put them in a frame or post to your Facebook page. Maybe they're badly out of focus, overexposed, or wildly bright, or maybe it's a fuzzy photo your kid took of their toes. I want to show you a few possible ways to save them in this chapter. Here are some of my photos that are Prognosis Negative:

▶ **Photo Study 51: Maximum Blur**—We literally have hundreds of photos where the subject is blurry. In this case, it's my daughter Grace. Instead of deleting this, I will turn it into stationery for notepads or letters.

▶ **Photo Study 52: Deblurification**—My youngest son, Sam, took this photo of my wife Anne (while she was changing his poopy diaper). It's a great photo if you overlook the fact that it's really out of focus and blurry. I'm going to make this photo usable by reducing it.

▶ **Photo Study 53: Camera War Photomontage**—What happens when you give young kids digital cameras and the freedom to run around and have fun with them? Camera wars! Watch me turn these otherwise useless photos into something memorable.

▶ **Photo Study 54: Last Picture Syndrome**—Film cameras occasionally mess up the last picture on a roll. In this case, my mom's side of the picture is ruined. Instead of throwing it away, I'm going to salvage something out of it.

▶ **Photo Study 55: Mega Flash**—Here is another photo of my mother. This time she's on the couch with my grandfather, and the flash probably blinded them because the picture looks completely washed out. Despite these problems, I can recover enough detail to make it a keeper.

▶ **Photo Study 56: Prognosis Pink**—Here is another poorly exposed print, which is of my wife at her third birthday party. It's so pink that you can barely make out any of the details. Watch me rescue what I can—and see how I do it.

Photo Study 51: Maximum Blur

FIGURE 9.1 IS A CLOSE-UP shot of Grace. She was playing in one of the boys' new shirts. We called them their vacation shirts because they were silky button-up types that you might wear on a vacation to Hawaii or some other tropical paradise.

I honestly don't know what to do with it. It's a terrible picture, but it also tugs at me. She looks cute, even through the blur. Well, in this case, I can make something else out of it that doesn't rely on clarity for its value. How about stationary or notepad paper? Here's how you can do it, too:

1. Open your photo (digital or otherwise) and save it as a .pspimage.

2. Straighten and crop if you need to.

3. Create a new raster layer above the Background, as seen in Figure 9.2. I'll call this *White Base Layer*. It will serve as our white base layer. Isn't logic grand?

4. Click the Foreground and Stroke Properties swatch in the Materials palette and select a fill color. I will choose white, but you can choose any color you would like your stationary to be. You can even have fun with gradients, patterns, or textures.

5. Use the Flood Fill tool to fill the base layer with the color. Figure 9.3 shows you how my layers are stacked up so far.

Figure 9.1
Through a glass darkly.

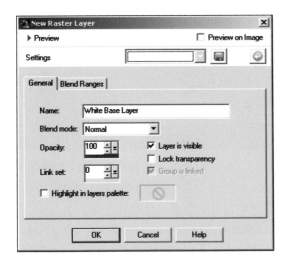

Figure 9.2
Creating a base layer.

6. Although you could convert your Background layer to a normal raster layer and move it up, I prefer to duplicate the background photo layer and arrange it so that it's the top layer in the Layers palette. This preserves the original Background and keeps it safely out of the way.

7. Lower the duplicated layer's opacity to blend it into the white base layer (Figure 9.4).

 You could also just lower the white layer's opacity and not fiddle with duplicate photo layers. That changes the artistic process, however. Rather than transitioning from the blurred photo to white you would be moving from solid white to blurred photo. That may or may not make a difference in how you evaluate the aesthetics of lowering opacity, but I prefer working from the duplicate photo layer.

Finishing the Photo Study

That's all there is to it. The critical steps were choosing a good color for the "paper" and setting the opacity for the top layer. You don't want it too visible because the flaws will be on full display. You want a subtle suggestion of the photo, almost like a watermark. Although I didn't feel the need to, perform a merged copy (Ctrl+Shift+C), paste that as a new layer (Ctrl+V), and continue to manipulate the effect. Try using the Text tool to put a name or a message on your notepaper.

Size the overall image to match the paper you want to use, or (better yet) send it to a professional printer and have them print it out and bind it into notepads. The final result (Figure 9.5) shows that you can turn a treasured yet flawed photo into something useful.

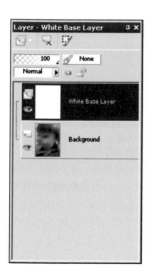

Figure 9.3
Making it white.

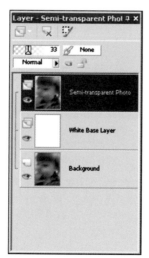

Figure 9.4
Change layer opacity to blend.

Figure 9.5
Cool stationery or notepad paper.

Photo Study 52: Deblurification

THE PHOTO IN FIGURE 9.6 was taken by our youngest son, Sam, while Anne changed his diaper. He was just over two years old when he took this. His composition is great, and he caught Anne with a fantastic smile—you would never know what she was doing.

The problem is, of course, that Anne is completely blurry in this photo. That isn't necessarily Sam's fault. We don't give the kids $1,500 cameras to run around with. This photo was taken with a Panasonic DMC-LZ8 which sells at around $100 at the time I am writing this (early 2010). Although it is a very capable camera (especially compared to our earlier 1MP and 3MP models), it is still a budget compact digital camera with no anti-shake or image stabilization features. When you combine that with the inevitable lag between the time you press the shutter and when the picture is taken, the photographer and subject often move, which makes the photo blurry.

Figure 9.6
Another really blurry photo.

You would think this photo was unsalvageable, but, quite by accident, I realized I could make something of it. I was looking at a small thumbnail of the photo and thought it was a good one. When I opened it up, I realized it was so blurry that it was basically useless. This happens a lot if you're looking at the LCD screen on the back of your camera to tell if photos are good or not and you don't zoom in. The small size fools you into thinking it's fine when it may be badly out of focus or blurry. To work with this photo, I'm going to do the same thing: reduce its size.

Shutter Lag

I hate shutter lag—the time between pressing the shutter release button to take the picture and when the camera "clicks" and tells you it has it.

It's possible to anticipate and work around shutter lag, but it's a pain. Unfortunately, shutter lag is mostly unavoidable in the current crop of compact digitals and super zooms, regardless of price—most have lags from between a third and half a second. With a few exceptions, you don't start getting cameras that respond as fast as you want them to (under a tenth of a second up to about a quarter of a second) until you increase your investment and get a digital single lens reflex (dSLR) camera.

Reducing

First, I'll reduce the size of the photo, which is the whole point. It gives me a sharper image that I can then retouch. As with many things, deciding the right size is largely a matter of trial and error. The original photo was taken with an 8 megapixel camera and has dimensions of 3624×2448. This photo was so badly blurred I don't think there's any chance of saving it anywhere near that size. How small it needs to be, I'll just have to find out.

I'll do this by using my mouse wheel to gradually zoom out and make the photo smaller. This simulates reducing the size on-screen so I don't have to continually do and undo. When I see the picture turn from something blurry to something that looks reasonably sharp, I'll stop and take note of the magnification. As you can see from Figure 9.7, it's 8%. That gives me a ballpark figure to start with.

Figure 9.7
Zoom out until it looks better.

Next, I open the Image ❯ Resize menu and resize the photo to 8% (see Figure 9.8).

Figure 9.8
Resize.

If this is your first time through, examine the photo at 100% (see Figure 9.9) after you've resized it to your initial target percentage. If it looks good, continue on or try a less severe reduction. If not, undo and choose a different percentage. You may decide later in the process to come back to this point and try a different percentage. Don't let that throw you—it has happened to me.

Figure 9.9
Examining 8%.

This Actually Works

I told my wife about this technique, and we had a good laugh about the circumstances of the photo (the diaper). She told her mom, who ended up using the technique not too long thereafter to put a blurry photo in a newsletter she designs, lays out, and edits for her church. She was able to use a photo that didn't look good large by resizing it much smaller. So, hey, this actually can come in handy!

Finishing the Photo Study

I settled on a reduction to 7% of the original size, which resulted in a photo that measured 228×171. That's a pretty big reduction, but it turned a really blurry photo into something usable.

After finding where the best reduction was, I made some additional adjustments to give the photo more life. I used Smart Photo Fix and accepted the suggestions, and then I used Color Balance to cool it down some (the original photo had too many yellows). I sharpened with Unsharp Mask and smoothed with a light touch of Digital Camera Noise Reduction.

The final result, shown in Figure 9.10, is a great little photo—certainly good enough to put in a newsletter or online on Facebook, MySpace, Twitter, or another site where you can use small photos to customize your pages.

Figure 9.10
Deblurification.

Photo Study 53: Camera War Photomontage

DIGITAL PHOTOGRAPHY ALLOWS you to experiment, play, and learn while you take thousands of photos—all at a very reasonable cost. We have more than one compact digital, so the kids get to have camera wars. They run around taking pictures of things that interest them, which usually includes their siblings (as shown in Figure 9.11). When this happens, they try to catch each other off guard or in the act of taking a photo back at them. It's very exciting and fun for them.

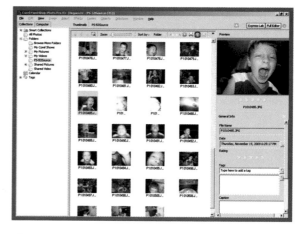

Figure 9.11
Kids take lots of pictures.

Cameras and Perspective

If you want to see how your kids look at the world, give them a camera and let them take pictures. (The cameras we let them use are real, so we teach them responsibility, but not so expensive that we can't afford to lose them.) Our kids are very interested in their toes and feet. They take dozens of photos of them. They are also smaller than us, so a good number of their photos are from that unique per-spective. They often take pictures of our backsides, waists, legs, knees, or other eye-level objects (for them). At other times, the photos look up.

The problem, as you might guess, is that when I download them, I find scores of blurry photos with very few in-focus shots worth printing. The overall effect is priceless, however. Anne and I love scroll-ing through slideshows of these photos because we get to see what the kids were doing and can track their progress around the house. It's hilarious.

My goal for this study is to take a series of shots that our kids took and put them into a context where the whole outweighs the parts. Specifically, I'm going to make a desktop wallpaper out of thumbnails of a number of photos.

Getting Ready

The great thing about this study is that you don't need to fuss over single photos. They are what they are, and they will all be resized small enough to cover up a lot of their faults. About the only thing I would do is correct the brightness with Levels if things are really (and consistently) off.

There are several steps to this, and they bounce back and forth between different aspects of PaintShop Photo Pro, so hold on.

1. First, identify the size of the wallpaper you want to create. This will tell you how many photos you can use and how large they can be. In my case, the desktop resolution is 1,680 pixels wide by 1,050 pixels tall. That's the size of the final file I will create and the context for the photos I will use in my montage.

2. Next, decide how small the photos can be and still be somewhat recognizable. There are a few ways to do this:

 Open a sample photo and resize it down until it's nice, sharp, small, but still recognizable. This is what Photo Study 52 is all about. You'll have the final dimensions based on the final image size.

 Or create a new image in PaintShop Photo Pro the size of your desktop. Open a sample photo, copy and paste it in the desktop-sized image, and use the Pick tool (in Scale mode) to resize the photo down until you like it (see Figure 9.12). Copy this image to a new file to determine how large it is (look in the status bar).

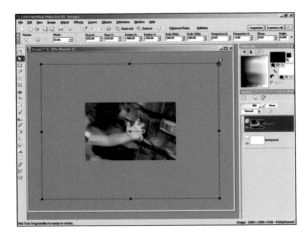

Figure 9.12
Shrinking down a test photo.

Or decide how many photos you want in the collage and work backward from there. Do the math to determine how small they need to be.

3. Determine the resized photo's dimensions. In my case, I like an image size of 210×158. That means I will resize the photos in question to those dimensions.

 There's no need to save anything you've done up to this point. You've been trying to find out how small the photos you want to use should be.

4. To find out how many photos of this size you can fit on a graphic the size of your desktop, divide the desktop dimension by the resized photo dimension. This comes out to 8 wide (1,680/210) and 6.65 high (1,050/158) for me, which rounds down to 7 by 6 if I want room for a border around the edge.

5. How many photos does that make? Exactly 42, which creates a grid of 7×6 photos. Therefore, I need to select 42 photos to make up this collage. The total dimensions of the collage (without the border) are 1,470×948 (7 times 210 from step 3 by 6 times 158). You'll need this for later.

It's a Mad, Mad, Mad, Mad World

No, this study is not a convoluted psychology experiment to see if you can follow instructions or where your pain threshold is for giving up. It's actually more easily done than explained, if that makes any sense. However, I didn't want to shortchange you in the instructions department.

Recording Scripts

With the dimensions figured, I can record the script I'll use later on all the photos for this study. I've decided that my script is going to do two things: lighten the images by the amount I determine and then resize them. Here are the steps I used:

1. Open a sample image to work with. This is just to get the script recorded—you won't save the image either.

2. Select the File > Script > Start Recording menu (see Figure 9.13). This gets the ball rolling. Everything you do now gets recorded into a script.

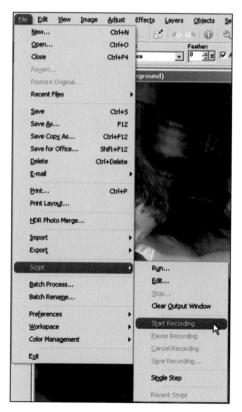

Figure 9.13
Recording the script.

3. First, select Image > Resize. In the Pixel Dimensions part of the dialog box, make sure the drop-down menu says Pixels and enter the Width and Height of the image you got these numbers from in step 3. Press OK. I always do this first because I have found that making brightness, contrast, and other adjustments to a large image can look different once it's resized. I would rather apply those adjustments to the image as it's going to be.

4. If you don't want to make any other adjustments, skip this step or replace it with one or more other adjustments of your choice. I'm going to select Adjustments > Brightness and Contrast > Levels, brighten a darker image a bit, and then press OK.

5. Now save the script (see Figure 9.14). Select File > Script > Save Recording. Enter a suitable name for your script.

 Remember, when you do this, the details of your script are going to be different than mine, based on what your image size is and whether or not you want to perform any other adjustments.

Figure 9.14
Saving the script.

6. Now, select the final photos you want to use. (You could have done this earlier but I think it fits well here.) I think the easiest way to do this is to create a new folder somewhere on your computer and copy the photos you want to use into that folder. That way, you can overwrite them during the batch process and not have to worry about the originals. In addition, isolating the photos in their own, separate folder makes selecting them in the batch routine very easy. It's a huge pain if they are mixed together with a bunch of photos you're not going to use.

Figure 9.15
Selecting the images to use.

Batch Work

At this point, you've figured out the size of your wallpaper, the size the photos need to be reduced to, created the script to use, and identified and copied the photos to a new folder. To run the batch process, follow these steps:

1. Select the File > Batch Process menu. This opens the Batch Process interface.

2. Choose Browse and then navigate into the folder that has the copies of the photos you want to use (see Figure 9.15). Choose Select All to load all these photos into the process.

3. Check Use Script and then use the drop-down menu to select the script you recorded above, as shown in Figure 9.16.

4. Choose to Overwrite. Remember, you're working on *copies* of the photos. You need to be absolutely clear on that. If you're not, please check Copy and identify a new name or folder.

Figure 9.16
Choosing the script.

5. Press Start. The script will run and make the necessary changes to each image (see Figure 9.17) and then overwrite the original (which is a copy, remember).

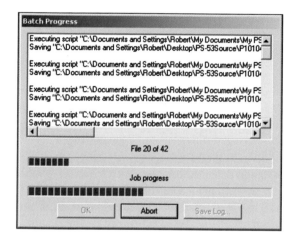

Figure 9.17
Running the script.

Figure 9.18
Creating the initial collage file.

Montaging

You're in the home stretch. All you have to do now is take the resized photos and put them in a photomontage.

1. Create a new .pspimage with the dimensions you decided upon way up in the fifth step of the first part. In my case, 1,470×948 (see Figure 9.18). This is not the size of my desktop because I want a border around the photos. It's easier to create the file with the exact dimensions of the photomontage and then extend it by enlarging the canvas later. You can create a solid background if you like now, or make a background layer later and fill it with the Flood Fill tool.

2. Open each resized photo, Copy (Ctrl+C), select the wallpaper file, and Paste As New Layer (Ctrl+V). This can get tedious, depending on how many photos you're using.

3. If you want, you can use the grid or guides to snap the photos in place or carefully align them yourself in a pattern. If you really want, you can just throw the photos in and not align them at all.

4. When you're done, enlarge the Canvas (Image ❯ Canvas Size) to the same size as your desktop (see Figure 9.19). Then make sure that your background color (or texture) is set.

My final image is shown in Figure 9.20. To finish, make sure that you've saved your .pspimage file so you can come back and edit it later. You might want to change some photos around.

I performed a few adjustments to all the photos. First, I merged the photo layers. I then sharpened with Unsharp Mask and smoothed with a combination of Digital Camera Noise Reduction and Edge Preserving Smooth (3). For kicks, I put it though Smart Photo Fix and liked it. I exported the result as a JPEG and then made it my Windows desktop wallpaper.

Remember not to overwrite your working .pspimage unless you know you don't want to come back and edit it.

Figure 9.19
Enlarging the Canvas to the size of my desktop.

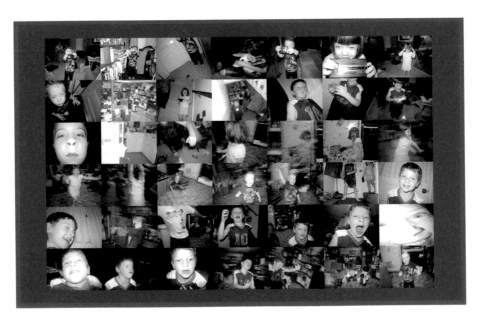

Figure 9.20
Capturing our kids' zaniness.

Photo Study 54: Last Picture Syndrome

FIGURE 9.21 IS ONE OF MY favorite pictures of my mom and me. I was graduating from the U.S. Air Force Academy and my family had come out to watch. We're over near the Chapel in this photo, with the west end of Sijan Hall in the background. I hiked up to the top of the rocky peak you can see behind and to the right of me, which is the beginning of the Rocky Mountains (technically called the Rampart Range).

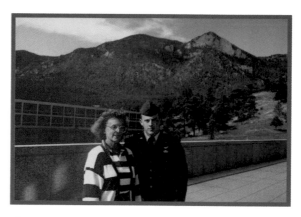

Figure 9.21
Can I rescue this?

This must have been the last picture on the roll because about a third is ruined. Although it is possible this was caused by an exposure problem, it seems more likely that there was a problem with the film's emulsion not being uniformly applied past the last "official" picture. If we had been positioned a little farther to the right in this photo, I could trim the overexposed parts out and be done with it. Because the flaw covers my mom, it has always been Prognosis Negative.

Cleaning Up

This is a print, so I had to scan it in. It had some dust and scratches that I cloned out first, as you can see in Figure 9.22. I got rid of these flaws first because much of the photo has the correct color. You can experiment with doing this later in the process if you like.

Figure 9.22
I'm cloning away dust first.

I haven't spoken about the Salt and Pepper filter much (Adjust > Add/Remove Noise > Salt and Pepper filter), but you can sometimes eliminate fine particles of dust using it and save yourself some time.

I am about to apply it in Figure 9.23. The key is to match the speck size and sensitivity to the specks on your photo you want removed without damaging what you want left behind. These small values are a conservative choice, and the result is effective.

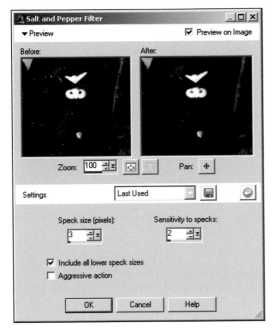

Figure 9.23
Finishing with the Salt and Pepper filter.

Color Adjustments

In terms of color, you have to treat a photo like this as if the two sides were entirely different pictures. There is the large difference between the correctly exposed side and the overexposed side. When you look closely at trying to mitigate this flaw, the photo naturally breaks into four areas: the sky, the mountain, the building, and mom. Those four areas are going to react totally differently to any sort of color adjustment. In fact, there is no single adjustment I can make that will turn this photo around. It's going to take several, targeted (that's the key) color adjustments.

After the initial touch-up, I duplicated the photo layer several times to make separate working layers and then moved on to retouch each separate area.

First, I matched the sky. I've opened up the Channel Mixer (Adjust > Color > Channel Mixer) in Figure 9.24 and am searching for the right settings to make the sky look right. Ignore everything but the sky when you're doing this sort of adjustment. This is taking place on the layer I've chosen as my sky layer.

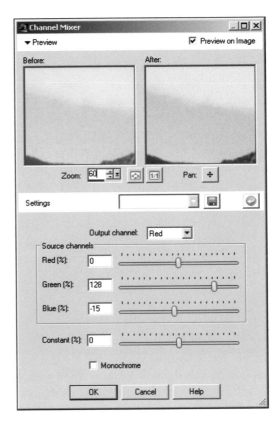

Figure 9.24
Matching the sky first.

Next, I focused on the mountain (Figure 9.25) and attempted to get the foliage to look good. It was a challenge, and I spent a lot of time tweaking the settings to find something that looked good.

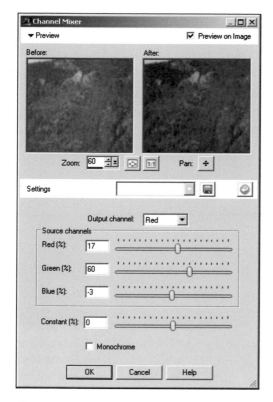

Figure 9.25
Matching the vegetation.

Figure 9.26
Masking out all but sky.

After I made these changes, I decided to mask out what I didn't want to see in order to make a composite image. I created a Show All mask in Figure 9.26 and carefully hid everything below the sky. I used variously sized Paint Brushes with different hardnesses to paint the mask on. You can see that I've hidden the layers beneath the mask group so what is masked out stays masked out. If the base layers are visible, you'll see them and think your mask isn't working.

After that, I created another mask for the left side of the mountain, as seen in Figure 9.27. Look closely at my Layers palette. This mask group rests on top of the visible sky so you can see both. All the other layers are hidden for now.

Figure 9.27
Adding foliage.

When the sky and foliage were done, I used the Change to Target Brush on another layer that had the building and wall to change their saturation and hue to match the wall on the right side of the photo. Figure 9.28 shows the resulting composite. Everything looks pretty good except Mom, who I will turn to next.

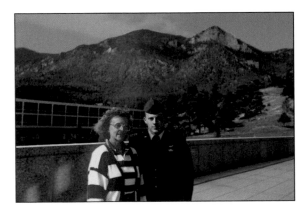

Figure 9.28
Everything but Mom is better.

Focusing on Mom

To finish Mom, I performed a merged copy (Ctrl+Shift+C), and pasted that as a new layer (Ctrl+V). I put it as the top layer in the Layers palette. This merged copy is my way of making sure all the changes I've made so far are locked into one layer. Next, I duplicated this layer, selected Mom with the Freehand Selection tool, inverted the selection, and deleted the surrounding material. I wanted her on her own layer. (You'll see this in the next figure.)

With this done, I could make a Histogram Adjustment to my mother (Figure 9.29) without affecting the rest of the photo. I'll erase the excess material (a mask would have worked here, too) around her when I'm ready to blend her in.

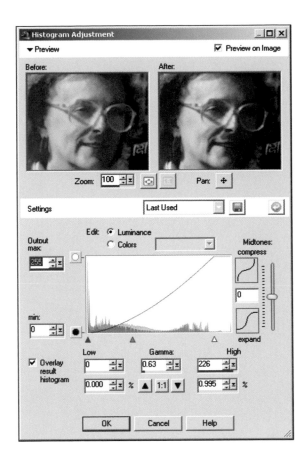

Figure 9.29
Adjusting her histogram.

I've done some of that erasing and am in the process of making a Curves adjustment. (I continually refine things, as I'm sure you know by now) in Figure 9.30.

Finally, I used the Change to Target Brush to match some of her skin tone with mine and lowered her saturation. That was rather touchy. Remember, Change to Target has four modes: Color, Hue, Lightness, and Saturation. You can switch to any of these, depending on what you're trying to match.

Figure 9.30
Adjusting her curves.

Finishing the Photo Study

I could have done this several different ways, none of which are "right" or "wrong." I used masks for the sky and mountain but used the "duplicate layer, select subject, invert selection, delete what you don't want, make changes, erase to blend in" techniques for the building and my mother.

When it came to making the color adjustments, I came as close as I could, realizing this photo was Prognosis Negative. Any improvements are welcome. I tried using the Channel Mixer, but it never looked right, so I resorted to the Histogram and Curves and that looked much better. The Change to Target Brush helped tremendously.

The final result is shown in Figure 9.31.

Figure 9.31
Although still flawed, this has been saved.

Photo Study 55: Mega Flash

FIGURE 9.32 IS A PICTURE of my mother sitting on the couch with her father, my Grandpa Johnson. In the photo, she and Grandpa are sitting on our shiny blue velvet couch in front of gold drapes. It was the late 1970s, which helps explain the color and fabric choices. My mom looks beautiful and has a great smile in this photo.

This photo is seriously flawed. I don't know why I kept it over the years, but I'm glad I did. It's a perfect example of Prognosis Negative.

Bringing Out Details

The whole point with a photo like this is to see what kind of detail you can bring out. Most of the information in this photo appears to be lost.

I normally make successive changes to a picture, each change using a separate layer. It's been my experience that making one change (especially to a really damaged photo) is rarely enough. You've got to whittle away at the problem one step at a time. If you make small nudges along the way, you'll end up with a much better result than making one huge change.

Figure 9.32
Youch, that hurts it's so bright!

The first and most dramatic step is to make a Histogram Adjustment. All the values are scrunched over in the far right side of the graph in Figure 9.33. This shows you graphically what your eyes can plainly see: the picture is too bright. To counter this, I've brought the Low slider up dramatically but left the Gamma alone.

That was probably the best thing I could do, and it's going to make the most difference. Now, I can try to make it look better through the successive application of different tweaks.

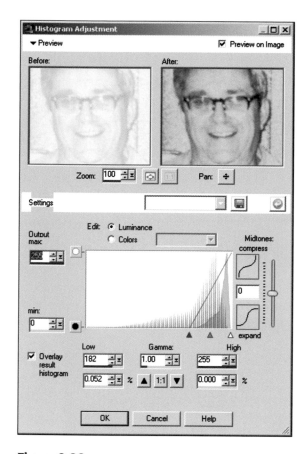

Figure 9.33
Bringing out details.

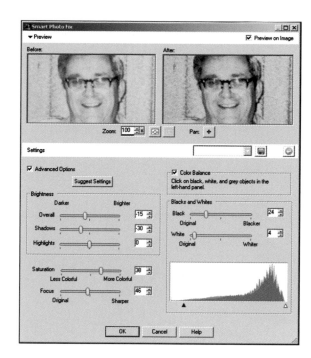

Figure 9.34
Tweak with Smart Photo.

First, I'll run it through the Smart Photo Fix (Figure 9.34). It's always a good idea to see what this tool says you should do, and many times I accept its suggestions. In this case, it has made good contrast and tone improvements. In cases where I don't use it, I can often tell from the settings it suggests where problems are that I may not have realized at first.

Next, I chose to remove some of the noise. I used One Step Noise Removal from the Adjust menu, with the results shown in Figure 9.35.

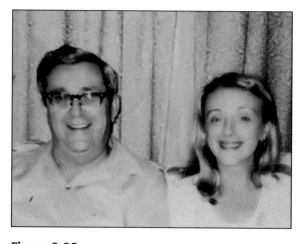

Figure 9.35
Effects of noise reduction.

This may seem like I randomly applied one effect after another. I didn't. I made each change and then evaluated where to go next, based on what I saw. I normally don't go back to something far earlier in the process unless it's clear I'm at a dead end.

Results Matter

In the end, it's *your* workflow—no one is going to grade you for whether or not your interim steps bore any semblance to rationality or consistency. Results are what count. I have tried different experiments with photos where I took a rambling course toward a solution that worked and then tried to accomplish the same thing with a more streamlined process, only to be unable to reproduce the effect with something that seemed more logical.

After reducing the noise, I turned my attention to Levels (Adjust > Brightness and Contrast > Levels). The minor tweak shown in Figure 9.36 helped the tone.

Then it looked like the contrast needed adjusting, so I used Local Tone Mapping (formerly Clarify). Figure 9.37 continued to show improvement, so I pressed onward.

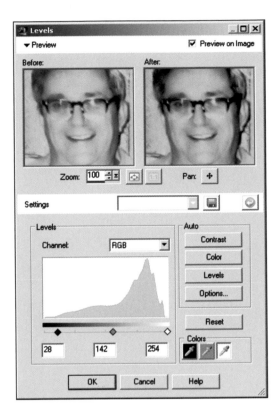

Figure 9.36
Continuing to tweak Levels.

I cloned away the specks and spots that were made visible from all the brightness and contrast adjustments (Figure 9.38). I purposefully waited until this late stage because it didn't make much sense to spend my time working on those (the ones I could see, at any rate) before I addressed some of the more important problems.

At last, I finished the photo study with the Sharpen Brush set to a relatively low opacity (5–10) and sharpened around Mom and Grandpa's faces (see Figure 9.39).

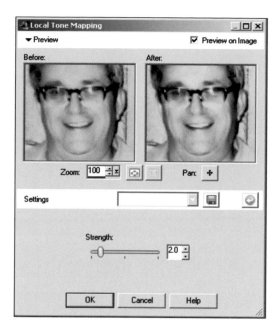

Figure 9.37
Clarify for added contrast.

Figure 9.38
Removing spots.

Figure 9.39
Sharpening selective details.

Finishing the Photo Study

Whew. This was a string of adjustments that I didn't think would stop. I started with a photo that looked far too bright and washed out. There wasn't much detail to be had. Through a Histogram Adjustment, I was able to bring enough out to make it look really promising. The rest was gravy. I improved the brightness, contrast, and focus of the photo. Coming from Prognosis Negative, the final result (Figure 9.40) is rewarding.

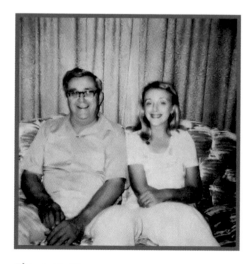

Figure 9.40
Now it's a great photo.

Photo Study 56: Prognosis Pink

FIGURE 9.41 IS AN UNSALVAGEABLE photo if I've ever seen one. You can barely tell, but this is a picture of Anne at her third birthday party. You can see part of her birthday cake in the lower-left corner of the photo. She is laughing and has a big smile. Something happened to the film when it was in the camera. Her mother says every photo on the roll turned out this way when it was developed. Prognosis Pink.

This is a challenging study, made more challenging because I wasn't able to duplicate the same effect in PaintShop Photo Pro X3. For some reason, the Channel Mixer (which was the whole shootin' match) left me with a very purple image. It didn't look as good as before, and I wasn't able to get the settings to work for me. So I decided to start over. That left me with a process that bears little resemblance to the study I wrote for the first edition of this book, but there is merit in telling you this story and continuing on with a new solution anyway because it paints the picture of real-world photo retouching and restoration.

Taking the Pink Out

Rather than try to keep color in this photo, I'm going to go straight to black and white. First, I decided to take a look at the Red, Green, and Blue channels to see where the most data was. Figure 9.42 shows that Green and Blue provide the most information. Red is almost a complete washout. I can use this to help me blend information from the channels to create the best-looking black-and-white image.

Figure 9.41
One of the worst photos I've seen.

There's an important point to note about the Red channel. It has good information at the top, which shows the counter and sink behind Anne. If I reject the Red channel, I will lose this. Since Green has the most detail and Red has missing detail, I can use a combination of the two to arrive at the best black-and-white image. I'm using the Channel Mixer in Figure 9.43 to do just that.

Next, I start correcting the levels. The Levels dialog box is shown in Figure 9.44.

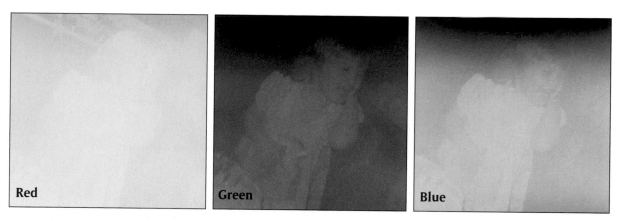

Figure 9.42
Examining the color channels.

Figure 9.43
Taking the pink out.

Figure 9.44
Correcting levels.

Favorite Methods

Over time, you will find your own favorite methods for tackling problems. The funny thing is, they change periodically. That's one reason why I've been careful to avoid telling you a particular method is "The Way" to do something. I've tried to expand your thought processes, your imagination, your horizons, and your creativity by sharing how I do things, telling you why, and at the same time letting you know that you have the power to make up your own mind.

Next, I decided it was time to sharpen the photo, as shown in Figure 9.45. Notice that I've not cloned any imperfections out. This is another case where fixing the other problems takes precedence.

Figure 9.45
Sharpening, but not too much.

After this, I took the bold step of bringing in Local Tone Mapping. Notice from Figure 9.46 that the settings are maxed out. Normally, I would not do this because the risk of creating ugly halos is great. However, the reward of the additional details in the photo is too great to pass up.

Figure 9.46
Boldly tone mapping the photo.

Next, I wanted to see what a good dose of Noise Reduction (see Figure 9.47) would look like. I think it does a good job of smoothing out the image. I'm almost done.

Finally, now that the specks and scratches are visible and the rest of the photo is in its final form, I can clone the problems out without worrying about tone or texture mismatches, as shown in Figure 9.48. At this point, if you can't match things very easily with the Clone Brush or Blemish Remover, don't sweat it. You've already saved the photo.

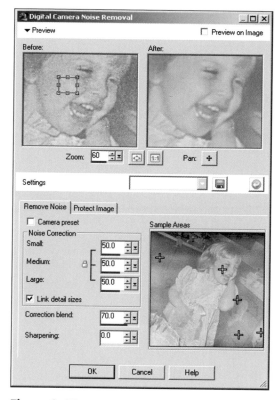

Figure 9.47
Smoothing with noise reduction.

Figure 9.48
Time to clone.

That makes it all worthwhile.

After laying this aside for a while, I came back and performed a Histogram Adjustment to lighten the photo and then did another round of light sharpening with Unsharp Mask and Digital Camera Noise Reduction. It may sound like overkill, but I thought I could get her a bit clearer and smoother.

Finishing the Photo Study

This photo was a challenge. Its original state was Prognosis Pink. There was no way to restore it to what it was intended to capture, but with PaintShop Photo Pro I was able to rescue a surprising amount of detail from the beautiful photo of a young girl having the time of her life at her third birthday party (see Figure 9.49).

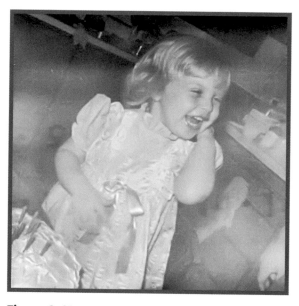

Figure 9.49
Priceless rescue.

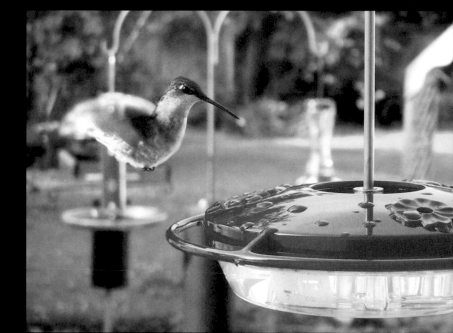

Making Good Photos Better

10

I LOVE GOOD PHOTOGRAPHS. I love looking at them, printing them out, sharing them with family and friends, and hanging them on my walls. My guess is that you do too. Otherwise, you wouldn't be interested in retouching and restoring photos.

I want to use this chapter to open your eyes to the fact that you can and should use PaintShop Photo Pro to retouch photos that don't have anything obviously wrong with them at first glance.

What do you think professional photographers working with perfect models/subjects under perfect conditions using the most sophisticated and expensive equipment money can buy as their assistants hand them their lattes are doing? Do you think they're taking terrible photos and rescuing them? No. They're taking great photos and making them fantastic. So that's the focus of this chapter. And pass me that latte.

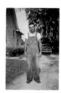

▶ **Photo Study 57: Working Man**—It's not hard for me to take this old, black-and-white photo of my wife's grandfather, Bud, and make it better using most of the techniques I've already shown you.

▶ **Photo Study 58: Hummingbird in Flight**—This photo of a hummingbird just outside our kitchen window made me want to write this chapter. It's already good. Can I make it better?

▶ **Photo Study 59: Lipstick, Please**—Here is a photo of my wife with nothing at all to repair. After we took some time to look at it (an important part of this work), however, we realized she could use some lipstick!

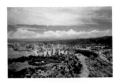

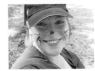

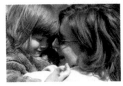

▶ **Photo Study 60: Waikiki from Diamond Head**—I didn't think there was anything wrong with this scanned photo either, until I opened it in PaintShop Photo Pro and started experimenting with different techniques to remove the minor imperfections. I discovered it needed to be brighter and more colorful.

▶ **Photo Study 61: Face Painting**—This is another picture of my wife at a local festival. Sometimes, you don't really notice these things at first, but her face is too dark in the original photo.

▶ **Photo Study 62: HDR Photo Merge**—I love high dynamic range photography because it brings out details in a scene that may not be visible in a single shot. Follow along with me as I use HDR Photo Merge to introduce you to this wonderful facet of photography.

▶ **Photo Study 63: Firetruck Tour**—This is an exercise in brightness and noise. Anne and Ben are a touch dark, and there is a subtle noise level in the photo.

▶ **Photo Study 64: Sharpen and *Sprucen***—This is another great example of a very good digital photo that needs just a little sharpening and *sprucening* up (that's me being funny—no one was asleep at the spell checker) to go from good to great.

Photo Study 57: Working Man

FIGURE 10.1 IS ANOTHER PHOTO of Bud (his name was Art but everyone called him Bud), my wife's grandfather. I've got several photos of him, Louise, and their kids in this book. As a family, they took a lot of pictures, and this is another wonderful photo. It was taken after he came back from the war (World War II). He started out farming and went on to become a very successful salesman.

For its age, this photo appears well preserved. It still looks good, and is a great candidate for this chapter. I'm going to see if I can make it better.

Getting Started

First, it's a good idea to clone the small stuff out when things are already looking good. There is a bend in the photo in the top-left corner that needs to go and miscellaneous specks throughout. I'm beginning to clone in Figure 10.2

Figure 10.2
Cloning away minor issues.

The cloning stuff should be old hat for you by now. Create a blank layer (my technique) to clone on, grab the brush, adjust its size, right-click to set the source, and you're off.

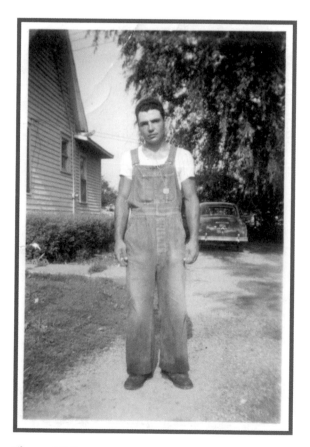

Figure 10.1
Great photo of a working man.

Next, I'm going to use Histogram Adjustment to improve the overall brightness and contrast (see Figure 10.3). I've brought the Low slider up and lowered the Gamma a tad to improve contrast. Both these adjustments have the effect of slightly darkening the photo.

Figure 10.4
Sharpening improves focus.

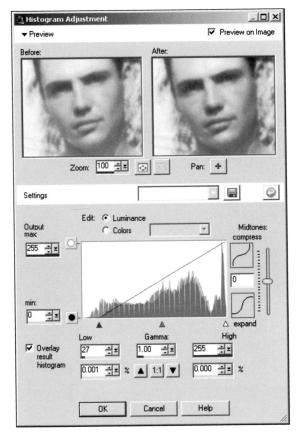

Figure 10.3
Histogram improvement.

Next, the photo could use a little sharpening. The Unsharp Mask filter (Adjust > Add/Remove Noise > Unsharp Mask) works very well (Figure 10.4), especially when you don't try to overdo it.

Tweaking

With those adjustments completed, I want to see if I can continue to tweak things a bit. I realize I just sharpened the photo, but I did that in part to prepare the way for a noise reduction. Applying the One Step Noise Removal (Figure 10.5) will help smooth Bud's skin.

Next, I almost always take a look at what the Smart Photo Fix suggests. In this case, I clicked on objects in the left windowpane of the dialog box (Figure 10.6) to get the right color balance and left most of the other settings alone.

Figure 10.5
Noise reduction to smooth.

Figure 10.6
Tweaking with Smart Photo.

Cleaning up the border will almost complete my work. I'm using my top working layer and have selected the photo; then I used the Selections ❯ Invert menu to change that selection so that the border is active. I've selected the Lighten/Darken Brush and am in the process of brightening up the border in Figure 10.7.

Figure 10.7
Cleaning up the border.

Finally, there is one area in the top-left corner where the Clone Brush didn't get a good gradient. It looks too obvious. I can create a new raster layer and use the Flood Fill tool to create my own sky gradient from scratch.

First, I'll use the Dropper tool to select a dark and light color from this area into the Foreground and Background swatches of my Materials palette. These will form the "end points" of the gradient, and I chose them by looking at this area of the photo and selecting the colors that are in the picture. Next, I'll create a point-to-point freehand selection of the area I want to fill (Figure 10.8).

Figure 10.8
Selecting a difficult area.

Finally, I'll use the Flood Fill tool to apply a Foreground to Background gradient into the selected area on the empty layer. I'm erasing (fuzzifying) the borders of that area in Figure 10.9 in order to blend it in with the rest of the photo. I've turned off the other layers so you can see this clearly.

Figure 10.9
Blending in a gradient.

Finishing the Photo Study

The funny thing about this photo is that I actually did a lot of stuff to it. I made contrast changes, cloned out blemishes, cleaned up the border, sharpened the focus, removed noise, and created a gradient to blend part of the sky better. To finish the image off, I made a small Curves adjustment to improve contrast, and I blended that layer in by lowering its opacity to 46 and changing its mode to Soft Light. The moral of the story? Even good photos can be improved upon (Figure 10.10 shows the final result), and when you start working, don't limit yourself to two or three steps. Go with it!

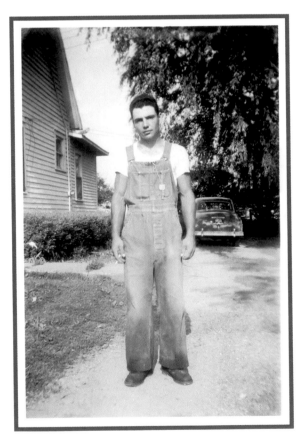

Figure 10.10
Contrast improvements make this better.

Photo Study 58: Hummingbird in Flight

FIGURE 10.11 IS A PHOTO OF a hummingbird coming in for a drink outside our kitchen window. Animal shots are very hard to capture because of the nature of the subject (animals are unpredictable) and the action. You can't just yell at a bird to stay still.

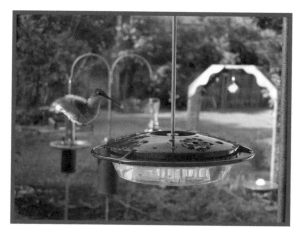

Figure 10.11
Close shot of a hummingbird.

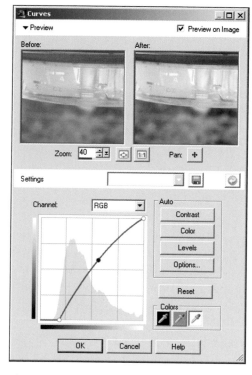

Figure 10.12
Subtle Curves adjustment.

Subtle Adjustments

The theme for this photo is that subtle adjustments can make a big difference. At first glance, the original hardly needs a thing done to it. However, when I opened the photo up in PaintShop Photo Pro and went to the Curves dialog box, I saw things were off. I made an adjustment upward and then bent the curve outward (see Figure 10.12). The preview window shows the bottom of the feeder. I didn't want to get this too light.

After this, I wanted another Curves adjustment to brighten the bird. Therefore, I went back to my Background layer (which I always preserve as the original photo), duplicated it, and performed a different Curves adjustment. Figure 10.13 shows the dialog box.

That last adjustment looked good for the bird, but came close to blowing out the feeder. Instead of using a mask to create a composite image, I decided to blend the two layers (one darker and one lighter) in the Layers palette (see Figure 10.14).

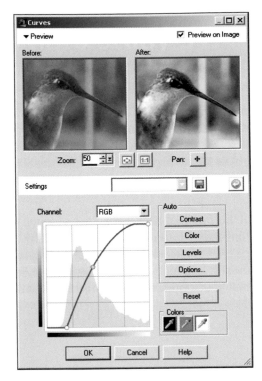

Figure 10.13

Making a new adjustment for the bird.

The initial, darker adjustment is on top with an opacity of 63 and a normal Blend mode. I thought this was the best of both worlds. It lightened the image, increased the overall contrast, and kept areas from being too dark or too light.

Figure 10.14

Blending the two adjustments together.

Finishing the Photo Study

To finish, I dodged and burned the hummingbird to create some liveliness and then performed moderate noise reduction over the image, blending that layer in at 50%. In the end, I decided to crop the photo to get a tighter look at the hummer. Then, at the very end (you see how this never ends sometimes?), I lightened the image just a bit with Histogram Adjustment by raising the Gamma.

This photo (see Figure 10.15) was good to begin with, but the final result is better than the original. Remember, this chapter is about making good photos better. Look around for some really good photos of your own and see what the histogram looks like. Open the Curves dialog box and see if there is any imbalance to the overall RGB or individual color channels. Be an investigator, and remember that even a few small changes can add up to a world of difference

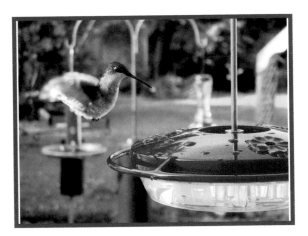

Figure 10.15

Better composed and much clearer.

Photo Study 59: Lipstick, Please

FIGURE 10.16 IS ANOTHER PICTURE of my wife, Anne. We bought the black child-size cowboy hat at the local supermart, and she's playfully tipping it at the camera. Ben, who had just turned five years old, took this photo. Great job, man!

I stumbled across the idea for this photo by accident. I was looking through all our digital photos, and this struck me as being a beautiful picture of Anne. Then, with a critical eye, I started looking for things I could fix. I didn't come up with any, but when I saw that her lips were devoid of any lipstick, that was that.

Applying the Lipstick

Since I'm going to apply lipstick, I need to decide what color it should be. To get the color, I opened up the Material Properties dialog box (see Figure 10.17), and browsed through different hues and shades. This dark red color was attractive and seemed appropriate.

My Lipstick Expertise

I know nothing about lipstick, so Anne was looking over my shoulder coaching me as I retouched this photo. It pays to have an expert tell you what's what!

Figure 10.16
Great photo, but missing lipstick.

However, and this is an important caveat, what you're seeing is not my first attempt to get the color right. I had to go through the technique a few times to be able to get the right color by the end of the process. I would choose a shade, finish the technique to see what it looked like, and then come back to recalibrate if the color looked off. In the end, I was able to choose the right *beginning* color so that when I was done, it looked the way I wanted.

Figure 10.17
Choosing a base lipstick color.

Next, create an empty raster layer to apply the lipstick on, and then select an appropriately sized brush to paint it on with. I'm applying Anne's lipstick with a brush 50 pixels in size and a hardness of 0 in Figure 10.18. It goes on rather thick!

Figure 10.18
Painting it on.

You don't need to be too picky when you're applying the lipstick because the next step is to switch to the Eraser and trim away at the excess, which I'm doing in Figure 10.19. I'm being careful to use a soft eraser so there are no hard lines.

Figure 10.19
Erasing to fit.

The next step relies on one of those features of PaintShop Photo Pro that separates beginners from more advanced users: Blend modes.

Ah, the Journey

When I first starting using graphics programs, including PaintShop Photo Pro, I didn't understand Blending modes at all. To me, normal was good enough and that's what I used. I didn't even want to learn about the other modes because they seemed too complicated and fussy.

Over time, I realized Blend modes were actually powerful tools that helped me achieve effects otherwise impossible. It doesn't take much to understand them, and they exponentially increase your creativity. The big thing is, start playing around with them and don't give up.

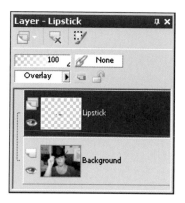

Figure 10.20
Blend mode changed to Overlay.

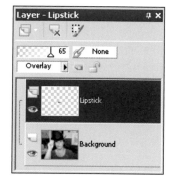 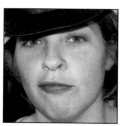

Figure 10.21
Lowering opacity for final effect.

Blend modes are the rules a layer follows to determine how it will blend in with the layer(s) below it. Normal is opacity based. If a pixel is opaque and on top, it covers all pixels beneath it. If it's semi-opaque, you can partially see through it to the layer below. Some Blend modes are based on color, hue, saturation, and other pixel-comparators. Overlay (which I am changing to in Figure 10.20) allows the color of the lipstick to "stick" to the detail of Anne's lips.

After changing the Blend mode, the effect was almost there, but the lipstick was too bright. I lowered the lipstick layer opacity to blend it in better (Figure 10.21). In effect, I'm blending the Blend mode. This double blending results in a very realistic lipstick effect.

Other Adjustments

With the lipstick done, I looked around to see if there were any other improvements that could be made. I'm making a very small Histogram Adjustment in Figure 10.22, just barely bringing the High slider down. This has the effect of brightening the photo.

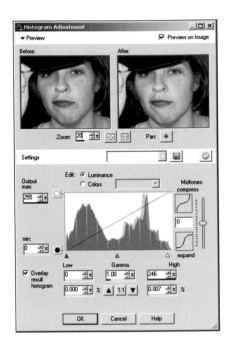

Figure 10.22
Tweaking overall Histogram.

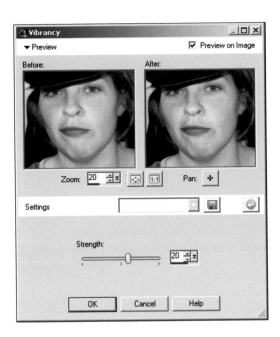

Figure 10.23
Strengthening colors a tad.

After this, I applied a small amount (the setting was 3) of Edge Preserving Smooth to smooth Anne's face out. I tried other noise reduction techniques, and this was the best for this purpose. Then I bumped up the vibrancy of the photo by 20, a fairly good amount. You can see the effect on Anne's face in Figure 10.23. Look at her eyes, cheeks, and lips. They're all definitely more colorful. Perfect!

Finishing the Photo Study

Figure 10.24 shows the final result. After the Vibrancy, I sharpened with Unsharp Mask and then applied One Step Noise Reduction to resize the last layer to effectively crop out some of the everyday aspects of the kitchen background. Don't be afraid to crop or recompose a photo. You can showcase the subject better and make the proportions much more pleasing.

You know, it fits in perfectly with this chapter's theme. Ben took a great photo of his mother, and by adding lipstick and making a few minor adjustments, I've made it better.

Figure 10.24
Lipstick and other subtle improvements.

Photo Study 60: Waikiki from Diamond Head

THERE ARE BUSINESS TRIPS, and there are business trips. I took this photo (Figure 10.25) on one of the best business trips I've had the pleasure of taking. I was stationed at Scott Air Force Base at the time, which is just outside of St. Louis, assigned to Intelligence Plans.

Planning is a huge function of any military, and in this phase of my career, I was heavily involved in ongoing contingency operation execution and war planning (ah yes, the jargon comes back easily to me). This was the mid-90s, and the United States Air Force was delivering food and supplies to many areas in humanitarian crises around the world.

I, therefore, helped develop the plans that we (Air Mobility Command) would follow in an emergency. In this case, there was a planning conference in Hawaii between different services and levels of command.

Still with me? That's how I came to be standing here, on the rim of Diamond Head volcano, on the island of Oahu, looking down on Waikiki and Honolulu.

Figure 10.25
Sightseeing on the island of Oahu.

Enhancing the Photo

Since this photo is basically in good shape, cloning out the specks and dust is a good place to start. Even the best photo will have some of these imperfections if you have to scan it in.

I started at a pretty high magnification (200%), and slowly worked my way around the photo in a search pattern, diligently looking for dust and scratches to clone out (see Figure 10.26). There were quite a few in the darker hills.

Figure 10.26
Cloning away specks.

Next, I had a look at Smart Photo Fix. By this point I could tell there were overall darkness and contrast issues. I have the dialog box open in Figure 10.27, and am carefully looking at the water, buildings, and sky to compare the before and after window panes.

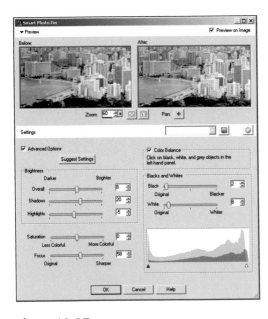

Figure 10.27
Smart Photo for starters.

Smart Photo Fix

You don't have to use Smart Photo Fix if you don't want to. I certainly don't. However, it's a pretty good diagnostic tool to help you get started working on a photo, whether you're new to this or have been doing it for some time. If you use it and accept its suggestions, fine. However, it can help you form a roadmap of what you want to do with a photo even if you disagree with it. The latter point is very important. Sometimes Smart Photo Fix will say the shadows need to be lightened or the entire photo needs to be brighter and I'll disagree (either entirely or by degree). That's doesn't mean opening up the dialog has been a waste of my time. It helped me decide what fork in the road to go down.

Smart Photo looked pretty good, but I wanted a little more contrast. I used Clarify in the first edition of this book, but that feature has been changed to Local Tone Mapping in PaintShop Photo Pro X3.

Use Local Tone Mapping in the same situations you would have used Clarify: to play with contrast and increase the details of what you can see in the photo. In this case, I decided to see what Local Tone Mapping would do, but kept the setting pretty low, as you can tell from Figure 10.28.

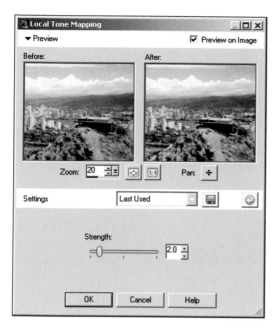

Figure 10.28
Local Tone Mapping boosts contrast and details.

Next, I was struck by the fact that the photo looked grainy. I spent some time investigating different techniques on this one because I realized I was removing a lot of detail in the buildings and foreground with One Step Noise Removal. The result looked great from a distance (low magnification), but not as much close up.

There are a few ways around this. First, you can accept more noise in the photo than you want. Sometimes, photo restoration is like that. Second, you can apply different levels of noise reduction to different parts of the photo. For instance, I could duplicate my working layer and apply heavy noise reduction to the duplicate layer and less noise reduction to the working layer and then selectively blend areas of the two together using masks or the Eraser. That way, I could have smooth clouds and sea and a reasonably well-defined foreground and buildings. Third, you can make the artistic decision to oversmooth and not worry about losing the details.

In this case, I chose the first approach: limited noise reduction using Edge Preserving Smooth, as shown in Figure 10.29.

Figure 10.29
Limited noise reduction.

Finally, after working on the photo for some time, I could tell it had a subtle yellow cast to it. I removed it by making the photo cooler through the Adjust > Color Balance menu. Take a look at Figure 10.30 and see if you can tell the difference. The buildings on the right look whiter and the blues look a little stronger.

Figure 10.30
A touch cooler.

Finishing the Photo Study

Figure 10.31 shows the final result (after another slight contrast boost with Curves). This photo had more problems than I realized at first. This happens a good percentage of the time. You'll look at a photo, think there's nothing wrong with it, load it into PaintShop Photo Pro, and after fixing or adjusting five or six things, realize how much better it is now. Not bad for a 15-year-old photo taken from a disposable film camera.

That's the point of this chapter. Exactly!

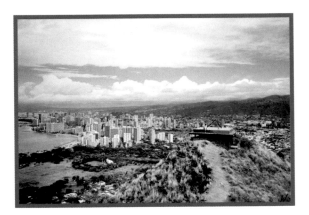

Figure 10.31
The final version is much better.

Photo Study 61: Face Painting

FIGURE 10.32 IS ANOTHER GREAT photograph taken in 2006 by my son, Ben. I was at the Recording Workshop for eight weeks, studying audio engineering and music production. Anne took the kids to the Johnny Appleseed Festival, which occurs annually here at the, you guessed it, Johnny Appleseed Park. We love the exhibits of what life in the Northwest Frontier of the United States was like a long time ago.

Figure 10.32
The original photo looks great.

Making It Better

My first step was to figure out what I wanted to do. After some exploring, I realized the photo was very dark, especially Anne's eyes. The challenge is to lighten her up without making everything else too bright. Figure 10.33 shows the Histogram Adjustment dialog box. The initial graph (in gray)

looked pretty good, but the midtones (controlled by the Gamma slider) needed to be moved up to lighten the photo. I used Anne's ear as a reference point to make sure I didn't brighten the photo too much. If that ear started to get so bright it lost detail, I knew I was going too far.

Figure 10.33
Brightening by adjusting midtones.

Brightening can often reveal contrast problems. In this case, I knew the next step was to resolve them using Curves, as shown in Figure 10.34. You may ask why I couldn't do both at the same time. After discovering that I wanted brightness *and* contrast, I tried to go back and start with Curves to brighten and add contrast simultaneously, but could never find the right settings. What's more, I also tried the Brightness and Contrast tool, but it kept blowing out the highlights. So the circuitous route is sometimes the only effective solution.

You know, if it seems like I'm wandering through some of these photo studies, I probably am. Remember, this chapter is about making good photos better. There's more meandering to this task than say, putting a missing corner back on. Photos that are damaged or need obvious retouching lend themselves to a more linear path from beginning to end. Not always, but much of the time.

At this point, I noticed that Anne's teeth could use a little polishing. I used the technique I introduced in Chapter 8, "Retouching People," and gently polished her teeth with the Lighten/Darken Brush (see Figure 10.35). I used a brush opacity of 50 and hardness of 0 for this application.

Figure 10.34
Adding contrast with Curves.

Figure 10.35
Polishing teeth.

It's funny how perception works. Spend time looking at your photos. Take breaks and come back. You'll be surprised at what your eyes see new, as opposed to when you first started working on a picture. This has happened to me many times as I've worked on photos for this book.

While writing the first edition, I realized Anne's eyes were still too dark, so I made a targeted Histogram Adjustment for her face and blended it in with the other work. This time around I felt like I did a better job of brightening the photo (in effect I moved a Histogram Adjustment from here to earlier in the process), but I still felt as if the second Histogram Adjustment was necessary.

Therefore, I made a second tweak in Figure 10.36, whose sole purpose was to lighten Anne's face and eyes.

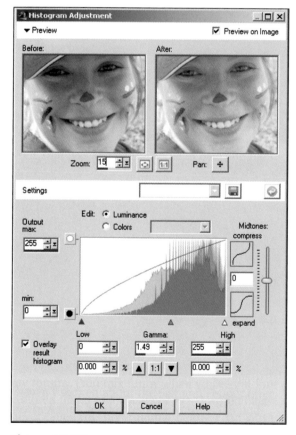

Figure 10.36
The second Histogram Adjustment.

Don't be afraid to get the job done in cases like this. I pushed the settings, knowing I was going to blend this layer in with the one beneath it.

I then selected her face (the brightness adjustment was done on a duplicate working layer) and deleted everything else around it. (I could have masked this material out instead.) I erased around her face with a soft Eraser to blend the borders (see Figure 10.37). Finally, I lowered the opacity of this layer (the one with her brighter eyes) to blend it in with the darker layer below.

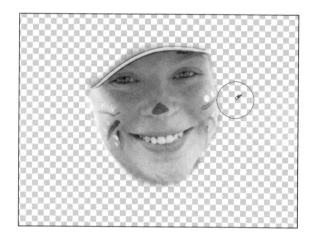

Figure 10.37
Erasing unnecessary material.

I've erased half the lightened layer and am showing the darker layer beside it in Figure 10.38 so you can see a side-by-side comparison of the two effects. On the left side, you have a much lighter, semi-transparent layer on top of a darker layer. (Try experimenting with Blend modes in cases like this.) The right side shows the darker, original layer. The benefit is clear, and because I did the extra lightening only to her face, it won't wash out the rest of the photo!

Duplicate and Delete Rather than Copy and Paste

When you want to make an adjustment on a specific area of a photo and leave the rest alone, don't just copy and paste a selection to a new layer. Try duplicating your working layer and then erasing what you don't need (or masking it out) before you make the adjustment. You can also make a selection and promote it to a layer. Why? Because when you paste something as a new layer it centers what you pasted on the canvas, which means you have to line it up with the pixels below it to get it back in place. This is always a hassle.

For the final step, I elected to perform Digital Camera Noise Reduction instead of Skin Smoothing. It was a tough call. I wanted Anne's skin smoother, but knew I was going to lose detail. I felt like the noise reduction did a better job of smoothing overall.

Figure 10.39 shows the dialog box with my settings.

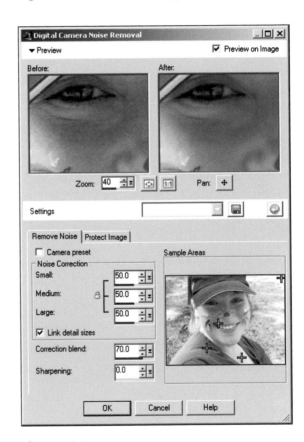

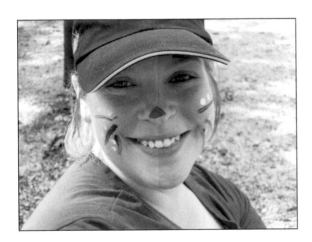

Figure 10.38
Comparing the difference.

Figure 10.39
Smoothing with noise reduction.

One alternative would be to do targeted noise reduction on Anne and mask that out for the rough background. I didn't bother with it because the background is nicely out of focus anyway (the effect of limited depth of field), but I want to mention that it's a viable strategy if you have the time.

Finishing the Photo Study

I want to briefly recap the steps I took to complete this study (it can be confusing at times):

1. Duplicated the background to create a working layer. I continue to do this after each step, except in cases where I create a merged copy.

2. Adjusted overall brightness using Histogram Adjustment (Figure 10.33).

3. Adjusted contrast using Curves (Figure 10.34).

4. Whitened teeth (Figure 10.35).

5. Duplicated the layer from step 4, which created a working layer to make new Histogram Adjustments on.

6. Performed the second Histogram Adjustment on the top layer (Figure 10.36). This lightened Anne's face.

7. Erased around Anne's face (on the Layer in step 6) to isolate the area that I wanted to be brighter and then adjusted the layer's opacity to blend and get the overall strength I wanted (Figure 10.37).

8. Created a merged copy (Copy Merged, Paste As New Layer) to lock in the work from the two layers in steps 6 through 8 on one layer.

9. Performed noise reduction (Figure 10.39).

10. Sharpened with an ever-so-gentle application of Unsharp Mask (not shown).

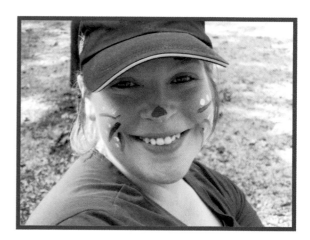

Figure 10.40
A much better, brighter photo.

Archiving

And now, let's take a break from retouching good photos and look at archiving. When I say archiving, I'm talking about preserving your photos electronically and then protecting those digital backups. Your photos could have been digital to start with, scanned photos that are now graphics files, scanned film or negatives, and, of course, the PaintShop Photo Pro Photo files that you generate as you work on restoring and retouching your photo collection. The whole shebang.

For this edition of the book, I can only recommend one approach: go buy hard drives. They're the cheapest and most reliable media out there. They hold tons of data, and external USB, FireWire, and eSATA drives can be easily swapped. I have a couple of external USB drives and an eSATA drive caddy that lets me swap even internal drives on my desktop as if they were floppy disks. I've looked into all the alternatives: tape backup (too clunky, proprietary, and expensive), DVD/CDs (far too little capacity), and online storage (for my purposes, this would take far too much Internet bandwidth). No other solutions are as inexpensive, reliable, and compatible. You just drop the files there to copy them—nothing to decode to reverse the process.

To conclude, the more distance you put between the originals and the backups, the greater the security if something drastic goes wrong. Of course, this safety tends to come at the cost of practicality and convenience.

Don't lose all your great work because you didn't think about this. Don't lose your family's history because you never backed anything up. Start now. Build. Plan to succeed.

Photo Study 62: HDR Photo Merge

THE PARTICULAR SCENE I'VE CHOSEN to use for this study is from the floor of the largest high school *field house* (a term we use in Indiana for a school gymnasium, most of which are devoted in part to basketball) in the world. It also happens to be where I went to high school. This interior is a challenge to photograph. It's a large space, obviously, which makes lighting problematic. The overhead lights brighten the floor while the stands remain in shadow. During the day, light comes in through windows in the doors at the top of the concourse. Even so, the ceiling also looks quite dark.

One way around this problem (that doesn't require thousands of dollars in additional lighting and a crew of 25 to bring it in and set it up) is High Dynamic Range (aka HDR) photography. I've become quite the fan of HDR photography over the last few years. In fact, I like it so much I've written two books about it since the first edition of this book. The premise of HDR is very simple: you can capture a wider total range of light, from very little to very much, with more than one photo than you can with a single shot.

You do this by mounting your camera on a tripod and taking three or more differently exposed photographs of the same scene. The shots, as seen in Figure 10.40, run the gamut from dark to light. The point is to get at least one photo that has the bright areas of the scene under control (so they don't *blow out* or turn completely white), one where the dark areas aren't so dark you lose all detail, and one in the middle.

After you take the photos and download them onto your computer, PaintShop Photo Pro has a routine called HDR Photo Merge that combines all the exposures together and allows you to make a few creative decisions.

The Merge

HDR Photo Merge is a very simple, yet effective, tool for creating basic HDR images. I say *basic* because there are other programs out there that specialize in virtually every aspect of HDR and offer quite a few different settings and options. PaintShop Photo Pro, as it stands now, gives you two HDR settings (which sounds pitiful, but is better than you may think).

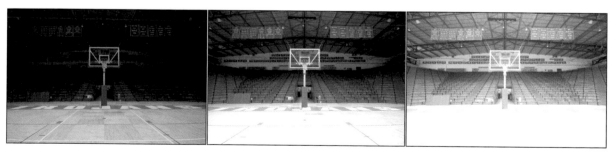

Figure 10.41
HDR photography uses bracketed photos.

The first task is to collect your bracketed photos.

1. Take the bracketed photos and download them to your computer. If you want to use your own raw editor like I did to convert the photos from raw to another format (TIFF or JPEG), do so now.

2. Open PaintShop Photo Pro and switch to Full Edit mode.

3. Select File ❯ HDR Photo Merge. This opens the HDR Photo Merge dialog box, which at the moment is blank (see Figure 10.42).

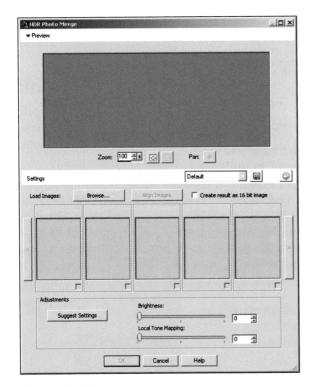

Figure 10.42
HDR Photo Merge.

4. Choose Browse and navigate to the photos you want to use. Select them (see Figure 10.43) and choose Open.

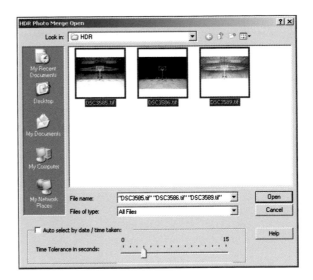

Figure 10.43
Choosing bracketed photos.

5. Select the HDR options you want to use, as shown in Figure 10.44. They are the following:

- **Browse:** Adds more images if you missed some.

- **Align Images:** Makes sure that PaintShop Photo Pro aligns the images according to their content and not simply their size. If you've shot using a steady tripod, this isn't always necessary.

- **Create result as 16 bit image:** Generates a 16-bit image to edit rather than a normal 8-bit image. Check this if you want to create the highest possible quality image. Sometimes that matters. At other times, it's pretty hard to tell any difference.

- **Thumbnails:** Unchecks or checks images to remove or add them from the process. This is often helpful if you think the image is too dark and want to take a dark exposure out of the mix. Be careful not to throw away good information. Try to use the settings below with all your images.

 Notice that PaintShop Photo Pro read my photos out at -3.9, -1.9, and 0.0 EV. (EV stands for Exposure Value, which in this context is a way to measure differences in exposure from the "correct" exposure of 0.0 EV.) Technically, they were shot at -2.0, 0.0, and +2.0 EV. Don't worry too much about that. As long as the difference between them is roughly the same as what you shot, you'll be okay.

- **Suggest Settings:** Gives PaintShop Photo Pro permission to tell you what you think the right settings are. Click it to set the Brightness and Local Tone Mapping. I normally press this to see what happens.

- **Brightness:** Raises the overall brightness of the image. Adjust to taste.

- **Local Tone Mapping:** Increases the clarity of the image. This is the "HDR effect" in action. Lower values produce a more realistic image. Higher values create a more "otherworldly" effect, sometimes to the point of "too much of a good thing." Watch the preview as you adjust this setting upward and see how details are brought out of the shadows and the contrast is enhanced—up to a point. Beyond that point, you'll start to see halos surround everything. I was aiming for a balance between the back wall and the stands in Figure 10.44.

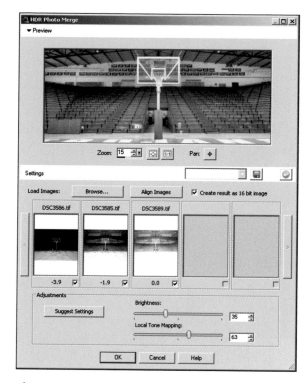

Figure 10.44
Choosing HDR options.

6. Select OK to finish. PaintShop Photo Pro generates the final image and should spit it into the Full Editor, ready for you to continue working.

At this point, you can be done, or not, depending on what you want. If you want to finish here, you can. I retouch my tone-mapped HDR images (see Figure 10.45) just as I would a normal photo right out of the camera. Continue reading to learn more about that part of the process.

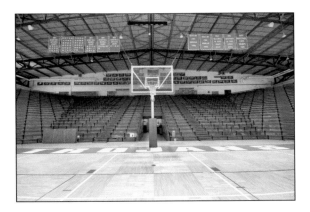

Figure 10.45
The initial tone-mapped HDR image.

Editing

Each image will be different, of course, but I tend to go through a regular series of steps with each image. The point is to end up with a final shot that is artistically and photographically what you want. Here are the things on my checklist:

- ▶ **Sharpness:** I start here. If the image isn't sharp enough, I'll use Unsharp Mask to fine-tune it (see Figure 10.46).

- ▶ **Noise:** HDR often generates images with more noise than traditional digital photos, especially if you're turning up Local Tone Mapping a lot. Use Digital Camera Noise Removal (see Figure 10.47) to take some of it out. Be careful not to overdo it and remove details. If you're up for the extra work, mask different areas of the image and create custom noise removal layers for the separate parts. You could really push it for certain areas and use a light hand in others. Resharpen select areas if necessary.

Figure 10.46
Sharpening adds crispness.

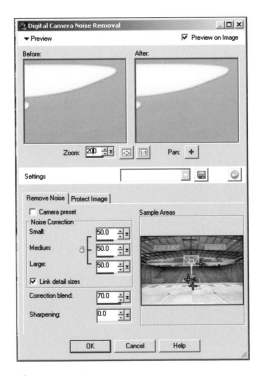

Figure 10.47
Noise reduction smoothes and blends.

► **Global Brightness:** Is the photo bright enough overall? If not, open up the Histogram Adjustment or Levels and correct it. If you nailed the HDR settings, this should not be much of a problem. Sometimes, the image looks better (and darker) when you adjust the contrast, so pay attention to how things work together.

► **Global Contrast:** Is the photo clear and contrasted? If not, use Curves or the Brightness/Contrast dialog boxes to adjust. I like contrast, so I normally use Curves to give it a little more. In Figure 10.48, I have created an odd-looking curve, which increased contrast but also brightened it a bit. In addition, I used the dropper to set the white-and-black points in the image, correcting the green color cast.

► **Color:** Are the colors correct? If not (and I haven't been able to fix them using Curves or another technique), I use Color Balance to either cool down or warm up the image. In this case, I think the image is just a bit too warm.

► **Saturation:** In general, I like creating highly saturated images. Therefore, I will use either the Hue/Saturation/Lightness routine or Vibrance (see Figure 10.49) to give it that little something extra.

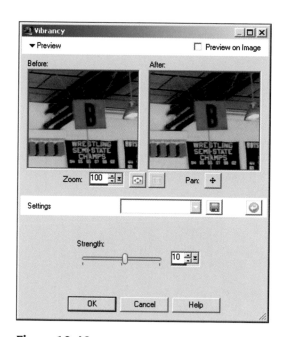

Figure 10.49
Adding a small punch.

Figure 10.48
Manage contrast with Curves.

▶ **Brush Enhancements:** Next, I use the Dodge and Burn Brush (see Figure 10.50) to selectively lighten or darken areas of the image. This is mostly an artistic decision. In this case, I brightened the wall in the background a bit with the Dodge Brush (limited to highlights with the brush to a lower opacity) and darkened the floor with the Burn Brush. (I exaggerated the effect for the figure.) If you haven't yet, PaintShop Photo Pro will ask you to convert your image to 8 bits if you want to use these brushes. That's one reason I save this for the end. Save your work beforehand as a 16-bit file and then convert the image to RGB 8-bits/channel and Save As another file if you want to preserve your work history.

Figure 10.50
Darkening midtones in the floor.

▶ **Remove Lens Distortions:** I remove lens distortion (Effects ❯ Distortion Effects ❯ Lens Distortion) or Perspective Correction before I straighten and crop because distortion tools are meant to work with the image the camera took, not something that has been changed.

▶ **Straighten:** With all the other adjustments done, I'll straighten the image, if necessary. To preserve the other layers, make sure that Rotate all layers and Crop image are unchecked.

▶ **Save Master:** I'll make sure that I have the image saved as a master .pspimage.

▶ **Crop and Publish:** I like to save cropping for last because sometimes I change my mind on what I want to do with the image. If I crop and save that as the master image, all the work I've done outside of the cropped area is lost forever. This way, I can preserve the master and publish the cropped image. The way I do this is to crop the image where I want and then choose Image ❯ Save As and save it as a new .pspimage, or simply go directly to File ❯ Export and save it as a JPEG to distribute on the Web.

Finishing the Photo Study

There you have it: HDR from start to finish using a nice shot of my high school field house. Figure 10.51 shows the final image. I hope you can see the potential of HDR and decide to give it a try. Remember, it's composed of two very important, yet different, tasks. The first is photography. You have to go out and take the bracketed photos.

That requires a bit more investment than normal photography, but the results can be astonishing. The second aspect of HDR is in the software. Without merging the brackets, you've got nothing. I like to extend the process into editing as well, which allows me to use all the tips (and more) that I've shared with you in this book.

Figure 10.51
Challenging interior shot made possible with HDR.

Photo Study 63: Firetruck Tour

OUR LITTLE FAMILY (at the time, we only had two kids in 2004) took a trip with my best friend and his family to his parents' lake house one summer weekend, and Figure 10.52 is a photo of Anne and Ben getting a tour inside a fire truck. It was the weekend before the Fourth of July, so the atmosphere was festive, and the local Fire Department had their trucks on display.

Figure 10.52
Getting the grand tour inside a fire truck.

Small Adjustments

I've opened this photo up in Smart Photo Fix in Figure 10.53 to see what it suggests. Very minor changes result in the photo looking much brighter. It looks better, so I'll keep it.

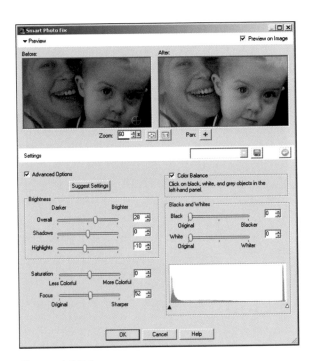

Figure 10.53
Starting with Smart Photo.

With the photo brighter, the noise is more obvious. I've opened the Digital Camera Noise Removal dialog box in Figure 10.54 and have chosen a few extra sampling regions. This helps point the program to the areas we definitely want smoothed.

The noise reduction softened the focus, but I like it. It adds an artistic element to the photo. Despite liking the soft focus, I want to enhance the contrast. I'll call upon a combination of Curves and the Local Tone Mapping filter to achieve this, as seen in Figure 10.55. Curves added contrast, and Local Tone Mapping enhanced it (see Figure 10.56). Just what I wanted.

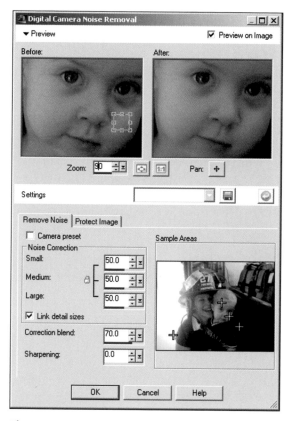

Figure 10.54
Reducing noise.

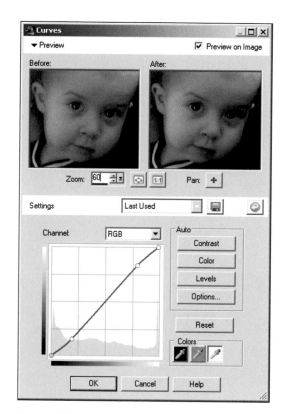

Figure 10.55
Curves for contrast.

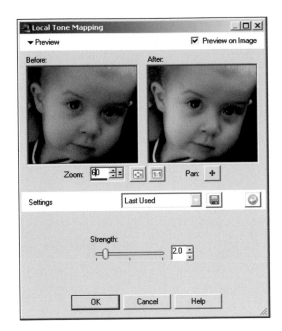

Figure 10.56
Tone mapping for oomph.

Figure 10.57
Now we can see them better.

Finishing the Photo Study

In retrospect, this photo was pretty dark and noisy in its original form. The scene had too wide a dynamic range for the camera to handle. The area to the left was blown out, and the area to the right was featureless.

After making the adjustments shown previously, I decided to pull out all the stops and recompose the photo to make it portrait-oriented as opposed to landscape. That rendered the unsalvageable areas of the photo irrelevant. I also thought twice about the softness of the photo and lightly sharpened with Unsharp Mask. Figure 10.57 shows the final result.

Blinded by Content

If you're restoring or retouching your own photos, don't fall in love with the content so much that you forget to look critically at the color, contrast, brightness, focus, and composition. That's why you're here.

Photo Study 64: Sharpen and *Sprucen*

FIGURE 10.58 is another photo of my wife, Anne, and my daughter, Grace. They were outside on the front porch one afternoon being cute and giggly. I had just gotten a new lens for my Nikon D200 dSLR and decided to go out and take some casual shots.

This is a very good photo, which is why it's in this chapter. I want you to see that you can improve even good photos, that it's worth your time, and that yours don't have to look exactly like the JPEGs that come out of the camera. In fact, the more time I spend looking at the original JPEG (Figure 10.58), the more I see that the camera overprocessed it. The colors are too strong and the photo is too dark.

Figure 10.58
The camera JPEG.

dSLRs and Lenses

One of the great things about dSLRs is that you can change lenses. I have ultra-wide-angle lenses for landscapes and interiors, high-quality prime lenses for portraits and close-up work, and multi-purpose zoom lenses to be able to capture a range of different types of shots. The point being, I can invest where I want and get the types and quality lenses I need at the time.

I used my Nikon AF-S DX Nikkor 35mm f/1.8G to take the photo in this study. I like this lens for portraits because I can get in close to my subject and the photos look very natural. If I want to stand further back and yet preserve the intimate feeling, I switch to my 50mm lens.

These lenses serve different purposes on *full-frame* dSLR bodies (cameras with a sensor the same size as a 35mm film frame). The sensor on my Nikon D200 has a diagonal length of 28.4mm, which is 1.5 times smaller than the diagonal length of a 35mm film frame, which is 43.3mm. That means the photos from my camera act as if they were cropped from a photo 1.5 times larger than it is. Therefore, my camera has a *crop factor* of 1.5, which affects the field of view. When I use a 35mm lens, my photos are comparable to those shot with a 52mm lens on a full-frame dSLR.

Working the Image

I'm going to use this study as another example of working with a raw photo. If you are using a camera that supports only JPEGs, I encourage you to follow along anyway. Here we go:

1. Double-click the raw image in the PaintShop Photo Pro Organizer, as shown in Figure 10.58 to begin editing the photo. If you select the image and choose Express Lab, you'll open the photo in the Express Lab with Smart Photo Fix running (which isn't what I want to do at the moment).

2. Make adjustments using the Exposure, Brightness, Saturation, Shadow, and Sharpness sliders. I am looking mainly to see that the image is correctly exposed and colored in this step. If I see problem areas that I can take care of now (for example, the image is too dark), I work with them. Otherwise, I don't fret over the individual settings too much. Does it look like it needs more color? Then I increase the Saturation. That sort of thing.

In this case (see Figure 10.59), I increased the exposure, saturation (remember, this is raw data—you're not working with JPEG), sharpness, and luminance noise reduction all by a small amount. I'll tackle the rest later if it needs it.

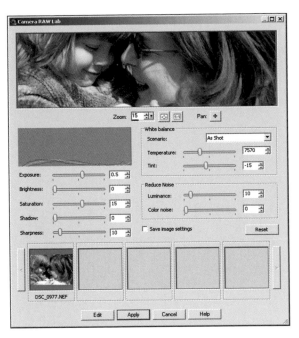

Figure 10.59
Making small changes in the Camera RAW Lab.

Working with JPEGs

For those of you working with JPEGs, each of these raw photo options is available to you in the Full Editor, whether from Smart Photo Fix, Unsharp Mask, noise reduction, Hue/Saturation/Brightness, and so forth. You'll have to open those dialog boxes up separately, of course. And in general, you'll have less "headroom" to push the settings to their extremes before the photo starts looking bad.

3. Make white balance adjustments, if necessary. Things look good here. I like zooming out to get a sense of how the photo looks as a whole.

4. Choose a noise reduction type and strength, if desired. I've increased it a bit, but nothing dramatic. Make sure to zoom in to get a closer look at the effects of increasing noise reduction.

5. Apply the settings if you don't want to continue working with the image or choose Edit to apply and open it in the Full Editor.

6. With the image open in the editor, continue as you would any other photo.

Finishing the Photo Study

Although I wanted the photo to be more colorful than the original preview in the Camera RAW Lab, I didn't want to oversaturate it like the JPEG that was processed by the camera. I knew I could increase saturation in the Lab and finish the job using Vibrancy in the editor. (I settled on a surprisingly strong Vibrancy setting of 35.) I did the same for brightness and contrast. I brightened the shadows some with Highlight/Midtone/Shadow and finished with a small Levels adjustment to add some contrast back in.

In a lot of ways, this is how it should be. There was nothing irritating to clone away; no damage to repair, tears to fix, or gross miscomposition to adjust. The photo was clean, good, and required little in the way of editing. It did benefit from my efforts, however, which is the point. Figure 10.60 shows the final result.

So Long and God Bless

I'm excited to have had the opportunity to update this book to reflect changes in PaintShop Photo Pro as well as my own abilities. I wish you the best as you retouch and restore your photos!

Sincerely,
Robert Correll

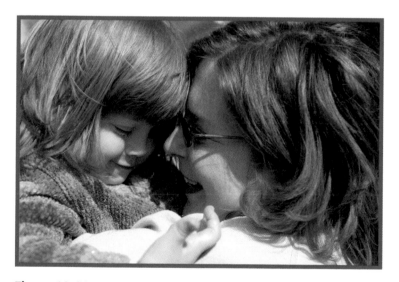

Figure 10.60
A little work pays off a lot.

Paint Shop Pro Tools

 Pan: Click and drag yourself around an image that's zoomed in. I rarely use it because most of the time I just zoom out and then back in where I want to see. Lots of people swear by panning, though.

 Zoom: Click in the image to zoom; right-click to zoom out. Another tool I rarely use. I like to use my mouse wheel to zoom in and out quickly. I also use the wheel on my Wacom pen tablet. There are times, however, when the wheels don't want to work so I select this tool to get back to zooming.

 Pick: Click to pick. A finicky tool if there ever was one. Make sure you are picking the right object. There are times when it's a good idea to hide a layer to get at the object you want on another layer. Despite what the name implies, you can move, scale, rotate, and deform objects with this tool. I often use this to resize a layer at the end of the process instead of cropping.

 Move: Seemingly redundant, but I do find myself using it at times. If you have linked layers, this is the only way to move them together. In addition, if you hold the Shift key down when you click and drag, only the material on the current layer is moved. That prevents a lot of inadvertent selections in complicated files.

 Selection: Muy importante for a graphic artist. Less so for a photo retoucher. Selections can help you selectively apply effects or modify parts of an image. This is many tools in one because you can change the type of selection in the Tool Options palette.

 Freehand Selection: Can be Freehand, Point to point, Edge Seeker, or Smart Edge. Each has its advantages. I use Point to point when I want to make a selection quickly where the borders don't need to be exact. Freehand is more exacting, and Edge Seeker and Smart Edge find edges for you. Try each of them out and compare.

 Magic Wand: Selects by matching pixels of an image (can be adjacent, not adjacent, and even on different layers) within a certain tolerance. Most of the time, you'll use color as the criterion, but you can change this.

 Dropper: Loads the color you click in your photo into the Materials palette. Left-click for foreground; right-click for background.

 Crop: Crops an image to the size and aspect ratio you choose. There are a lot of cool little features to the Crop tool, such as "Crop as New Image," which creates a new image with what you're cropping and leaves the original intact. You can also rotate the crop window or rotate the photo upon cropping.

 Straighten: Used after scanning or with digital photos where you accidentally had the camera out of alignment. Straightens an image. Be careful to select the right options. You can straighten individual layers and automatically crop.

 Perspective Correction: Useful in retouching when it's obvious that the perspective is a bit out of whack.

 Red Eye: Pretty self-explanatory. Click to correct someone's red eyes.

 Makeover: Five tools in one. The original Makeover tools are the Blemish Fixer, Toothbrush, and Suntan. Sounds like a pretty good spa treatment to me! Two tools made their appearance in X2: Eye Drop, which added whitening eye drops to eyes, and Thinify, which compressed pixels to make people look thinner. I can't wait for Nose Wiper and Waxer.

 Clone Brush: My all-time favorite tool. Take parts of a photo and paint them to another part. You'll use this to cover up things, remove things, clean up dust and specks, and even clone from other photos. Know it. Trust it. Clone it.

 Scratch Remover: Pretty good tool, actually. It's like applying the Clone Brush in a straight line.

 Object Remover: I've used this, and it's very good for removing objects quickly. Your mileage may vary, depending on the complexity of the background.

 Paint Brush: Paints what you have in the Materials palette onto the canvas. Lots of options and different choices for brushes.

 Airbrush: To be truthful, I've never really figured out why this is needed. I just use the brushes. However, if you want to get technical, the longer you hold the mouse button down, the more paint is applied with the Airbrush. With the Paint Brush, the full amount is applied immediately.

When Selected

My entries in this list assume that you have selected the tool you are reading about at the time and it is active. I got tired of typing, "When selected..." so I thought one note would do the trick.

 Lighten/Darken: Very useful when you want some artistic control over what you want to lighten or darken. Change brush properties and opacity to get different effects. Left-click to lighten and right-click to darken.

 Dodge: Not as strong as Lighten, and with different tool options. Very effective when you modify the opacity.

 Burn: Not as strong as Darken, and with different tool options. The terms, Dodge and Burn, come from the photographer's darkroom. Dodging is the technique used to lighten a print by underexposing it, and burning is used to darken the print by exposing it longer. Very effective when you modify the opacity.

 Smudge: Smudge pushes paint around with a brush and smudges it. Try it out for some interesting effects.

 Push: Push smudges paint around with a brush and pushes it. I couldn't resist that. Push is identical to Smudge except that Smudge picks up new colors as it smudges (like sticking your finger in wet paint), and Push doesn't as it pushes.

 Soften: A very useful tool. I use it when I clone and want to soften the edges of pixels or a border region between where I've cloned and the original photo.

 Sharpen: Another very useful tool for sharpening exactly what you need without applying an effect to the entire photo.

 Emboss: Cool effect where you brush over parts of the photo and it appears as if they are embossed.

 Saturation Up/Down: Changes the saturation where you brush. Left-click and brush to saturate; right-click and brush to desaturate.

 Hue Up/Down: Changes the hue where you brush. Left-click and brush to change hue in one direction on the color wheel; right-click and brush to go the other direction. This effect is best when it is used very subtly and the opacity is very low.

 Change to Target: Left-click to change where you brush to the foreground color in the Materials palette; right-click to use the background color. My first reaction to this tool was ambivalence, but I've been won over. Make sure to set the mode correctly in the Tools Options palette.

 Color Replacer: Replaces the color where you click with the foreground color.

 Eraser: Erases things. This doesn't work on vector objects or text created as a vector. Until you save the file or duplicate, move, or transform the layer you erase on, you can right-click with the Eraser and material will be unerased. This is very nice, but don't count on it as you work your photos. Think of it as a short-term feature that adds convenience.

 Background Eraser: Detects the border between where you click and the edge of the brush and erases the background (which is where you should be clicking).

 Flood Fill: Fills an area with the current foreground color, pattern, or texture. You guessed it: If you right-click, it fills an area with the background color, pattern, or texture.

 Color Changer: This replaces color ranges (as opposed to replacing a single color) pretty realistically. The Color Changer also preserves a photo's details as it changes the color.

 Picture Tube: Allows you to squish preset images out of a Picture Tube onto your canvas.

 Text: If a picture is worth a thousand words, this is where you add the words. I rarely use text when I am restoring or retouching. About the only time I use it is when I want to re-create text in a border, which was a common feature of photos in the 1960s and early 70s, or when I retouch house numbers.

 Preset Shape: Enables you to choose a preset vector shape, such as an arrow or thought balloon, and draw it on your canvas.

 Rectangle: Not surprisingly, this is the tool you should use to draw rectangles (and squares).

 Ellipse: Draws ellipses and circles.

 Symmetric Shape: Draws shapes. You can set the number of sides from 3 (triangle) to 1,000 (who knows what it's called, but it looks like a circle).

 Pen: Creates vector lines and nodes. A very powerful tool. I use it when I want to make a precise selection, most often when I am working with a mask.

 Warp Brush: Warps the photo in the mode of your choice. Modes include Push, Expand, Contract, Right Twirl, Left Twirl, and Noise. Great for losing weight or adding muscle.

 Mesh Warp: Instead of brushing a warp, use a mesh to drag nodes that warp the photo. This is an easy way to make people skinny.

 Oil Brush: Art Media tool that emulates oil painting. You must use this and the subsequent tools on an Art Media layer.

 Chalk: Art Media tool that emulates chalk drawing.

 Pastel: Art Media tool that emulates pastels.

 Crayon: Art Media tool that emulates crayons.

 Colored Pencil: Art Media tool that emulates drawing with colored pencils.

 Marker: Art Media tool that emulates marking with a marker.

 Palette Knife: Art Media tool that emulates using a palette knife to lay down oil paint on a canvas, much like Bob Ross, my favorite PBS personality of all time.

 Smear: Art Media tool you should use to smear paint (or the other mediums) around the canvas.

 Art Eraser: The tool you use to erase Art Media.

Methods Summary

THIS APPENDIX IS A SUMMARY of some of the important methods I use and the explanations of why. This information is scattered throughout the book, but collecting it here lets me focus on the techniques instead of the photo studies.

Working Layers

I don't perform multiple edits on a single layer. I create working layers at each stage by duplicating the last working layer and renaming it according to what I'm doing (e.g., Unsharp Mask), or by performing a "Copy Merged." Figure B.1 shows the Layers palette from one of the finished photo studies.

Sometimes, I put the settings I used in the name of the layer so I can keep track of more details. For example, if I increased the Vibrancy by 30, I might name that layer "Vibrancy +30." Other times, I abbreviate. For example, I might put "USM" for Unsharp Mark or "Sat +15" to indicate that I increased the saturation by 15.

Figure B.1
Tracking changes with working layers.

Duplicate Versus Copy and Paste

It's easier to duplicate a layer and erase or mask out what you don't need than it is to select what you want (assuming it doesn't fill the canvas), copy it, paste it to a new layer, and then try to align it precisely. That's because a duplicate layer starts and ends perfectly aligned without you having to do a thing to it.

For example, in Chapter 10, Photo Study 61, I wanted to brighten Anne's face but not the background. I duplicated my last working layer, brightened it, and then erased around Anne's face instead of selecting her face on the working layer, copying it, and pasting it as a new layer to brighten it. If I had done the latter, I would have had to spend time trying to line the pasted material up with what was underneath. That's a major headache when you're working with photos, and it's why I duplicate layers and erase or mask whenever possible.

One technique I use when I absolutely have to is select the Paint Brush and dab some obnoxious color at the four corners of the palette (see Figure B.2, which are Ben's nostrils from Photo Study 48) on a layer that I simply must copy and paste and don't want to realign. This sets the boundaries of Select All to the canvas, which means that when you paste what you've copied, it lines up perfectly.

You can also promote a selection to a layer. Make the selection and hit Ctrl+Shift+P. This works better than duplicating a layer and erasing in many situations, but be careful. You can't promote a selection from more than one layer at a time (in other words, you can't copy merged and promote the selection at the same time). You also can't unerase material from the layer you promoted because it was never there to begin with. If neither of those situations bother you, try promoting selections to automatically align them.

Figure B.2
Setting corners to copy the entire layer.

Copy Merged

I use the Copy Merged command to lock in edits from Adjustment layers or layers with transparent areas , such as Mask groups or layers that I've erased on. I use the term "Copy Merged" sometimes as shorthand to indicate this process, or give the basic commands: Copy Merged, and Paste As New Layer.

The detailed steps are pretty simple:

1. Make sure that the layers you want visible are visible. It doesn't matter what layer you have selected because this technique copies everything that is visible, although I normally select the layer I want to paste above, which is usually the top layer. Figure B.3 shows a Layers palette with layers ready to be consolidated and changes locked in.

Figure B.3
Ready to be copy merged.

2. Choose Edit ❯ Copy Special ❯ Copy Merged (Ctrl+Shift+C).

Your keyboard shortcut might be different for Copy Merged. Older versions use Ctrl+Shift+C, but X3 has this blank on the menu. The odd thing is that Ctrl+Shift+C works, whether the menu has it listed or not.

To "officially" change it (so that the keyboard shortcut shows up in the menu listing), select the View ❯ Customize menu and then choose the Keyboard tab. Choose Edit from the Category list and then select Copy Merged from the Commands list. Click in the Press New Shortcut Key box and then press the combination of keys you want to assign to the command (see Figure B.4). Press Assign to assign it; then Close to get out of the dialog box.

3. Select the layer you want to paste above from the Layers palette and choose the Edit ❯ Paste As New Layer menu (Ctrl+V). The new layer will appear and be selected.

Figure B.4
Customizing keyboard shortcuts.

4. Rename and continue. When I do this, I tend to paste the result and rename it "Merged" (see Figure B.5) and then duplicate that to start a new working layer. That keeps the merged layers separate from edits, which saves me the time of having to copy and paste over again if I need to delete a working layer (because I don't like the result) and start over.

Figure B.5
Merged layer pasted and ready to move on.

Figure B.6
Clone layer in action.

Figure B.7
Locking in changes.

Cloning Layers

For the most part, I do not clone directly on a photo layer unless I have to. I create an empty raster layer above a working layer to clone on (see Figure B.6) and check the Use All Layers option.

Later, I'll lock the changes in with Copy Merged (see Figure B.7). This doesn't work with tools like the Blemish Remover or Scratch Remover. In those cases, I create a duplicate working layer specifically to use those tools on.

Masking Versus Erasing

Just about every time I use the eraser in a photo study I could have used a mask and vice versa. The truth is, though, masks are much better in most cases. Here are some of the reasons I generally prefer to use a mask over the eraser:

► You can see the mask in the Layer palette. That makes it more obvious (even to yourself) what you're doing.

► You can stack masks inside a mask group to create very complicated behaviors.

► It's easy to create a gradient on a mask layer so you gradually transition from opaque to transparent or vice versa. You can also experiment with textures or patterns. The creative possibilities are endless, but fairly simple to apply.

► You can come back and edit masks later if you see something you missed or accidentally erased.

► You can also create complex selections from masks, invert them, stack them, and so forth.

Despite these things, the Eraser is still very useful—it's easy to understand, simple to use, and doesn't bloat the Layers palette with extra layers and layer groups. You can modify the opacity of the eraser as well as other brush parameters like density and rotation. You can use the default or choose a different brush if you like, and load or change Brush Variance values like Position Jitter. You can also unerase material that you've previously erased by right-clicking as you "erase" instead of left-clicking.

Frankly, I have had a hard time getting used to being able to unerase. I've always considered the eraser a "use it and lose it" tool. However, I've performed tests on multiple layers in the same file, performed adjustments on them, saved the file, closed PaintShop Photo Pro, and come back to find that unerase still works.

There are a few caveats, however. First, you may not be able to unerase material from an old Paint Shop Pro file. Second, you'll get black in areas where there was no material to unerase. That's one way of knowing it doesn't have data hidden in the file somewhere to put back on the layer.

Adjustment Layers

I rarely use them, despite the fact that they are nifty (I do love the fact that they have a built-in mask, ready to be edited), because I use working layers instead. Comparing different effects with different adjustment layers is harder to do on the fly than just toggling different working layers on and off. If you love using Adjustment layers, then modify your workflow to take that into account. There is no actual difference in the photo whether you use them or not.

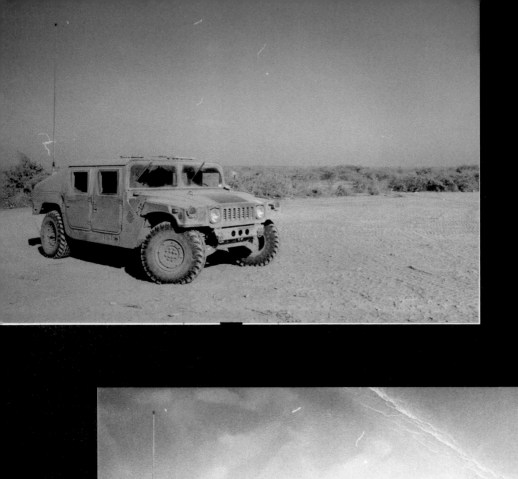
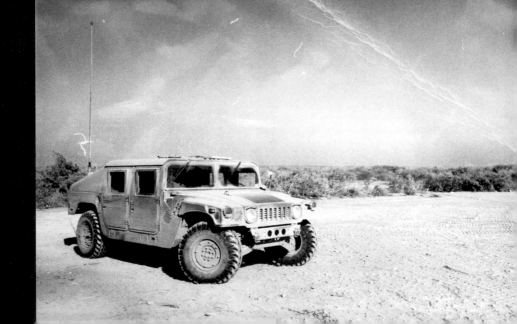

Download the Bonus Chapter

T HIS APPENDIX SHOWS YOU WHAT'S waiting for you in the bonus chapter, "Artistic Restoration and Retouching." It's a free download available from the Course Web site. You can find it at: www.courseptr.com/downloads.

The studies are no less challenging than the more traditional retouching and restoring photos you've seen in the rest of the book. They are fun and rewarding in their own right.

Some of the studies are pretty involved, while a few are very simple. Coming up with ideas is undoubtedly the hardest part of artistic restoration and retouching. Use what you see as a starting point: a place to find ideas, inspiration, and encouragement. Have fun!

▶ **Photo Study 65: Cool Cat**—Edge effects and equalizing the histogram turn a photo of my former cat, Beetlejuice, into an artistic print.

▶ **Photo Study 66: Roses Are Red—**This photo draws attention to our wedding flowers by oversaturating them.

▶ **Photo Study 67: Pen and Path—**Watch me take a photo of my son's dump truck (a foam wall-hanging my wife made for his birthday) and turn it into vector art.

▶ **Photo Study 68: Adding Dramatic Film Grain—**Here, I take an otherwise normal photo of a concrete worker and turn it into something more memorable.

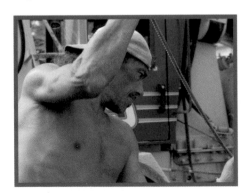 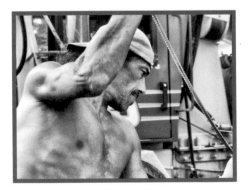

▶ **Photo Study 69: Liquid Sky**—In this study, I use displacement maps to create a decidedly less boring "liquid" border around a photo of clouds.

▶ **Photo Study 70: Unleashed Talon**—I took this black-and-white photo of an airplane on static display at college. Watch me turn it loose 20 years after the fact.

▶ **Photo Study 71: Smudge Painting**—See why smudge painting is so cool as I try my hand at it.

▶ **Photo Study 72: Reflections**—Instead of making the border look like drops of water, I turn the entire photo into a watery reflection.

▶ **Photo Study 73: Photo De-Restoration**—I'm doing some weird things in this photo—retouching a photo of a HMMWV (aka Humvee) in Somalia only to make it look older and beat up. Fun stuff!

Index

Course Content

Submitting an Assignment.

An instructor may choose to use the Assignment feature to send and receive your course work. To submit an assignment-

1. Click on the **name of the assignment** you want to complete.
2. *Optional:* enter any comments you want in the Comments box.
3. Click on the **Browse** button.
4. Locate and select the file you want to attach.
5. Click the **Open** button.
6. *Optional:* To attach additional files, click on the Add Another File button. Click Browse, locate another file, and click Open.
7. **Do only one of the following:**
 Save: To save the assignment to send at a later time, click the Save button.
 Submit: To send the assignment to your instructor, click the Submit button.
8. **Click OK.**

Submitting an Assignment with SafeAssign

1. Find the assignment description for the assignment you are submitting and click **View/Complete** under that assignment.
2. Add any **Comments** in the Comments box.
3. Click the **Browse** button to upload your file. You should upload only Microsoft Word, text, rtf, html, or PDF documents using this submission method. If you have a file in a different format, please discuss this with your instructor before submitting.
4. To finish submitting your assignment, click **Submit**.

Viewing your SafeAssign Originality Report

It will take between 1 hour and 3 days for your originality report to be generated. To view your originality report and comments from your instructor follow the same steps you used to Submit the SafeAssign Assignment (outlined above). Click OK o the screen that indicates you have already turned in the assignment.

You can view your grade on this screen as well as on the My Grades button in your Blackboard course.

Marking an item Reviewed.

⊙ Mark Reviewed

An instructor can use the review status feature to track the course content that students have reviewed. To mark an item as reviewed, simply click on the button.

Note: The mark reviewed button will change to reviewed.

Taking An Assessment (Test, Quizzes, Exams)

There are several types of Assessments that you can take in Blackboard.

1. Find the **Assessment** that you would like to take.
2. Click on the name of the Assessment.
3. Click the **OK** button to confirm that you are ready to take the Assessment. (The gray box at the top of the Assessment provides you with information about the assessment.)
4. When you are finished taking the assessment, click the **Submit** button. Then click **OK** button to confirm assessment completion. Click the OK button to see your results. *Note: Some assessment types will have to be graded by your instructor. Your results will then be posted in the My Grades Menu button.*

Course Tools

Viewing Grades

1. On the course page click the **My Grades** menu button.
2. Click the OK button when you are finished.

Creating a Student Homepage

1. In the course page, click the **Tools** shortcut under the course menu.
2. Click on Homepage.
3. In the **Homepage Information** section, enter your information in the **Introduction and Personal Information** boxes.
4. In the **Upload an Image** section, click the **Browse** Button, locate and select the image you want to display and click **Open.**
5. In the **Favorite Websites** section, enter Web site information.
6. Click **Submit** when you are finished.
7. Click **OK.**

Communication

Sending a Message

You can send a course specific Message to any user enrolled in a course without leaving Blackboard.

1. On the Course Page, click the **Communication** button under the main Course Menu.
2. Click on **Messages.**
3. Click the **New Message** button.
4. Click the **To** button.
5. Select the recipient in the **Select Recipient** box, and click the **Add Recipient** button (right arrow). Repeat for all users you want to send a Message to.
6. Click the **Submit** button.
7. Enter a message subject in the **Message Subject** box.
8. Enter your message in the **Body** box.
9. Click Submit button and click OK.

IVY TECH COMMUNITY COLLEGE

Home Help Logout

Blackboard Student Guide
Version 8.0
Updated July, 2008

Access Blackboard at http://dl.ivytech.edu

Ordering Your Text Book and Materials

All text books and materials for online courses can be ordered through the Online bookstore. You can also order Microsoft and other software at discounted rates. To order the texts required for your courses, go to http://www.ivytech.bkstr.com.

My Institution Page

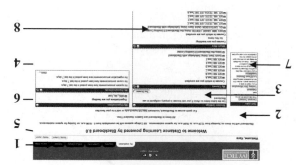

1. **Tabs**– Navigate common areas of Blackboard.
 - **My Institution**–Brings you back to the default page as shown above.
 - **Courses**– takes you to a page and displays all courses in which you are enrolled.
 - **Community**– Lists all organizations in which you are enrolled.
 - **Virtual Library**– Takes you to the college's virtual library for all your research needs.
 - **Scholar**–Takes you to the Scholar site where you can add, categorize, and socialize about the web sites you find useful.
 - **Click for Help**– Here you will find answers to frequently asked questions about Blackboard and other College tools.
2. **System information**- Information about the system. Read each time you log on.
3. **Browser Settings**- Test your computer for the correct browser settings
4. **My Courses**- Links directly to your courses
5. **Modify Content/ Modify Layout/**-Allows you to customize your My Institution Page.
6. **My Organizations**- Links directly to your Organizations
7. **Hot Links**—Links directly to frequently used Ivy Tech websites.
8. **What's New**—See quickly the new material posted since you last logged in to Blackboard.

Navigating your Courses

To get to your courses, simply click on your course on the My Institution Page. Once inside your course you will see the following.

1. **Course Menu**-Used to navigate to your course content items. Descriptions of each menu button are listed below.
2. **Tools**– Communication takes you to e-mail, messages, group pages, discussion boards and much more. Course Tools takes you to the users manual, digital drop box, and My Grades and many more.
3. **Course Frame**– This area will display all course content once you click on a menu button. By default the course announcements are displayed each time you enter your course. Please make sure to read all announcements.

Course Menu Items:

- **Announcements**– All course Announcements from your instructor will be displayed here.
- **Syllabus**– Click here to access the course syllabus and course calendar.
- **Class Sessions**– Your course typically is broken into sessions. Click here to access each session of your course, as well as your assignments and tests and quizzes...
- **Resources**– Click here to access any resources your instructor wants to share with you.
- **Discussions**– Click here to access the course discussion boards.
- **My Grades**– Click here to access your grades for this course. Note: You are the only one that has access to your grades, besides the Instructor.
- **Professor**– Click here to access information about your professor.

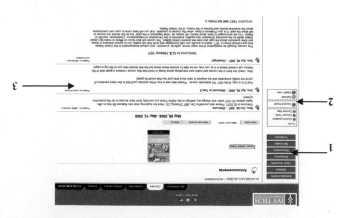

Communication (continued)

Reading a Message
1. On the Course Page, click the **Communication** button under the main Course Menu.
2. Click on **Messages**.
3. Click the Inbox button.
4. Click on the subject name to open the message.
5. Optional: *Click the Reply, Reply All, or Forward button. Select recipients, enter message, and click Submit.*
6. Click the **OK** button when you are finished reading the message.

Note: In the inbox, you will see an envelope icon which is closed or open. Closed means you have not viewed the message and open means you have viewed the message.

Sending an E-mail Message
You can also send an email to any user enrolled in a course without leaving Blackboard.

1. On the Course Page, click the **Communication** button under the Course Menu.
2. Click the **Send E-mail** button
3. Do One of the following:
 To send an e-mail message select either **All Users**, **All Groups**, or **All Instructors**.
 To send an e-mail message to a specific user or groups **Select Users** or **Select Groups** and select the users or groups you want to send the message to.
4. Enter a subject for the message in the **Subject** box.
5. Enter your message in the **Message** box.
6. Optional: *to send an attachment, click attach file, click browse, locate file and click Open.*
7. Click the **Submit** button to send the message.
8. Click **OK**.

To read email messages
1. Log into your Campus Connect Account and click the email button

Using Pronto

Pronto is an Instant Messaging (IM) tool. Pronto is Ivy Tech specific so you need to know only the user ID of the student, faculty, or staff to find them in Pronto. You can use the Ivy Tech White Pages (http://whitepages.ivytech.edu/) to find a user ID you don't know.

Send an Instant Message (IM)
Double-click the user's name, type a message in the chat box and press **Enter** on your keyboard.
To respond to an instant message, type your reply into the same text box and press **Enter**.

Using Pronto (continued)
Using Voice Chat
To "call" a user for voice chat, double-click the user's name and click the **Phone icon**. Once the user accepts your call, hold down the **Talk** button while you speak into your microphone. *Note: You must have a microphone and speakers to use this feature or a microphone mounted headset.*

Using Group Chat
You can communicate with several people at once via IM (like a chat room), or voice chat (like a conference call), using Group Chat.

1. Invite users by **selecting their names** from either the Classmates or Contacts tab.
2. With the appropriate names highlighted, click the **Contacts** Menu. Select **Invite to Group Chat**, followed by **New Group Chat**.
3. **Enter a name** for your Chat Room in the Invite to Group Chat window.
4. Once users have joined, type a message, or click the **Phone icon** and hold down the **Talk button** (or click the **Lock button**, for hands-free mode), to communicate with the entire group.
5. When finished, click the **disconnect button** to stop the voice chat.

Discussion Boards
Viewing a Discussion Board Forum
1. On the Course page, click on the **Discussions Menu** item. (You can also click the **Communication** button under the main Course Menu and click Discussion Boards).
2. Click the **forum** name to access the forum.
3. Click on the **thread** name to view that thread and all replies.

1. **Thread** – Click the Add Thread icon to add a thread to the forum.
 Collect– Click Collect button to collect all threads and replies to read them all on one page. Note: you must first click the box next to all threads you want to Collect.
2. **Display**– By clicking the dropdown button you can select Show All, Hidden, Locked, or Published. This displays either all threads, those that have been saved, or those that have been hidden or locked by an Instructor.
3. **Threads**– This shows a list of Threads that were created by other students or Instructors in the course.

Creating a Discussion Thread

1. Click the **Add New Thread** button.
2. Enter a subject in the **Subject** box.
3. Enter the thread text in the **Message** box.
4. Optional: *To add an attachment, click Browse, locate and select the file you want to attach, and click the Open button.*
5. Click **Submit** when done.

Replying to a Thread

1. Click the **Reply** button to reply to a thread.
2. Enter text in the **Message** box.
3. Click **Submit**.

Groups

Viewing Group Information

Instructors can create groups to help students collaborate within a course.

1. Click on the **Communication** button under the **Course Menu**.
2. Click on the **Group Pages** button.
3. Click on the name of the group you would like to view that you are a member of.
4. In the **Group Members** section of the **Group Page**, the names of the all the members of the group are displayed.
5. Click on a students name to see the **Students Homepage**.

Adding a File to the File Exchange

You can use the File Exchange feature to post and access files from group members.

1. In the **Group** page, click the **File Exchange** button.
2. Click the **Add File** button.
3. Enter a name for the file in the **Name** box.
4. Click the **Browse** button.
5. Locate and select the file you want to add to the **File Exchange** and click the **Open** button.
6. Click the **Submit** button.

Removing a File from the File Exchange

1. In the **Group** page, click the **File Exchange** button.
2. Click the **Remove** button next to the file you would like to delete.
3. Click the **OK** button to confirm deletion.
4. Click the **OK** button to return to the **File Exchange** area.

E-mailing Group Members

You can also e-mail group members from the Group page as well.

1. In the **Group** page, click the **Send E-mail** button.
2. In the **To** section, select the group members you want to send the e-mail to.
3. Enter a subject for the e-mail in the **Subject** box.
4. Enter e-mail text in the **Message** box.

Emailing Group Members (continued)

5. **Optional**: *To add an attachment, click the **Attach a File** button and click the **Browse** button. Locate and select the file you want to attach and click the **Open** button.*
6. Click the **Submit** button to send the e-mail.
7. Click the **OK** button.

Using the Group Discussion Board

The instructor must create the group discussion board forums.

1. In the **Group** page, click the **Group Discussion Board** button.
2. See the section on **Discussion Boards** on the previous page to learn how to navigate them.

Getting Help

Click for Help

The Click for Help tab should be the first place you look for answers to any questions about Blackboard. The Click for Help tab contains quick guides to a number of Blackboard features and tools as well as answers to many commonly asked questions. There are also quick links to the Help Desk web site where you can submit a trouble ticket and the Feedback form you can use to give praise or express concerns about a course.

Using the Students Manual

If you ever have any questions on how to use any feature in Blackboard, you should first take a look at the Student Manual located in your course.

1. In the **Course** page, click the **CourseTools** button under the **Course Menu**.
2. Click the **User Manual** button.
3. Click a **Book Icon** in the **Contents** area to expand a topic and view all its subjects.
4. To search for **Help** information, enter the text you want to search for in the **Search** box and press **Enter** on your keyboard.
5. Click on a topic to view **Help** text for the topic.
6. When you finished, click the **red X** at the top right of your screen to close the window.

Helpdesk Information for Ivy Tech

Helpdesk hours (Indianapolis time)
Tuesday-Thursday 7a.m.-10 p.m.
Friday 7 a.m.-12a.m.
Saturday-Monday 24 Hour availability
Helpdesk requests received after hours will be processed the next business day.

Contact the Helpdesk

Toll Free Telephone: 1-877-IVY-TECH (1-877-489-8324)
Email:helpdesk@ivytech.edu
Online helpdesk request form
https://helpdesk.ivytech.edu/createissue.php

Always make sure to contact your Instructor or Local Distance Education Departments with any issues you might be experiencing.